MISS ULYSSES
from
PUKA-PUKA

DOCKSIDE SAILING PRESS®

Newport Beach, California

Newport Beach, California
www.docksidesailingpress.com

2

MISS ULYSSES
from
PUKA-PUKA

The Autobiography of a South Sea Trader's
Daughter

By

FLORENCE (JOHNNY) FRISBIE

Edited and Translated by Her Father
ROBERT DEAN FRISBIE

2nd Edition

Being a faithful reproduction of the original book written in
1946 plus additional unpublished stories by the author.

In memory of my mother
Ngatokura ꞌA Mataꞌa

Introduction to the First Edition

This is an authentic autobiography of a South Sea trader's daughter, Florence (Johnny) Frisbie. Parts One and Two were written in from memory, with occasional use of my journal when names and dates were needed. Parts Three and Four were taken principally from Johnny's own diary. Both diary and manuscripts were written in three languages—English, Rarotongan, and Puka-Pukan—and I have helped in editing and in translating from Polynesian languages to English. When it was a matter of straight narrative Johnny managed pretty well in English, but in exposition, description, and imaginative work she usually resorted to one of the Polynesian languages. Her vocabulary and style follow my own, because I taught her English, but she has a freshness, vitality, and natural felicity of expression all her own.

In translating Johnny's Puka-Pukan I have, time and again, found my English inadequate to interpret her mood, humor, and ingenious philosophy of life. Puka-Pukan is an excellent medium for poetical expression. It is not a primitive language serving only the bare necessities of intercourse, as so many of my European friends believe. A story can be told in Puka-Pukan as well as it can in English, and some stories can be told much better. The same applies to Rarotongan but in a lesser degree, for it has been corrupted by foreign influence. I only wish you could read the Polynesian languages, for then we could offer you a much finer story.

While writing Part Three, Johnny's head was confused by knowledge of many languages, among them Samoan, Fijian, English, and of course Rarotongan and Puka-Pukan, and while writing Part Four she was in the period of transition from Polynesian languages to English. It was not until toward the end of the book that English became her spoken language. Unevenness in diction was therefore inevitable, but we have thought it best not to attempt

uniformity, believing that her story, as it stands, is the record of a young mind, striving for self-expression and progressing from the Polynesian to the European way of thinking.

Johnny started writing her story in January 1945, when she was 12 years old, and I typed the final copy in July and August 1946. The finished work is, I believe, unique in South Sea literature, being the first book, to my knowledge, written by a native South Sea Islander. Johnny looks at civilization with eyes both appreciative and amused, incredulous and, at times, disapproving. I hope you will enjoy her story as much as I have enjoyed helping her write it, and I hope you will forgive the all too evident signs of the meddling hands of a middle-aged father.

Robert Dean Frisbie

Letogo, Samoa
September 15, 1946

Preface to the Second Edition

Miss Ulysses has been out of print seventy years, a very long time, and how lucky we are that she is getting a "face lift" at last. *Atawai wolo* (Thank you in Puka-Pukan!) to good friends and readers of Frisbie books, who over the years have persistently reminded me of the need for *Miss Ulysses* to be in print again, pointing out how it would inspire the new generation of writers.

While taking my time, as is common among atoll people (tut-tut on me!), a magical gift appeared: Gemma Cubero Del Barrio of Talcual Films, a film-maker living here in Hawaii, talked to me of a dream she'd had of making a Puka-Puka film. She even said we'd need to make the journey back to my ancestral island home. Well, memories of my childhood growing up in Puka-Puka flooded back— indeed, it was magical, a deep longing suddenly fulfilled.

The film *Homecoming* is due out in 2016. While celebrating the movie, as you can see, this book is a homecoming for me as well.

Added to the new edition are several stories I wrote that were not in the original *Miss Ulysses*. One, "I Become a Writer" might be a source of inspiration to you to take a paddle in two hands and begin your journey by paddling your canoe full speed ahead. As the mother of children keenly interested in expressing their stories in the art, and also driven by the need to learn a new language, I know the difficulties. I really, really hope that I will inspire you to take up the challenge.

<div style="text-align: right">

Florence (Johnny) Frisbie
Honolulu, Hawai'i
March 1, 2016

</div>

Contents

PART ONE

The Cowboys at Puka-Puka

Introduction to the 1st edition (Robert D. Frisbie) iii
Preface to the 2nd edition (Johnny Frisbie) v
We Sail to Puka-Puka 1
Elaine Joins the Family 7
At Home on the Far Islet 13
Our Puka-Pukan Neighbors 23
White Shadows on Puka-Puka 32
Our Mother Falls Ill 41
Our Mother Goes Away 51

PART TWO

Adventures in the Fiji Islands

We Leave for the Fiji Islands 60
Aboard a Leper Ship 67
The Black Islands 73
I Visit a Leper Island 77
The Old Lady Who Talked to God 84
I Go to School in Fiji 90
Araipu and the Bombardment 93
Ratu Somebody's Village 97
Demons and Sugarcane 105
We Sail on a Luxury Ship 108
Trade Goods for Puka-Puka 113
We Go to Sea in a Tub 118
We Return to Puka-Puka 122
I Become a Writer 128
We Leave to Work for Uncle Sam 143

PART THREE

The Treasure Island

How I Write My Book	151
Miss Ulysses at Sea	154
Cowboys in the Jungle	164
Night on a Haunted Island	172
We Explore an Uninhabited Island	178
The Sea Against the Land	188
The Hurricane	194
Life on a Desert Island	201
The Adventures of Captain Cambridge	209
From the Diary of a Castaway	214
The Gold Diggers	224

PART FOUR

The Cowboys Abroad

Ashore on a Siren's Isle	229
We Dance in the Moonlight	237
The Life on a Siren's Isle	242
Departure for Civilization	254
Brother Charlie	262
The Island that Died	274
Northbound for Penryn Island	278
The Bomber, the Commandant, and the Jeep	286

PART FIVE

Epilogue and Author's Notes

We Go to America	298
Return to Puka-Puka and Ghost Death Sickness	303
Epilogue	321

Glossary and Notes 324
Acknowledgments 327
Further Reading 328

Illustrations and Maps

Illustrations

Our House in Tahiti 3
Johnny and Mother Ngatokorua. Puka-Puka, 1938 4
Johnny and Father Robert Dean Frisbie 6
The Causeway Leading to Yato Village 8
Grandmother Tala's Cookhouse, Puka-Puka 25
Women of Ngake Village, Puka-Puka 27
Johnny Writing 141
Frisbie Family, Motu Kotawa, 1941 145
Typical 4-Man Outrigger Canoe 166
Suvorov After the 1942 Hurricane 196
We Searched the Rubbish Pile for Food 197
Johnny with Fish Spear, Rarotonga 268
Johnny and Papa, Rarotonga 270
Our House on Motu Toto, Penrhyn Isle, Where
 We Lived for 5 Months Waiting For Papa to
 Get Stronger 283
Papa, Johnny, and Captain Charles Powell,
 Army Doctor, Penrhyn Island 284
Papa and Johnny. Apia, Samoa 1946 292
Elaine, Papa, Nga, Johnny, Jakey. Apia,
 Samoa 1946 295
Johnny on *New Golden Hind*. Rarotonga 1948 300
Johnny, Nga, looking right, Elaine, far right.
 Queen's Surf Luau, 1956 322
Johnny and Elaine, 1998 323

Maps

Cook Islands and Puka-Puka ix
Travels of Johnny Frisbie in the Eastern Pacific 12
Travels of Johnny Frisbie in the Central Pacific 58

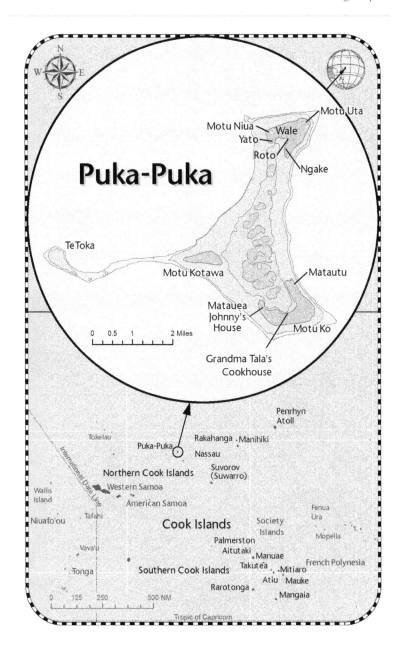

Puka-Puka

Motu Uta
Motu Niua
Wale
Yato
Roto
Ngake
Te Toka
Motu Kotawa
Matautu
Matauea
Johnny's
House
Motu Ko
Grandma Tala's
Cookhouse

0 0.5 1 2 Miles

Penrhyn
Atoll
Tokelau
Rakahanga Manihiki
Puka-Puka
Nassau
Northern Cook Islands Suvorov
(Suwarro)
Wallis
Island Western Samoa
Niuafo'ou Tafahi American Samoa
Fenua
Ura
Society
Islands
Mopelia
Cook Islands
Palmerston
Vava'u Aitutaki
Manuae
French Polynesia
Takutea Mitiaro
Tonga Southern Cook Islands Atiu Mauke
Rarotonga Mangaia

0 125 250 500 NM

Tropic of Capricorn

PART ONE

The Cowboys at Puka-Puka

1

WE SAIL TO PUKA-PUKA

My Grandfather Mata'a was descended from the war lords of Mangaia, which is one of the coral islands in the Lower Cook group. When still a young man he graduated from the Missionary School in Rarotonga and sailed to Puka-Puka, so that the fresh sea air would cure his lungs. He had the sickness called asthma, and later tuberculosis, which killed him. At Puka-Puka he married Tala, of the tribe of the Kati, and when the clean sea air of the atolls had eased his sickness he and Tala both served God as missionaries to Papua New Guinea. There he took long journeys back into the mountains and jungles, where he preached to the cannibals, baptized them, and built churches. Tala worked for the white missionary's wife, cooking, washing, and sewing. She learned to do these things well, and later she taught her daughters and their children the civilized way of living.

In Papua, Mata'a caught the jungle fever, which never left him, yet with all these sicknesses he lived to be an old man, and he had twelve children, most of whom were daughters. My mother was his fourth daughter. Of the three who came before her, two died when they were little girls, and for that reason Mata'a called my mother Ngatokorua, which means in English, "In Memory of the Two Who Died."

My father came from Tahiti to Puka-Puka in 1924, in Captain Viggo Rasmussen's schooner the *Tiaré Taporo*, to open a trading station for A.B. Donald, Ltd., of Rarotonga. First he married Taiki (Little Sea), a cousin of Ngatokorua, but he divorced her when she grew fat and lazy. Then he married Ngatokorua and straightway left with her to sail all over the Central and Eastern Pacific, from Fiji to the Marquesas. The people said that was as it should be, for when Mata'a and Tala had married they had sailed far and wide, and travel has been the lifeblood of my people from ages back when they sailed their double canoes from Asia to Easter Island, from Hawaii to New Zealand. My mother's first baby was born at sea aboard the *Tiaré Taporo*, but it came too soon and died, for my mother had been capsized in a boat on the Manihiki Reef and had hurt the baby when falling across the gunwale.

Then Charles Mata'a was born in Rarotonga and was adopted by Piki-Piki, an aunt of my mother. Later my mother and father were sorry they had given the baby away. He is now sixteen years old and is one of the champion boxers of the Cook Islands. I was the next child, and I was born in the Maternite in Papeete, Tahiti. Papa nicknamed me "Whiskey Johnny," because while my mother was in labor, he and his friend Captain Thompson were drinking Johnny Walker whiskey. Then, on October 8, 1933, my brother William was born in the nature men's colony in the mountains of Moorea, an island twelve miles from Tahiti. He was named William to please one of the nature men, who had no children of his own. When he grew big and strong my father called him

Jakey in memory of "Hard Pan Jake," a friend from Cowboyland where he used to live.

Of course my mother told me all this, for I was little more than a baby when Jakey was born.

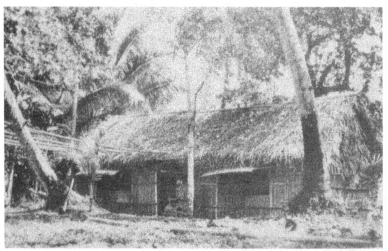
Our House in Tahiti.

We were very poor at that time. We lived on the $50 a month pension that Papa received as a disabled veteran of the First World War. By and by we went to Papeete, where Papa borrowed some money from his friend James Norman Hall, and with this money we sailed to Raiatea and then to Tahaa. It was at this last place that my father met Mr. James Starr, a rich young American who owned a thirty-six-foot yawl but could not sail it. Papa agreed to teach him navigation if in return he would take us back to Puka-Puka. That was in January 1934.

The boat was very small, and we had 1,080 miles to sail. There was Mr. Starr aboard, who couldn't sail or navigate, and an Atiu boy named Taiono who used to be a sailor on the schooner *Tagua* when my father was mate of that ship, and there were Mama and Papa and Jakey (only three months old) and I. I do not remember the voyage, but my mother told me that I fell overboard in the middle of the

Pacific Ocean, and that the sailor Taiono jumped after me to rescue me while my father turned the yawl around and picked

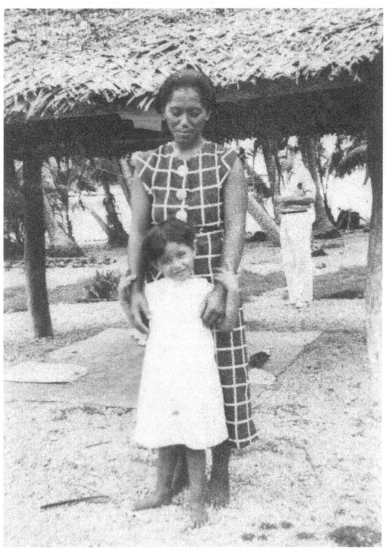

Johnny and Mother Ngatokorua. Puka-Puka, 1938.

us up. And my mother told me of the hardship of that eight-day voyage to our first island, Suvorov Atoll: how seasick she was, what a trial it was taking care of me and little Jakey,

and how Mr. Starr could not be trusted with his own boat even in broad daylight, while Taiono was not much better. My father had to do everything from standing twenty-four-hour watches to changing Jakey's diaper and washing them! There are lots of exciting things I could tell about Suvorov—things my mother told the Puka-Pukan people when she returned that now are legends old men tell at night as they squat around their tiny fires of coconut shells, for Mama was a famous woman among her own people, and everything she did became a part of that island's history.

For instance, while we were at Suvorov Mr. Starr went crazy from the loneliness and from drinking too much Tahiti rum. Papa took his dinghy away from him so he couldn't leave his yawl, which was anchored an eighth of a mile from shore. He might have swum ashore, but sharks were bad at Suvorov, and he was afraid of them even when he was crazy. So he started shooting his rifle and his revolver toward our camp in the bush. I seem to remember the noise of his shooting, the way I remember the racket the millions of sea birds made. Well, we moved our camp to the other side of the island, the sea side, and from there we saw Starr and his man Taiono sail through the passage and out to sea. He was leaving us marooned, without any food except what the island provided.

But Mr. Starr wasn't a very brave man. It wasn't long before he returned, and from then on he stopped drinking rum and his craziness left him.

And there was the time the sailor Taiono tried to make love with my mother. She screamed, and when my father heard her he ran to meet them and knocked Taiono down. Then the sailor jumped to his feet and they started fighting, until they saw me toddling toward them, then they became ashamed and stopped. Later Taiono apologized. He was really not a bad man, only the loneliness and maybe some of Mr. Starr's rum had made him foolish.

There were lots of fights in Suvorov in the old days, when pearl divers worked the lagoon. Several men killed

themselves or were murdered there. And of course Suvorov is famous for its buried treasure—but I will tell you those things later on when I come to the time we were marooned there in 1942. Now I must write of the things I remember. Imagine that two years have passed and we are back in Puka-Puka, living in the two-story coral-lime trading station.

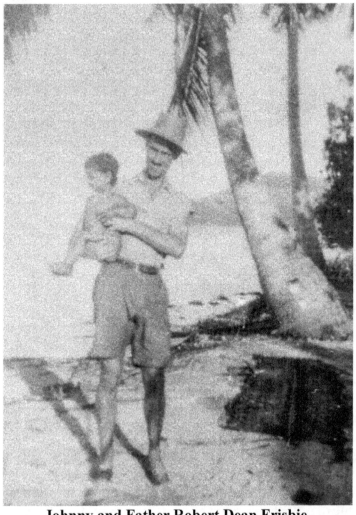

Johnny and Father Robert Dean Frisbie.

2

ELAINE JOINS THE FAMILY

Probably because I had been trying to think back as far as I could, last night I dreamed of my mother, and in my dream she was just as she had been in life, the most beautiful woman in the world. I dreamed about her and the birth of Elaine about as far back as I can remember, and so I will start the story of our Puka-Puka life with Elaine's birth, on November 29, 1935.

But first I must tell you a little about Puka-Puka. It is shaped like a man's leg from the knee down. At the heel is a big islet named Motu Ko, inhabited only when the people go there to make copra and plant taro. At the toe is a smaller islet named Motu Kotawa, and it is also inhabited only a few months of the year. *Motu* means "islet" and *kotawa* means "frigate bird," and the islet has this name because of the

thousands of frigate birds that roost in *puka'ama* trees on the west point. The third islet is at the knee, and because of the three villages there it is called Wale, that is, Houses. The biggest village is Ngaké (Windward); the second is Yato (Leeward), and the third is Roto (Central).

We were living in the trading station in Roto Village, for my father was the trader for Cook Islands Trading Company. There were a store and an empty room downstairs, and upstairs were two rooms with a veranda in front and in back. Between our station and the beach, about a hundred yards away, was the rainwater tank, cookhouse, eating house, copra shed, and boat shed.

The Causeway Leading to Yato Village.

When my mother felt the first pains of labor she moved her things downstairs to the empty room next to the store, and she sent for her mother Tala and her sister Tangi, and later for the witch doctor Taingauru. She sent for this last person only to please her relatives, for my mother was too civilized to believe in witch doctors or to let them meddle with her baby. She wouldn't let Papa come near her, but she

said he could come when the baby had dropped, to put the medicine in its eyes and cut the cord. Papa would have been angry had she not agreed to this, for he believed the Puka-Pukan babies often had sore eyes and big navels because the witch doctors didn't take proper care of them, and he said the babies sometimes died because the doctors prayed instead of taking care of them as soon as they were born.

Our Puka-Pukan relatives often were angry with my father because of his white man's ways, but my mother knew he was right, for she had lived in Tahiti, where she learned civilized ways and to speak French. You would never know my mother was a Puka-Pukan unless she told you so.

For the first part of the night I stayed with my mother downstairs. I remember that when her pains had eased for a few moments she asked me to go with her to the cookhouse. There she sat at the table while our old cook Luita made her a cup of tea; it was then that her pains came again, and she groaned. I ran to her to stand behind her with my hands pressed on her stomach like I had seen Tala do. Then all at once I felt the baby kicking inside her! My! My! It made me so excited and scared that I cried, "Mama! Something is moving inside you!"

Then my mother laughed in spite of her pain, and she said, "It is the baby, Johnny!"

"It wants to get out, Mama!" I cried. But she only laughed a little more, though her face was screwed up with pain, and told me the baby was all right, and for me to bring her tea.

Later, when it was dark, an old man named William came down the beach with a torch of coconut leaves. He threw the torch into the lagoon when he reached our house, and then climbed up the stairs to where Papa was sitting on the back veranda. William was a funny old man who never went to church and who spoke a little English. He had been to sea on a whaling ship when he was a young man. At the time I am writing about he lived with his old wife, Mama, near the taro swamp to one side of Ngake Village.

William and Papa sat on the back veranda until Elaine was born, drinking beer and singing songs. Once Papa sent me to ask Mama if William's singing bothered her, but she told me to tell Papa that she liked it, for it took her thoughts from her pain. I remember one of the funny songs William sang, for afterward Jakey and I would often sing it to please Papa when he was homesick for the atolls. The first of it goes like this:

> Huneree, t'ousan'ee, millionee milee!
> Hippo! Hippo! Hooray!
> Go t'hell t' Call-ay-oh!

It must have been an old sailor song. The first line would be, in real English, "Hundred, thousand, million miles!", and the "Call-ay-oh!" is the sailor name for Callao, a port in Peru. Or maybe it was a slaver chantey, for in the old days the blackbirders used to capture South Sea Islanders to dig guano in the Chincha Islands. Two hundred were stolen from Puka-Puka.

Elaine was born so close to midnight that we were never sure if her birthday was the twenty-ninth or the thirtieth of November; but later we decided it was the twenty-ninth, because two years later Nga was born on the thirtieth of September, and we thought that each child should have a birthday all its own even to the day of the month.

I was sound asleep in my mosquito net upstairs when Elaine was born. I heard that Tala had sent for Papa as soon as the baby had dropped, and that Papa had made the witch doctor angry by taking care of the baby in the middle of the prayer instead of waiting until he had said "Amen!" Anyway, Papa took good care of Elaine, for her eyes were never sore and her navel was smooth.

I didn't know that Elaine was born until the next morning. Papa woke me early to tell me to go downstairs and kiss my mother. I went down to her room to find everybody asleep except her. She was sitting in a pile of pillows,

rubbing coconut oil on Elaine's body. I guess I must have been half asleep, because I asked: "Whose baby is that, Mama?" and she replied: "It is the little baby who was trying to get out last night, Johnny. She is your new sister." Then she asked: "Aren't you going to kiss your little sister, Johnny?"

I shook my head. All at once I felt terribly unhappy. I remember even now so many years later, how terrible I felt. It was as if I didn't have a friend left in the world.

But Mama only laughed, for she was a wise woman and knew I was jealous—the way Elaine was jealous, later, when Nga was born. Elaine sulked around for days and cried when Mama fed Nga. She wasn't happy again until Mama fell ill and a neighbor took Nga away. So you see it was only natural that I was jealous.

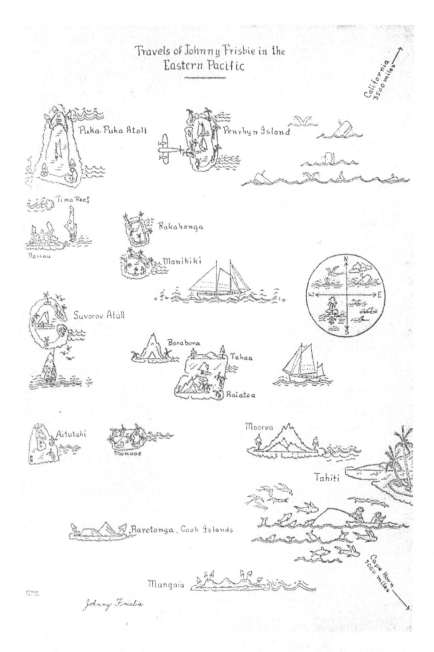

Travels of Johnny Frisbie in the Eastern Pacific

3

AT HOME ON THE FAR ISLET

When Mama was strong again Papa took us to our house at Matauea Point on Ko Islet; and let me tell you now that I have been all over the South Seas, but I have never seen a place as beautiful as Matauea. I am sure we went there after Elaine's birth because Papa hated the trading station and would not live in it except when his schooner was in the offing or something like a birth, death, marriage, or epidemic (for he was doctor as well as trader) made it necessary for him to be there. And of course I can't tell you what we did day by day at Matauea, so I'll simply describe what our life was usually like on the *motu*.

Matauea is four miles from Walé, but it took us less than half an hour to sail there in our big thirty foot canoe

with its four outrigger cross booms and its enormous lateen sail. Like the best canoes, it was made of cordia wood, which we call *tou*, and it would last more than a lifetime. Go to other South Sea Islands and you will find good for nothing little tubs made of pine boards, which will last only four or five years. You never see sailing canoes on any of the South Sea Islands like the ones on Puka-Puka. Ours would carry only twenty men, so it was small in comparison to some. Old Araikonga's canoe, with its six outrigger booms, and two huge sails, would carry five men on its outrigger alone, and nearly a hundred in its hull. Many times Araikonga carried eight tons of village copra from Motu Kotawa four miles to my father's copra shed in Walé. And there are men living in Puka-Puka who remember when two seagoing canoes sailed four hundred miles from Puka-Puka to American Samoa. Ué of Yato was the captain of the last canoe to make the voyage. He steered by the star Melemele, or Antares. The name of his canoe was *Punga i Witi*, which means "Coral of Fiji." I tell you these things to prove I am not fibbing. Most people will not believe a canoe can sail four hundred miles in the open sea.

Our house at Matauea was so big it was used for a schoolhouse later, when we had moved to Motu Kotawa. It had a thatched roof and low sides not four feet high, and being on the end of a point, it had only one inland side. Of the other three, one looked out to sea, one over the lagoon toward Walé, and one across the big horseshoe bay toward the copra makers' village of Te A. There was a cookhouse with an iron roof to catch rainwater, an eating-house, and a new house we had built on the tip of the point.

Papa was always building houses. It was his hobby. At this time he had six big ones, not counting the trading station which belonged to Parson Karé Moana, and lots of little ones stuck away in lonely places where he used to go when the village noises or those of his own children got on his nerves. And let me tell you that we Puka-Pukan children knew how to make noise! There was nothing we liked better

than to make horns of coconut leaves, tom-toms from sections of bamboo, and whistles from the hollow twigs of the magnolia bushes, then get our playmates together, dig up a few rusty kerosene tins for drums, and go to it, yelling for all we were worth at the same time. When the Cowboy Orchestra and the South Sea dancers got to work, Papa would start throwing dictionaries—so he made that quiet little house on the end of the point to write books in, and when it was not quiet even there, he would go to one of his huts stuck away in the jungle.

Papa is very proud of us because we dance so well, because Jakey is such a lusty boy on the kerosene drum and Elaine and Nga are so graceful and unselfconscious when they dance before a big audience of white men, as they did in the Royal Hall in Rarotonga. Wherever we go he makes us learn the songs, dances, and drum rhythms of the people, and you should see a group of us children dancing at night on the moonlit beach of a coral atoll. Ta, ta ta ta, ta, ta ta ta—ta! sounds the wooden gong. "Ki runga! Ki raro! Ki runga! Ki raro!" yells the dance leader. Brrrr! goes a pair of sticks on a kerosene tin, and Boom! Boom! Boom! thunders the sharkskin drum.

Dancing was best, but we had game crazes the same as civilized children have. Usually we would start a craze, then the grown-ups would join, and toward the end everybody would play even to the grey-headed deacons and the old women. It wasn't at all uncommon to see the village fathers shooting marbles or flying kites, and often they would start a craze, as when during the Christmas holidays or on the King's Birthday, there would be spear-throwing contests, wrestling matches, and cricket games with sixty men to a side. Papa taught them baseball one year, but it wasn't as popular as cricket because the players had no gloves and the catcher used to get badly hurt unless he stood far back from the plate and stopped the ball with a copra sack, which he usually did.

Other games were: marbles played with *wetau* nuts;

cat's cradle; a Puka-Pukan kind of jackstones played with shells or cat's eyes instead of jackstones; dart throwing or *tika*, in which light reeds were thrown on the ground so they would bounce up and soar a long way; guessing games, and European games such as checkers and cards.

One of our favorite crazes, which lasted a month or two, was kite flying. Often Jakey and I would take our kites to wind-swept Matautu Point, across the bay from Matauea. There we might find Grandpa Mata'a and his old friends, shifty-eyed Tapipi or Kuru whose legs were swollen and knotted with elephantiasis, or Raku-raku, the councilman of Roto Village. They would be sitting in the shade of a tournefortia tree, braiding ropes from coconut-husk fiber or rolling strands of pipturus bark between the heels of their hands and their ankles to make the strong white fish line. Their great kites would be drifting high above the lagoon, tethered to the tree. Now and then they would glance up at them with admiration, then perhaps they would roll a pinch of twist tobacco in a pandanus leaf, light it from the coconut husk that was always kept smoldering, and return to the work of old men.

Jakey and I would set our smaller kites sailing, and if Elaine was with us she would fly her little kite made from a taro leaf. We, too, would fasten the string to the tournefortia tree, then sit in the shade to play jackstones or to make cat's cradles. But oftener we would ask Mata'a and his old friends for stories, which they were always willing to tell, for of all the pastimes at Puka-Puka, storytelling was by far the favorite. If it was big-legged Kuru, his stories would be full of laughter and happenings not for a child's ears at any place except Puka-Puka. If it was Raku-raku, he would chant by the hour one of our *makos*, which are epic poems of the old wars and voyages of discovery. I don't know what I thought then, but now, when I recall Raku-raku's chanting, I seem to see his eyes staring as though he were lost in the past and had forgotten that we were with him, flying our kites over the wind-rippled lagoon.

If Grandpa Mata'a told the story, it would be of his adventures among the cannibals of Papua or else of the old times in his island of Mangaia. With his eyes round and full of wonder, whispering and pausing to gasp for breath, he might tell of the great oven of Aitu into which a whole tribe was thrown and burned to cinders. Or of Ono and Ngiti and how Ono would call his sweetheart from her house at night by blowing a whistling note on a blade of grass held between his thumbs. Or of old Rori the hermit who lived in the desolate Rai Keré and who stalked and clubbed people when they molested his sacred tropic birds.

There were lots of wonderful stories about Rori. One was of his marriage. A woman named Nunuku had drifted to Mangaia in a canoe, and because she was afraid of the Mangaians she lived alone in a cave near the Rai Keré where people seldom ventured. One moonlight night Rori saw her snaring mullet with a slipnoose made from her own hair. He swam silently to her, clubbed her, threw her across his shoulder, and took her to his cave hidden in the depth of the Rai Keré. That's how they married in the fierce old days before Jehovah came to the South Seas.

Our principal playmates were Tala's children, Ropati-Cowboy Motuovini, Tiriariki, and Pojila. The first two were girls, and Pojila was a boy. Though they were only little children they were our aunts and uncles—sisters and brother of Mama Ngatokorua. Now I'll tell you how Ropati-Cowboy Motuovini got her name. She was born when Papa and Mama first started living together, and because Mata'a was proud that his daughter had a white husband, he asked Papa to give the baby a name. I think Papa must have been drinking some home-brew that day, for he said: "Name her after me—Ropati-Cowboy. And give her a second name of Motuovini, for that's the name of the first ship I ever sailed." You see, Papa's first name is Robert, but the Puka-Pukans pronounced it Ropati, and because they knew he used to be a cowboy they often called him Ropati-Cowboy.

Pojila was the champion tree climber and bird hunter

of all the village children. He was only six or seven years old, but he would climb the tall hernandia trees and perch among the topmost branches, easily a hundred feet from the ground. Squatting up there among the leaves, he would be as much at home as a noddy tern. He would break off sticks to throw at the fledglings of seabirds, knocking them to the ground where we captured them. Then, when he had climbed down, we would make a fire, pluck the birds, and roast them black. When we ate them we would smear the fat and grime over our faces, getting more fun from dirtying ourselves than from eating. I wonder why we children loved to be so dirty? We would smear our faces with paint and charcoal, and when Mama asked us to go with her to the taro beds we were always willing, for it meant that we could wade in the deep black mud and feel it oozing up between our toes. Sometimes we would lie in the mud, roll over, and duck our heads under. Then mama would laugh and send us to the lagoon to bathe.

I'm sure we spent half our time in the lagoon. Papa had built a little wharf and had anchored a raft about fifty feet from shore. There was a ten-foot diving platform on the wharf, and it was about the most used thing in Puka-Puka. Every afternoon the village children would come to Matauea, take off their clothes if they had any on, and join the merry-go-round down the wharf, up to the platform, into water backsides first, back to the shore, and down the wharf again, yelling, whooping, and screaming for all they were worth.

Then by and by Papa would come with Elaine, and Mama with two-year-old Jakey. We would swim out to the raft, with Elaine hanging to Papa's belt or crawling on his back, because she wasn't a bit afraid of the water and could swim when she was one year old. Mama would carry Jakey, for my brother did not learn to swim well until he was over three years old, which is terribly slow for an atoll child.

After a rest on the raft we would swim from coral head to coral head until we came to the long reef that stretched across the bay to Matautu Point, about three quarters of a mile. Maybe we would walk along the reef

hunting for periwinkles and cowrie shells, but usually Papa and Elaine would swim on from reef to reef for an hour or more, sometimes to dive down and explore the coral caverns where the mother-of-pearl and conch shells were found. We could swim across the Puka-Puka lagoon, fully four miles, without being more than a hundred yards from a reef on which to rest, and because the lagoon was so narrow from east to west the water was always calm. On windless days it was a sheet of painted glass, and so warm that we loved to dive deep down to the chill water beneath.

I preferred to hunt periwinkles with Mama and Jakey, and for some reason—maybe because my mother's eyes were so sharp she always saw shellfish first, or because of the way she had of pretending not to see them so I could have the fun of digging them—I don't know what it is, but even today, so far from Puka-Puka, I will sometimes see a basket of periwinkles in the market, and I will feel a lump rise in my throat and tears will come from my eyes. People will ask me why I am crying but I will not tell them, for it would sound silly if I said a basket of periwinkles had reminded me of my mother.

The lonely wind-swept point of Teaumaroa was a good place to gather periwinkles—and coconut crabs too, A few scraggly pemphis bushes were scattered here and there among the bleached coral boulders, and to one side were three fresh-water pools where the Ngaké women washed their clothes. A little inland, in the deep beds of leaves beneath the pandanus trees, we found the coconut crabs. Sometimes we had only to poke among the leaves to find them, but at other times, when they were breeding, we had to dig for them. When we saw fresh earth piled up we knew a female crab was down there some place and had filled her hole behind her. To find in what direction she had burrowed we would cut a short stick, sharpen one end, and prod it here and there in the ground until we found a soft place where the stick went down easily. This, of course, was her hole. We would continue poking in the same direction, following the

hole by the soft places until our stick struck the hard shell of Old Lady Crab. Then we would dig down and capture her.

Coconut crabs look like gigantic hermit crabs, which means that they look something like a lobster. The body of a big one may be over a foot long, while his claws may be longer still. To hold a crab safely we would grab him by the back, and if we wanted to kill him we would reach forward to the little horn above his mouth and pull upward until we broke off the top of his head. But it was better to break off the crab's legs and claws instead of killing him, for then he stayed alive and did not spoil. To do this we would first break off the end section of one of his legs, then prod the toe into the soft membrane that attaches each leg to the body, when the crab himself would throw off his leg. When I first saw this done by a Manihiki man I could hardly believe my eyes. It was like a conjuring trick. The man broke off the toe end of a leg, jabbed the toe into one membrane after the other, and I heard a click, click, click, as if the legs were snapped off and fell to the ground!

There was a village law against hunting coconut crabs except at certain times, when all the villagers gathered several hundred, brought them to the village, and divided them equally among all the people. But we children often broke the law, and the village fathers didn't mind much so long as we didn't do it too often and remembered to bring them a few claws on the sly.

It was a little after Elaine's birth that Ropati-Cowboy, Tiriarika, Pojila and I went crab hunting at Teaumaroa. We sneaked through the bush on our hands and knees and lay flat and quiet when anyone passed. It was lots of fun; we were real cowboys! When we had found a few crabs we took them to Matautu Point, which is across the bay from Matauea and about the loneliest place in the world. There we cooked our crabs and ate them, thinking that no one would know anything about it. But at Puka-Puka there are eyes everywhere, even on the darkest night, watching you.

And so when we got back to Tala's house in Te A

Village everybody knew we had been breaking the law. Papa and Mama were at Tala's house. They didn't say anything, but along about dusk we received our punishment in the Puka-Pukan way.

The *pulé* (guard) came marching down the village road, and about every hundred feet they stopped, sang a song, did a dance, and then stood at attention while the headman of the *pulé* hitched up his pants, took a deep breath, and shouted: "Noo akalelei Korua. Sit prettily, you in this house, and listen to the law of the *pulé*. A word has come to us from a little white singing bird. The little white singing bird has whispered to us that he was on the Point of Teaumaroa this afternoon, fluttering here and there, when suddenly he was astonished to see Johnny the white man's child, Ropati-Cowboy, Tiriariki, and Pojila sneaking through the bush with 167 huge coconut crabs thrown across their shoulders. And the little white singing bird has whispered…"

He shouted everything we had done, even how Pojila had refused to give me any of the crab's fat and how I stole one of the claws from Ropati-Cowboy. Now, how did they learn all that unless Ropati-Cowboy herself told them, to get revenge on me?

My! My! I was never so ashamed in my life. I was ready to bawl. I didn't dare look at Papa; but he must have known how I felt, for as soon as the *pulé* had gone down the road to repeat their speech at the next house, he hitched up his pants, took a deep breath, and, "Johnny," he asked, "did you do that?"

I just managed to get out a choking, "Yes, Papa."

Then Mama spoke: "What shall we do to her, Ropati?" She always called my father "Ropati."

"Spank her!" Papa said sternly. "Spank her for getting caught! She's a hell of a cowboy! Now, when I used to run cattle in the Sierra Nevada, sheep stealing was my specialty. Sit tight, now, while I give you a complete account of all the sheep I ever stole from the headwaters of the San Joaquin to the King's River Basin."

I felt better then. I cuddled close to Papa, and it was no time at all before the villagers knew that he was telling another of his stories of Cowboyland, so they crowded about the house, the *pulé* amongst them, their ears as open as their mouths.

4

OUR PUKA-PUKAN NEIGHBORS

When I was a baby my father would not let anyone touch me except to take me from my crib, feed me, and bathe me. That is why, even today, when I have been a specially good girl, my father will say: "You see, it's because I didn't let any females fiddle around with her when she was a baby. These damn-fool female relations spoil everything they put their hands on—food or babies or a man's peace of mind." My mother either thought he was right or let him have his own way to please him. It was difficult to know what was at the back of her wise sweet mind.

Anyway, when we returned to Puka-Puka my father soon gave up all hope of keeping us away from our relatives,

but to this day he blames every naughty thing we do to their influence. Elaine and Nga escaped plenty of spankings on that account. Of course Papa hardly ever spanks any of us, but when he thinks we deserve it he just says: "Oh, it's not their fault. What can you expect from kids spoilt by a lot of damn-fool females?"

Jakey was the favorite of grandaunt Kani, a woman so old and evil-looking you would think her a witch, but with a heart so gentle she wouldn't hurt a fly. For a long time Papa hated Kani because she told Jakey stories of heathen demons that made him afraid of ghosts. Even today Jakey is sometimes afraid to go out alone at night, but he is getting over it fast. I know it used to make him terribly ashamed to wake me at night, when he wanted to go outside, and to ask me to go with him. He would say: "I hope Papa won't get mad. You won't tell him, will you, Johnny?" But I don't want you to think badly of Jakey. He is a wonderful brother; he often fights the Samoan boys who bother me; he is the best pupil in Le Ififi School; I've never known him to steal or lie, and he is not afraid of anything except the darkness.

Elaine and I spent lots of time with Grandma Tala. She had a soft brown face, straight black hair, and was so fat she never walked around except to go to church or the cookhouse. She would sit all day on a ragged old mat in the cookhouse, with naked little Elaine on her lap. Often she would pat Elaine's fat belly, wag her head as though astonished, and say over and over again, *"E apinga tikai! E apinga tikai!"* (True thing! A true thing!) That's one way to say in Puka-Pukan, "This is a wonderful baby!" Mama Tala loved Elaine because she was so fat and fair-skinned and always laughing. Even today Elaine is the same. When we were out last week to see Papa at Mr. Berking's place she ran to him, crying: "Spank Nga, Papa! She threw a sweet potato at me!" Then Papa asked, "Was it a raw one?" And Elaine replied, "No, Papa—boiled!" And right away she saw how funny it was, so she started laughing and forgave Nga. It is hard to be sympathetic with Elaine; there is always

something funny about her troubles. It must be terribly disappointing to be that way!

While Mama Tala played with Elaine she would teach us to cook, plait mats and baskets, and such woman's work. There would be Tiriariki, Ropati-Cowboy, me, and maybe one or two of Tala's bigger daughters—Vaevae, Pati, or Tangi. Tala taught us to cook native food and white men's food also, for she had learned to do these things in the civilized way when she worked for the missionary's wife in

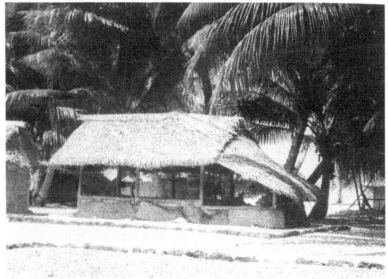

Grandmother Tala's Cookhouse, Puka-Puka.

New Guinea. And when my mother was a little girl she was taught to cook and sew and wash, so when my father married her she was a good useful wife. Before I was six years old I could cook, wash, starch, iron, sew my own dresses, and all such things. Sitting in one place in the cookhouse all day long, Tala would tell Tiri to do this and me to do that, and thus she would get her work done and mind Elaine at the same time without getting up once.

Often Mata'a would sit with us in the cookhouse. He was very tall and thin, with cheeks and eyes sunken because

of the asthma and the jungle fever. When his sickness was worse than usual Papa would give him powders, which he would burn under a quilt, inhaling the smoke. His favorite pastime was making cat's cradles. These cat's cradles were nothing like the ones the girls in Samoa make, but very intricate, with all kinds of criss crossings and loops and things. When one was finished he would spread out his fingers to show it to us, and he would explain that it was "The Oven of Waitala," or some such thing; and then, in his whispering, gasping voice, he would chant a little song, or mako, made up specially for each cat's cradle.

Also Mata'a taught us our Puka-Pukan family tree right back to *Te Maté Wolo*, or the Great Death, about two hundred and fifty or three hundred years ago; for it is part of the schooling of every atoll child to learn the family tree on both the father's and mother's side of the family. The kings can name their ancestors back fifty or sixty generations, to the gods, but we Puka-Pukan children learned them only to *Te Maté Wolo*. There were at one time 2,000 people on Puka-Puka. (There are 650 today.) Then a great wave washed across the island, drowning everyone except fourteen men and a few women and children. All the Puka-Pukans living today are descended from those fourteen men and every Puka-Pukan can name his ancestors back to one of them. *Te Ingoa* (The Name) was our ancestor on Grandma Tala's side of the family at the time of The Great Death. When we had learned our Puka-Pukan family tree we learned the names of our Mangaian ancestors. Then Mata'a started taking us to our family *po* or burial ground, and showing us where our ancestors were buried. He showed us, too, where he and Tala would be buried, and Mama Ngatokorua, and ourselves. Papa, he said, being a white man, would be buried in the churchyard.

Sometimes Papa would let us stay all night with Tala and Mata'a. In the late evening Mata'a's oldest son Aumatangi would light a fire of coconut shells, and if we had any fresh fish we would let the fire die down so we could lay

the fish on the coals to broil. There is nothing that makes my mouth water more than the smell of fresh fish roasting on coconut-shell coals. When the fish were cooked Tala would tell us to open the native oven in the cookhouse. This we would do; then Tala would divide the food from the oven and the fish we had cooked. Aumatangi would pile fuel on the coals and blow it to a blaze, and we would sit around the fire to eat our supper with our fingers. Of course Mata'a would say grace first, for he was very religious. After supper there would be no dishes to wash, for we had eaten on the little green mats of coconut leaves, which we threw in the fire. It took only a few minutes to make clean ones for the next meal.

Women of Ngake Village, Puka-Puka.

Then maybe we would play *tango-tango*. It was something like tag, except that the boys were always "it." We girls would walk down the road, arm in arm, singing, talking, and laughing, pretending we expected nothing, when suddenly, with a great yelling, a dozen boys would jump out

of the shadows to chase us. Of course we would scream, pretending we were scared. When the boys caught us they would kiss us in the Puka-Pukan way, which was pressing their noses on our cheeks and smelling us—*ongi*. After that the boys would hide and we would play the game over again.

The white missionary used to tell us in church, when he came to Puka-Puka once a year, that tango-tango was a sinful game. Of course some of the grown-up boys and girls got married while they were playing tango-tango, but they did it in a respectable way. I know that plenty of girls who played tango-tango remained virgins until they were married in church; but I think they were ashamed of it, for people used to say that they were too ugly and bad-tempered for men to want them. We were not supposed to know anything about this, but Puka-Pukan children knew a lot, if they didn't know everything.

When we were tired of playing tango-tango we would take our mats down to the beach, under some young coconut trees—but we wouldn't go to sleep for a long time, especially if it was a moonlight night. We would sing all kind of songs, from the ones Papa taught us, like "It Ain't Gonna Rain No More" and "Clementine" to the old Puka-Pukan makos, which haven't much tune to them but are nice and exciting because of the stories they tell.

Or maybe old Heathen William would come hobbling down the beach to join us; then Mata'a and he would tell stories of the ancient days, and that was the best of all. Mata'a knew lots of heathen stories. Even though he was a missionary he seemed to believe them, the way he told them, with his whispering voice low and serious, his dim old eyes staring into the past.

I remember how he scared us once by telling the story of Te Atua Pulé, a sort of demon who lived in the underworld where he had a great oven in which he cooked the souls of bad people, later eating them. Mata'a said there used to be a deep hole near where the London Missionary Society Church now stands. At the bottom of this hole was a black twisting

cave that led to the underworld. Te Atua Pulé would climb up the cave to the hole and crouch there until some evildoer passed, when he would poke out his head and shriek, "Boo!" scaring the poor passer-by to death. Then he would snare the man's soul with a sort of lasso and take it down to the underworld to cook and eat it. When Mata'a told this story in his whispering voice, Jakey and I would edge close to Grandma Tala and clutch her arm, trembling with dread.

And then maybe William would tell of the Peruvian slavers. When he was a young man a strange ship with a black-bearded captain, who Papa thinks was William (Bully) Hayes, came to Puka-Puka. There had been only two ships before that, so the people were very excited. They went out to her, and when they saw how the captain smiled in a friendly way they climbed aboard. For a little time they stared at all the things on the ship. They thought the sails were mats plaited by hand. When a Puka-Pukan man went in the galley and saw the cook cutting up salt beef he thought it was a human being for he had never seen an animal bigger than a rat. He yelled that the strangers were cannibals, then jumped overboard and swam ashore. One or two followed him, but the rest were brave enough to stay aboard.

Pretty soon the captain took off the hatch covers and invited the Puka-Pukans to go inside his ship. Down in the hold he had plenty of flashy trade goods as well as cases of square-face gin and palm-tree rum. About two hundred of the bravest and strongest Puka-Pukans, King Pereto among them, climbed down in the hold, thinking they would trade the coconuts and fish they had brought aboard for white men's goods. But, as soon as they were in the hold, the captain clapped the hatches on, stopped smiling, drew his pistols, and started shooting at the people still on deck. They jumped overboard; and then of course the captain sailed away to the Chincha Islands, where he sold the Puka-Pukans for a bag of gold.

Only King Pereto returned. A British gunboat named *Rosario* found him on the Chincha Islands about twenty

years later, and brought him back to Puka-Puka, and from him the people learned that all the others had died on an island where rain had never fallen, where men were beaten to death with horsehide whips, and where the incurably sick were thrown over the cliffs for the sharks to eat!

Then William told us that a year or two later another blackbirder came to Puka-Puka. William was out fishing on the reef when the ship was sighted. He watched her heave to in the offing, and because he was the smartest man on Puka-Puka—or anyway he said he was—and also very brave, he swam out to the ship and climbed aboard. The captain met him on deck, very friendly and smiling, just like Captain Blackbeard. He took William into the cabin and gave him rum. Then he gave him a beautiful suit of black church clothes, a pair of boots, a silk hat, a picture handkerchief, and a fancy shirt with a stiff collar and a red necktie. And he told William, by talking with his hands, to bring all the Puka-Pukans aboard his ship, when he would give them beautiful presents for the love of God Almighty.

William said, "Okay," climbed into the captain's boat, and was rowed ashore. But as soon as the boat touched the beach he jumped out, waved his arms around, grabbed his silk hat so he wouldn't lose it, and yelled, "Run for your lives! Blackbirders!" and with that he went like a streak of blue lightning for the bush, the rest of people at his heels.

Well, the slaver sailed away without stealing any people, and of course from that day on William became the hero of Puka-Puka. And even today, when the people make fun of the poor old man, he will close their mouths by reminding them of how he had saved their fathers or grandfathers from a terrible death in the guano islands.

William and Mata'a told us lots of stories those moonlight nights on the beach by Tala's house in Yato Village. They told of the cannibals of Mangaia and the heathen wards and the coming of the first missionary and how he was cooked. And they told of the witch doctors, Wotoa and Te Yoa, and how they visited the underworld just

as Orpheus did in the Greek story, only where Orpheus was stopped by a three-headed dog named Cerberus, who growled and showed his teeth, Wotoa and Te Yoa, found a giant lizard, who snapped his jaws and rolled his eyes.

Someday I will fill a book with those stories I heard at night on the beach of Yato, particularly about the heroes who sailed their canoes to distant lands where they had as exciting adventures as Ulysses; but in this book I must stick to the story of my life, so in the next chapter I will tell you of the great change that came over Puka-Puka when the trading schooner lay in the offing.

5

WHITE SHADOWS ON PUKA-PUKA

It was like living on another island when the trading schooner came to Puka-Puka. Supercargoes, missionaries, government people who visited our island for the few days that the schooner lay in the offing never knew what a beautiful place it was, for all the life had changed the instant they set foot ashore. The canoe-making and house-building, the singing and dancing on the outer beach on moonlight nights, the games of tango-tango, the fishing trips, and the work in the coconut groves and taro beds—all this was interrupted for the big work of loading copra and landing goods. This was the one time in the year when the people could make a little money, trade their hats and mats aboard ship, or gossip with the passengers about the happenings in the far-away outside would.

Usually the people slept most of the day, from the middle of the morning to the evening, while the work was done on moonlight nights or during the cool hours of the early morning. In the evening and late into the night the people would sit on the churchyard wall or on their narrow porches, watching the games of tango-tango, gossiping, and swatting mosquitoes, or maybe they worked a little by the light of the moon.

But as soon as the cry of "Sail ho!" sounded through the villages everybody prepared for the people who would come off the ship. Women pulled their mats down from the tie beams and wondered how many yards of print they could trade them for. Young men asked my father for work, and the men who owned big canoes tried to hire them for loading copra. Old Karé Moana, the preacher, puttered around tidying his house for Reverend Johns, the white missionary, who came to Puka-Puka once a year. Geoffrey Henry the native resident agent, worked himself into tantrums getting his government books and papers ready for Judge Ayson, the governor, who also came once a year. Then, of course, the village girls put on their brightest print dresses, oiled and combed their hair, and made flower wreaths, while even my father and mother straightened out the trading station and carried cases of home-brew to the living quarters upstairs. All the old life had stopped; a new life had begun: Puka-Puka was a different island.

It was all very wonderful and exciting for us children after six months without a ship. Each time we had almost forgotten what ships and white men looked like, so it was about the same as a first experience. I would leave Elaine with old Luita, our cook, and then Jakey and I would run to the boat shed to watch the people go off to the ship. First, the government boat would pass, with its British flag waving from a little flagpole aft and with four boys rowing, each dressed in a white singlet with N.Z.A. (New Zealand Administration) painted on it. Geoffrey Henry and his two constables sat stiff and important in the stern sheets, the latter

dressed in their khaki uniforms and police hats, while Geoffrey would be dolled up in a stiffly starched white suit and a cork helmet, black shoes and a black bow tie. He was only an Aitutaki native, but being very vain, he loved to show off before the half-naked Puka-Pukans. There was nothing he liked better than to go aboard ship in the government boat, with four uniformed oarsmen and his constables and maybe my father.

But Papa usually went in his own boat. He didn't have any dressed-up oarsmen with N.Z.A. painted on their singlets, but he would be properly dressed himself, for my mother saw to that. When he left the trading station to walk down to the boat shed she would follow him to see that his necktie was straight and his shoes laced. Then she would kiss him goodbye, just as if he were going on a long voyage, and tell him not do drink too much beer aboard ship.

When Papa had left, and Araipu the branch storekeeper had passed in his leaky old tub, Jakey and I would run through Roto Village, across the causeway, to Yato Village, which faced the offing where the trading schooners plied to and from outside the barrier reef. All the children of Puka-Puka would be on Yato Beach. By and by some of the village fathers would join us, each one with a little basket of green coconuts. These were for the passengers as soon as they stepped ashore, so they could quench their thirst and know they were welcome.

No native would dream of accepting money for these coconuts or for anything he gave to a stranger. The Puka-Pukan people were very proud in that way; they did not want anyone to think them mean or ungenerous. When the passengers walked up the road my people would call, "Come and eat!" or, "Come and drink a coconut in my house!" Or, "Life to the stranger! Eat in our village tonight!" And they meant it, too. No matter how many passengers there were— fifty or even a hundred—they would be fed twice a day. The first day Yato Village prepared their food, the second Roto, and the third day Ngake, and so on over and over again until

the ship sailed, when all the villages sent boatloads of taro, coconuts, fowls, and pigs aboard as a parting gift. Any passenger could make himself at home in any house, sleep there and eat there, and if he left his luggage lying around and unlocked, no one touched it. I never heard of a Puka-Pukan stealing. We often left our trading station open and unguarded, and though we didn't have even a door on our living house, we would leave it for weeks at a time when we went to the *motu*.

Before long we children on Yato Beach would see the boats returning from the ship. When they had crossed the reef, about half a mile away, we would start guessing who the passengers were. "There's Reverend Johns!" old Tapipi would shout. "Yes, and that's Judge Ayson with him!" King Ariitoka would grunt as he squatted under a bush rolling a pandanus-leaf cigarette. And, believe it or not, Tapipi and the king had no more than said these words than Karé Moana, a quarter-mile away, and Mrs. Henry, on the other side of the island, knew that the missionary and the judge were on their way ashore. We could hear the news travel, from mouth to mouth, soon to be shouted across the causeway to Roto Village, where it became a distant subdued mutter like that of a rain squall moving away from you across the water, then silence, while Puka-Puka waited for the next bit of news.

The boats would beach close to us. The passengers would jump ashore, grinning and self-conscious—and how strange, if not ridiculous, they looked, the men in their store clothes that needed washing and ironing, the women and girls in beach pajamas, short pants, and dresses made in new styles. My! My! All the Puka-Pukan women would be shocked, as they were shocked when my mother wore the beach pajamas she had brought from Tahiti. Yet Puka-Pukan women think nothing of walking stark naked through the village and down to the lagoon to bathe. It's just what you're used to I guess. But, believe me, while Reverend Johns was at Puka-Puka no girl walked naked through the village! They put on all the clothes they had, for Johns' special bug was

clothes and more clothes and still more clothes. He'd have had us dressed like Eskimos in midwinter if he had had his way.

I have seen pictures of circus parades, and that is what the line of passengers climbing the beach and marching through Yato Village looked like to us. They would drink the coconuts handed to them by the very dignified and courteous village fathers, grin foolishly, make some wisecracks and start through the village, with every child on the island tagging along behind. This used to annoy some of them. "Go 'way! Go 'way!" they would shout, waving their arms as if they were shooing off flies, but like flies we were, for we wouldn't have missed the parade for anything.

It was the same when they had their meals with Karé Moana, Geoffrey Henry, or Papa. Hundreds of urchins—and grown-ups too—crowded around the eating house, their noses pressed to the screening, a brown mass of staring, grinning faces watching the white men eat. They watched every movement. When Reverend John's fork was raised from his plate to his mouth, a hundred eyes followed it. When Judge Ayson chewed a mouthful of tough chicken, a hundred heads wagged sympathetically. And when Supercargo Gelling's big bony Adam's apple bobbed up and down, a hundred tongues muttered how astonishing were the ways of the white men. Of course people like Reverend Johns and Judge Ayson sputtered with rage. They yelled at us and even sent the constables to drive us away. But it didn't do much good. Staring at the strangers was as much fun for us as a picture show is for a civilized child; we didn't intend to miss it for all their growls and mean looks.

When Papa came ashore he would be just a little tipsy—just enough so to make him red-faced and happy, and to make him wear his hat on one side of his head and joke with everybody. He would go straight to the government house for his mail, maybe taking a few laborers with him to help him carry it back, for if there were six bags for Puka-Puka, five of them would be for him.

But there was no time to read any except the most important of his letters while the ship was in the offing, nor to answer more than one or two. Dimly, I remember watching him weighing copra, and feeling sorry for him. I wasn't used to seeing my father work; he wasn't the kind of man you'd expect to work. All day long he weighed copra, sitting in a steamer chair by the platform scales, with a striped beach umbrella shading him, and now and then sending for a bottle of ale when weariness overcame him. Later in the evening he had to be in the store, while Frank Gelling, the supercargo, took stock, and then, often until dawn, he had to entertain Frank and Andy Thomson, the captain of our trading schooner *Tagua*. That meant more beer, and playing his accordion and listening to their songs.

So you see Papa was a busy man. But still lots of people tried to make him open his cases of trade goods while the ship was there. Even we cowboys tried. I remember more than anything else how Jakey and I poked around the cases, wondering what they contained. Sometimes we would find a broken case, and then it was as exciting as digging for buried treasure, poking our fingers into the broken places, tearing away the paper packing, maybe to find a bolt of gorgeous flowered voile or flaming red print. Once, the luckiest time of all, we found a case with a big open knothole, and inside the hole we saw some blue cardboard. Scared, feeling guilty, we poked and scraped until we had broken the cardboard, when we dug out some raisins. We didn't know what they were; but Jakey, being braver than I, tasted one and said it was good. After talking it over, we finally ate all we could dig out. Later we were scared again, thinking they might be poisonous. We confessed to Mama. She looked severe and said: "Yes; I think they were poisonous because you stole them. Children often get stomach ache when they eat stolen food." I don't remember whether or not we had stomach aches, but I know the raisins were sweeter because they were stolen.

There was always plenty of excitement when the ship

lay in the offing. We children would crowd around the open government house to hear Judge Ayson fining people for committing adultery and for letting their pigs stray in the village. Those were the only court cases I ever heard in Puka-Puka. Or we would watch Geoffrey Henry strutting like a turkey cock, with an awfully swelled head, while his nice motherly wife baked cakes, cooked all kinds of food from dawn to late at night, and at the same time kept her eye on her husband so he wouldn't sneak away to flirt with some girl off the ship. He was like that; it seemed that half his time was spent fining people for committing adultery while the other half was spent in trying to sneak away from his wife so he himself could do it.

Or we would go to Parson Kare Moana's house to stare at old "Ahem-ahem Johns." We called him that because he was everlastingly muttering: "Hm...Ahem!...Yes, yes!...Ahem, ahem!" He didn't really look like a billy goat—but later, in Fiji, when I saw billy goats, I always thought: "Reverend Ahem-ahem Johns!"

The day he arrived all the church members would bring him presents of food or money or hats and mats and such things. There would be three or four hundred church members lined up in the mission yard and out the gate and down the road past the trading station. My mother would be among them, taking her one-pound note, for she was too big a woman to give the Reverend a smaller present. Jakey and I would join the line maybe with Elaine tagging behind us, a penny clutched in her fat little hand. We would watch the church members pass Reverend Johns, who stood on the mission porch, dressed in his black frock coat and parson's collar. When each member gave him a present, Reverend John's smiled, bowed, and said, "*Iaorana*" (Life to you), and then went on with his, "Ahem! Ahem! Yes, yes! Ahem!" with maybe a few "To be sures," until the next church member handed him a present.

For a long time after the ship had sailed we children would mimic Reverend Johns. At the table Jakey would say,

"Ahem, ahem! Please pass the chicken, Johnny. Yes, yes! Ahem! Hm! Ahem!" Or when we were walking down the road, every now and then one of us would clear his throat to mutter, "Yes, yes! Ahem, ahem!" Even little Elaine soon caught on to the game. It was funny to hear her squeal, "Papa, me *kaikai*! Ahem, ahem!"

When the ship sailed Papa would take a day off, though all the people, and Mama with them, tried to make him open the cases of trade goods. He might go fishing, but more probably he would pack a spare shirt, a toothbrush, a few bottles of New Zealand beer, and his mail, and sail to Matauea Point. He wouldn't let even Jakey or me go with him. When he returned he would be in a fine humor. He would send for the supercargoes of the three villages and for Geoffrey Henry and Araipu. The supercargoes were the men who took care of the village business, such as weighing copra and buying goods. They would help open the cases, with Jakey and me sitting on the counter watching them, and little Elaine in my lap, her eyes open for things like lollipops, for even when a baby she was a little glutton.

There would be the usual prints: muslin, voile, calico, dungaree, khaki, white drill, singlets, shirts, Swiss embroidery, sailcloth, fishhooks and lines, bully beef, salmon, oval tins of sardines, pipe knives, axes, tomahawks, iron pots, teakettles, buckets, whale spades, Lifebuoy soap, and another kind we called "smell soap" because it was scented. There would be these regular lines, but also there would be surprises like a few cartons of all-day suckers or some tins of roasted peanuts, which we had never seen before; or mouth organs, Jew's harps, glass marbles, firecrackers, or playing cards. When such things were found in the cases Papa would hold them limply in his hands to stare at them in his dazed sort of way, and presently he would say: "I am a philosopher." (I didn't know what a philosopher was in those days, except that it was a word Papa used often.) "I am a philosopher," he would say. "I know you will worry these things out of me eventually, so, to save myself much

misery, I give them to you now." With that he would fill our cupped hands with marbles or lollipops or some such things. Then Mama would take them away from us to give them back later, a little at a time.

Papa sold most of the trade goods to the three supercargoes to be divided among the villagers in payment for their copra, and to Araipu, who kept a little branch store where he sold things like fishhooks, matches, and tobacco. Then Geoffrey Henry would buy his supplies, all the purchases would be taken away, and Papa would close the station, usually to go back to Matauea and stay there for several months.

He was always impatient to get us away from the villages as soon after the ship had sailed as possible, for he was afraid of the epidemics that always followed a ship's visit. Generally it was no more than a common cold, but on an atoll, where sickness is almost unknown, even a cold will mean death to several people.

So we would go to the *motu*, and, invariably, in a few days we would see a sailing canoe headed for our camp. We would know what it meant. When the canoe had beached, one of the village headmen would jump out, approach my father in an embarrassed and humble manner, and, after a lot of stuttering and beating around the bush, tell him, with downcast eyes, that a terrible sickness had come to the island, and beg him to return to Wale to doctor the people.

Of course, my father always went. He would pack a few things, order us to stay on the *motu*, and sail back to the trading station. We wouldn't see him again for two weeks or more. When he did return it would be to tell us of friends or even relatives who had died of the new sickness. That is what killed my aunt Tangi and what killed Grandaunt Kani, too—just a common cold.

6

OUR MOTHER FALLS ILL

I have told you that my father did not like witch doctors. Well, when Elaine was born he didn't say much, but we knew that he was angry because Mama had asked the witch doctor Taingauru as well as her relatives to be with her. So when the time came for Nga to be born, which was nine months and five days, after conception, he bundled us in his new canoe *Panikiniki*, "Skipping stone," and took us to Matauea Point.

Panikiniki was made from a big Hernandia tree. It was flat bottomed, had high bows, and two strong outrigger cross booms. Its tall mast carried a spritsail that my father had made, with me helping him sew the holes the ropes went through. Though it was much smaller than our other canoe, it was the apple of my father's eye, and for that reason he

would seldom let anyone else sail it.

I am going to break from my story to tell you how *Panikiniki* got her name. One Saturday morning, Papa, Mama, Jakey, Elaine and I sailed the new canoe for the first time, on a day's picnic to Motu Kotawa. It was just the right kind of day to test the canoe: a strong wind, with sharp rain squalls blasting down on us, and the lagoon so rough that we could scarcely see the reefs and coral heads until we were on top of them. But this did not worry us, for we had the shallows inside the barrier reef on our lee, so if we capsized we could swim with the canoe to shoal water.

A sharp gust of wind caught us as soon as we had shoved off, and away we went, spooning over the waves, with a cloud of spray rising from our bows and the water boiling in our wake. Papa's steering paddle made a humming sound; the sail bellied out; the mast creaked and the long sprit yard bowed till I thought it would break. Beyond the lee of the land the full force of the wind struck us, and the outrigger flew out of the water until Papa eased off the sheet. Then he yelled for me to crawl to the outrigger. Steadying myself by gripping the windward stay, I crawled slowly out the crossboom to sit on the front end of the outrigger itself, with my legs stretched out stiff along it and my back braced against the boom, to which I held for dear life. It was a wonderful sensation, let me tell you, there on that six-inch pole that skimmed over the water, sometimes plunging through a wave until I was ducked under the rushing water, or at other times riding two or three feet above the surface and then plunging down again!

But still we were in danger; it was all Papa could do by continually easing off the sheet and hauling it in again, to keep from capsizing. He shouted for Jakey to crawl out as far as he dared. His eyes sparkling and his teeth clenched, my brave little brother jumped on the crossboom and grabbed the stay to stand upright four feet from the canoe, close above me. Then Mama sat a little way out on the boom, but with her feet in the canoe and holding Elaine in her lap.

"E teré, e teré, e teré, te vaka,
E teré ki uta i te tautua…"

She sang. We joined her, and away we went, singing and laughing, squalls pelting us, our canoe as alive and excited as ourselves.

Then suddenly Jakey and I both sighted a reef at the same time, close in front of us! A second later Mama saw it!

"A' ama!" (to windward!) I yelled.

"Katea!" (to leeward!) Jakey yelled.

"A' ama! Ekiai! Katea!" (to windward! No! to leeward!) Mama screamed.

Papa swung the canoe first one way, then the other, and finally, not knowing what to do, he steered straight ahead! In about a second the canoe struck the reef, and, because it was going a mile a minute, it spooned to the top of the coral, scraped across it, slid down the other side and away we went for Motu Kotawa!

"E *panikiniki*" (A skipping stone!) Mama shouted. And that was how our canoe got its name.

It was about two weeks later that we sailed for Matauea Point so Mama could have her baby some place where we wouldn't be bothered with her relatives and the witch doctors. We took with us only our old cook Luita, and I think Papa let her come because he knew she was so afraid of him that she would obey him.

The two or three weeks at Matauea before Nga's birth, and the two or three weeks afterward were the last really happy days we had together at Puka-Puka. They were the end of a beautiful fairy tale.

We must have sailed there about the middle of September 1937, for my mother's labor pains started on the afternoon of September 20th. At dusk we lighted three long palm-frond torches and stuck them in the beach as a signal for old William to come over from Walé, four miles away. He would walk the reef at low tide. Then my mother went to the big house, where a hurricane lantern had been hung on one of the tie beams. She told us to go to bed. Luita went to

the cookhouse and there kept awake, minding the teakettle. The hot water was to bathe my mother, not the baby, for Papa never let any of his cowboys bathe in warm water (or sleep on a mattress). He said we should grow up strong and tough like the children of Sparta, a city in Greece.

Jakey, Elaine, and I went to the other big house. We didn't talk very much, for the mystery of birth frightened us. It seemed so strange and awesome that soon another child would be in the world—a little brother or a little sister like ourselves. "I'll give him some of my marbles," Jakey said. "He's going to be my best friend and sleep with me every night. I won't let you girls monkey around with my brother."

Soon we were asleep. This was as my mother wanted it. For some reason she would have none of us near her, not even Papa. She sent him to his little workhouse down on the beach, and from then on sat alone with God in the big house, and with her pain.

When we awoke early the next morning our baby sister had arrived. A little scared, we peeped around the open end of the big house to see, in the dim light, Luita sitting by Mama, holding the baby in her lap, crooning to her, while old Heathen William sat to one side with his back to a house post, drinking homebrew and grinning as though he owned the world. William was very proud of Mama, Papa, and us cowboys. The arrival of a new baby meant more to him, I am sure, then if it had been his own.

Mama was asleep. She was very beautiful, I thought, lying back in a pile of pillows, her face relaxed from its pain. Papa was asleep too, in his little workhouse, for he had been up most of the night after Nga was born, doing his doctor's work.

I wasn't jealous of my new sister, but Elaine was and I think she still is. All the big rows in our family are between Elaine and Nga. This is wrong of my sister, for Nga is a gentle child, but then Elaine is such a fat, happy, laughing cowboy that we forgive her this one fault. Jakey was not jealous, but he was really angry because his mother had not

given him a little brother to play with. Later Nga became his best friend, and even today he likes Nga better than Elaine or me, but not so well as his brother Charlie in Rarotonga.

Mama and Papa gave the baby a real Puka-Pukan name. In these atolls a name is supposed to be an *akairo*, which is something to remember something by. For instance, when we cowboys each planted a *mangaro* (coconut) at Matauea they were supposed to be our akairo. Years later, when a man saw the grown coconut I had planted, he might think: "This is Johnny's tree!" And if he picked one of the nuts he might say: "Thank you, Johnny!" Well, they named the baby sister Ngatokoruaimatauea. Now, my mother's name was Ngatokorua, which means, "In Memory of the Two." The "I" means "at," and Matauea was the point of land where the baby was born and where we lived for so many happy years. So the whole name really means: "In Memory of Mama Ngatokorua at Mataua." Of course, no one ever called her Ngatokoruaimatauea, but simply Nga, which is a common name in the Cook Islands. My mother, Ngatokorua a Mata'a, was called Nga—or Na in Tahiti, where the people couldn't pronounce "Ng."

Now that I am telling you about native words I will explain that the name Puka-Puka is not pronounced the way some white men say it, "Piuka-Piuka" (making one think of seasickness), or "Pucka-Pucka." It is pronounced with the u like oo in "moon"—"Pookah-pookah." Papa thinks it means "Little Hills," but I think it means "Fat Land," as you would use the word in speaking of a fertile land.

Two weeks after Nga was born my mother went swimming with the baby and that night she fell ill with a high fever and a bad cough. Papa thought it was pneumonia. For nearly a month she was very close to death; then she grew stronger slowly, but she coughed a great deal and had dizzy spells. I remember how one day she was sweeping the yard, and how she smiled and said: "I am happy now, Johnny, because I can work again. I want to work hard every day of my life. It is terrible being sick, for then I cannot work."

My mother nursed little Nga only the first two weeks. When she fell ill I became the nursemaid. Old Luita didn't like that at all, for Nga was her favorite. She was about seventy years old, with dirty reddish grey hair and a deeply wrinkled face, but her body was wonderfully plump. She loved little Nga in a fierce sort of way. I am sure she would have given her life for the baby. Later she did save Nga's life, as I shall explain. Poor dear old Luita! She never had a baby of her own or even an adopted one, so I guess Nga meant a lot to her.

It was fun taking care of my little sister, for I seemed to think of her as my own baby. And there really wasn't much to do, for she never wore diapers except when she was taken to church for christening. Diapers are not sanitary. On Puka-Puka where the house floors are of gravel and the yards of clean white sand, it is easy to keep everything sanitary. Nga could crawl around the ground without getting dirty, and if she soiled herself all I had to do was to take her to the lagoon, where the little wharf was, and wash her off. I often swam with her out to the raft, where we spent hours. I dived and swam while she sun-bathed, and, later she swam a little, too. Nga could swim before she could walk properly, and I guess that was because I spent so much time with her in the water. We got as black as little heathens out on the raft, in the bright sunlight.

People never believe me when I tell them how Nga was fed. Mama nursed her for two weeks, and after that she never tasted milk for nine months. You see, on an atoll like Puka-Puka, where there are no cows, milk is almost unknown, though sometimes the white trader will order a few tins to be used in times of sickness. If a mother cannot nurse her baby the child is given grated green coconut. That's what people won't believe, but nevertheless little Nga had nothing else to eat for nine months. After that she was given some condensed milk, which didn't agree with her. Of course we didn't feed her the mature nuts, but the soft jelly you find in young drinking nuts. Luita would scrape it out of the shell,

very fine, then put it in a green coconut shell and bake it for fifteen minutes, and, when it was cool, feed it to Nga. Lots of atoll babies have been raised on coconut alone, and they are just as fat and healthy as the babies that drink their mother's milk.

Nga was born on the last day of September 1937, and it was not until June 1938, that a ship came to Puka-Puka; then it was not our trading schooner, but a British warship named *Leith*. Just when we wanted a ship so we could buy good nourishing food for Mama or take her away to the hospital, none came. And all that time my beautiful mother was slowly slipping away from us, spitting blood sometimes, and once having a bad hemorrhage. One night she said to me: "Oh, Johnny, Johnny, my dear Johnny! Pray for a ship, Johnny! Pray for a ship! I want to go away and get well! I want to live so I can see my babies grow up! Pray for a ship, Johnny; pray for a ship!"

How heart-breaking that was! Even now I cry when I think of how much she wanted to live so she could take care of her children and see them grow up and have babies of their own. I am crying now, as I write this, and I am not ashamed of it; it is because I loved my mother so much.

We stayed at Matauea Point almost all the nine months. That was when Papa started his school for us. Jakey was too young to learn much but he went to Papa's school nevertheless and even little Elaine used to sit with us for a few minutes each day, trying to draw pigs and houses or to count on her chubby fat fingers. My father was the best teacher we ever had; he taught us for five years, and after that, right up to the present day, he has been our schoolteacher part of the time.

It made Mama happy to hear us recite our multiplication tables or read the little fairy tales and poems that Papa wrote for us on his typewriter. I still have all the schoolbooks he wrote, and I think there must be a hundred. Even when we were marooned on Suvorov and were fighting for our lives, Papa still kept his school going. Maybe that is

why Jakey and I are the best pupils in Le Ifiifi School now.

And it made Mama happy to see Papa teach us good manners: to eat sometimes with a knife and fork; to say, "Yes, sir; I beg your pardon; Excuse me," and "Good night, Mama," before we went to sleep—only we said, "Good night, Mama! O.K., Mama!" and this was the reason:

When Jakey, Elaine, and I were very little we would say, "*Moe ai koe akalelei!*" (Sleep prettily!) Then papa thought we should learn to say "Good night!" properly in English, so one night he made me repeat it over and over again. At first I said something like, "Goo ny!" but when I had learned to pronounce the words right Papa smiled. "O.K., Johnny!" he said. Then he started teaching Jakey, and then Elaine, and, when they had pronounced the words right, he said, "O.K., Jakey!" and "O.K., Elaine!" meaning "That's good!" But we thought the "O.K." was part of the lesson, so next night, when Papa said, "Good night, children!" we replied, "Good night, Papa! O.K., Papa!" Papa and Mama both laughed at that but they did not correct us, so right up to today we say to our father every night before we go to sleep, "Good night, Papa! O.K., Papa!"

While we studied our lessons Papa worked on his typewriter. He worked from daylight to dark, stopping now and then only to help us with our work or to eat. He said later that when he was writing he did not hear Mama coughing; it took his thoughts away from her terrible illness. At night he slept in the mosquito net with her, but he wouldn't let us sleep with her or even kiss her, for he was afraid we might catch her sickness.

In June we went back to the trading station at Walé to wait for a ship. It had been nearly a year since the last vessel visited our island. In all that time we had not seen a single smudge of smoke on the horizon to tell us that a steamer was passing. Of course, we were afraid that a war had started, that maybe no ship would come for years; then "Sail ho!" was shouted through the villages, and a little later the *Leith* was off the reef of Yato.

Papa went aboard with the resident agent, while the rest of us waited in the trading station, neatly dressed but about as unhappy as it is possible to be in this world of ours. How miserable we were that day! It seemed that the end of the world was upon us, that there was no happiness now or in the future. To our eyes everything seemed black and dismal as grave clothes. Huddled together, not daring to speak, our hearts in tears, we watched the naval officers pass from the ship to the government house, until finally Papa returned, with the ship's doctor.

When he entered the station to examine my mother, Papa lifted her onto the counter. "Don't tell me anything," the doctor warned him. "I haven't much time, and if you say anything you will confuse me."

Soon lots of natives were staring through the window and the doorway, but when Mama whispered for Papa to send them away and he spoke to them, they smiled and nodded their heads as if they were ashamed and sorry for us at the same time, and went quickly away.

The doctor told Mama to take off her blouse and lower her chemise so her chest would be bare. She did this. I stared at her and stared at her, and I began to feel even worse than before. The doctor listened to her chest, and tapped and told her to say, "Ninety-nine, ninety-nine." My sweet patient mother, panting for breath, did as she was told, glancing at us at the same time, with grief in her eyes.

Then I started crying, and Papa, because he did not understand, said: "Don't cry, Johnny. The doctor won't hurt Mama."

Jakey edged up close to put his arms around me. He is always sympathetic when someone is in trouble, but I couldn't stop crying, I felt so bad.

"What is the matter, Johnny?" Mama asked, and then I sobbed, "Oh, Mama, you are so thin! I can see your bones!"

"That's all right, little girl; we all have bones," the doctor said, with a foolish laugh, and then, patting my mother's shoulder, he told her he thought she had

tuberculosis, but he couldn't tell for certain. Then he and Papa left the trading station to go to Geoffrey's house where the man-of-war captain and some other officers were having tea. There the doctor told the captain that the only hope of saving my mother's life was to take her to the hospital in Samoa. At first the captain hesitated, for there is a strict rule in the British Navy that no woman shall travel on a man-of-war. But in the end he agreed to take her if Papa went with her to nurse her aboard ship. He agreed also to take Jakey along.

I never saw so much crying in my life as I saw when Papa carried Mama down to Araipu's boat. I remember that she wore her house slippers and that one of them fell off. I picked it up and carried it to the boat, and, when Mama was aboard, with Papa holding her in his arms, I put the slipper back on her foot. It was then that she started crying for the first time. "I can't kiss my own daughter Johnny!" she wept. "I can't kiss my children goodbye! I'll never see my children again! I can't kiss them goodbye!"

Her words seemed to make her feel worse than all the bawling and screaming of her relatives. Jakey, Elaine, and I were huddled close together, crying our eyes out, while Luita stood behind us with Nga in her arms. Mama stared at us, her lips trembling and tears flowing down her cheeks; then with a quick desperate motion, she threw her arms around my father and pressed her face against his shoulder. I could see her poor frail body trembling and shaking with grief. Maybe it helped a little, though, to have Jakey with her. Papa nodded to Araipu. The men started pulling the boat toward the reef.

"Goodbye, dear ones!" we heard our mother call. "Goodbye, my children!" and we sobbed back, "Goodbye Mama, O.K. Mama!"

A little later we went to Geoffrey Henry's house, where nice old Mrs. Henry gave us some rice pudding with raisins in it to make us stop crying. Little Nga was left with the new preacher Metua.

7

OUR MOTHER GOES AWAY

Mr. Geoffrey Henry was a sort of Hitler of Puka-Puka. He was the resident agent, postmaster, registrar, schoolteacher, judge, chief of police, prosecuting attorney, and jailer. He would order one of his constables to arrest someone. Then he would defend and prosecute the man at the same time, preach to him about sin, sentence him, and either collect his fine or be his jailer. Almost always the criminals had to work out their fines. If they were men they would chop wood, weed the yard, go fishing, or gather coconuts for Mr. Henry; if they were women they would make hats and mats, wash, or clean house for Mrs. Henry. Once in a great while there would be some government work to do, like rowing Honorable Geoffrey out to the ship.

When there were births, deaths, or marriages he would register them, and when the mail came he would give my father his five or six bags, keep his own twenty or thirty letters, and give the Parson his letter from the Reverent Johns.

As schoolteacher he wasn't much good because he wanted to teach the children English and no one wanted to learn it. He taught school for about fourteen years and in all that time there was not a single pupil who learned to speak English. If you met a boy on the road he would grin and shout—not just say—"Goodbye! Oh, yeah!" or perhaps, if he was a specially good pupil, "Where you coming?" But Geoffrey loved to teach English because of his vanity. He loved to talk English to pupils who could not understand him, and he always talked like an Englishman, saying: "Ah you theyah?" for "Are you there?" and "Open the doah," for "Open the door." I went to his school while Papa, Mama, and Jakey were in Samoa, but of course I knew too much for any of his classes and probably spoke better English than he, so he let me help Mrs. Henry teach the first and second primers. That was the first time I was a schoolteacher, when I was eight years old.

And one thing more: Mr. Henry was one of the *tauturu orometua* (preacher-helpers, or vicars). I think he liked that job best of all; it gave him a chance to dress in his flashy clothes, climb to the high pulpit, and preach about adultery. He would wave his arms around, sweat, look wild, shout, and pound the pulpit with his fist—and all the time he was the worst adulterer on the island and everybody knew it, even we children. One day Elaine and I caught him blackening his white canvas shoes. Elaine didn't understand what it meant, but I did and I couldn't help laughing, which made him look down his nose and punish me the next day in school. You see, every child in Puka-Puka knows that white canvas shoes are easy to see on a dark night when a man is sneaking through the bush to commit adultery.

Mr. Henry's wife was a very kind old lady and very

loving to us cowboys. From daylight to dark she would fuss about in the kitchen, cooking pies and cakes and scones and puddings and all kinds of nice things. Though she talked all the time she was very hard to understand, for she continually forgot what she was talking about. We used to mimic her the way we mimicked Reverend Johns. I would say to Jakey: "When I was in church last Sunday I heard the most scandalous thing…I mean to say, when Geoffrey and I went to church—and I had the hardest time making him go, because of his boil, you know—and that reminds me that I must ask Ropati to lance the boil—and I'm sure I don't know what I should do if Ropati didn't help us with these sick people…Why, when the ship was here—that is, I mean to say…." She would keep rattling on like that for hours, and at the same time putter about with her pies and cakes and things. So you see she really was a nice old lady, even if she was a little stupid.

The Henrys had two boys, Ru and Koa, and a daughter named Marguerita—also plenty of retainers. William was one of their retainers a part of the time—when Geoffrey had killed a pig or had received a roll of tobacco from Aitutaki. But William was my father's retainer when there was plenty of free home-brew in the trading station. Of course, while Papa and Mama were in Samoa, William stayed with the Henrys all the time. That pleased us because we loved to hear the old heathen tell his hair-raising stories of cannibals, blackbirders, demons, and murders.

I have told you that little Nga was left with Metua, the new preacher. Well, about a month after Papa, Mama, and Jakey had left, we began to worry about our little sister and thought she might have caught Mama's sickness. She didn't cough, but she lost weight until in about three months she was as thin as my mother had been. We could see every bone in her body. Dear old Luita came to us nearly every day to beg Mr. Henry to take Nga way from Metua. She said the preacher was starving our sister. At times she wept and raved, and once she became so hysterical that Mr. Henry had

to throw her out of the house. Geoffrey said that she was nothing but a crazy old woman and that Nga was all right except that she had caught tuberculosis from my mother.

Well, Papa, Mama, and Jakey returned to Puka-Puka about Christmas 1938, aboard Burns Philp's new *Matafelé*. We met them on the beach by the boat shed, and when we saw our father lift Mama gently out of the boat, we knew that the Samoan doctors had not cured her. We didn't have time more than to greet our mother before old Luita came running down the beach, her hair flying every which way and her eyes wild. When she was still fifty yards away she started screaming at the top of her lungs, so fast and excitedly that we could hardly understand her. Mama listened quietly, her eyes hard and angry.

While Papa carried Mama to the trading station, Luita kept talking, or screaming, and when we were home again Mama said: "Johnny, go to Metua's house and bring Nga to me."

I ran to the mission, and, strangely enough, when I turned to the corner I saw Metua's big fat boy Akirai standing in the doorway, with a tin of sweetened condensed milk to his mouth, sucking the milk out of a little hole he had punched in the top. It was one of the tins Papa had bought for Nga from the warship *Leith*!

That's the kind of man Metua was! He let his fat lazy boy drink poor little starving Nga's milk! Well, he paid for his wickedness later when he was caught committing adultery, hauled to court, and fined two pounds and ten shillings. Then his wife flew off the handle, sued him for divorce, and came to us with a story about how he had been drinking Nga's milk in his tea every morning. That's one reason why I don't like native missionaries and seldom go to church, though I believe in God and the Bible.

When Reverend Johns heard about Metua's wickedness he fired him from the London Missionary Society. Then Metua joined the Seventh Day Adventists, thinking they would make him a pastor—but they didn't.

And one thing more: I nearly overlooked telling you that Metua was not a Puka-Pukan. He belonged to one of the high islands in the Lower Cook Group. I couldn't bear to have you believe that a Puka-Pukan would be so cruel to a child.

Papa had built a new house on the windward beach between Ngake Village and Geoffrey Henry's house, and he took our mama there so the fresh air from the sea would cure her sick lungs. But it did no good; we knew our mother was dying.

Only Papa, Mama, and Aunt Maloku lived in the new house. We cowboys stopped with Luita in the trading station. I will never forget how gentle and loving Luita was to little Nga. She would sit up all night, with the baby in her lap, crooning over her, and weeping when she felt Nga's bony little body. And she would cook good nourishing atoll food and warm milk for Nga, day and night. It seemed she never slept. Papa said she saved her life by love as much as by food. Anyway, we could see the little darling grow fat, her dull eyes brighten, laughter come from her lips.

So even with our mother dying, we had consolation in seeing our little sister grow fat and strong again. And we forgot our sorrow for a little time when Jakey told us his adventures in Samoa: how he rode on horseback and in motor cars, was circumcised, and ate ice cream every day, but didn't go to the picture show because Papa didn't want him to form the habit. After he told us these true things, and found what a big boy we made of him, how our eyes popped and we wagged our heads with astonishment, he started making up adventures as thrilling as the stories of Ulysses. My! My! He told us how he and Papa were arrested for trying to take Mama out of the hospital against the doctor's orders (which was true), and how they were thrown in jail but broke out and hid in the mountains while all the policemen of Western Samoa searched for them (which of course was a lie); then, seeing how we believed him, he told of his three real cowboy friends, Peter Thompson, Alan Grey, and Bill Harrington who lived in a cave, shot Indians for the fun of it,

robbed the stores at night, and made every law-abiding citizen tremble. Of course Jakey claimed that he was the leader of the gang and wore two six-shooters and a long knife.

"Why didn't you bring your six-shooters and your long knife to Puka-Puka?" Elaine asked thinking that maybe Jakey had exaggerated.

"I did," Jakey replied with a disdainful glance at his little sister. "I've got 'em here now, hidden where you won't find 'em. The first time any of you females get cheeky I'll use 'em on you, like this…" and with that he clenched his teeth, looked fierce, and crouched down with his hands at his hips as though he were holding a pair of pistols pointed at us.

So we could forget our sorrow now and then, but not for long. Every afternoon we visited Mama. Then, on January 14, 1939, very early, before sunrise, Maloku came running to the trading station to tell us our mother was worse and wanted to see us right away. We ran with Maloku across the island to the new house, and there we found Papa sitting on the floor with his back to a house post, holding Mama in his arms. She was sitting between his legs, leaning back against him as women do in the pains of labor. Papa looked terrible; the light had gone out of our mother's eyes.

She stared at us for a long time, her eyes moving from one to another, and her lips trembling as though she were about to cry. Then she said to Papa, falteringly, "Keep all my children, Ropati. Give none of my children to the relatives. Promise me, Ropati, that you will keep all my children and love them and bring them up like white children."

"I promise, Mama Nga!"

Then again she stared lovingly at us. We were all crying; we knew our mother was speaking to us for the last time. Tears came from her pain-dulled eyes. "Johnny, Jakey, Elaine, Nga," she said in a voice so weak and low we could scarcely hear her. "Stay with your father, love your father, obey him. I know my people will try to take you away. They will quarrel over you as they will quarrel over my dresses

and my jewels and my lands. Do not listen to them. Stay with your father and love him."

She was silent for a little time, with her teeth clenched and her face tense with pain. "*S'il vous plaît! S'il vous plaît!*" we heard her groan. It was an expression she had learned in Tahiti and often used jokingly, but now she was asking God to ease her pain.

Papa leaned over to kiss her lips. Then I ran forward to kiss her, but she shook her head, whispering, "No, no, no!" and then, fiercely: "I will kiss you tonight, Johnny! I will kiss all my children tonight, and every night!"

Suddenly she closed her eyes tightly and bit her underlip. A shudder passed over her. Papa motioned for us to go. As we passed our mother, weeping, she bade us each goodbye!

Trying to be brave, we each whispered some kind of a farewell, but Jakey, clenching his fists and throwing out his chest, stopped in the doorway and turned to his mother.

"Goodbye, Mama! O.K., Mama!" he called.

Maloku closed all the blinds and hung a sheet across the doorway. In a little while we heard the neighbors screaming. We knew our mother was dead.

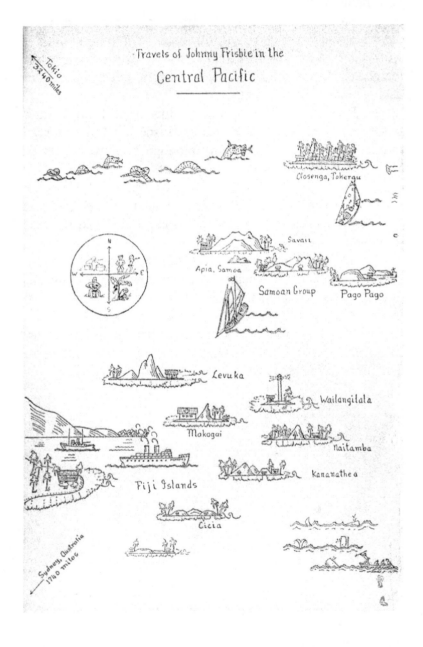

Travels of Johnny Frisbie in the
Central Pacific

PART TWO

Adventures In The Fiji Islands

8

WE LEAVE FOR THE FIJI ISLANDS

There was lots of trouble after our mother went away. Just as she had feared, our relatives started squabbling over her chestful of pretty dresses, her jewels and lands. They squabbled over us children, too, for they thought father should farm us out to them, in the native way. Grandma Tala wanted Elaine and me, Kani wanted Jakey, and Luita wanted Nga. Of course, no one could blame them. It was only because they loved us so much that they wanted us. It wasn't to get money from Papa for our upkeep; no one dreamed of that. And as for Mama's pretty clothes and jewelry, you must remember that about a pound a year was the average income for a Puka-Pukan, so to them my mother's things were the same as a great fortune to a

civilized man. And that wasn't the only reason. More important was their wish to have some *akairo* to remember Mama by.

One day Grandma Tala said to me, "Who will feed you and protect you when your father dies?" And when Taingauru, the witch doctor, gave us some fish and drinking nuts he said, "Who will give you fish and coconuts if your father takes you to the foreign land? The people in the foreign land are cannibals. They will kill you and eat you. I know this to be true, for when Mata'a was a missionary in Papua he saw the foreigners kill and eat their own children!"

Finally they went to Geoffrey Henry to demand that Papa be arrested because he kept his children, which was against the law of Puka-Puka. I think Papa could have murdered them when he heard that. He said: "Now they have killed the goose that laid the golden eggs! Now I will give them none of Mama's things, but I will take Mama and the children away from Puka-Puka forever!

Also he said that Mama would return in a few days to ask what had become of her children and her chestful of pretty things. You see, Papa wasn't right in his mind; for a while he thought that Mama was still alive. While he was writing his new book called *The Island of Desire* he would stop suddenly, and shout to me: "Johnny, run and ask Mama to make me a pot of tea!" Or, when we sat down to dinner, he would ask where she was, and we would tell him that she had gone to the *motu* for a few days. Then he would stare at us in a dazed sort of way that frightened us.

Every night he talked to Mama as he lay with us in the mosquito net. He told her his troubles and his plans: how he thought soon he would have enough money to buy his ship and sail with her all over the world, and how he would take us to America to meet his friends in Cowboyland. Presently, when he grew drowsy, he leaned over to kiss me, lying by his side, and to whisper good night, thinking I was Mama. But Mama heard him. We felt her sheltering presence with us every night; we felt her caress; we seemed to hear her

bid us good night, and we knew she awaited our reply, "Good night, Mama! O.K., Mama!" a reply we never failed to give, with love in our hearts.

At first I didn't believe he meant it when Papa said he would take me to visit the Fiji Islands for a month or two, for Papa was always talking about going to places, one day to Honolulu, the next day to Brazil, and the next day to Lapland—yes, Lapland: it was the place that fascinated him most, because of a book he had read. But this time, when I saw him packing his suitcase and turning over the trading station to Geoffrey Henry, I knew we were really going, Papa and I and Araipu.

Araipu was our branch storekeeper and also a vicar of the L.M.S. church, which made him a big man at Puka-Puka. He had adopted Nga soon after Mama came back from Samoa, on the promise that he would return her to us when we asked for her; and old Luita had gone to live with Araipu because she could not bear to be away from her baby. That old woman certainly loved Nga, so did Araipu. If anyone tried to fondle her, Luita would glare and snarl like an old she-dog protecting her puppy.

Jakey felt pretty bad about being left behind. Once I found him crying in the copra shed. That was one of the few times I ever knew my brother to cry. He was terribly ashamed when he saw me, but he admitted that it was because he was being left behind. Then, straightening up and looking mean, he told me to bring him a pistol with lots of bullets, a bagful of glassies, and a mouth organ. Also he told me to visit his cowboy friends in Samoa, Peter Thompson, Alan Grey, and Bill Harrington, and give them presents from him of Puka-Puka mats and hats.

Elaine didn't seem to mind being left behind, but she cried a lot at losing her papa for a few months. She was certainly a loving little girl and a pet to all of us except Nga. It didn't take much to make her cry or make her stop crying. If we told her Papa didn't love her she would be bawling in two seconds, then if we gave her some bananas we could

almost see the rainbow across her face as the sunlight shone through her tears.

That reminds me of the big feast we had a few days before we sailed. It was on September 30, 1940, and it was given by Araipu to celebrate Nga's third birthday. He and his fat wife Toia brought the food to our new house in Yato Village, the finest house Papa ever built in Puka-Puka. I think it was the finest house in the South Sea Islands. White men from the ship always stopped to stare at it, and exclaim, "I say, there's a dinkum shack!" and "blink their eyes," as the Pukan-Pukans say of a man who is astonished.

Geoffrey and Mrs. Henry came to the feast. There were also Heathen William, Tala, and Witch Doctor Taingauru, Kani, Maloku, Ropati-Cowboy, Tiriariki, Pojila, and Parson Karé Moana with his wife and daughter Alice— whom they wanted Papa to marry.

The food was spread on banana leaves on the floor, and we sat around it on mats. We ate with our fingers in the Puka-Pukan way, dipping the food in bowls of coconut sauce and sucking it into our mouths as noisily as we could. This was supposed to be good manners, for it showed how much we liked the food. Usually Papa made us eat with knives and forks, but he allowed us to eat like natives at feasts or picnics on the uninhabited islets.

We had about everything imaginable: roast pigs and curried fowls, pigeons and young sea birds, a very fat duck, lobsters and coconuts crabs, a big albacore and shellfish and sea centipedes, which are called varo and taste like fresh-water prawns. And of course there were taro, bananas, sweet potatoes, and *utos*, which are the white spongy things that grow inside sprouted coconut. The Samoans call them *o'o* and the white men "absorbing organs."

It was a grand feast, even though it didn't cost Araipu a penny. Directly in front of Elaine was a pile of very big and very ripe bananas, just an even dozen. After Karé Moana had said grace, all of us except Elaine started eating, but she sat as stiff and quiet as a girl in church, staring at the bananas

with big round hungry eyes, her breath coming a little faster than usual. Then she glanced up at Papa in her funny way, as though she were pouting and begging and loving all at the same time, and in a small voice, a little scared, she asked: "Papa—the bananas?"

Papa grinned. "Dig into them, Elaine," he told her.

"How many, Papa?" she asked. By her tone anyone would know that this was a never-to-be-forgotten moment of her life. Bananas are scarce in Puka-Puka, and never before had she sat at table with a whole dozen very big and very ripe ones before her, and furthermore there was nothing in this world of ours that she liked better than very big and very ripe bananas.

"All you want," Papa said. "See if you can eat the whole dozen."

Elaine caught her breath in a little gasp of emotion. Without another second's delay she started in, eating one after the other, but not gobbling them down, for my sister is a well behaved girl. She wouldn't taste the roast pig or the curried fowl. She stuck up her nose at the delicate sea centipedes and even the fat duck. She just ate bananas, at first perhaps a trifle too fast for the very best society, but slower and slower after five or six were gone. In the end she ate eleven! I was sitting by Papa. I saw him watching her out of the corner of his eye and smiling to himself. When Elaine had finished the eleventh banana she sat very still for a long time, her eyes glued on the twelfth and last one. It was pitiful the way she stared at it, knowing, of course, that she couldn't hold it. She almost wept. One by one the rest of us rose to wash our hands and lie on the couches that stood on all sides of the room. But Elaine stayed at the table. Finally she moved guiltily this way and that; then she brought her hand back and suddenly, heaving a tremendous sigh for such a small girl, gasped, "Pataitai! Pataitai!" (The waste! The waste!) She tried to rise but failed. She looked up to see Papa grinning at her, and then all at once she saw how funny it was and burst into laughter. In the end Papa leaned over to lift her

to her feet. He gave her the twelfth banana, to be eaten later, and laid her on one of the couches to sleep.

Well, a few days after the feast the leper ship *Tagua* arrived—the ship that had been our trading schooner. Dr. Rose, the Chief Medical Officer for the Cook Islands, came ashore to examine a few people who Geoffrey Henry thought might have leprosy, but as usual he found the island clean. He gave Papa permission to take Araipu and me to the Fiji Islands, and later the captain agreed to give us passage. So for the rest of the day we rushed about, getting our things packed and taken aboard ship.

A little before sundown we left the trading station to cross the causeway to our new house in Yato Village. There we picked up our hand baggage and then hurried through the village to the west beach, where we could see the *Tagua* plying slowly off and on beyond the barrier reef. But we had no more than time to glance at our ship, for all our friends were on the beach, raising as big a hullabaloo as when Mama left for Samoa. I felt pretty miserable, of course, but I laughed when I saw skinny old Araipu stalking stiff-legged down the beach, dressed in his black graveclothes, with tears streaming down his cheeks, while his fat wife Toia clung to him and wailed: "Oh, my husband! I'll never see my husband again! He will be murdered and eaten in the foreign land! Aué-aué, I'll never see my husband again!"

Grandma Tala was crying softly over me and trying even then to take me from my father. "Stay with old Mama Tala, Johnny dear," she whispered, "and eat fat chickens and nice taro puddings every day of your life! Don't go to the bad foreign land, little sweetheart! Who will take care of you in the bad foreign land if your father dies? The Fijians will make you their slave, you'll never see nice old Tala again! Stay with Grandma Tala, Johnny darling!"

Elaine was crying too, but not enough for a loving sister. Nga didn't seem to understand much about what was going on. As for Jakey, he gritted his teeth and looked mean to keep from crying, and he ordered me in a nasty tone to see

to it that I gave the presents to his cowboy friends in Samoa and didn't forget to bring back his pistol, glassies, and mouth organ.

As for me, I didn't cry much while I was with Grandma Tala; but when I had climbed into the reef boat I threw my arms around Papa, and buried my face on his shoulder and cried my eyes out, just as Mama had when Papa took her to Samoa. I felt that I was going to another world where I would never again see my friends. The feeling was the same as when I stood over my mother's grave. My father often says that we die many deaths before we really die. Well, I certainly died one death when my mother passed away, and that evening on Yato beach I died a second one, almost as painful as the first but lasting only a few moments. For when we had crossed the reef to the open sea that green monster Seasickness laid his clammy fingers on my stomach, and, oh! How I wished myself back ashore again! All the romance of a voyage to strange and distant lands went *ka-plunk* over the side with my dinner, and it was only when my stomach was empty and I was lying on the midshiphouse that I felt a little better.

Karé Moana had prayed on the beach before we climbed into the reef boat, but aboard the *Tagua* Araipu prayed again, while the crew and the thirty lepers stood bareheaded and respectful and Captain Broadhouse and the other white man aft pretended they didn't notice anything unusual. That was the custom aboard South Sea schooners. No native would go to sea without plenty of praying before the ship sailed, as well as morning and evening services during the voyage.

After the prayer, the *Tagua's* great white sails were hoisted, the engine, which had been used for standing off and on, was stopped and we sailed into the sunset for the Fiji Islands.

9

ABOARD A LEPER SHIP

Araipu was homesick from the moment he left Puka-Puka to his return. He seemed bewildered. He thought and spoke of little else except his home, and the things he saw aboard ship and in foreign lands served only to remind him of similar, but far better, things at home in Puka-Puka. Papa said that he was still living in Puka-Puka; only his earthly clay had gone awandering. Sometimes he would point to me, and say: "It would be terrible without the little one. When I look at the little one I am happy again, for I think of home."

He was scared, too. He was afraid we would journey so far away we could never find the way home, or that Papa would desert him in some distant cannibal land, or that the white heathens would steal his iron cashbox. There was none of the fatherly old vicar of Puka-Puka left in him; he had turned into a scared little boy with white whiskers and a half-

bald head that was always so cold he kept it wrapped up in dirty old towels and rags. This used to make my father angry, and though at first he only laughed, later it annoyed him when Araipu jumped to the windward side of the vessel to cling to the stays every time a puff of wind laid the *Tangua* over. Araipu imagined he was sailing in a canoe that would capsize if he stood on the lee side.

Often he would open the three locks on his camphorwood chest, take out his iron cashbox, and count his money. That made him feel a little better. He would say to me, "Teia to tatou metua!" (This is our father!) meaning that the money would feed us and pay our passage back to Puka-Puka—like a father. The journey almost killed poor old Araipu, though there wasn't a thing the matter with him except homesickness.

I'm afraid I wasn't as homesick as I should have been. As soon as I got over being seasick, which was in two days, I had as exciting a time as Ulysses in his hollow black ship. It was a good deal the same, too, for you must remember that I was a wild little savage from the most primitive island in Polynesia. I had never seen a dog or a horse or a motorcar, or heard a radio or a phonograph or a "talkie," or even seen a white man except for the South Sea traders, missionaries, and officials who visited Puka-Puka twice a year. And though I was born in Tahiti I did not remember having seen any land except Puka-Puka. I didn't know what a mountain looked like, or a river, lake, or town, let alone things like railways, airplanes, three-story buildings, traffic policemen, sugar mills, and big cannons, all of which were in Fiji. So foreign lands to me were as strange and romantic as the Greek isles must have been to Ulysses.

We had bunks in the cabin, but the weather being fine until we reached Apia, we slept and lived on the forward part of the midship deckhouse, close to where the lepers had a makeshift shelter built in the waist of the ship. That was fine, for we could see everything that went on. The sailors had a big cabin where the trade room used to be, and only the black

and woolly Tongan cook was forward, in the galley. He came aft with our food over a sort of bridge that had been built from the galley, which scared me a little, for I remembered how the witch doctor Taingauru had said that all foreigners were cannibals. I asked my father if the Tongan people ate little girls, which showed how ignorant I was in those days.

Our mat was spread on deck about three feet from the leper house. But the patients in this house were not very far gone; the bad ones were down in the hold where some bunks had been built for them. Most of the deck passengers came from Manihiki, an atoll famous for its songs and dances. Give a Manihiki man an old kerosene tin on which to beat drum rhythm and in no time he will have a crowd of dancers around him. It was the same aboard the *Tagua*; the fact that they were lepers didn't dampen their spirits. Every evening a sailor named Timi Marsters got out his guitar, then Dr. Rose, Captain Broadhouse, and Mate Matheson climbed on the midship deckhouse to watch the fun. First Timi would thrum a few chords, then there would be some singing, then one of the lepers would get hold of a kerosene tin or an old stewpot and a couple of sticks, rattle off a few *rat-a-tat-tats*. With yells and laughter they would start in, each one doing his own dance and doing it for all he was worth, girls and boys at first but older people later on. One little ruffian from Rakahanga used to jump on the leper-house roof to dance like mad, and once he fell overboard in the excitement of the thing. Everybody roared with laughter except Captain Broadhouse, who was peeved because he had to turn the ship around and pick up the boy. He even threatened to stop the dances if there was any more falling overboard. The captain was a bit of an old grouch, if you ask me.

Now I will tell you about Timi Marsters. He was formerly a sailor on the *Tiare Taporo*, one of our trading schooners. Way back in 1923, when he was young and handsome, he lived on Penrhyn Island, where he had a sweetheart named Tepou Marsters, a married woman and a cousin of his. Timi thought the moon had been made

specially to shine on Tepou, he was that madly in love, and Tepou agreed with him. They were so madly in love that one night they stole a pearling cutter about eighteen feet long, loaded her with coconuts, and put to sea. They didn't know where they were going and they didn't care, so long as the moon kept shining on them and their love. But Timi had been a sailor long enough to know that the ocean was full of islands and you were sure to find one of them if you kept sailing long enough.

Well, they sailed for about two weeks. Then one dark night when their private moon had deserted them, and while Timi was asleep and Tepou held the tiller, a squall struck their cutter and turned her over, bottom side up! Think of it, out in the middle of the Pacific Ocean, on a dark, moonless, starless night, capsized! But if you think they were greatly worried you are badly mistaken, for the Palmerston Islanders are just a little more at home in salt water than on dry land. After playing around in the water for a little time and trying but failing to collect a few of their coconuts, they righted the boat and bailed her out; then they hung their clothes on the rigging to dry, and again set sail for Question-mark Island.

For about ten days longer they sailed, drinking when it rained and eating the flying fish that plunked into their boat every night without a miss. When the moon came back they said, "Thank you!" and kissed each other, and spoke about how happy they were and how they would love each other for ever and ever and a day. And finally, when they were almost dead, but still happy, they piled over the reef of one of the Ellice Islands, where the people were good to them, gave them food, said they were heroes, and agreed that it was wonderful to be in love.

And when a ship came to the Ellice Islands they were sent back to Penrhyn by way of Pago Pago, where they had a wonderful time except that they were afraid the mountains would fall on them. When they were back in Penrhyn, Timi went to jail for three long months and that's what spoils my love story! For how could a Polynesian be away from his girl

so long a time and still expect his love to last? When he was turned loose he found that Tepou was very very much in love with another man, and as for him, he was very very much in love with a girl who had smiled at him every day through the prison bars.

So on the leper ship *Tagua* Timi played his guitar while the Manihiki lepers sang and danced. One of the lepers was a Rakahangan woman who was big with child and also had a year-old baby with her. Dr. Rose told us that she had smuggled the baby aboard at Rakahanga, in a roll of mats, because she could not bear to leave it behind. He said that the mother was sure to die at the Makogai Leper Station and the baby would certainly become a patient.

Three days later things started to get exciting, for we sighted the islands around which so many gruesome Puka-Pukan stories were built. Our first sight of the Fiji Islands was Wailangilala with its great beam of light moving slowly through the darkness, glaring on the ship for a second or two, then moving slowly on. It filled me with awe. When Araipu had stared at it a little time he made the *Tch! Tch!* noise that meant he was impressed. But he spoilt the illusion of unearthliness by mumbling that it was shameful to waste so much kerosene just to keep a light burning out there at sea where not one ship in a blue moon would sight it, and that the torches of the flying-fish netters off the lee reef of Puka-Puka made a much finer—and cheaper—sight. Then he grumbled something about wishing he had a nice juicy hot flying fish and a piece of coconut, because he couldn't digest the ham and eggs and beef and potatoes that the wild and woolly Tongan cook prepared, and thereupon he lay back with a grunt and went to sleep.

Maybe that wasn't exactly what Araipu said, but all through the journey he refused to admit himself impressed. Nothing that we saw or heard or tasted or smelled or felt was as fine as similar but much better things in Puka-Puka. A taxi was inferior to a sailing canoe, a hotel bedroom was less comfortable than a thatched hut on the outer beach, and a

soda pop was miles behind a good drinking nut.

As for me, I sat hugging my father and staring at the light, strangely excited, while Papa told me of how he had been storm-bound in Wailangilala's lagoon nine years before I was born, and of the lighthouse keeper, a cripple named Jack Fitzpatrick, and of his beautiful Samoan wife who made life miserable for him by her nagging ways, and of the assistant lighthouse keeper, a Hindu, who was deathly scared of pigs—not because they might bite him but because he would never go to Paradise if they touched him. And finally, after we had sat in silence for a long time, fascinated by the great silver cone reaching out for the stars, Papa leaned over to kiss me and whisper: "Johnny! Johnny! Wouldn't it be wonderful if the rest of the cowboys were with us tonight— and Mama!" His words made me cry, and when the light flashed on us again I saw that there were tears in my father's eyes, too.

10

THE BLACK ISLANDS

The next morning we started "picking up islands," as the sailors say. Every few hours we would hear the cry of "Land ho!" from a sailor perched high on the fore rigging, and we would see dainty little coral reefs with pea-green islands waving their fans in welcome, or gloomy black mountainous islands rising so high in the clouds that staring at their peaks made me dizzy.

I wish I could make you understand why that voyage to Fiji was for me a truly great adventure. To me Fiji was the "Witi" of Puka-Pukan stories. Many a night, when we were visiting Grandma Tala and had spread out mats on the beach by Yato Village, Mata'a told us of the fierce black cannibals from Witi, with filed teeth and bushy hair, who came to Puka-Puka in ancient times to burn villages, steal women, kill men and eat them! If I close my eyes and think the name "Witi," I will see, stalking along the beach of Yato, a black

giant, his red glinting eyes peering into the shore bush, his strangling cord hanging from his wrist, his great war club across his shoulder.

So that was what Fiji meant to me when I stared at the grim mountains. From those mountains came the Yayaké warriors. Watumanavanui, who built the huge coral seat on Teaumaroa Point, was born on one of those jungle-tangled islands. Thrilled to my toes, I anticipated how Jakey, Elaine, Nga, Grandma Tala, Kani, Maloku, Heathen William, Luita would gather round me when I returned, all ears to hear of my adventures in the immensely distant Fiji Islands! I guess I was a pretty vain little girl.

That night there were two lookouts and we were very careful to show no lights. The lantern was taken from the leper house, the red and white sailing lights were dark, and Captain Broadhouse growled when Papa struck a match to light his pipe. It was the time when Japan was sending raiders into that part of the Pacific, under the German flag; ships were being shelled or torpedoed almost daily. When we thought of our danger we always remembered that we had only one small leaky reef boat aboard—and there were more than sixty of us!

Some time during the night Papa carried me below to tuck me in my bunk, for it was raining. I remember that the engine had been stopped, that the ship seemed very silent except for the patter of raindrops on deck and the washing sound the old schooner made as she wallowed in the trough of the sea. Papa told me we were close to Makogai. I fell asleep, to be wakened at dawn by the noise of the ship under way again. I went on deck to see beautiful Makogai, the leper island, a mile off our port beam. We were steaming along a barrier reef, but before long we turned to enter the lagoon through a narrow passage. There the water was so shallow we could see the bottom, the coral mushrooms and the antler coral, the schools of mullet finning away or rising to leap from the water. We passed between two little storybook islands and entered the tiny bay of Makogai. The leper

colony lined the shore: a white church, groups of small buildings, and the long hospitals with big red crosses on their roofs.

Close to shore the captain stopped the engine and shouted to let go the anchor. For a moment we heard the chain jangling through the hawsepipe, then it stopped, and we heard, from a half mile away on a low point, the sound of someone drumming on a kerosene tin! Araipu let his mouth drop again, Timi Marsters glanced at me and winked, the lepers grinned, and the Rakahanga boy started dancing. I grabbed Papa's arm and, for a second, I thought myself back in Puka-Puka.

"That's a Manihiki tune!" I heard captain Broadhouse shout. "The Manihiki lepers are practicing their Christmas dances!"

"Of course," Dr. Rose agreed. "No one on earth but a Manihikian would dance at this time in the morning."

So there we were, so far, far from home and yet among our own people. And I realized this even more when the doctor's boat came out and one of our lepers shouted, pointing to a boy in the bow: "That's William Ford's boy! He's well again!" William Ford was the pilot of Penrhyn Island. He was a friend of ours and had been to Puka-Puka many times.

When Dr. Austin, the Makogai medical officer came aboard, he invited Captain Broadhouse, Dr. Rose, and Papa ashore but he wouldn't let me come! He said Araipu could accompany them if he wore shoes; but the stingy fellow wouldn't do this for he had only one pair of shoes and was afraid he would wear them out—so he stayed aboard with me; and there we were all day long with not a thing to do. We couldn't even go swimming, for the sailors told us that sharks were bad in Fiji. In the evening, when Papa came back aboard, he told Araipu to put on his shoes and come to the picture show. But Araipu didn't want to go even then—and to a picture show! My! My! He told Papa he never wore his shoes except to go to church on Communion Sunday, but

when Papa flew off the handle he sighed, opened the three locks on his sea chest, and dug around till he found his precious shoes. After a lot of head wagging, sighing, and grumbling about how much the shoes had cost and how many years he had owned them, he finally put them on and climbed into the boat with Papa to go ashore. I was left alone! I didn't cry! I was too mad. I sat on deck and pouted and wouldn't talk to the sailors until about eight o'clock when I managed to see some of the show anyway, for it was held in the open air close to the beach. From the *Tagua's* deck I could see the screen, with figures moving to and fro. It wasn't much of a picture show, but I enjoyed it just the same, for it was the first one I had seen.

Papa came back about midnight to sleep with me on deck. Next morning he told me that the people ashore were coming out to fumigate the ship, and Dr. Austin had decided that I might go ashore if I promised to wear my shoes in the leper colony. Araipu had to go whether he wanted to or not, for no one was allowed aboard while they fumigated. I guess it nearly broke the old miser's heart to put on his beautifully shiny black shoes again, but he had to do it and wear them most of the day.

So I went ashore in Makogai, and I guess I was the first little girl who was not a leper ever to visit the colony!

11

I VISIT A LEPER ISLAND

The only thing I like better than arriving at a strange port is going to one. I like ships and the sea and the anticipation of arrival. When some day a young man says to me, "Johnny dear, be my wife and settle down with me in a cozy cottage," I will reply:

"No, siree! Buy me a steamboat ticket and give the cozy cottage to some other girl!"

I guess it's in my blood, this wandering spirit. On my mother's side I am descended from navigators as bold as the Vikings. I have read in schoolbooks about how Captain Cook discovered some of the South Sea Islands and Bougainville discovered others. What nonsense! My people discovered all Polynesia centuries before Cook and Bougainville were born. When the white men were living in caves my ancestors were sailing their double canoes in the Great Migration from Asia to the Pacific islands; when Ulysses was returning from Troy, the Polynesians were having equally thrilling adventures in

the Great South Sea; and when Columbus set out to rediscover America, the great navigator Kupé had already sailed from Tahiti to explore the Cook Islands and then pressed on to discover New Zealand. Many a time in Puka-Puka Grandpa Mata'a chanted for us an old *mako* which told of a voyage to Te Tawa o te Langi, a place of cold winds and beautiful flowers, surrounded by a dark sea on which white stones floated. Perhaps the stones were icebergs, and the land America! And why not? A voyage to America would be no farther than a voyage to Easter Island, which the Puka-Pukan voyagers called Te Pito o te Wenua—"The Navel of the Earth."

I have told you two canoes sailed from Puka-Puka to Samoa in recent times, and how Timi Marsters and Tepou sailed an eighteen-foot boat from Penrhyn to the Ellice Islands, a distance of about twelve hundred miles. That's the way with my people: the soles of their feet itch as much today as they did in the past. Every trading schooner is loaded with native passengers, who cruise from island to island for no more nor less than the thrill of traveling. Often twenty or thirty men and women will leave their home island on what they call a *tutaka*, which is nothing in the world but a tourist cruise. My mother often told me that the second-best fun in the world was traveling. The best fun was going to the picture show, and I suppose this last is traveling, too—for a South Sea girl, anyway.

It is hard to describe the thrill I feel when I go to sea and return to the solitude of the great lonely ocean. Days of calm and days of storm and blessed nights when I lie on deck with the wind steady, fresh, and clean-smelling across me—the rolling, plunging motion of the ship, making me believe that she is a sea giant, my slave; and more than any of these, the friendly company of the moon, stars, planets, clouds, and the wild and lonely sea birds. Ashore I forget what the sky is like; the first night at sea I want to shout with happiness when I see my old friends the stars; I feel like reaching out my arms in a huge embrace.

And there is the thrill when I hear the shout of "Land ho!" and later see the misty outline of an island. And the particular thrill of arrival: the ship nosing cautiously into the harbor, the shouts of "Hard over!" "Let go there, forward!" "Lower away!" the clangor of chain passing through the hawsepipe. And then the thrill when I put my foot ashore and all but shout: "You've done it again, Johnny, you've done it again!"

First we visited the Sisters of Mary—or Papa did while Araipu and I sat on a bench outside to watch some lepers playing football. They seemed perfectly healthy, and maybe they disappointed me a little, for I had come ashore expecting to see some gruesome sights. Later we were told that the bad cases were in the big long hospitals with red crosses on their roofs. The Mother Superior asked us if we wanted to see them but Papa replied that we would rather walk to the point where the Manihikians lived.

We went to the store first, which looked like a trading station except that it was much too clean and the goods were too cheap. As a South Sea trader's daughter, I know that a customer feels uncomfortable in a very clean place. He stands in the middle of the floor to finger his hat nervously, afraid to examine the goods lest he soil them, while if the place is reasonably dirty and disorderly he feels at home, fingers the goods, sprawls over the counter, and buys plenty. And if the goods are too cheap he believes they are inferior. So Lesson One in the South Sea Trading Course is: "Don't sweep your store oftener than once a week, and if you can't sell a line of goods, raise the price."

The Sister of Mary who ran the store told us that all the goods were sold at cost, which I guess Araipu will puzzle his head over his dying day, asking himself: "Then how do they make their profit?" Running a station without making all the profit you possibly can is simply beyond his understanding. Well, Papa and I bought a carton of cigarettes, a pound of Derby Honey-dew plug tobacco, and five pounds of lollipops, and, carrying these, we followed the shady

beach road to the point where we found about fifty people from Manihiki, Rakahanga, and Penrhyn Island living in little thatched houses exactly like their home in the Cook Islands. Papa and Araipu recognized many of them, and lots of them had even heard of me!

We weren't allowed to shake hands but we could talk with them as much as we pleased. They told us they received good food and clothes (four dresses a year for each woman and two pairs of pants and two shirts for each man), and if they needed money to buy tobacco, candy, or pretty clothes they could work on the road or the farms for three shillings a day. They were contented except for one thing, and they did not seem anxious to return home.

Perhaps you can guess the one thing that made them unhappy. Manihikians live only to sing, dance, and make love. At Makogai they were allowed to sing and dance to their hearts' content but love-making was taboo. The Sisters of Mary were very strict in keeping the boys and girls separated, and they did their best to make them forget such things as love and kisses and sweet whisperings on the moonlit beach. Even in the picture show, when a scene showed a boy kissing a girl, the Sister who operated the machine held her hand over the lens, so, of course, when it came to the real thing the young folk had to work on the sly!

The men's and women's houses were about a hundred yards apart, with a high barbed-wire fence between them and a huge, fierce-looking Hindu policeman on guard. Before long we took a Manihiki boy named Teofilo to one side, where we asked him how the boys managed to carry on their love affairs. He grinned when he replied that they wrote letters to their girlfriends and hid them in the laundry, which was sent to the women to wash; in that way they often made dates. But he added, if they were caught the boy was forced to work on the road for a week while the girl had her head shaved. And thus the poor girl, as usual, was the goat—and she no more wicked than the boy!

Teofilo then pointed to a plump and pretty girl whose

head was as shiny bald as old Parson Karé Moana's, and he admitted that he was responsible for her disgrace. Maybe the sisters of Mary thought she would hide herself in shame—as they would, I suppose, if they were caught out in the bush with a boy and had their heads shaved. Still, even I could tell the Sisters that the girl was probably peeved because her good looks were spoiled but was proud to have it known that she had a boyfriend who would risk a week's work on the road for her love, and I bet plenty of the other women were green with jealousy.

I have told you that there was a policeman on guard between the men's and women's villages. Huge, fat, as fierce-looking as our wild and woolly Tongan cook, he had a black beard and mustache about six inches long and turned up at the ends. While we were talking to Teofilo the boy suddenly whispered, "Look! Over there!" and jerked his head toward the cop.

Well, there he stood, as black-bearded as Jove, twisting his club, glaring like anything. My! My! He was really fierce! I could imagine him cutting babies' throats for the fun of the thing and eating them raw without salt or pepper. He was like Mansur the Lord High Executioner in Arabian Nights.

Well, while we were staring at the fierce Hindu policeman, we saw a little witch of a girl, as plump and happy-looking as Elaine, slip cautiously behind him, closer and closer, until she was only a foot or two away. Then she stopped, raised her hand, and tickled the fire-eater's ear with a straw! Of course, the tremendous black man scowled fiercer than ever, stopped twirling his club, reached up, and swatted his ear, thinking the straw was a fly.

The girl tickled him several times, while Papa, Teofilo, and I giggled, and Araipu stared solemnly, with his mouth open and making his *Tch! Tch!* noise. Talk about excitement! Everybody in the village was watching them. Once again the girl reached up, oh, so cautiously! We could see the straw creeping along the edge of his ear! Our own

ears tickled! The Hindu scowled fiercer and fiercer, swatted harder and harder, and then, suddenly spinning around on his heel, he saw the girl, and, believe it or not, started giggling like a silly girl! Yes, giggling! I thought he would fly into a rage and bash the girl over the head with his club—but he only giggled like a silly girl! Which shows that you can never tell by a man's looks how gentle his heart may be.

We gave Teofilo the cigarettes and tobacco, the cop-tickling girl the lollipops, to be divided among the villagers, and started back toward the head of the bay. It was then that I felt my shoes really hurting me, for you see I had never before worn shoes except to go to church, and then I would take them off as soon as I was seated in my pew. Araipu's shoes hurt him, too, but in another place. He glanced at them every step or so, with a worried expression, as though expecting them to wear out before he got them safely back in his chest. Papa wouldn't let us take them off, but he stopped a truck that came up behind us, and, after asking the driver for a ride, he climbed in the front seat, while we sat in the back. Neither Araipu nor I had been in a truck before, but we had ridden once in a taxi in Apia. Sitting in the back, with our legs hanging down, we clutched each other, held our breaths, and watched the road flying away beneath us. But pretty soon, getting used to the speed, we felt braver, except when the truck whizzed along the side of a precipice, when I leaned far over on the upper side and started to cry. Then Araipu put his arms around me to comfort me, but his hand trembled so much I knew he needed comforting as much as I.

The truck took us to a pretty little village in the "clean" half of the island, where there were no lepers, and where we were allowed to walk barefooted. Believe me, it was a relief to get out of our shoes!

First we visited the soap factory. It didn't interest Araipu and me very much—just a lot of machinery, some big kettles and some trays of soap drying. But my father was interested. He asked the manager how to make soap, and when he was told he wrote down the formula, which I will

give you so you can make your own soap during the next depression.

Take one imperial gallon and one pint of water, dissolve in it two pounds of caustic soda, stir it, and let it cool. Then add one imperial gallon and one pint of coconut oil, stir it, and pour it in your molds, and that's all there is to it. Later we took caustic soda to Puka-Puka and made our own soap for the trading station. It was better than the mutton-tallow and beef-dripping soap we bought from the trading schooner.

We had an exciting adventure before we walked the four miles back to the leper colony. The man in charge of the soap factory took us to the dairy farm, where we saw our first cows and horses. The horses interested me most, for I was allowed to ride one, but Araipu was most interested in the cows. He stood beside a nice gentle milch cow for at least fifteen minutes, while I galloped around the field on the horse. When I returned he was still there, staring and staring and making his *Tch! Tch!* noise.

Well, the manager and I came up behind him just as he got down on his hands and knees, crawled under the cow, and twisted his head around to stare at the cow's udder. He studied the udder a long time, reached up to feel the teats and count them, "one, two, three, four," as though to be positive how many there were. "One, two, three, four, and two little ones that don't work."

When, after several minutes, he cried out and glanced at me (with his mouth open, of course, and his *Tch! Tch!* going full blast), he wagged his head, opened his eyes until they were almost as round and big as coconuts, and, "The cow has only one breast, but she has four big teats and two small ones that don't work!" he exclaimed. "Mea umeré! Mea umeré!" (A marvelous thing! A marvelous thing!) "The pig has twelve breasts and twelve teats! The woman has two breasts and two teats! The cow has only one breast but she has four big teats and two small ones that don't work! Mea umeré! Mea umeré! *Tch! Tch!*"

12

THE OLD LADY WHO TALKED TO GOD

That evening we went back aboard the *Tagua*. The ship was smelly from the fumigation, so Araipu and I stayed on deck, but Papa went below to change into his white-drill suit, then went ashore to have dinner with Dr. Rose and Captain Broadhouse at Dr. Austin's house.

I must have been pretty tired, for I remember little of what happened for the next twenty-four hours, but I do remember Araipu sitting beside me on the midship deckhouse, with a dirty quilt wrapped around his head to keep it warm, and praying for hours and for hours, it seemed, asking God to protect us in the distant heathen lands, asking Him to show us the path over the vast ocean back to Puka-Puka, promising Him, if ever we got safely home again, to praise His name every Sunday in church and reduce the price

of twist tobacco in the trading station. Because of Araipu's praying I am sure that I thought of Jakey, Elaine, Nga, and my dear dead mother, but from then on there is almost a complete blank in my memory until we were off the harbor of Suva, Fiji.

Then I started to remember again, because the captain had brought the *Tagua* too close to the passage, and, war regulations being very strict, the soldiers ashore had fired one of their cannons at us. The shot struck the water two or three hundred yards over our bow with a plunking noise and a big splash; a second later we heard the boom from shore, and it sort of wakened me, I suppose, for I remember everything from then on.

When the pilot boat came out, it nosed slowly around us like a shark circling and sniffing a baited hook, while the armed men aboard her watched us and talked to each other. I guess they were scared of the enemy at that time, for, as I have told you, there were lots of raiders in that part of the Pacific, and islands were being shelled and ships sunk every day or so.

Well, when the men on the pilot boat had decided we were harmless, they came aboard. We were lined up on deck so the doctor could look in our mouths and at our hands and feet; then we were taken into the cabin where a policeman examined our papers. We didn't have a passport—only a letter from Geoffrey Henry saying who we were—but Papa had written to the Governor of the Fiji Islands, Sir Harry Luke, asking for permission to travel in the Western Pacific in wartime, and Sir Harry had replied in a friendly letter saying that we might go anyplace we pleased. I had better explain that Sir Harry wrote books, like my father, so he was glad to be nice to a man in the same business.

When Papa told the policeman who we were, he smiled and exclaimed: "Yes, yes, Mr. Frisbie! His Excellency is expecting you! You, your pretty daughter, and your retainer can go ashore in the pilot boat!"

It made me proud to hear the policeman talk that way

to my father and then let us go ashore in the pilot boat like government officials! Let me tell you that we were no small potatoes in those islands—except when we were among the New Zealanders, who won't believe that anyone except themselves amounts to anything.

I have never understood why my father talked Araipu into coming with us, unless it was for the fun of seeing how an old Puka-Pukan man who had never before left his island would act in the great outside world.

So you can picture him stalking along behind us on the streets of Suva, his eyes hollow with homesickness, his feet shuffling, clucking at sight of the three-story buildings, the Fijian traffic cop, and the soldier parade, for those were the three most exciting things we saw on our first day ashore. I clung to Papa's hand. He said later that I jabbered like a monkey: "What's that, Papa? . . . Oh, look at the funny man with a big nose! . . . And the soldiers! And the big guns! . . . and the band! . . . and all those pretty dresses in the shop window!"

During the four months we were in Suva I never tired of staring at the cop on the crossing between Burns Philp's big store and the Metropole Hotel. He was a toy policeman, freshly painted, with a machine inside him which made him lift his right hand and moved the stiffened palm to right and left as snappily as you please. And how spick-and-span he was in his tightly fitting black tunic with shiny brass buttons and a silver badge on each shoulder, and his wide red sash worn like a belt, and his clean white gloves and his white *sulu* with its saw-toothed lower edge and three red bands! His hair was stiff, wiry, and combed upward so that it stood six inches from his scalp. I'm sure he recognized me each time I passed; I could tell it by his eyes—and maybe he knew how much I admired him, for one day, when crossing the street, I glanced at him out of the corner of my eye, and my heart gave a jump when he smiled.

My father bought me a tricycle the day we landed, and often I rode it the three miles from Lami, where we lived,

to Suva. When Papa went to town to drink beer I would follow him about two hours later, and when I reached Suva I would pedal from one pub to another until I found him. Then I would sit on a stool at the bar, while all the men suddenly became very respectable and talked in solemn voices. The barman would give me a bottle of soda pop, and afterward I would take Papa home. Otherwise Lord knows when he would have come home, for he started drinking too much after Mama Ngatokorua died.

The first day in Suva we saw a parade of several thousand Australian soldiers. It wasn't as grand as I had expected it would be except for the band, which was so smart it made a shiver go down my backbone. The soldiers marched any old way, joking with the people along the street and not even keeping in step. But the big guns were grand, bumping along the road on their carriages, hauled by trucks. You couldn't compare the Australian soldiers with the Fijians for snap and discipline. The latter were as smart as the traffic cop. They marched stiff and scowling, their heavy shoes striking the ground with a single click. When an officer gave an order he barked it, and the way those black soldiers obeyed, you'd think they'd shake their joints loose. An Australian soldier told us that his outfit couldn't drill anything like the Fijians. Later these same Fijians went to war in the Solomon Islands, where they were the terror of the Japs. They must have been awful, with their crinkly hair brushed six inches up, their flat noses and big mouths and mean glinting eyes set in faces as black as charcoal, yelling their war cry, their bayonets glinting, rushing into the Japanese camps at night! Their ancestors sailed to Puka-Puka to steal women and eat men; I can imagine what terrors they were to my people.

There was only one room in our house at Lami, but there was an outhouse with a shower, a w.c., and a kitchen. We rented it from Mrs. Peck, a crazy old woman with a mustache and dirty grey hair who lived next door and who poked around in her garden all day, talking to God. Beyond

her lived a woman named Mary, and her husband Mr. Exham, who painted pictures of devils jabbing pitchforks into Hitler. If someone cheated him or made some nasty remark about him, he would paint a picture of him roasting in hell. He was nice to me but I didn't like Mary because she was always kissing me and calling me "Little Johnny Moonlight." I hated that silly name. She got it from Papa's novel *Mr. Moonlight's Island*. She thought Papa was Mr. Moonlight so I must be Little Johnny Moonlight!

At first Mrs. Peck was friendly because I went to church with her and a very religious man named Mr. Robinson, but she thought Araipu was a wild heathen from some cannibal island and that Papa was not very respectable. You see, we knew everything she thought because she used to tell God her troubles and the gossip of Lami as she weeded her garden. She would gossip with God just the same as with Mr. Robinson, like this, without any punctuation marks:

"Well Lord I don't know what to do about the people next door nobody tells me anything Lord but just the same these Lami people are the worst scandalizers I ever saw but they don't tell me a thing I have to go to Suva Lord for every bit of gossip I hear and I am sure the people next door will tramp on my flowers and there's a black heathen and a man who wears pajamas all day like my late and lamented husband Lord and I'll give my puppy dog to the little girl if you will watch over it Lord and see that she feeds it twice a day regular...."

I guess she was pretty lonely, with her husband dead and all the neighbors except Mr. Robinson thinking her crazy. Anyway, she gave me the puppy dog. It was a female and it scared Araipu, for of course he had never seen any dogs except the fierce barking ones on the streets of Apia and Suva. Araipu was so scared he jumped on a chair and sat there with his legs folded beneath him so the puppy couldn't bite him.

I wasn't scared, but I was cautious. After a few minutes I got a stick, shooed the puppy into the outhouse,

and locked the door. Then Araipu got off the chair, smiled with relief, and said that things like puppy dogs shouldn't be allowed in the homes of good Christians.

In about five minutes the puppy started whining to be let out. Being very deaf as well as half blind and crazy, Mrs. Peck didn't hear the puppy whine, but she heard it, all right, when it started howling and scratching the door with its paws. We saw her straighten up from her weeding, with one hand on her back and one cupped behind her ear. The puppy howled some more, then Mrs. Peck stamped her foot, waved her arms around, and screamed: "Oh Lord the black heathen is killing my puppy dog!" The puppy howled and yelped for all it was worth. Then Mrs. Peck got really angry. Oh Lord give me back my puppy dog give me back my puppy dog Lord!" she shrieked.

At that I went to the outhouse with a stick. When I opened the door the puppy jumped on me and tried to lick my hand, so I hit her with the stick and sent her yelping back to Mrs. Peck. When I had returned to the house I saw through the window the crazy old lady with the puppy in her arms, petting it and letting it lick her face (which was not nice), and I heard her say: Oh thank you Lord I prayed to you and you heard me and gave me back my puppy dog Lord!"

She didn't like us after that. She told God nasty things about us as she weeded her garden. I didn't go to church with her and Mr. Robinson any more, which was a big relief, because their church was a funny kind in which they turned out the lights and asked the spirits of dead people to come and talk to them.

13

I GO TO SCHOOL IN FIJI

During the trip to Fiji my father taught me my school lessons every day, including Sunday. Sometimes we would go for a walk during school hours, when Papa would have me repeat my multiplication tables as I tagged along behind him, or he would make me write and draw on the sand. It was always fun because there was plenty of joking and laughing and never any scolding and hard looks such as I have to put up with here in Le Ifiifi School in Apia.

At other times I would teach Papa the words I had learned in Fijian and pidgin. I remember how one day we talked and joked about the three words, *puakatoro*, *pisupo*, and *bulamakau*. Each of them means "bully beef." The first is Rarotongan. *Puaka* is "hog" and *toro* "horns," so bully beef is 'hog with horns." The second, *pisupo*, is the Samoan way of pronouncing "pea soup," and it, too, means bully beef. I have heard that in the old whaling days the sea cook put salt beef in the pea soup every Saturday for an especially good meal, and that when a Samoan chief asked the name of

the meat the cook said it was pea soup, thinking the chief had meant the whole contents of the pot, and that's why, to this day, they call bully beef pea soup. The last word, *bulamakau*, is both the Fijian and the pidgin word for bully beef. *Bula* means "bull," *ma* is "and," *kau* is "cow." When a Fijian king saw the first two cattle unloaded from a ship he asked a white man what they were, and was told, "A bull and a cow," and from that day it was the name for bully beef in the Fijian Islands.

On some mornings Papa would walk to Suva while I followed him on my tricycle, repeating tables of weights and measure, poems, rules of grammar, or working out problems in mental arithmetic. When we got to town we strolled up and down All Nations Street, staring at the strange people and talking about them: Chinese women in baggy black trousers and tunics, with their hair done up in hard knots on the tops of their heads; Indian jewelers squatting on the sidewalk, hammering away at brass bangles; Australian soldiers with their Tongan and Samoan girlfriends on their arms; Indian women with their long sickly-yellow saris wrapped around them a half-dozen times to cover everything from their toes to their hair. And of course we would see a few colonial Englishmen in their everlasting topees and sloppy Palm Beach suits, looking snobbishly down their noses; and some huge Fijian chiefs, black, immensely strong, dignified, their crinkly hair standing up from their heads like the spines of a sea urchin, their huge chests bare, colored *sulus* wrapped round their waists; and we would see a few hungry-looking beachcombers needing a shave and a meal, and perhaps a few Solomon Island laborers down from the big plantations, ugly, vicious-looking dwarfs, perhaps cannibals when in their home jungles.

Papa and I would talk about these people, and he would tell me to smell the place and hear the sounds, and later to taste the food in the different restaurants, because in that way, using all my senses, I would feel the presence of the familiar spirit of place. He was always talking about the

familiar spirit of place. He would have me listen to the singsong speech of the Chinamen, the high-pitched, excited jabber of the Indians, the screaming of street children, the tapping of the shoemakers' mallets and the jewelers' hammers, and the noise of traffic. At the same time he would have me smell the spicy odors from the Indian shops, the appetizing ones from the Chinese restaurants, the smell of fish and meat in the market, of tobacco, stale beer, sweating horses and humans.

"Listen, and look, and smell at the same time," he would say. "Then let your mind go blank and you will feel the spirit of this place. And now let's make the lesson complete by tasting." So we would eat chop suey in a Chinese restaurant, or curried goat in an Indian one, or maybe have a civilized meal at the Grand Pacific Hotel. I liked best the shabby little Chinese places; they were more picturesque.

So that was my schooling. I learned a little Fijian and pidgin and plenty of English. In those few months I changed from a wild little Puka-Pukan to a civilized young lady. But I didn't realize this until I had returned to Puka-Puka. Then I saw what a big change had come over me: how I liked to be clean, brush my teeth, comb my hair, manicure my nails, eat with a knife and fork, drink tea out of china cups rather than Chinese rice bowls, and wear pretty clothes.

14

ARAIPU AND THE BOMBARDMENT

A few days before Christmas my father gave me five pounds to buy presents, so I jumped on my tricycle and rode the 3 miles to Burns Philp's big store in Suva. In an open space in the middle of the store was an oblong counter decorated with colored ribbons, bells, and holly leaves. On the counter was everything needed to make a wild little Puka-Pukan happy! Even today I would be excited, though now I own two dolls, a bicycle, a sewing machine, a wristwatch, lots of books, and a trunkful of pretty clothes. I guess that was the last display of Christmas things in the South Seas. Even now, with the war over, there is not a thing for Christmas in the big stores.

Well, Mr. Robinson, who works for Burns Philp, helped me choose and saw to it that I got the discount Papa is

entitled to as a South Sea trader. First, of course, I bought Jakey's pistol, a lot of caps, a bagful of glassies, and a mouth organ. Then I bought a doll each for Elaine and Nga, a red necktie with yellow flowers painted on it for Papa, and a black necktie for Araipu. I didn't buy any of the stick candy shaped like canes because it would melt in a few days in the tropics, but I bought some firecrackers, another mouth organ, some tin horns, lots of toys, and a little mouse that ran along the floor when you wound it up. I had better say now, so I won't forget it, that the toy mouse made a tremendous sensation in Puka-Puka. For days, until it busted, crowds of people came to our house on Yato Point to see the toy mouse run along the beach. Don't ask me why. I am a Puka-Pukan girl, but I don't know why that little mouse made an even greater sensation than the red necktie with yellow flowers painted on it, which Papa wore only once before he gave it to Araipu.

I also bought some flying pinwheels, and next to the toy mouse they made the biggest sensation. You put them in a basin, light them, and they whirl around for a second or two and then rise spinning in the air, maybe a hundred feet, where they go off with a bang. It's the truth that when Papa set the first one off, men yelled and kicked up their heels and even rolled on the ground. That night, when he promised to set off another one, every man, woman, and child came to Yato to see it—and I doubt if anyone slept that night for talking about it. So, Mr. Would-Be South Sea Trader, if you want to make a big sensation on some lonely island, and establish yourself as a man of importance, bring some toy mice and a box of flying pinwheels. You see, since the days of Captain Cook men have been bringing so many shiploads of mirrors, nails, and colored beads to the South Seas that they are becoming a joke among my people.

Well, I bought presents for Tala, Kani, Ropati-Cowboy, Tiriariki, Pojila—all my friends. Then Mr. Robinson helped me tie the packages on my tricycle, and there were so many of them that I could not get on myself, so

I had to walk home, pushing the tricycle. It was that day, when crossing the street, that the smartly dressed Fijian cop smiled at me—so it was a grand day even if I did have to walk home.

There are hundreds of things I could tell you about Suva and Lami, but this is page 100 of my manuscript, and when I think of all the adventures ahead of me, like the hurricane, the Sirens of Manihiki, and the Navy bomber, I realize I must pass over all kinds of interesting things if I expect to finish my book—but I mustn't skip the story of the bombardment.

My father had gone to Levuka in Ovalau, leaving Araipu and me alone in the house. That meant I had to take care of the man. Well, I have told you that enemy raiders were in the Pacific at that time. Ships were being sunk right and left, mines were being laid in harbors, islands were being shelled. Also, everybody expected the Japanese at any time, and that is why there were so many soldiers in Fiji. We believed ourselves in danger, and we were continually reminded of it by the two big searchlights reaching out slowly to finger the sea beyond Suva Passage, and the hundreds of machine-gun nests hidden along the beach, and the fighter planes roaring over the harbor every day. We were keyed up, expecting trouble ahead, and so it was no more than natural that Araipu and I should jump out of bed, scared stiff, when in the middle of the night we heard the boom of a great cannon, followed by the whine of its shell passing overhead!

We didn't pause to take anything with us. Jumping out of the mosquito net, we dashed from the house, ran down the main highway to the roads that led inland, and hot-footed it for the mountains!

What a sight we must have been, I in my chemise and Araipu in his striped pajamas, with his head bundled up as usual in dirty old rags and towels to keep it warm! We ran about a mile, and every time the cannon boomed we leaped in the air like the men do in the comics, and put on more

speed!

Then we met an old Fijian woman hobbling slowly toward the beach, and of course we stopped.

"For why you run?" the old woman asked us.

Just then the cannon boomed again, and a shell whined over our heads.

"You no hear him?" I gasped. "Cannon go along *bang-bang*! Jap fellow come!"

At that the old lady doubled up with laughter. "Heh, heh!" she snickered. "He makem practice shoot!" And with that she hobbled down the road, laughing in a nasty way. Araipu and I went home, feeling very foolish.

But Araipu never got over it. A few days later, when my father had returned from Levuka, he took me to the picture show, when we returned to the house we found Araipu squatting on the floor, panting for breath! At first he wouldn't tell us what had happened, but later he confessed that a coconut had fallen on the iron roof and frightened him! It had sounded like a cannon, he said. Papa sent for a taxi immediately and took him to the hospital. The doctor listened to his heart and injected some medicine in his arm, then he asked Papa a lot of questions about Araipu, where he was from, and if he had been away from home before, and what sort of place Puka-Puka was, and so on. When Papa had replied, the doctor said: "You had better take this man to a quiet place and get him back to Puka-Puka as quickly as you can, or he may die on your hands!"

From that time until we boarded the ship to take us home, Araipu was a millstone around our necks.

15

RATU SOMEBODY'S VILLAGE

His excellency Sir Harry Luke, Administrator of the Western Pacific and Governor of the Fiji Islands, invited my father and me to tea. I wore a flowered voile dress, socks and black shoes, a white Puka-Pukan hat, and the pearl-shell pendant as well as the ring with three cream-colored pearls that my mother had given to me before she died. Papa got into his white drill suit, black shoes, and cork helmet, took a big drink, and off we went in a taxi, our Hindu friend Joe driving us, and he, too, dressed for the occasion in a white coat.

At the gate to Government Grounds the Fijian soldier on guard saluted us and motioned for us to enter. We drove up the hill, through the botanical gardens, to the front veranda of Government House. There a slick Indian servant,

dressed in clothes even smarter than those of the traffic cop, ran down the steps, opened the taxi door, and stood back at attention while my father and I stepped out and climbed the veranda steps. Mr. Reid, the Governor's aide-de-camp, met us, shook hands, said I was a pretty girl, and showed us into the house.

First, Mr. Reid introduced us to Mr. Iremonger, the Resident Commissioner for the Ellice Islands, and Mrs. Iremonger, who also said I was a pretty girl. They shook hands with us, pointed to two of Papa's books lying on a table, said they had enjoyed them very much. Then they led us to another room, where we met Sir Harry, who shook hands and said how kind we were to come but did not rise from his chair on account of having the gout. In his shirtsleeves and without a necktie he was settled back comfortably in an easy-chair. His foot was bundled up in flannel cloths and rested on a pile of pillows. It reminded me of Araipu's head, but of course the cloths on Sir Harry's foot were very clean.

I sat by Mrs. Iremonger while Papa talked with Mr. Iremonger, Mr. Reid, and Sir Harry. They talked mostly about Puka-Puka. Sir Harry asked Papa if his books about the island were true, and when Papa said they were, Sir Harry said it was incredible that in this world of trials and tribulations there should still be left a little Arcadia. That was the first time I ever heard the word "Arcadia." I asked Mrs. Iremonger what it meant, but she replied that she didn't have the "foggiest idea."

When we were leaving, Sir Harry asked Papa if there was anything he could do for him, and Papa replied: "Yes, sir. My daughter and I wish to drive around the island, and we will appreciate a few letters to the principal kings and chiefs." Then His Excellency said he would be glad to furnish them and told Mr. Reid to see to it that we received them the next morning.

So that is how we were fixed when we started round the island, on December 31, 1940. Also, we had four dozen

bottles of beer, one case of rum, and about twenty pounds of yaqona root—which is called kava in the eastern islands—to make ceremonies with. Mr. Robinson looked awfully unhappy when we bought all those things, for he was a rabid teetotaler.

Our car was a very old limousine with some of the windows missing, and our Mohammedan friend Joe was the chauffeur. First Araipu insisted on saying a prayer, just as if he were going on a long and dangerous journey, for that is the way with natives. They even pray before they go fishing. After the prayer Araipu and I climbed in the back seat, while Papa sat in front with Joe. He handed Joe his purse with about fifty pounds in it, and said: "Joe, you be my secretary. Take care of the money. I might lose it, because I intend to have a good time, no matter what Johnny says."

First we drove to the Rewa River, then followed it for seventy miles, at first through mangrove swamps but later into the hills, where the road twisted around precipices that made me dizzy. But Joe said not to worry, for he had driven a bus over this road for two years. At one place we stopped to swim in a deep cold pool and picnic on its bank. Araipu certainly liked the cold fresh water; he wallowed in it for a time, but he thought it awfully wasteful for so much water to run into the sea where it got salty and was no good for anything except fishes and steamboats.

Beyond the river Joe showed us a precipice where an automobile had toppled into the river; then by and by we crossed a ridge and zigzagged down to the sea. We intended to stop at Bau Island the first night, with King Cakabau. When we stopped where a boat ferries you across to Bau we met the king, waiting for the boat. Papa introduced himself and gave him the letter from Sir Harry. King Cakabau, who was a young man and had been to Oxford and pronounced his name "Thakmbau," said he was sorry but there was going to be a big New Year's party at his palace, so he couldn't possibly put us up. Then my father said he thought that was a hell of a thing, seeing that we had come all this way to meet

him, and with a letter from Sir Harry to boot. From then on Papa and the king started arguing and both of them got pretty hot under the collar until suddenly the king shouted: "If I had a gun I would shoot you!"

"Oh!" said Papa. "Have a beer instead?" and he reached into the car for a bottle.

"I don't mind if I do," the king said.

So they forgot their quarrel while drinking the beer, and presently the king left in his boat for Bau while we drove toward the village of Ratu Somebody—I've forgotten his name.

It was dark when we stopped at a Chinaman's store, there to leave most of our baggage, park the car, and buy a few tins of boiled mutton. We didn't buy bully beef because Joe's religion forbade him eating it. With the meat, four bottles of rum, and four packages of ground yaqona root we started up a path toward Ratu Somebody's village. (*Ratu* means "chief.") It was very dark. A drizzling rain had started to fall, the path was muddy, and all around us the slimy jungle edged closer and closer to the trail, full of sinister whisperings and guttural sounds. The darkness was like black mud squirming with maggots and smelling of dead things. "Are you sure you know where you are going?" Papa asked Joe, and he replied that he had been there "hundreds of times." Using our flashlights, we managed to follow the sloppy trail for about two miles, when we came to a swamp bridged over with coconut logs from one hillock to the next. In one place we had to cross a mudhole on a single slippery log. Believe me, it was dangerous business, with the black slime ten feet below us and no way of rescuing a person should he fall in. It was the sort of place where murders are done, and it didn't make me feel any better when I remembered that Joe was carrying our purse. "I wonder if he would murder us for our money?" I thought. Then I heard my father's voice. "Can you make it, Johnny" When I told him I could, he ran quickly across the log to stand on the far side with his torch, lighting the way for the rest of us. A few

moments later we came to Ratu Somebody's village.

Fijian houses look like haystacks because the roofs and sides are thatched with grass. Usually there are two doors but no windows, which makes them damp inside, and that is why the Fijians light fires in their houses every day, to dry them out. Inside the houses, at night, with their dark and sooty walls and with only one untrimmed kerosene lamp flickering, the gloom is so deep that the nearly naked black men seem like shadows moving here and there. It is downright eerie.

And that's the kind of house Ratu Somebody lived in. After shouting in Fijian and hearing a grunted reply, Joe led us through the doorway. At first we could see only a huge black man squatting in the center of the room before a kerosene lamp. He was dressed in a *sulu*, which is like a Samoan *lavalava*, but his chest was bare. When Joe had introduced us we laid our presents of rum, yaqona, and boiled mutton before the ratu, then handed him our letter from Sir Harry. He couldn't read or speak English, so he sent for a boy to translate the letter. When this was done he scowled, nodded his head, and started barking orders.

It was New Year's Eve so I guess the kava and rum were welcome gifts. First they had the yaqona ceremony, which is given only to specially important and honored guests. A virgin (You can tell a Fijian virgin because her hair is combed down at the nape of her neck) brought in the kava bowl, mixed water with ground yaqona root, stirred it, strained it through a bundle of bark fibers, and then filled a polished coconut shell with the stuff. At that the ratu and everyone else in the house started clapping their hands and chanting, "A-ma-tha! A-ma-tha!" and the virgin, holding the shell in both hands, crept on her knees to the chief, with her head bowed and her eyes on the ground. The ratu motioned for her to take it to my father, which she did, still humbly on her knees. Papa drank all but a few drops, which he poured on the ground for the gods; then he threw the shell, with a spinning motion, toward the kava bowl, where it spun like a

top, for that was part of the ceremony.

"Now, listen, Araipu," Papa said. "I know you are a vicar and all that, and you think you shouldn't drink kava, but I want you to drink every time they offer it to you. Otherwise they'll get peeved and Lord knows what will happen. You want to be polite to these people, Araipu. We're not in Suva now, where there's law and order. This is a bush village full of savages. I remember Sir Harry warning me to be careful and telling me that if we came here it would be at our own risk. Only a few years ago these people were cannibals, feeding every day on men like you and me. Just you remember the Fijians never did like the Puka-Pukans . . . so you drink plenty of kava to show them how friendly you are . . . and by and by give them a snappy Puka-Pukan song and dance."

Araipu wagged his head, sighed, and whispered that he would feel better if the girl who served the kava put on a dress. It was wicked, he said, for a girl to expose her breasts; but, on the other hand, if our lives were really in danger he would drink the unholy stuff. So when the virgin brought Araipu the shell he looked solemn and downed it. Then he handed the shell back to the virgin, but she drew away with a scared look, and wouldn't touch it, for that would have been against the rules of the ceremony. Araipu had to set it on the floor before she would take it back to the bowl. During the night Araipu drank lots of kava; it made him foolish enough to do a Puka-Pukan dance, which wasn't very hot.

Well, after the yaqona ceremony four men and four women entered, dressed in *sulus* only, but with anklets, wristlets, and necklaces of flowers and leaves, and with their bodies glistening wet with bad-smelling coconut oil. Squatting on the floor, accompanied by two tom-toms—one sounding a high note and the other a low one—the men sang and moved their arms around and joggled their shoulders; then the women did the same thing. I suppose the Fijians thought it was fine, this *meke* dance, but to a Cook Islander, who had seen real dancing, it was awfully tiresome. They

kept it up until nearly midnight. We had our meal in the middle of it; then Papa and the ratu drank rum and chewed the fat through Joe the interpreter, but along about midnight the chief rose and said that we must go to church for the big New Year's service.

The church was the gloomiest place I have ever seen. It was like a cave. Only one lamp cast a feeble misty glow on black men squatting on the floor, scarcely visible save for the whites of their eyes. Ratu Somebody led us to some benches behind the pulpit; then he told us through Joe the interpreter that it was their custom on New Year's Eve to have many sermons, preached by many people, from midnight to dawn, and would Ratu Araipu and the distinguished white gentleman from Puka-Puka please preach a few sermons to them?

"I can't possibly preach tonight," my father replied; "I've been drinking rum." But the chief just grinned in his fierce way and replied:

"So have I, but I shall preach six sermons tonight!"

Well, Araipu preached first, in Puka-Pukan, and he was so scared I was afraid he would have another heart attack like the one he had when the coconut fell on the roof. Papa translated his sermon into English. Then Mohammedan Joe translated it into Fijian. I understood all the languages pretty well, so I heard Araipu, like a silly sacred ninny, use for his text (I remember this, for Papa and I have often joked about it): "And men shall worship him, everyone from his place, even all the isles of the heathen."

Papa smiled in his unhappy way at Araipu's text. He didn't want to start a row, so he translated: "My text is, 'Consider the lilies of the field, how they grow; they toil not, neither do they spin,'" and when Araipu said it was wonderful that Christ's message should have come even to a heathen cannibal isle like Fiji, Papa translated that it was wonderful to learn that the Fijians alone of all the people of this world of ours obeyed Christ's message.

Like his dancing, Araipu's preaching wasn't very hot.

He couldn't think of more than about ten words to say at a time, but Papa spun it out to fifty or more, and when it came to Mohammedan Joe's turn to translate, he spun it out to over a hundred, though Lord knows that it wasn't Christianity—maybe something out of the Koran.

When Papa preached his own sermon it was really fine. I felt proud of him, and very surprised, too, for my father is not the kind of man you would think of as preaching a sermon. He didn't make any wisecracks either, as I was afraid he would.

It must have been dreadful, preaching into the gloomy church, with the whites of a thousand eyes staring at you from a mass of black faces and the heat and smell of sweating bodies, and outside the drizzle of rain and the monotonous drumming of tom-toms, one high-pitched and one low, all the weary night through. . . . I woke at dawn, with Papa shaking me and telling me to hurry so we would get to Mr. Gatwood's Tailevu Hotel in time for breakfast.

16

DEMONS AND SUGARCANE

Tailevu Hotel was built on top of a little hill so perfectly round and dainty that we thought someone had piled up earth and rounded off the sides, until we were told otherwise. Mr. Gatwood let Papa and me have a room to change our clothes in but he sent Araipu to the servants' quarters, because in Fiji the British were very strict about the color line. They wouldn't allow even me in a hotel except with my father. That's the way the Britishers are. I've never known a native who wouldn't prefer his country run by the Americans.

After a bath I got into my flowered voile dress and then nosed around to the back of the hotel, looking for Araipu. I found him sitting a little way from the servants' bathhouse, looking scared as usual. "What's the matter, Araipu?" I asked, and he replied in a gasping tone:

"There's something in the bathhouse, Johnny,

something terrible in the bathhouse! Let us leave this house of demons quickly, Johnny! There's a demon in the bathhouse!"

"What kind of a demon?" I asked. Then I stepped to the door but Araipu called me back.

"Keep out of there!" he gasped. "There's something dangerous in there! I think it's a Fiji demon!"

"All right; I want to look at it," I said, opening the bathhouse door. The next instant I jumped back, with a little cry of fright, for in the middle of the floor I saw a slimy green thing, with livid spots and a grinning mouth that stretched across its face! As I stared it jumped about three feet to land on its belly with a plunking sound! At that I slammed the door, ran to Papa, and told him there was a horrible-looking thing in the bathhouse that Araipu thought was a devil. He returned with me, opened the door, and saw the thing. With a laugh he reached down to pick it up, while I screamed and Araipu nearly fainted.

It's only a frog, Johnny," he said. Then he tried to hand it to me and Araipu, but I ran away, while Araipu turned sickly green with terror.

Later, of course, we got used to frogs, but up to that day we had never seen or heard of one, and you must admit that they are not nice things to look at the first time.

After a fine bath and breakfast we got back in the car and drove toward Lautoka, but after we had gone a little way I found I had lost my shoes. I got them back, though, for Mr. Gatwood sent them to Mr. Robinson, addressed: "To the Little American Girl Who Stopped at Tailevu Hotel on New Year's Day." I remember how he addressed it because it made me happy to be called an American girl instead of a New Zealander—you see, the Cook Islands are a part of New Zealand.

We drove past the gold mines, and then for miles and miles and miles we drove through sugarcane plantations where we saw big locomotives hauling mile-long trains loaded with cane for the mills. Papa said to Araipu: "Just

look at all that sugarcane, Araipu! You are lucky to grow a dozen stalks on Puka-Puka!"

Thereupon Araipu only grunted that the Puka-Pukan cane was much sweeter than this big coarse stuff, which wasn't fit to eat. But just the same, as we drove through endless plantations of cane and saw more trainloads a mile long and more big locomotives, Araipu was so impressed that he made his *Tch! Tch!* noise at shorter and shorter intervals, until by and by it got on Papa's nerves, and, "Oh, shut up!" he shouted. "You make a noise like a typewriter!"

That night we slept at the Lautoka Rest House. It was very noisy, for there were about a thousand soldiers in Lautoka and they were celebrating the New Year with rum. Next day we visited a pineapple cannery and then started for home. My! My! It was a long and weary ride! I kept awake until dark; then I closed my eyes, and when I opened them again it was to see the dawn through the window of our house in Lami and to hear old Mrs. Peck talking to God as she weeded her garden.

17

WE SAIL ON A LUXURY SHIP

When I started this book I planned to tell the story of our voyage to the Fiji Islands in twenty or thirty pages, but now I find so many memories returning to life (and so many suggestions when I read my father's journal—but I don't crib) that it would be easy to write a whole book about the adventures of three Puka-Pukans in the Fiji Isles. Still, I am going to cut it short because while writing these last chapters I have been as impatient to get myself safely back to Puka-Puka as I myself was impatient to return and tell my adventures to Jakey, Elaine, Nga, and the neighbors—nearly as impatient as poor old Araipu was to return to his good wife Toia, his tame duck, and his breadfruit tree. When we told him we were leaving by the *S. S. Monterey* for Pago Pago the old dear nearly had another

heart attack, for Pago was about seven hundred miles closer to Puka-Puka.

We bought our tickets at Morris Hedstrom's office for twenty pounds, and toward evening Mohammedan Joe drove us to the great white luxury ship, where there was another departure to make shivers run up and down my backbone. A big space around the dock was fenced off, and stern Fijian guards with bayonets fixed paced inside the fence, allowing no one but passengers and people with passes near the ship. At the gate we showed our tickets and said good-by to Joe. Then two huge Fijians, with badges on their wrists marked "Porter," grabbed our gear, yelled "Yes, sir. Room 580!" and rushed panting and sweating down the dock and aboard the luxury ship. All about us was the bustle and noise of taxis, trucks, and cargo drays; yelling stevedores, sailors, and Fijians; Englishmen shouting, "I s'y theyah!" and Americans, "Hey, you!" There were people running every which way and all shouting at once, the steamboat's siren shrieking, Araipu clucking for all he was worth, and Johnny Frisbie screaming to herself: "You're traveling again, Johnny; you're traveling again!"

Then we were inside the ship and suddenly everything was quiet except for the gentle purr of the engines, a steward whispering courteously: "Yes, sir. Room 580. Downstairs and to your right, sir."

"Did you hear him?" I whispered to Papa as we climbed down the carpeted "ladder." "He said, 'room' and 'downstairs' and 'right!'" It seemed so strange to me; for to an atoll girl, brought up among traders and seamen, even the floor of a house is the "deck"; you shout to a man passing on the road, "Come aboard!" You "turn in" your "bunk" at night, and you climb down the "ladder" to the "galley."

In our cabin Araipu and I had our first taste of real luxury. There were hot and cold running water, a thermos jug of ice-water, "smell" soap, individual washcloths wrapped in cellophane, a basketful of peaches, pears, apples, grapes, and oranges, wonderfully soft beds—not berths—with pure white

linen and blankets as soft as feathers. Electric fans hummed us to sleep, and when Papa wanted a bottle of beer, he had only to telephone for it and in two ticks a steward brought it. That first night Papa telephoned for the laundryman and sent our clothes to be washed, and next morning before daylight they were returned washed, starched, and ironed!

We had expected Araipu to be thrilled with all the comfort and luxury aboard the *Monterey*, but he scarcely let out a *Tch!* Papa told me it was the same when he took some native sailors from the schooner *Tagua* ashore in San Francisco. They just gaped, seemingly not at all impressed, but after about six months, when they were back in the Cook Islands, their eyes would suddenly sparkle, they would straighten up, grin, and, "Do you remember the elevator?" they would exclaim. Then they would start an exciting story about how they had been taken up twenty floors in an elevator without knowing they had left the ground floor, and how flabbergasted they had been on looking out of a window to see the street far below them.

That's the way it was with Araipu. He just gaped, his eyes dull and seemingly observing not a thing, but months later, in Puka-Puka, he talked about the *Monterey* by the hour, even preached sermons about "the Babylonian luxury" of the wicked white men, ending with the moral that, though the white men's luxury ships were good enough to travel on once in a lifetime, for downright comfort and safety he'd take his good old flat-bottomed boat any day. All Puka-Pukans are like that: they won't admit that anything in any place is as good as what they have at home—and in a way they are right.

It's no use describing all the marvelous and beautiful things aboard the *Monterey*—the lounge, picture show, masquerade balls, swimming pool, tennis court, bar, ping-pong tables, elevators, and the pretty lady passengers, because all that would interest no one but a Puka-Pukan.

The first night aboard we had roast fancy duckling for dinner with lots and lots of other delicious food. I guess that

fancy duckling must have reminded Araipu of his tame duck at home, for he only picked at the food, sighed, and mumbled that he was hungry for a nice juicy dish of raw clams and a piece of coconut. As soon as we left the dining room he hurried to our cabin and turned in, and he didn't leave his bunk again until we were in Pago Pago. . . . Well, I've got to admit that I hardly left my bunk again, either. The sea was calm; there were none of the bad smells that make me sick aboard a trading schooner; the ship scarcely rolled at all—but I was never so seasick in my life! I guess it was the slow easy motion that got me.

So, with the adventure of a lifetime to thrill us, there lay Araipu on one bunk, in his striped pajamas and his head bundled up in Matson Line bath towels, and there I lay in the opposite bunk, in my pink pajamas, but where I was quiet, Araipu groaned and grumbled: "It would be terrible if it wasn't for you Johnny—terrible on this great lonely ship! Where do you think it will take us, Johnny? Are you sure it is going to Samoa? It would be terrible if the captain couldn't find Samoa and took us instead to some faraway savage land like Sydney or New Yawka!"

Or he fretted: "I never feel safe on these ships of the white men. They are dangerous, Johnny, dangerous! It would be terrible, Johnny, if this ship capsized and we were drowned out here in the cold lonely ocean where there's not even a parson to say a prayer over us or a good woman to weep! Oh, Johnny, will we ever see Puka-Puka again?"

When Araipu talked that way it did seem terrifying to be drowned in a luxury ship, with all the ladies screaming and the men in dinner jackets yelling, "Help, help!" but I suppose drowning in a schooner would be just as bad as in a steamboat.

We got into Pago Pago early the second day, with rain pouring so thick we could hardly see the shore. The three of us put up with a friend of Papa's named Suiava à Utu, who was Headmaster of Poyer School and very much of a gentleman, which is an uncommon person in Samoa. Pago

Pago is an unpleasant place run by Navy officers as snobbish as Britishers and natives as snobbish as Navy officers, so I'll not describe it now except to say that it was full of marines and sailors and contractors and three thousand native laborers from Western Samoa. The docks were crowded with antiaircraft guns, cannons, trucks, tanks, munitions, and so on, for at that time, about March 1941, our Uncle Sam was fortifying his islands. As everybody in the South Seas knew, the United States would soon be in the war.

Five days later we sailed to Apia in Western Samoa in a little coasting schooner named *Amy*. There we lived on the lean of the land for three months, waiting for a ship to take us back to Puka-Puka.

18
TRADE GOODS FOR PUKA-PUKA

O ne day Mr. R. H. Brown, the manager of Burns Philp and Company Ltd. told us that Captain Cambridge's *Taipi* would arrive in a few days and would take us back to Puka-Puka for £25. It was cheap, of course, for we would have his ship to ourselves.

My father and I wanted to stay in Samoa longer, but we had only enough money to make a big splurge buying trade goods; also, we had to return on Araipu's account. The old man was getting very feeble and a little off his head, though nothing was wrong with him except homesickness, as Dr. Monaham said. We were terribly fed up with hearing about his everlasting good woman, his tame duck, and his young breadfruit tree, all of which might fly away to the moon if we didn't hurry home. That man was certainly a bother!

Well, early next morning Papa bundled us into a Gold

Star taxi, which took us in style to Burns Philp's store, and there we blew in £600 for trade goods! Believe me, we were big people in a big store that day! We had only to "Hmm!" or raise our eyebrows to bring a department manager running to us with a sales book in his hand. Araipu got bilious seeing all that money spent, and it worried him to see the manager take my father down to the basement and buy him drinks. He thought the manager might trick my father into buying bad goods. I think it worried Araipu even to see the salesmen give me candy. Each time we bought in a new department the salesman would say: "And won't the little girl have a few lollies?" Then he would give me a jar of hard candy or a tin of butterscotch. I collected about a dozen, which I packed in my chest for Jakey, Elaine, Nga, and the rest back home.

We bought thirty-pound caddies of Lord Beconsfield twist tobacco and twenty-pound caddies of Derby Honey Dew plug tobacco; twelve-gross tins of Horse Brand safety matches and two-and-one-half pound cartons of Yankee Doodle cut plug in vacuum-packed tins; "pipe knives," tomahawks, canoe adzes, whale spades, axes, and bushknives, cast-iron pots, dutch ovens, kettles, frying pans, charcoal irons, and carpenter tools; copper and galvanized nails; Butterfly scent, Three Girls talcum powder, Tiki hair oil, and Erasmic "smell" soap; tons of flour, sugar, rice and biscuits; cases of soap, kerosene, trade beef, chum salmon, oval tins of sardines, Oak jam, and Highlander milk; fishhooks by the thousand, fishline by the mile, and fish spears by the hundred-weight. This was our chance to stock the trading station properly, and we were doing so in the grand manner right down to things like lamp chimneys, tableware, and patent medicine, which we didn't sell often. We even bought some umbrellas, sewing machines, and shotguns, for sometimes a Puka-Pukan will make a fortune: he may find a pearl, or a relative in Rarotonga may send him a few pounds, or he may work on the nearby copra island of Nassau to return with twenty or thirty pounds, when he will always buy an umbrella, a sewing machine, and a shotgun, as

well as things like charcoal irons, cast-iron pots and kettles, and carpenter tools. You see, a Puka-Pukan will waste his pennies on hair oil and firecrackers, but he will use common sense when he has lots of money, buying things that will last a lifetime.

We bought lots of fancy goods for our own use: Hormel hams, chickens, and chili con carne; a case of ginger ale and one of canned peaches; some tins of lollipops, bottles of lime juice and Log Cabin syrup—lots of nice things—not a one of which we gave a damn for when we got home and opened them! It's funny about that: food that tasted fine in Samoa was so much swill in Puka-Puka, and likewise, the coconuts and fish that we loved at home were tasteless in the civilized islands.

The greatest fun that day in the store was in the drapery department, with its manager, pussyfooted Mr. Sims, serving us, and the crafty old trader, Mr. Menzies, trying to make us buy more than we needed. Silly man—with stingy Araipu and a crack trader like my father against him! The big wholesale drapery room smelled nice; it was so quiet that I walked on my tiptoes and spoke in a whisper. Only Araipu's creaking shoes jarred on the churchlike stillness.

"We'll take three hundred Pearl River," my father would say.

"Yes, sir, three hundred Pearl River. Red or blue, sir?" Mr. Sims would reply in a whisper, so his breath wouldn't ruffle all those thousands of yard of drapery displayed around the big room. (Pearl River is the red-and-white or blue-and-white cloth that the Tahitians call *pareu*, the Samoans *lavalava*, the Fijians *sulu*, and the Puka-Pukans *kie*.)

"And a thousand each of *paruvai* and *faraoti*," Papa would add, *paruvai* being white calico and *faraoti* unbleached calico. "Now let's look over the prints."

So we would walk slowly down one aisle and up another, with thousands of yards of lovely drapery stacked on either side of us, to pick out a few bolts here and a few there,

but always pricing them first, for few Puka-Pukan women can afford to pay more than a bob or one-and-threepence a yard for print. It was mostly Japanese stuff priced wholesale at five to sixpence a yard, and it was very pretty, even though the colors would fade badly in the first washing and disappear in the second. We would finger the cloth, and often Papa would tickle me pink by asking: "What do you think of this line, Johnny? You're a younger flapper, so you ought to know what the Puka-Pukan gals want. Make yourself useful; pick out a few bolts!" Then I would point to bolts I thought pretty, and every time Papa would jerk them out of the pile and hand them to one of the store boys to be put with our great heap of goods.

Prints, muslins, voiles, black rayon for mourning and white Victoria lawn for weddings—we bought about three thousand yards all told, and also dungaree, khaki, light canvas for canoe sails, singlets, work shirts, and white shirts, canvas shoes, a great gross of sewing cotton, Swiss embroidery, ribbons, pins and needles and buttons and what not and this thing and the other. Mr. Sims seemed surprised when we bought one thousand packages of brass pins, for he had no way of knowing that the Puka-Pukans made fishhooks of them to catch a bait fish called kaloma—red mullet minnow. And he looked a little startled when we bought six cases each of Painkiller and Butterfly scent, for how would he know that we resold them to the supercargo of the *Tiaré Taporo,* who resold them to the Penrhyn Island natives to drink. But we also sold plenty of Painkiller and Butterfly scent in Puka-Puka, for the witch doctors mixed it with soap and the juice from coconut roots to make stomach medicine.

It was a grand day. When the little *Taipi* got in and we looked at her alongside the wharf and then at our mountain of cases, bags, and cartons we didn't believe it possible to stow so much goods in so small a vessel, but in our cargo went, and with room left for Araipu, Papa, and me on top of it, there being no cabins on the *Taipi.*

Araipu went aboard with his gear the day the *Taipi*

arrived, afraid she might sail without him. And the old dear was a changed man from then on. He shuffled off about twenty years, became cheerful, spry, and boyish. He helped Teinaki and the captain; but if they asked him to leave the boat, even on a short errand ashore, his face would fall—his lower jaw, too—his eyes become miserable, and he would refuse in a sullen pouting sort of way, like a spoiled child. I doubt if he left the *Taipi* to step on the wharf unless it was to help load cargo. Maybe he was afraid the old tub would suddenly take wing if he got a few yards away, leaving him marooned in that distant heathen land—marooned, never again to see his good wife Toia, his tame duck, and his young breadfruit tree!

19

WE GO TO SEA IN A TUB

The *Taipi* was a cutter with one headsail inboard—which means she had no bowsprit—and a big gaff mainsail, but later Captain Cambridge turned her into a ketch with a short gaff on both sails and a small mizzen staysail. She looked odd, standing high out of the water, painted black with yellow trimmings, and with an old tin trunk lashed to her taffrail for a stove. But she had an easy motion, the seas didn't bother her, and though we had squally weather and a nasty chop the first few days out I was not seasick once during the three-week voyage to Puka-Puka. Yes, it took three weeks to sail 404 miles, but that wasn't so bad when one recalls that there was a head wind all the way.

When I think back I remember the voyage as three weeks of fun and excitement; but I remember also that we growled a lot about the everlasting porridge and dough balls boiled in sea water, which was about all the food Captain

Cambridge gave us. But nearly every night flying fish flew aboard, which helped a lot, for they were nice fried in coconut oil. One night a flying fish hit Captain Cambridge *ka-plunk* on his big nose! He howled bloody murder, and from then on kept pink sticking plaster on his nose until we sighted Puka-Puka, when he took it off because it wouldn't look dignified to go ashore with pink sticking plaster on his nose.

We growled also about having to sleep in the hold on top of the cargo in squally weather. When the weather was clear, as it was most of the time, we slept on deck, under the stars, and when a squall humped its back over the horizon to roll down on us we enjoyed the grandest thrill of a South Sea voyage. At first it would blow great guns; the captain would hold the *Taipi* up in the wind till her mainsail fluttered, and we would put our backs to the rain, which pricked us like pins and needles. But when the wind had died down, the mainsail slatted, and the rain poured straight down, we would take our dirty clothes on deck, sit naked in the scuppers, soap our clothes and thump them with our fists. We would wash the sticky salt from our hair, soap one another's backs, and feel the cold rain water pouring down our naked bodies! Let me tell you that on a really hot day a squall is about the grandest thrill in life, ashore or afloat. Everybody whoops and sings, soaps themselves and washes off; a canvas trough is tied under the main boom to catch water, and we all lend a hand carrying buckets to fill the water drums.

Captain Cambridge had a professional lion tamer named Bruce Robertson aboard as passenger. Huge, pink-skinned, red-haired, dressed only in bathing trunks, he would lie on the cabin top all day long, with the sun beating down on his bare skin. He told us he had been sick and this was his way of getting well again. When a squall came he wouldn't move except to roll over once or twice so the rain would wash his back as well as his front, and he would ask me to soap him, which I would do. His skin tickled the palms of my hands, it was so rough and hairy. At night he would stay on

the cabin top until maybe midnight, when he would go below to one of the two berths in the captain's cabin.

In the evenings I would sit beside him to hear his funny stories, mostly about wild animals. One evening we heard Captain Cambridge snoring, and that reminded Bruce of a story. "Did I ever tell you why men snore, Johnny?" he asked me. When I told him that he hadn't, he went on:

"Well, you see, it's like this: a long time ago, maybe a million years, there were lots and lots of gorillas and baboons in Africa, but no men. Now, Africa was a dangerous place, full of lions and tigers that liked nothing better than to eat gorillas and baboons without salt or pepper. Well, these gorillas and baboons were afraid of the lions and tigers, so they slept high up in the trees, and, you know, they learned to snore in their sleep so as to scare the lions and tigers away. When the lions and tigers heard the gorillas and baboons snoring, they thought it was dangerous animals growling, so they hopped it off for the jungle.

"Well, by and by these gorillas and baboons had specially fine young ones, and these specially fine young ones had extra specially fine young ones, and so it went, they getting better and better, until, before you could say 'Jack Robinson,' they had turned into men!

"Yes, that's what you call evolution. They got better and better until they didn't look like gorillas and baboons any more, but like men. Even then, Johnny, they never forgot about all those lions and tigers that used to eat them when they were gorillas and baboons, so these men kept snoring in their sleep to scare the lions and tigers away—even when they were sleeping in the captain's cabin on the *Taipi*! Nature is a funny thing, ain't it, Johnny?"

Then there was Captain Cambridge, who was short and skinny and wore pink bathing trunks all day but bundled himself in a pea jacket and dungarees at night. He had a very large nose, which made it bad when the flying fish hit him; and though he was a teetotaler, he liked my father because Papa played cribbage with him every day and let him win,

and because Papa always spoke of the *Taipi* as, "Your ship, Captain," although it was nothing but a little sea louse. Also, Papa would say, and I think more than half mean it: "Captain, I'd rather sail on your ship than on any luxury vessel that ever tossed her proud head above the main!"

So the captain liked Papa and tried to make him sign the pledge, which was a paper saying he wouldn't drink any more. Papa said he would think it over. I guess Captain Cambridge would be glad to see my father now, for he is a rabid teetotaler, though he hasn't signed any pledge!

20

WE RETURN TO PUKA-PUKA

We sighted Puka-Puka early one morning, but with both a strong current and a fresh wind against us it was evening before we were in the offing by Yato Village. Araipu hadn't been much impressed with the great big beautiful world, but when he saw little low-lying Puka-Puka, misty and unreal against the horizon clouds, he scrambled up the rigging, whooped, scrambled down again, danced, prayed, and sang hymns. I guess Puka-Puka was the first land we sighted in all our voyage that he understood or cared a rap about.

Araipu's boat came out to get us, with Constable Benny, Heathen William, Tapipi, and a man named Uka. I put on my very prettiest clothes to go ashore in, but when I jumped out of the boat on the beach of Yato nobody

appreciated my pretty things a bit! Talk about jealousy! Jakey looked me over from head to toe. Then in a mean tone he asked if I had brought his pistol with plenty of bullets, his bag of glassies, and his mouth organ, and if I had seen his friends Peter Thompson, Alan Grey, and Bill Harrington and given them each a hat and a mat. When I said I had done so he turned away to continue his game of marbles with some naked little native children. I nearly cried, especially when I remembered that when he had come home from Samoa, wearing his sailor suit, his sandals, and his Navy hat, we all made a lot of him.

Nga didn't recognize either Papa or me but just clung to old Luita, staring at us—but maybe she was faking. As for Elaine, she kissed me and then jumped on Papa to laugh and cry and kiss him all over the neck and face like a puppy dog licking its master. When Papa reached in his pocket for a package of Lifesavers and slipped it in her chubby hand she was tickled pink. She ran to Jakey, Nga, and the village children to show it to them; then she danced and screamed as happy as if he had given her a motorcar. Elaine needs only love to make her happy. I really believe she'd rather have a kiss and a kind word from Papa than a bag of lollipops from someone else—and that's saying a good deal, for she certainly is strong on lollipops.

Well, that's the kind of homecoming I had, but they were nice later when they got over being jealous and I had let them ride on my scooter and my tricycle and had given them all the nice presents from Fiji and Samoa. As for the rest of the people—Grandma Tala, Kani, Luita, Taingauru, William, Pati, Vaevae, Ropati-Cowboy, Tiriariki—My! My! They crowded around me for days and days while I jabbered away, telling the whole story of our journey over and over again so many times that now, in writing this book, it is just like repeating the story once more, and I hardly ever have to look in my father's journal.

The first things the people wanted to know were the songs, dances, and games I had learned, for, where a white

man will ask first of all of a traveler: "What are the business opportunities in the islands you have visited?" a South Sea native will ask, "What songs did you learn, and dances, and games?" So for weeks I taught my friends Fiji's famous song "Isa Lei" and the Samoan song "Tofa, ma Feleni" and the white men's songs like, "When the Lights of London Shine Again," "Hula-Hula Hands," "I'd Hate to Get the Mumu in Samoa," and lots and lots of others. Then I taught them how the Fijians danced the *meke* and the *tra la la*, the Samoans danced the *sa sa* and the *ma ulu ulu*, and how the Fijians played hopscotch, and the Samoans shot marbles with their index fingers. Believe me, I was a big little girl in Puka-Puka, and word flies so fast in the South Seas, from island to island over hundreds of miles of ocean, that later, when we visited Manihiki and Rarotonga, one of the first things the people asked me was to teach them "Isa Lei" and the other songs of Fiji and Samoa.

That's the way with the atoll people. Even in ancient times, when the great navigators like Tu, Tonu, and Wue explored the remotest islands in the Pacific, they were welcomed home, and remembered right to modern times, by the songs, dances, and games they had brought from other islands. Our history tells that, when they visited a distant land, one of the first things the people asked was to be taught the pastimes of Puka-Puka. It was the same with Mama Ngatokorua. When she returned with Papa, Jakey, and me from Tahiti, she was busy for months teaching the people, old and young alike, all the songs and dances of the eastern islands. Had she come home without this knowledge she would have been in disgrace. And one of my father's biggest jobs in Puka-Puka, after doctoring, was teaching the people stories like the ones of Ulysses and Aeneas, which they made into theatricals for May Day and King's Birthday.

As for Araipu, for a long time he had nothing to say, but no one minded that much because they knew he was thinking up a grand sermon for the Sunday following Communion, when it was his turn to preach. Talk about

excitement and anticipation! I guess that sermon was about the most important one ever preached in Puka-Puka: a vicar, who had been "all over the world," would settle, once and for all, the question as to whether or not there was another land as grand as Puka-Puka. The Puka-Pukans are very touchy about their homeland, very proud. They won't believe that any other land amounts to a damn in comparison to their own. To them the earth is the planet holding Puka-Puka—also some other "islands" like "Lonitoni" and New Yawka." Most of the natives want to travel, but not a one of them would dream of settling on another island. To them the principal fun in traveling is in proving how inferior other islands are and in returning home to make sarcastic remarks about them.

So the island was eager to hear what Araipu had to say, and, believe me, he didn't disappoint them. Everybody was in church accept my father—even old William the Heathen was there! Araipu mounted the high pulpit dressed in the flashy checked suit Papa had given him, a blue Arrow shirt, the red necktie with yellow flowers painted on it that I had given to Papa, and his precious shoes.

Men straightened up, frowning, steeling themselves for the worst. Women quieted their babies; even the children were silent. There was an excited feeling in the air; then, suddenly:

"Bula! Mothé!" Araipu shouted the Fijian greeting—about the only words in Fijian he had learned.

"Talofa, Alii!" The Samoan greeting too! Everybody was impressed.

"Good morning, ladies and gentlemen!" That settled it. Araipu had come home speaking three languages. Anything he said must be true!

"Kia orana kotou!" which wasn't so hot, being only Rarotongan, which plenty of Puka-Pukan spoke.

Then Araipu gave his text, which is the same one he had used in Ratu Somebody's village, and immediately started to tell of our journey. I, listening, wondered if he was

lying or really believed he had seen the things he described, and I began to understand what a strange and terrible experience he had been through. Araipu claimed that he alone had saved us from the cannibal oven in Ratu Somebody's village. He said he had seen the fierce savages sitting in their heathen temple, licking their lips as they glared hungrily at fat little Johnny. It was only through fear of him, Araipu, that I was not cooked and eaten on New Year's Eve!

"All the foreigners are brands for the burning!" Araipu shouted. "They are dark-minded heathen, while only the people of Puka-Puka have seen the light of God's way. In the foreign lands you starve and sleep like pigs on the bare cold ground unless you have bags of gold to pour into the hands of the money changers. No one meets you on the beach with a drinking nut in his hand and a word of welcome on his lips. No one asks you into his house to eat and sleep. When you beg for a mouthful of food they curse you and turn their eyes away. You must pour gold into their hands before they give you a roof to shelter you—and then your nights are made hideous by the thunder of great cannons, the whining of shells, the croaking of demons or the crash of bombs on your roof, the whispering of cannibals plotting for your life! It was only through terror of the name Puka-Puka and prayer to the Almighty, that I lived to look once again on my happy home and my good woman Toia!"

Then he spoke of the thousands of pounds he had spent. Araipu claimed he had returned to Puka-Puka a pauper, both because of the money the foreigners had stolen from him every time he had wanted a little piece of taro or a coconut, and because of the money that that spendthrift Ropati had squandered! There's gratitude for you! He blamed Papa for all his troubles, and he lied that Papa had spent his money, when in truth we had fed him and housed him and nursed him like a baby! Give a native a little money and a store and he becomes the meanest man in the world. I've seen lots of them like Araipu. As soon as they learn the value

of money they become greedier than a white man.

Oh, well, Araipu's sermon didn't bother us much. Papa just laughed when I repeated it to him. He said all natives were like that, and he had been foolish to take Araipu because natives are pleasant company only on their own islands, living their own way of life.

From that day on Araipu became a hero like Wue, the great navigator of ancient times who told such tall tales of his travels that even today people say of a liar: "He has the tongue of Wue!" They'll say that of Araipu some day. They'll say: "He has the tongue of Araipu!" for Araipu's stories got worse and worse—for lying—and I think he believed them himself. Before long he was telling of his battle with the frogs, and how he had saved me from the Japs during the bombardment of Fiji, and how he had converted the savages in Ratu Somebody's village by preaching and praying all night long. . . . But I guess I'd better let it go at that or you'll be saying that I have the tongue of Wue. You have to live in a place like Puka-Puka to believe the things that happen there.

21
I BECOME A WRITER

My home is an atoll, fifteen feet above sea level, rather small and flat, a paradise like no other on earth. If you are curious as to where she is to be found, look at a global map with the aid of a magnifying glass and you will find Puka-Puka, a dot the size of a grain of sand about ten degrees below the equator. There are fifteen islands in the Cook Islands, of which my ancestral home, Puka-Puka, is one. Her population during the time of my formative years remained a constant six-hundred and fifty lovely people, all of whom are descended from the handful of survivors, some four-hundred years ago, of a devastating tsunami—or it may have been a hurricane—no one knows for sure. Her ancient name is Ulu O Te Watu, meaning "Head of Stone." Yes, we are as strong as the many boulders embedded securely in our reefs. It is on that remote atoll that my story takes place.

My father, Robert Dean Frisbie, in San Francisco

during the early 1920s, boarded a tramp steamer sailing for the South Seas, where, eventually, he settled on Puka-Puka. There he fell in love with my mother, Ngatokorua a Mata'a, and married her when she was only sixteen years old. She loved him to the day she died in 1939, of tuberculosis, after the birth of their fifth child.

There were not many on Puka Puka who could speak the English language, perhaps THREE in all, until my father decided to invite me into that special group of people.

Goodness gracious! I was eight years old when my father introduced me to his world of things literary: such as books, pencils and rubber (which was our eraser), carbon paper, hand-written letters from his mother and brother in California, and his most precious beloved possession, the Underwood typewriter.

He was different from the rest of us, yet he was one of us.

I compare my father to an *uto*, the white spongy mass contained in a matured coconut, protected by the hard outer shell. He was his own man, who came from afar with a completely open heart and mind, who knew exactly what he was looking for and where he needed to be. He came to understand the people and the environment; there was no way he could be a native Puka-Pukan, and he never tried to be one. He was not a pretender.

The *uto's* world was a square little room. Within its protective four walls, I was privileged to enter a world unlike anything else on the island. It was in that room that he typed letters to his mother and brother, to his agent in New York, and a pen pal in China. There were books, some bound in gray, others tightly protected in cloth the color of the coarse muslin-like material we strip from the base of a coconut frond to make into strainers—it is light brown. The books were his precious treasures, placed upright on shelves resting against the limestone wall.

I did not know, for a long time, that there were books other than the Bible and wondered why he owned so many of

them. I was curious why he didn't share his extra Bibles with our villagers.

In the typewriter room the tamanu table was set up in the coolest spot, next to the window that invites the ocean breezes as they head inland toward the taro patches, there to ruffle the young leaves of the taro. There were reams of pure white paper in folds of cotton fabric to assure them protection from the penetrating heat of the corrugated tin roof. Papers covered with penciled scribbling resembling chicken scratches were fastened with a rusty metal clip onto a wooden board taken from an emptied condensed milk box (such boxes were never thrown away for they had many uses, including the fashioning of coffins for toddlers). The clipboard was upright, supported from behind by a large sun-bleached pretty coral.

Other papers were weighted down with mottled cowry shells that seemed to appear mysteriously now and again on the table, so close to the typewriter that my father would smile at them. There were several red, square rubbery things that could magically scour away letters on paper like we scrub dirty feet with a coconut husk, or like a wave-swallowing tell-tale crab claw trails on pure white sand. Erasing was one of the best magical tricks ever when my father first showed it to me. Dozens of sheets of carbon paper filled a cardboard tray—thin papers that were precious to my father, for then he could type duplicates of his stories all in one go. There was a glass jar containing unused postage stamps, and sharpened yellow pencils filled an empty condensed milk tin. A kerosene hurricane lantern stood firmly in the middle of the table, reflecting light on the typewriter keys.

A treasured book bound in gray muslin prided itself to be the only one to reside on the right-hand side of the table. Within its many pages were neatly recorded accounts of our birthdays, right to the very minute our mother handed us to him. Also his favorite bush-beer recipes filled many pages of the diary. Even though brewing beer was illegal, he

limited it to one or two times a year, when the required beer-brewing ingredients were shipped to us by inter-island schooner once, and sometimes twice, a year—if we were lucky! There were addresses of family in California, pen-pals (friends in China, Canada, New Zealand, Australia, Samoa, Tahiti, and Rarotonga), and of former girlfriends here and there and everywhere—before he met my mother, you must understand! It is now in my care, wrapped in a pretty, pareu cloth alongside my mother's Tahitian Bible, which is inside an old remnant of a very worn-out embroidered quilt.

Also on the table were dozens of letters from his mother and brother in California, securely and neatly tied into bundles with strips of dry pandanus leaves, placed in a pandanus leaf basket. To learn that my father had come from another kind of people was confusing. He was so important to me, it was hard to think of him as not being just like me. But I had to brag to my small group of playmates that he was!

My father, at certain moods, would read his mother's letters to me, but first, slowly and lovingly, he would unfold the letters in a way that the pages would not be harmed. I listened carefully, memorizing as much as I could the simple words like *and*, *with*, and *my*. Then he would briefly explain the content of his mother's letter as well as the definitions for *and*, along with other words I could hold in my head. Sometimes, after finishing a letter, he would cover his face with his hands and I would put mine on his back, understanding that the letter which caused my father to cry came from a faraway place called *Ameriki*.

In the beginning, all the books placed on shelves were simply called Bibles by the rest of us lucky individuals who were given the privilege of being invited into the sacred writing room. Though it was a thrilling adventure to learn that there were other stories told and preserved in books that looked like Bibles, it was also a challenge for me to accept that the Bible was no longer unique; that God had other books we didn't know about!

I was fascinated by the black paper in the cardboard tray, so one day—a very memorable one indeed—I crawled under my father's working table with a handful of it and rubbed the sooty paper vigorously and joyously over my stomach and face, up and down, sideways, and 'round and 'round until I was peculiarly beautiful! Father was busy tapping the keys of his Underwood typewriter with desperate forefingers, as if they were racing each other as to who would finish the line first.

Standing to the left of my father, so I would not distract him, I waited patiently for him to take the necessary pause once the last line on the page had been completed. I dared not move in the meantime, for I would surely be sent out of the room. He did say to me in later years that the head—not brain, for I would not have understood the difference at the time—must not be disrupted while in the story-making process, for the story often leaves the brain never to return.

Finishing the page, he turned to me, and I, expecting the usual welcoming smile, marveled at my half naked father leaping into the air with both arms flaying crazily like coconut palm fronds in hurricane winds! His eyes, the color of the flesh of a hazel tridacna, bulged out like those of a shocked octopus. Usually, such actions would have been the result of a threatened centipede biting his backside. That was why, at first, I was confused, thinking that was what had happened!

"God dammit, baby," he growled. It was his favorite swear word. Then he crawled under the make-shift table with me following behind his half-bare white backside. We collected the crumbled black precious papers, ironed them flat with the palms of our hands, one by one. He did not utter another word because his lips were clamped tight like that of a defensive tridacna shell. But it was when he began muttering those two words "God dammit" that I ran out of the house with them echoing in my ears, burdened of wrong-doing yet also excited to meet my playmates waiting for me

as usual, in the shadow of an ancient barringtonia tree where we played together every day except on Sunday, when the rule was we normally go to church, eat, read the Bible, and sleep. FULL STOP!

Seeing my face and bare stomach black as the ashes of burnt coconut shells, they were speechless, not knowing what had happened to me. I invited them to touch my stomach and, with all fingers they drew pathways down to my belly-button. Then we sat in a circle as I explained the nature of the black paper that smudges everything and, for a moment or two, they admired what they were seeing as something mysterious. Soon they were scraping off what they could of the soot to paint their own faces so that we could all look alike! Happy with ourselves, in my innocence I taught them to write *god dammit* on the underside of a scaevola leaf, using the midrib of a coconut leaf, but in a kinder manner. We practiced pronouncing the words, and others that came later. We spent a long time simply digesting the thrill of this peculiar kind of a gift, which did not seem real even though it came from the mouth of my father the white man.

Not very long after the carbon paper disaster I sat under the table again, by my father's bare feet, with the jar of precious and rare unused postage stamps. I needed to please him to make up for the carbon paper experience. So, one by one, I wetted the back of stamp after stamp with saliva, pressing each one onto my bare brown stomach, completing an interesting and pretty mural around my navel. I did not know that it was a minor crime to disfigure postage stamps representing British royalty, as these were the only stamps printed during those times. Happy again that I had created a masterpiece, I stood at attention by his side waiting anxiously for him to see me all dressed up in postal royalty.

My father, with a satisfied sigh, pulled out a page of many words, scanning it quickly before noticing me. I expected the usual loving smile, but was surprised instead when he roared like the screeching cry of the pig he had

slaughtered two weeks before Christmas.

"God damn it, Johnny! What have you done?"

My father always spoke in Puka-Pukan to me but not when he was angry, for then he seemed to favor his mother tongue which was a very good thing, for the swear words in *my* mother tongue would have been too descriptive for my innocent ears!

Carefully, in dark silence, he peeled off the stamps and placed them on the table upside down to dry. When the last of the precious square pieces of paper were neatly put back in the jar and sealed, he kindly suggested I go find my friends.

There in the peaceful shade of the barringtonia tree with Puka-Puka note pads and coconut leaf midrib pens in hand, waited my friends. One of them called out, "What did he say this time, Tiané?"

"He repeated the same words: 'God dammit, Johnny.' He also said the word 'god' many times. He was very angry because I decorated my stomach with stamps that had pictures of our King George who looks like my father."

We stared at each other, confused and a little scared, remembering that whenever the minister of our church bellowed "God" in his sermons, which was all the time, it was not of a loving god, but of a constantly angry and disappointed one. It seemed like we were always bad in the eyes of God. So, it was not only Satan we had to fear but also God.

"So, he was telling you that God was angry at you. We must pray for you."

We looked up at a pair of pure white tropic terns on a branch of our tree and together we chanted the Lord's Prayer with sincerity and earnestness, imploring so lovingly that the scent of heaven touched us when we reached "forever and ever Amen." We watched as the terns fluttered in approval as they departed.

I described how my father in his frustration danced like a bony ghost thrusting his skinny arms above his head,

stomping bare feet on the white pebble floor now and again banging a knee on the edge of the table and mumbling words I had never heard before.

"He was so agile he would make a winning drum dancer," I bragged.

We laughed—but not so loudly as for him to hear. The picture in our heads of a dancing white ghost was scarily thrilling.

And so for that day's lesson we practiced pronouncing "damn it," suspecting that it was meant to be spoken in times of anger or disappointment or frustration, or when one does not like a person. They were swear words that had to be added to other English words we learned, but those which must not be repeated outside of our gang.

It was my good fortune to be invited often to my father's private room where I would stand next to him, becoming familiar with his world of books, pencils, envelopes, and other treasures of literary nature. I would stand by his side in silence, absorbing the sounds of the typewriter, feeling warmly comfortable, welcomed and a part of his world even before I understood what he was writing and for what reason. I would stare wide-eyed at his two forefingers rhythmically tapping hard at the keys with letters imprinted on each one. When the bell rang, he would grab the shiny handle on the right of the carriage and, without wasting time, drag it from right to left—Bang! Goodness gracious. I was hooked! I was eager to make words to add more to my meager vocabulary. But he would not allow me the chance to touch the typewriter. Not yet, he said, for he was afraid I might pull the keys apart to show to my friends, or find the mystery thing inside the typewriter making the letters appear. If only he would allow me to touch the typewriter I would have so much to share with my friends. Now, of course, I understand why I was not allowed in the taboo room on my own. I am sure of it.

My father's private little writing room was a stone's throw away from my grandparents' thatched roof cook house

where they would often sit close together listening to the rhythmic tapping of the typewriter keys. It was in that place, pulsating within the unseen world of the mind—creativity, as some people would call it—that I began to learn the alphabet. My father asked me to hand him the dictionary by directing me to it with his talented brows.

"The Bible?" I replied, not knowing that there was a difference between the holy book and the other books on the shelf.

"The dictionary, not the Bible," he whispered. "It's the big one on the left hand side of your mother's Tahitian Bible, which is the only Bible among those many books."

Well, that was a surprise to me, and a mind-boggling discovery. The other books were not Bibles! What could they be?

He turned the delicate pages while carefully pronouncing the mystery word he needed—for my benefit, I realized later. The word was "equinoxial."

"Here it is: '*e-qui-nox-ial.*' I need it for this new story I'm writing."

My tongue refused to acknowledge it. The dreaded excitement of having to memorize it, when I didn't even understand the reason for the alphabet, caused my heart to beat very fast! How will I be able to explain all this?

He then revealed to me that every word in his language was to be found in that one book.

The mere act of turning the pages of the dictionary grabbed me in a powerful, emotional, and incurable fixation. I have been in love with the book of many words from that moment to this day, more so than the revered Bible. But I never, ever, shared this with my grandmother and preacher grandfather.

Of course, the new word had to be shared with my loyal friends, who, curious as usual, questioned me on the validity of the letters "q" and "x." After that discussion, I convinced them that, if we are to dream of visiting his island, we should learn his tongue.

Each one of us, with enthusiasm, carefully fitted the new word quite well onto a Puka-Puka notepad leaf all its own. A leaf notepad is made up of four or five leaves of the scaveola shrub layered one on top of the other and pinned tightly together at the wide end of the leaves with a coconut midrib. The top part of the leaf facing the sky is shiny and was not good for writing onto, but the underside facing our bare feet is waxy, allowing for the coconut midrib pencil to make an imprint.

As I became more and more comfortable in my father's unique world of literary things, I found myself vicariously typing on any object that resembled a typewriter, be it a coconut, a wooden bowl or even the bow of my uncle Aumatangi's one-man outrigger canoe. Then, one day in the shade of our tree, also the favorite nesting shelter of white tropic terns, my friends helped me launch my writing career by co-writing a story with me in our language on a rectangular lead slate. Though cracked in several places it did not matter, for we had no other choice. I feel it now as I write, the gripping, nervous excitement of stepping onto a new path with my friends, who would not have let me go alone anyway.

The story, three very short sentences in length was to be a gift for my father, who could read our language as well as anyone.

Then, after reciting a short prayer seeking God's help to convince my father to like the story, I handed it to him with a pleasant smile on my nervous lips.

Slowly and thoughtfully he chanted the three sentences. I heard the pounding of drums coming from afar, but it was only the run-away beating of my own heart, and those of my friends, far away under our tree. Twice he paused to smile at the slate, nodding his head as he pronounced each word perfectly. Thank goodness for a *full stop* the size of a marble at the bottom of the slate! My father was then able to take a breath, as we made certain he would, because, as he once explained, the *full stop* was the chance to

stop and take a big breath, unlike the frivolous comma.

"The story and hand-writing are very good. The full stop finishes it off nicely, big and strong. How long did it take to write it?"

"Well, papa, my friends and I practiced writing the story on ngayu leaves yesterday and today. And we memorized what we wrote, that is why it's a nice story."

"Good girl—and your friends, too. Now, I think it's time for you to learn something more about 'commas' and 'full-stops.'"

"But I already know where to put the full-stop, right at the end of the story. I have to go, Papa, my friends are waiting. I must tell them that you are happy."

When I returned, they asked: "E wea tau mea e Tiané?" (What do you have, Johnny?)

"Papa likes our story very much, and would like us to write more. He said for us to write our stories in a singy-songy way, as if we are composing a chant—that should be easy for us because we speak in a singy-songy way anyway. And, he said that it is very important to pay attention to the sounds and moods of the ocean, the rattling leaves of coconuts in the wind, the cries of many of our birds flying home at sunset, and the noises crabs make when they busy themselves scratching around under rotten leaves for food, or scuttling to safety."

The message from my father inspired us to cover many slates with stories of the young coconut fronds clinging to each other for dear life during a storm or playfully flinging raindrops at each other, rattling and tickling each other in an equally playful young gust of wind. Totally mentally absorbed, we giggled at what we wrote. We are a people who are eager to find a reason to laugh. So it was easy and lots of fun for us to write those humorous stories.

One memorable day my father announced that he would write a sentence that would include a comma or two and a full stop for certain. He set up these surprises at inconvenient times when I was in the middle of play. But, at

the same time, I could not resist the powerful urge to learn more and later to share what I had experienced with my friends. As it happened that day's lesson consisted of a sentence of frightening length. To prepare myself to take a speedy breath, or maybe two, I scanned it quickly to establish where the commas were. I expected the full stop to be at the bottom of the slate—and it was, thank goodness! When I reached it, I would be free to join my friends at our tree. No need to describe what state of emotions that they would be in, for you, the reader, already know.

Sitting on my father's lap I delivered the story in a Puka-Pukan accent with all the "rs" replaced by "ls," enunciating each word slowly like my father would read it to me, pausing to inhale ever so quickly after each comma. I then finished off by proclaiming the full stop a winner with an ear-piercing "FULL STOP!"

"Excellent!" my kind father blurted with enthusiasm, tapping me on the head as if I were a typewriter. "You deserve a lollie for that!"

From the interior of a large square tin he unstuck a single lollie the size of a marble, painted with many colors of misty rainbow, from the large heavenly sticky clump within. Safely secured on my tongue, I ran as fast as I could to my friends who could see through my clenched teeth the delicious, rarest treat of all. Sitting in a circle shaded from above, I very carefully bit off a sliver for each of my beloved friends, thin slivers the size of a half grown parrot fish scale. In a rare delirium we sucked the sweet yumyum slowly so as not to end the experience too quickly, staring at each other in a state of dizzying ecstasy until the divinely sweet gift became a nothingness.

I asked my father, "Can I write about the night stars asking a massive thick cloud to catch the next big wind and move out of the way so that they, the night sparklers, could be admired by us people?" This was a suggestion my friends and I had wondered about—whether it was a good idea?

"No problem," my father replied. He pointed out that

an enkindled imagination was the tool to creative writing. He said there was also a place for creative writing in non-fiction, though I did not fully understand that one. He said the imagination was bottomless, like the deepest part of the ocean over the eastern reef—and could be a frightening place. He whispered, as if it were a secret between us, that I must not be afraid to explore and put into writing the secrets in my mind, emphasizing the word "secrets" because they were solely mine; they belong to me until they are shared. Also, a fearless imagination was a way of honoring the spirit of my soul, giving it freedom so that it would be happy.

I nodded to please him, even though I did not understand.

He made me happy when he told the story of how my ancestors imbued godly spirits into inanimate objects, thus giving them life. "Johnny," he said, "Those are the workings of the imagination. Your imagination is the essence of your very being. Explore the vastness of it. Full stop! A BIG full stop!"

It was always a one-sided talk, for I did not know what to say. The lessons about the imagination allowed me the pleasure of living a life other than this life, the earthly one. It frees the soul to be able to travel into the dream worlds of your imagination.

For an example, my friends and I on a beautiful day by the seashore, made up a story, using our imaginations, about a gigantic boulder. It was firmly seated on the sand, frequently smacked by high seas, brushed dry by gale force winds, and moisturized at the first opportunity by white terns leaving their fishy smelly droppings. We laughed sometimes, but were also nervous about pretending to enter the realm of our wise ancestors. We imbued it with a brain to think, a heart to feel, and lots of big muscles to hang on to the ground with during a frightful storm. We daringly created a divine being right then and there, and, with our hands caressing it, we prayed with all our might to any god who was within listening distance or willing to lend an ear or two. We forgot

that those pagan and heathen gods were replaced later by a new one. Anyway, this was a time devoted to enjoying the mysteries of our collective imaginations, although one of my friends did suggest we pray to my father's god—just in case.

"My father does not have a god," I said. "So maybe we should pray for him."

We all agreed, and we prayed for him, too.

The sun-tanned boulder became another object for us to play with. It told us of its harrowing journey to shore many years ago, tossing and tumbling over a jagged reef, scratched and chipped and covered with clinging seaweed when it finally reached the beach of sparkling pebbles. We immortalized our story in a booklet of ngayu leaves secured tightly together.

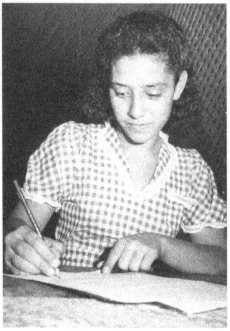

Johnny Writing

My ambitious father knew what he was doing for me in those early years, guiding me lovingly—and sometimes

not so lovingly—to hold on to the mystery of a fertile imagination. One that would allow all of nature to have feeling, including the boulder sitting on a sandy beach at Utupoa, gazing longingly toward the place it was born, only to be shoved onto shore by angry hurricane waves.

My uncle wrote a chant as a gift to me, knowing that I "lie" a lot. In the chant, he described my mother's sister during their courtship. He "imagined" her description as being "straight as a log," "fat as a delicious albacore," "with tinea marks on her skin bright as rows of morning stars," and "pubic hair silky as feathers of the tropic bird."

I challenge anyone who brands this masterpiece as a "lie," to part his fears and discover the wonder of imagination.

It is true that my father was more interested in teaching me to trust my feelings, to take advantage of the imagination and not be held back by worrying too much about grammar or the pestering demands of punctuation. He left it up to me to find out about their correct usage on my own. It has not been achieved, nor will it be during my lifetime, for sure! But—I *did* learn to…

"Just write, god dammit Johnny!"

22

WE LEAVE TO WORK FOR UNCLE SAM

We didn't stay long in Puka-Puka—only long enough for my father to finish his book about Mama Ngatokorua. Puka-Puka was not the same for any of us. The big companies had stopped sending their ships to the remote atolls, so copra-making had stopped, and by the time our trade goods were sold nearly all the money was in our hands. We turned over to Araipu what little business there was left and became beachcombers, loafing on the uninhabited islands, swimming, fishing, playing, bird-hunting, or sitting with the neighbors at night to swap stories and join their *himenes*, or singsongs. School was about our only work, and writing the book about Mama Ngaokorua, in which we all helped our father.

Sometimes we would work for a few days on plans

for a ship, to be built in Tahiti and sailed around the world. We often made plans like that, but something always spoiled them—like not having enough money. Or we would decide to go to Honolulu or maybe Brazil or Mexico or the Far North. Often we would talk over our plans on Mama's grave, hoping she would hear us and later tell us in our dreams the best thing to do.

When I think back I remember only the happy part of our lives, but by thinking hard I know we weren't very happy, what with our mother gone and the relatives everlastingly scheming to break up our family. Grandma Tala and Witch Doctor Taingauru—her new husband after Mata'a's death—went so far as to write to the Resident Commissioner in Rarotonga, telling him it was wrong for Papa to keep us because he was living without a wife and drank beer. Of course their letter had no effect, for we cowboys were citizens of the United States. Uncle Sam was our boss—not John Bull, thank goodness!

When we visited Grandma Tala she would purr and fret and cry over us, saying, "The little darlings! Tiri, bring some nice ripe bananas and drinking nuts for them! Kill a fat hen for them! The poor dears don't have enough to eat with that bad father of theirs. The poor dears should live with old Grandma Tala, who will give them fat chickens every day, and love them, and tell them stories every night! Eh, Johnny dear? You'll live with old Grandma Tala, won't you?"

Then I'd tell her my father was the boss, but it did little good. She'd keep nagging me, and sometimes she'd try to scare me by telling me that I would be left to starve when my father died in some far-away foreign land.

Of course I loved gentle old Grandma Tala. At times I thought she was right and that maybe I should stay with her, but later I remembered my mother's last words about keeping the family together, and when I returned to our father's house there was no question about leaving him. How glad I am now that wise Mama Ngatokorua made that last request to Papa and he obeyed her! I love Puka-Puka, I intend someday to

return there; but I want to return as a civilized young lady who has seen the world and has a rich husband and nice clothes. I don't want to be a ragged ignorant Puka-Pukan girl with bugs in her hair!

Then there was Araipu, his wife Toia, and foolish old Luita, who loved little Nga so fiercely. At one time we almost left our youngest sister with them. It was only the remembrance of our mother's words that saved her. Nga wanted to stay, but she was too young to know her own mind. Luita had only to give her a pretty new dress or a bag of lollipops and she would agree to anything.

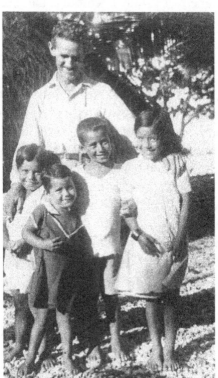

Robert Frisbie, Elaine (6), Nga, (4), Jakey (7), Johnny (9). Motu Kotawa, 1941.

I guess it almost killed Luita when we took Nga away. Maybe it did kill her—but what could we do? We

couldn't desert our baby sister. With all the Puka-Pukans it's the same thing—they love children. No child, even a miserable, ugly, sickly brat covered with sores would have any trouble finding loving parents. It's different in Samoa. Samoans adopt children to make them slaves. They have to work hard for the fat lazy chiefs; they are fed only taro and bananas, and they are clothed in dirty old rags. But worse still, if they are girls they are often sold to the marines for money! I'm the oldest, and that is why Papa decided to put our bank account in my name, and all the money Papa receives from America comes to me and I bank it. Papa is taking no chances of our becoming the slaves of a fat Samoan chief or of me becoming the mistress of some soldier, who will soon say: "Good-by, Johnny! You've been a good sport and I have enjoyed your company very much. Thank you. I can't send you any money but I will remember you forever!" Then he will sail away to America to marry a white girl. If our father dies we are to draw our money out of the bank, board an airplane and return to the Cook Islands, where there are hundreds of people who will fight for the chance to adopt us, and where our big brother Charlie will watch over us and protect us, he being the champion lightweight boxer of the Cook Islands.

When the *Taipi* returned on New Year's Day, 1942, with news about the Japanese bombing Pearl Harbor and the United States joining the war, our father said: "Let's go! Maybe we can help our Uncle Sam!"

We started packing right away, for the *Taipi* was leaving the next day. Papa sent Jakey and me to bring Nga from Luita. The old woman didn't say much when we took our sister away, but I know she was heartbroken. Her face turned gray. She gaped at us, and her eyes were dead. Then she wrapped a bundle of old rags around her head, as Araipu used to do in Fiji, put on her dirtiest, raggedest old dress, and stumbled to an old outhouse in the bush, where the pigs were kept, there to crawl under a pile of old mats and rubbish. We did not see her again until we were aboard the *Taipi*, and then

only for a moment. My! My! What a lot of heartaches there are in this world of ours, and not a thing we can do about it!

It didn't take us long to pack, for we believe that worldly possessions are the bane of life, truly a millstone around one's neck. We collect no more property than we need, and when we move there is always a grand splurge of giving things away—this time a fishnet to Tapipi, an iron stewpot to Yala, a wash basin to Tala. Geoffrey Henry wanted our books but we took them with us. Everyone was a classic which someday we cowboys might read. For baggage we each had a small sea chest, and Papa had two extra chests full of household things, a packing case of kitchen utensils, a tool chest, a box of writing material, a sewing machine, a typewriter, a roll of mats and bedding, and *Panikiniki*, our sailing canoe.

For our expenses we had three bags of money, each one containing one hundred pounds in New Zealand silver.

While we were packing, our friends and relatives came with gifts of mats, hats, fans, baskets, pearls, and such things. There must have been nearly one hundred big beautiful mats worth $5 each in Honolulu, and nearly that many hats. The hats alone paid our passage to Rarotonga, though it took us a long time to get there.

I don't know why I am telling you all these unimportant details unless it is because I am following my father's rule to jabber away without trying to write fine English or make every page exciting. If you are getting bored you can blame him. But here is something a little more interesting:

The day before we sailed, Papa said: "Let us gather flowers for Mama Desire, make leis, and bid her good-by." He called her Desire in those days because of the book he had just finished.

We left our Yato village house to cross the causeway, then we turned inland to the taro beds, where the gardenias and frangipanis grew. Everything seems sweeter on an atoll than on a high island, whether it is the water from a drinking

nut, a mummy apple, or a flower; there are few things that we atoll girls like better than gathering flowers and stringing them into garlands. We prefer the *pu'a*, which are buds matured enough so you can see the white petals. These we gather into bundles, which we wrap tightly in green leaves so they will keep fresh and the buds will not open. When we have enough bundles to make a really beautiful wreath we open them, pile the buds in our laps, open each one by pressing on its tip, and string them with little pieces of fern leaf, the bright-red skin of pandanus fruits, or anything that has a nice smell and color.

The gardenia bushes on Puka-Puka are very large, and often they are white with flowers. There were lots on this day, for the inland beds had been closed—only Papa and his cowboys were allowed to go there. We gathered our hats full of the nicest buds, sat under a big gardenia bush to string them on sewing cotton, and then, towards sunset, we went to Utupoa, where our mother lay under the clean white sand.

Her grave was just like the others in the family burial ground, for our Puka-Pukan relatives had asked Papa not to buy a special stone from New Zealand with her name on it, as we had wanted to do. You see, the atoll people believe everybody should live alike, be married alike, die alike, and be buried alike. No one must have anything special or he will be proud and the rest of the neighbors jealous. It was the same with our mother: she must be buried as her people were, under a *punga* coral headstone.

We greeted our mother and hung the wreaths on her headstone, footstone, and the four side stones. Then little Nga took a gardenia bud from her hair, stuck it in a tiny hole in the headstone, and whispered, "Teia to piki, e Mama e!" (Here is the bud for your ear, Mama dear!) Nga is always surprising us by doing little things like that.

The sun had set. "I think Mama is here," Papa said suddenly. "I've got a feeling that she is with us. Let us sit here and explain things to her."

So we sat on the white coral gravel that old Kani kept

fresh and clean, and we told our mother how Uncle Sam had gone to war against the Japanese and had called all his sons to join him. We said we were leaving Puka-Puka to help our Uncle win the war. Maybe Papa could sail a ship or write a book. And we also told our mother that we had kept the family together in spite of the relatives doing their best to break it up. Each of us took our turn talking to Mama Ngatokorua. I told her about the voyage to Fiji; Jakey told how we had school every day but now would go to the big public school in Rarotonga. Both Elaine and Nga, very serious and maybe a little scared, had something to say, too, if it was no more than, "Moé ai koé akalelei, Mama e!" (Sleep peacefully, Mama dear!)

It was deep twilight when Papa rose to lead us home. "Goodbye, Nga!" he said. A strange note had come into his voice. It frightened me.

"Goodbye, Mama! O.K., Mama!" I whispered, kissing her headstone. Then big strong Jakey, fat laughing Elaine, and gentle little Nga each kissed the headstone, and whispered, "Good-by, Mama! O.K., Mama!"

We were all crying, then. Even Papa was crying. We took the roundabout way home, through the coconut groves where no one would see us, but before long Papa laughed and started to joke with us, and suddenly he scared me by saying: "Let's hurry home, Johnny! I am sure Mama Nga has tea waiting for us."

I knew then that it was high time we left Puka-Puka, forever. We sailed the next day.

PART THREE

The Treasure Island

23

HOW I WRITE MY BOOK

Before we left Puka-Puka my father gave me a bookkeeping journal. "Now, Johnny," he said, "because we are leaving Puka-Puka to start a new life, and you are learning English, this will be a good time to start keeping a diary. Every day write down what you have done and particularly what you have thought, because thoughts are much more important than deeds. Cows and alligators have exciting adventures but only men think about them and put down their thoughts in printed books with flashy jackets. When you have filled your diary you can make a book of it. Then, some lucky publisher will pay you a lot of money for it."

Later he gave me a little package done up in red tissue paper tied with a ribbon. When I opened it I found a fountain pen. "That is for writing your diary," he said, "for if there is anything I do detest, it is a diary sloppily written in

pencil."

I was supposed to write my diary in English, but for the first year or two I found that I could express myself well only in Rarotongan or Puka-Pukan, so most of my diary is written in those languages until toward the end, when we came to Samoa in 1945 and English for the first time really became my spoken language.

I did not start my diary aboard the *Taipi*, but at Suvorov it was officially opened, on January 11, 1942. Now, in Apia, four years and six months later, the big bookkeeping journal is full to the last page. The first half is not written very well but it gives me plenty of ideas nevertheless. In the second half, where I started to write better, there are entries that I may translate and copy into this book with only a few changes, but I don't want this to be a "fake" book, so I will tell you that my father polishes everything I write and does lots of the translating. Now I am wondering if his prophecy will come true. My book published? A voyage to San Francisco! Visits to the zoo, and circus, the Wild West Show, and the theaters I have heard so much about! It sounds like a dream!

It is easy for me to understand why my father has kept a journal all his life, and why he was so careful not to lose it during the hurricane we went through later. I use it for ideas, but I don't copy and I couldn't if I wanted to, for there are only little entries like these:

Blowing great guns. At Naitamba. Owner Hennings. Fred Rebell stopped here aboard 18ft skiff Elaine: later to Samoa, Puka-Puka, Honolulu, Los Angeles where he piled up his skiff to get past immigration authorities. See his book. Title? John Murray, publisher. Claimed God piloted him. A few good murders cover a multitude of bad sentences. The Samoans pray all day Sunday and steal your watch on Monday. Note on Western Samoa: Two young half-caste girls, Tina and Maria, met two old lady tourists on the Taufusi Road. Because the tourist

ladies were nice, the girls walked with them to the Mau Village, answering their questions and showing them the sights. When they passed the Mormon Mission one of the nice old ladies asked: "Is it true that the Mormons still practice polygamy here?" The girls hesitated, neither of them knowing what polygamy was.

"You tell her," Maria finally whispered. So Tina, believing the old lady had asked about church services, replied:

"Oh, yes, ma'm—twice every Sunday without a miss.'

That's the way my father writes his journal, jumping all over the map and the calendar, and I'm afraid my diary is not much better. I copied more than I had intended to because I thought the last part would amuse you. Anyway, the notes in his journal gave me so many ideas that I had only to choose the best of them, like picking chocolates from a box of Whitman's Sampler.

And that is how I am writing this book, with my father's journal and my own diary before me, jabbering away in three languages as though I were talking to my brother Jakey, and then handing the mess to my father to try and make something out of it. One thing I can say is that it is all true, and because I want you to believe me, I have written this little chapter.

24

MISS ULYSSES AT SEA

I felt like a murderer when I stared from the *Taipi's* deck at Grandma Tala, Kani, and old Luita, all in Araipu's boat. Though they were only a few yards away, there was between us a barrier like that of life and death. Already we belonged to another world. There was something brutal about that separation. I never knew there could be such pure misery as I saw in their faces—and maybe hate, too—hate toward my father for taking us away. That old woman Luita, with her terrible love and her dark savage mind, could have poisoned my father and grinned while she watched him dying.

There were no wreaths thrown on the water, no cheers, no band playing "Aloha Oé," no colored tape such as you see in pictures of tourist steamers leaving Honolulu. Oh, no! Only misery and tears until we were seven miles on our way, passing the sand cay called Te Toka (The Rock). Then Jakey got out a little wooden steamboat, tied a piece of

fishline to it, and dropped it over the stern, making the line fast to the taffrail. "My ship will follow us to Rarotonga!" he shouted. "How far is it, Papa?"

"About a thousand miles, the roundabout way we'll go," Papa told him. Then we cowboys crowded aft to watch Jakey's steamboat skipping over the waves, and from then on we forgot our tears.

The word "skipping" reminds me that we had the *Panikiniki* on deck. It took up half the length of Captain Cambridge's "ship," but it was a fine place to sleep, with a tarpaulin over it and tented up with two short poles lashed to the outrigger booms—or it was a fine place until Jakey said it made him think he was in a coffin, when we didn't like it any more.

Bruce Robertson was still aboard, sun-bathing all day long on the cabin top and getting pinker and pinker—also, who in the world but ex-parson Metua, the Puka-Pukan preacher who had adopted Nga and nearly starved her to death. Now he was cook aboard the *Taipi*, which shows you that pride hath its fall and whatsoever a man soweth so shall he reap.

The *Taipi* had been changed to a ketch with a tiny mizzen staysail that I could put in my sewing basket, but the captain was proud of it. At the first sign of a squall he would sing out: "Get that stays'l in, Teinaki!" And when the squall had passed he would shout: "Let's get that stays'l on her, Teinaki; we'll put on a burst of speed!" His little green eyes would twinkle when he used expressions like "burst of speed," or when he called Teinaki his "First Officer" or the *Taipi* his "Ship." He was nobody's fool; only he had a feeling for the picturesque.

It was lots of fun sailing on the smelly little sea louse as she crawled ever so slowly for eight days, the 215 miles to Suvorov, which island, as it happened, we nearly missed because the Captain's chronometer had run down. This meant he could take only latitude sights, which tell you how far you are north or south of the equator, but not longitude

sights, which tell you how far you are east or west of a place named Greenwich, which is near London in England.

The captain had leased Suvorov Atoll from the Cook Islands Administration for twenty-six pounds a year. He couldn't make that much off the place unless he dove for pearl shell, which would be dangerous because of the sharks. Also, he wanted the island for an anchorage during the hurricane season, when he overhauled the *Taipi*—and so he could say he owned an island. Also, he spoke of starting a pleasure resort there, and a shark-oil factory, and a culture-pearl station—lots of wild schemes such as optimistic people figure out.

We drifted down to Suvorov on the sweetest dimpled ocean I've ever seen. The captain seemed to pay no attention to his ship. He let Papa and Bruce navigate and Teinaki attend to the sails while he read detective story magazines and novels by Mr. Dickens, played cribbage, and tried to make us all sign the pledge—even we four cowboys, saying it was a good idea to start life with the right resolutions.

Often, during calm days, we cowboys would climb to the cross-trees and jump overboard, backsides first. Or we wallowed in the warm ocean, "within the shadow of the ship," swam races, dived under the *Taipi* to come up on her other side, or played a Puka-Pukan water game something like prisoners' base. Bruce and the captain often joined us; then, with skins pink and brown, bathing costumes blue, green, yellow, and red, hair red, yellow and black we were like the water snakes in The Ancient Mariner:

Within the shadow of the ship
I watched their rich attire:
Blue, glossy green, and velvet black,
They coiled and swam; and every track
Was a flash of golden fire.

We stopped at little Nassau, called in Puka-Pukan *Nuku Ngaongao*, or "Lonely Uninhabited Island." There was a radioman ashore and two coast guardsmen on the lookout for enemy raiders. These guardsmen were sent for only a few

month's duty, otherwise they might go mad from the solitude. But captain Fred Williams lived on Nassau for over ten years, raised a big family, and educated them so well that now they have fine jobs in Apia. Captain Williams didn't go mad, and I don't know what is the matter with these New Zealanders who start singing hymns and seeing spooks as soon as they are left alone on an uninhabited island. It has happened to about all the white men who have lived on Puka-Puka.

My happiest remembrance of the voyage aboard the *Taipi* is of the peaceful moonlight nights, lying on a mat on the hatch covers, telling stories or talking about the stars. For almost every bright star or constellation my father had a story. If it was Sirius, he would tell us about the pyramids and how, thousands of years ago, the same star that we watched from the *Taipi's* deck shone down a long tunnel onto the dead face of a Pharaoh; if Orion, he would tell the story of the gigantic hunter-god who shot his wife by mistake, thinking her head was a coconut floating on the water; if Castor and Pollux, he would tell the story of the Golden Fleece and then point out the ship *Argo* that they had sailed in, now moored to the Southern Cross. A and B Centaurii would remind him of the ancient people who were half horse and half man, and the Pleiades and Hyades would awaken stories of nymphs and fauns in ancient Greece.

Or Jakey and I might tell the Puka-Pukan legends of the stars, like the one of the Coal Sack being The Little Fish or Kiri-Welo and Coma Berenices being his bald head, or the one about the Magellanic Clouds being Mr. North Wind and Mrs. South Wind.

That was the way we cowboys learned the names of the stars and the principal constellations, but even better than the star stories were the ones about Ulysses and Aeneas. I don't know how many times we heard those stories of Troy and its heroes, but they are just as exciting today as they were when first we heard them—to Papa, too, for his favorite books are the *Iliad, Odyssey, Aeneid*, and the Bible.

Lying on deck one night, staring into the dark-blue sky and at the steadfast stars, Papa said: "I guess Ulysses and Aeneas did this very same thing about three thousand years ago, after the fighting around Troy. I guess they lay on the decks of their black, hollow ships—which really were nothing like as comfortable or as seaworthy as this black, hollow ship we're on tonight—and they stared at the waning owl-eyed moon perched on the eastern cloud-bank, and they looked up at the stars, wondering what it is all about and whether or not they would fetch up at their home islands—just the same as we are wondering if we will fetch up at Uncle Sam's island this year or ten years hence; only, where the Greek heroes were returning from the battle before the gates of Troy, we are on our way to join the warriors before the gates of Tokyo!"

Then we cowboys grabbed our father's arm, petted him, teased him, and, "Please, Papa," Elaine begged, "tell us about Ulysses and the fair goddess with braided hair, who lived in a cave and never grew old—what was her name?"

"Calypso, of course," Jakey guffawed.

"Yes, Papa; and about the witch who turned sailors into pigs."

"She means Circe," Jakey growled, full of importance.

Then, when our father had agreed, we children, just about as happy as it is possible to be in this tearful world of ours, lay back to listen once again to our father's story. Our muscles tightened when he told how Scylla reached down from her cave with long octopus arms to snatch sailors from the deck of Ulysses' ship, or how the one-eyed Cyclopes bashed the heads of the Greek warriors against the rocks, or of Ulysses' voyage up the River Oceanus . . . until by and by the swishing sound of water along the *Taipi's* sides, the soft gurgling sound from under her counter, the tiny plash of the feather at her bows got all mixed up with the droning sound of our father's voice and the heroes he told about—and so we slept, under the moon and stars.

We drifted on, with little puffs of wind pushing us toward lonely Suvorov, and maybe once a day a fine blustering squall bellowing down on us to wash the sticky salt from our skin and hair. On the sixth night we heard the far-away thunder of seas on Suvorov's barrier reef—a sound about as unearthly as anything this side of fairyland. The next morning we were close to the reef on the west side.

I was wakened by a shout from Metua: "Eika! Eika! E atu!" (Fish! Fish! Bonito!)

When I sat up and rubbed the cobwebs from my eyes I saw and heard about ten thousand sea birds a quarter of a mile ahead of us. They were diving, swooping, squawking in the confused way that told us a school of flying fish or squid was below them, and a minute later we saw a sleek bonito rise flashing from the water to curve through the air and dive back without stirring a ripple, then another and another, until the sea was alive with leaping, plunging fish.

"Eika! Eika!" Jakey yelled, then jumped from beside me to dash aft where Teinaki was rigging his bonito pole with its polished mother-of-pearl lures. Metua had gone forward, with another pole, to fish from the bow. Elaine and Nga woke to run squealing to the taffrail, while I stood with Papa and Tom Marsters, at the wheel.

A man goes crazy when he is in a school of bonito. He simply cannot keep his head when ten thousand sea birds are squawking, screaming, diving, fighting on every side, many within a yard of his head, plunging down with folded wings to catch the flying fish in the water, swooping over the waves to catch them in mid-air, fighting ten to one to steal the fish from each other; when ten thousand flying fish are skimming panic-stricken from crest to crest, often enough landing in the ship; when ten thousand bonito are leaping to catch the flyers on the wing, dashing this way and that to catch them below the surface, all hunger-mad, confused, excited as we are aboard the ship!

"Look out there, Jakey!"

"Wow! Another one!"

"Land that fish, damn you!" And the captain shrieking as loudly as Elaine and Nga, while Metua and Teinaki, with mighty heaves on their poles, swing in one sleek steel-grey bonito after the other, to toss them on deck where they thwack about until we cowboys club them with belaying pins!

And then in about two minutes the fish and the birds are gone! The sea sleeps. Here and there a shearwater rests drowsily on the water, preening her feathers, or an old man-of-war hawk soars on frozen wings in the empty sky. Only aboard ship is there any sign of the excitement we have just been through.

When the fishing was done I noticed for the first time the foaming barrier reef of Suvorov. Tou Islet, vividly green in the early morning light, lay over our starboard quarter. We skirted along the reef for a mile, leaving Tou Islet behind us and coming abreast of Bird Islet. I stared at the little green paradise beyond the breakers, and all at once the words came to me: "What a racket the birds make!" It is true that the birds, circling about us, were drowning the thunder from the reef combers. That sentence, I soon realized, had come to me because Papa, Mama, Jakey, and I had camped on Bird Islet when I was scarcely two years old, and my only memory of the place was the racket the sea birds had made at night, when we were trying to sleep in a little palm-frond wigwam near the beach. It gave me an odd feeling to stare ashore, knowing I had lived there a few days and yet remembering nothing save the clamor of the birds. And, of course, it made a lump come up in my throat to be reminded of my mother, left behind, never again to be seen or kissed or loved until we met in heaven.

Jakey helped Metua clean two of the fish for breakfast and tie the rest by their tails to the taffrail. Elaine and I kindled a fire in the tin-trunk stove and put the kettle on; then suddenly we were roused again, this time by the captain, yelling: "Jumping Jehoshaphat! Look at that shark! Teinaki! Get out my fishing gear!"

It seemed that the spirit of Suvorov Atoll wanted to show us all the beauty, danger, and savagery of his lonely island, and so he had sent us this man-eater as a warning and maybe a threat! Again there was yelling, dashing this way and that, confusion aboard the *Taipi*, but I noticed that my father stood by Elaine and Nga, his arms around them, for children sometimes fall overboard when they are excited and lean over the rail.

This huge black brute, twelve feet long, with a body bigger around than the hull of the *Panikiniki* and with the pointed nose that told us he was a man-eater, rose till his dorsal fin cut the surface. Then, with a quick angry movement, he shot round our counter, bringing his tail out of the water to slap it down with a bang! Then he sounded slowly, seeming to dissolve in the water until he was a shadow that gradually disappeared. Jakey, who had gone to the other side of the *Taipi* to pull in his toy steamboat lest the shark grab it, suddenly gave a yell that whirled us round, and then we saw the shark again, on the port side, and with him two man-eaters as huge and evil-looking as himself.

By then Teinaki had brought the captain's shark gear on deck: a hook about eight inches long attached to three feet of chain that was tied to a fish line as big around as my thumb. For bait he used a whole bonito, and no sooner had he dropped it over the side than one of the monsters banked up to it in a slow easy motion, rolled a little on his side, and grabbed it!

Then things started happening ten times quicker than I can tell them. "Got him!" the captain yelled, but a second later screamed bloody murder as the line burnt through his hand. Teinaki jumped to help him. Together they bent the line over the taffrail and secured it. I felt my father's arm around both Elaine and me, holding us tightly as we watched the shark plunging from side to side, sounding and rising, when suddenly, like a flash, one of the other brutes rushed in, rolled over so that his dirty-white belly gleamed, and with a vicious thrust forward, sank his jaws in the hooked shark's

belly! By then the line was fast to the taffrail and the *Taipi's* way had been stopped. We saw blood in the water. Then the third shark rushed in from the other side to make a tearing bite at the hooked shark, and, for a few seconds, hell broke loose in a turmoil of thrashing bodies, blood, foam, hate, and terror! It was a fearful sight. But in a few seconds the strain on the fish line broke the taffrail, the line slipped off, and, though Teinaki and Metua jumped for it, it ran off the deck before they could secure it.

The sharks were gone; only a muddy patch of water showed where two of them had murdered their companion. The *Taipi* got under way again, in a light falling breeze. I glanced at my brother and sister. Jakey's eyes glinted and his breath came in excited gasps. Elaine and Nga were pale with fright, and as for me, that little glimpse of savagery gave me a shivery feeling in the backbone and made my knees weak for an hour or more. At breakfast I was too upset to eat my bonito steak. I guess all of us were thinking about what the sharks would have done had we fallen overboard. It would have made no difference if our names had been Franklin Delano Roosevelt or Jack Robinson, for we would have been torn to pieces between those hungry man-eaters just the same!

Captain Cambridge felt pretty peeved about his broken taffrail and losing his shark gear, and his temper wasn't improved when the wind fell lighter and lighter. As we nosed past Turtle Island and the Bird Cays, every hundred yards we made good seemed to take so much force out of the wind. The closer we got to the passage on the east side of Suvorov, which opens to the lagoon, the slower we sailed, until finally, when we had Anchorage Island one hundred yards off our starboard bow, the wind fell flat and the ebbing tide carried us back to sea!

I won't bore you describing that dreary day in sight of land, with sometimes enough wind to take us back to the passage but never enough to get us inside. We made the best of it, loafing and playing—but not swimming—and that

night, when the wind came fresh again, we lay off and on close to the passage.

I woke at 4:00 A.M. to see a melon-rind of moon. It gave me a forlorn feeling, as the last of the waning moon always does. A misty pool of light shimmered above the horizon clouds. In a few minutes I heard my father's voice, wakening Jakey. With everyone else except the helmsman below or asleep on deck, Papa, Jakey, and I went aft to take the wheel from Metua and send him below. Then Jakey and I steered while Papa piloted the *Taipi* past the reefs and coral heads. "Port a little . . . Hold her! . . . Hard up!" he would call softly, and we would obey, throwing our weight on the wheel as though we were steering a full-rigged ship. When we were abreast of the old stone wharf he told us to hold her hard up in the wind, then he went forward to let go the anchor and take in the headsail.

"What t' hell!" Captain Cambridge shouted from his cabin when he heard the anchor chain jangle through its hawsepipe.

"We're there, sir," my father replied.

25

COWBOYS IN THE JUNGLE

When I think of the past I often picture myself as a sort of Miss Ulysses, wandering from island to island in the Aegean Sea, and this is because the two books of Homer have meant so much to me.

I find myself explaining things by some story in Homer. For instance, there is a beachcomber on the island where we now live, who has a beautiful wife with the eyes of a witch. She is leading her beachcomber husband into the jungle of madness, where all is confused and there is no way out. Each time I see him his clothes are a little dirtier, his beard a little longer, his brain more fuddled with bush beer, and he is lazier and more vulgar than before. How can I help but think that a South Sea Circe has turned another of her lovers into a swine? And there are six or eight white men who live in one of the clubs of Apia. All have money. They have nothing to do but loaf and drink beer, eat the wonderful

meals Mrs. Somebody cooks for them, go to the picture show, and sleep. This is all they have done for years, since I was here the first time, because they are like the strange people in the Odyssey, the lotus-eaters.

Now I hope you will understand what I felt when we sailed into Suvorov's lagoon in the early dawn, and later when we broke into the bush to feel the mystery of an uninhabited island. Hidden away in the jungle there might be a beautiful witch like Circe, giants like the Cyclopes, or another Calypso—but the feel of the place made me think more of sirens or old King Aeolus.

After lowering the *Panikiniki* over the side we paddled to the stone wharf, where we cowboys jumped out, leaving our father to return with the canoe to the *Taipi*.

"Rustle some kaikai!" he called. "I never want to taste porridge again so long as I live—or dough balls either! See if you can scare up a lot of fat fledglings and some coconut crabs and plenty of drinking nuts and *utos*. And when you have time build a wigwam to sleep in tonight. The captain and I will bring a pot of bonito and some sweet potatoes ashore when we come."

Just as if he had to tell us to rustle food! It may seem strange to you that four little children—Nga was only four and Elaine six—would be left alone to explore an uninhabited island, gather food and cook it, and build a wigwam, but you must remember that we were born to this life. It was as natural to us as feeding the chickens and driving home the cows would be to a farm child in America. I know that if we four kids had been marooned alone on Suvorov for a year or longer we would have been terribly lonely and scared of ghosts, but we would have had plenty to eat and a snug house to sleep in, while a civilized man would have died from hunger.

We picked our way down the old stone wharf, full of wonder and awe. To one side was a school of perhaps a hundred blue, green, and red parrot fish, packed closely together and milling slowly. They seemed unafraid, as were

the darling white love terns that fluttered like butterflies a foot or two above our heads to stare at us curiously, turning their heads this way and that, and the big yellow-fin shark that cruised lazily on the other side of the wharf. Only the hermit crabs were frightened. They clapped into their shells the moment we reached the beach. Jakey's eyes sparkled when he saw the sand crisscrossed with hermit crab tracks, for they meant plenty of bait and no trouble to find it. And Elaine's eyes sparkled when she saw a green turtle's track leading from the lagoon to the shore bush and back again, for it meant turtle soup with big lumps of green fat floating in it to her heart's content.

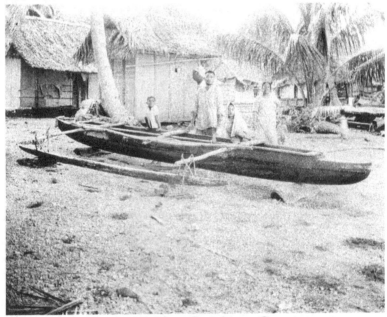

Typical 4-Man Outrigger Canoe.

Uninhabited island! I have told you what a thrill I feel on stepping ashore in a strange port, but it is nothing to standing for the first time on the beach of a desert island, with the jungle before you, wondering what adventures await you! And when you break into the island, as we did, you are

entering the unknown, where anything might happen!

"You babies had better stay on the beach," big Jakey said to little Elaine and Nga.

"Who's a baby?" Elaine pouted, suddenly about ready to cry, for that's Elaine—laughter one minute and tears the next. "I'm going!"

"Me too!" Nga squealed, and at that the four of us disappeared from the everyday world into fairyland.

There was a path leading inland, and though it was grown up with young coconut trees taller than our heads, we could follow it three hundred yards to the "clearing" by watching for the upright slabs of coral that lined it. Never had we seen jungle so dense. We parted the young fronds, took two steps forward, and the whole outside world was blotted out. The stillness was unearthly; it frightened us to raise our voices. Here, instead of the sharp salty smell of the sea, there was the damp odor of rotting logs, of leaves, mildew, and sea bird's droppings. Land crabs scurried this way and that, hermit crabs and golden-green lizards crawled and leaped among the branches, centipedes wriggled in the piles of rubbish; sometimes we would see a huge coconut crab rearing back with claws spread out. They were the only real danger in the jungle, for their claws were sharp enough to snap off a man's toe. We killed four by breaking off the tops of their heads, tied their claws with strips of bark from coconut fronds, and carried them with us.

In the clearing all the big trees had been chopped down except a few coconuts, some young breadfruit, and five huge *tamanus* that grew in a line, close together. Under these trees lay the wreckage of the old trading post that Hartley Sterndale built about sixty years ago, a pearling cutter full of holes, and a brick underground water tank covered with a roof of galvanized iron which caught rain water. Four poles leaned against the inside of the tank, placed there, we guessed, so rats and crabs that fell in the tank could crawl out again. We though it a clever idea; without the poles the water might have been spoiled by dead things.

The breadfruit trees were heavy with ripe fruit, and there were bananas ready to cut and a few mummy apples—and all this hidden away in the deep jungle of a desert island! To a castaway it would have been a miracle, and even to us it was wonderful, though we knew that gangs of Manihikians and Palmerston Islanders came here every two or three years to dive for pearl shell.

In the clearing we could hear the sea birds again, and we could see them swooping down to their fledglings in the trees, and sometimes passing overhead in such numbers that they seemed a cloud darkening the sun. And we could hear the sea pounding on the fringing reef.

"Come on!" Jakey cried. "There will be lots of birds on the outer beach!" With that he broke into the jungle again, this time on the sea side of the clearing.

"Let's make an Indian trail," Jakey said. He broke off a twig by his head, grabbed a long frond to tie its end in a knot, jammed a handful of leaves in the fork of a tree, and so on, leaving a trail behind him that even a city man could follow.

The jungle was denser on the sea side of the island. Our trail must have zigzagged, made spirals and figures-of-eight all over the place, for our feet seldom touched the ground. We moved like monkeys, swinging from branch to branch; like tree snakes, wriggling in and out among the branches; like rats, creeping along the ground. The air was so hot and stuffy that sweat streamed from us. In some places, where we crawled under thick clumps of bird's-nest ferns, tangles of liana vines, bunches of pandanus and cordia leaves, it was as dark as night.

Presently the jungle thinned a little, and we rested between buttresses of a big hernandia tree. At our back a hole led into a hollow six feet across, its floor covered with the fibers many a coconut crab had torn from the husks of many a nut. Elaine and Nga crawled in the hollow to pretend they were grizzly bears or wild Indians; Jakey climbed a coconut tree, and I gathered the nuts he threw down.

We opened the green nuts by cutting square holes in the soft white *mokomoko* at the stem end of each one, and, tilting them up, we poured the water in our mouths. Then we cracked them open by pounding them against the edge of one of the buttresses, and with the back of our thumbnails scraped out the soft jellylike meat, and ate it.

Afterward Jakey dug into his pant's pocket to bring out a Capstan tin. In it we found some cigarette stubs, matches, and pandanus-leaf papers, so we each rolled a pinch of tobacco in a strip of leaf and smoked it. Jakey had saved the stubs at Puka-Puka for poor old men who were always hungry for tobacco.

It didn't make us sick, for, though we seldom smoked, we had puffed now and then at our father's cigarettes for the fun of it since we were babies, but for a minute I thought I was sick because all at once the jungle seemed to grow darker and I heard a humming sound that seemed to come from nowhere, yet filled the air. I threw my cigarette away and gripped Jakey's arm. Nga frowned; Elaine giggled in a panicky way. The jungle grew darker still; the humming sound rose to a roar! Then rain drizzled down, and we laughed in relief, for we understood that a squall was passing, up in the other world, above the jungle.

A gust of wind snarled at us from the treetops. We crawled in the hollow tree to crouch snuggly there until the rain had passed, and when we crawled out again it was to see, for the first time, the headpiece of a grave only a few feet from where we had been sitting.

JACK BUCKLAND
October 1914

What a lonely place for a man to be buried! We wondered what sort of relatives he had and whether they knew he had been buried in such a desolate spot. Then, very quiet for a gang of cowboys from Puka-Puka, we started off again for the outer beach.

It was not far, but we hurried nevertheless, both because of the thing behind us and because we atoll children

knew the thrill that lay ahead. First, we saw dashes of blue sky in openings among the leaves, then the underbrush cleared away a little and we crossed a patch of coral boulders, which were painful to walk on barefooted. A few pandanus trees were scattered among the boulders; beyond were the bushes that lined the outer beach. Not a breath of wind touched us; the sunlight beat down, hot and dry, and the stiff branches tore our clothes and scratched our skin. It was hard going for fifty yards or so, climbing over or worming under the tangled mass of bush, and the heat became so terrific that sweat streamed smarting into our eyes until finally we broke a path between two *pemphis* bushes and came suddenly to the outer beach.

"Suddenly" is the right word, for that was our feeling when we broke out of the bush on to the clean sweep of white sand. It was like plunging from a steam bath into a pool of cold water. The sparkling sea, the foaming reef, the clear blue sky struck our eyes like something solid. The fresh trade wind flowed across our sweating bodies, cold and fragrant. The muffled roar of breakers, the cries of many birds rose to a grand uproar.

From where we stood, with the sea before us and the passage to our right, we could see the long, curving reef stretching from far away to the north, where lay many tiny islets. Jakey reckoned this reef would be a wonderful place to fish, and later we found it so. Where the reef turned in along the passage there were scarcely any breakers, and we found we could stand on its outer edge with a fish pole to drop our hook in deep water and bring up huge groupers weighing ten to twenty pounds. But the most fun was with a hand line and a small hook baited with hermit crab, fishing in the little holes that sucked in and blew out the tide. When we dropped our hooks in these holes a little red fish called *malau* would take them, while elsewhere these fish were night-feeders only. Moray eels took our hooks, too, and always carried away the lines.

We walked along the beach to pick fat noddy tern and

love tern fledglings from the bushes. It was as easy as picking strawberries, but hard for me to kill the fuzzy little darlings. I let Jakey do that while I looked the other way.

When we had thirty or forty fledglings we took them into the deep shade under a *guettarda* tree to pluck their feathers; then, each with a love tern on his shoulder for a pet, we followed our Indian trail back to the clearing, where we picked a few breadfruit and then returned to the lagoon beach. There we gathered utos and drinking nuts, which we piled with the rest of our food in a grassy glade between two young coconut trees. When Papa, Captain Cambridge, Bruce Robertson, and the sailors came ashore, bringing a pot of boiled bonito and another one of sweet potatoes, our own birds and coconut crabs were roasted and the utos and drinking nuts were opened; so we made one grand and glorious feast of it on that lonely, far-away desert island somewhere in the Sea of Neverness.

26

NIGHT ON A HAUNTED ISLAND

In the afternoon we went to the north point of Anchorage Island and there we found a pool of sea water about sixteen feet across and five feet deep at high tide, with a narrow inlet leading to the reef shallows. On calm sunny days the water in this pool became pleasantly warm, but on rough days waves surged through the inlet to fill the pool with cold foaming water, which was just as nice in another way. The bottom of the pool was as smooth as a porridge bowl, and of course there was no danger from sharks. As we wallowed in the warm water Papa told me he had taught me to swim in that same pool, long long ago when we had stopped at Suvorov on the voyage from Tahiti to Puka-Puka.

Before long we cowboys got fed up with wallowing around and listening to the Captain, Bruce, and Papa chew the fat, so, it being low tide, we ran out to the reef shallows to chase trigger fish and butterfly fish among the crevices and

pools. It wasn't long before we had at least fifty of them strung on some twigs; these we left on a lump of coral. Then we went to the barrier reef itself to hunt periwinkles and cowrie shells, and before long we found another pool, on the dangerous outer side of the reef. It was about three feet across and three deep, and it also was round and smooth as a porridge bowl.

The tide was coming in. Big rollers broke on the sea side of the reef, hurtled over a ridge of coral, and tumbled foaming into the pool. We four children waited for a calm spell between breakers, then ran down the sea side of the reef to the pool and squatted in it, bracing ourselves and holding our breaths with excitement. It wasn't dangerous for us, because we knew what we were doing. In a minute we heard the thunder of a great comber behind us. We ducked our heads, braced our feet, and gripped one another. With a noise like an airplane motor the comber hurtled over the ridge to crash down on us and rush in a mass of foam four feet deep above our heads! In ten seconds it had passed. We bobbed up our heads, whooped with excitement, took a few deep breaths, and waited for the next comber.

Leaving the pothole was just a matter of jumping out as soon as a breaker had passed and running to the top of the reef and down its lagoon side before the next breaker could catch us.

When we had picked up our fish and returned to the swimming pool the three grown-ups were ready to leave, so we put on our clothes and followed the beach a half mile back to the stone wharf. There Captain Cambridge whistled for his canoe and returned with Bruce to the ship, while the five of us went to work making wigwams and a canoe tent for the night. This is the way we did it.

First, we cut three poles eight feet long with little forks on one end, and made a tripod of them with the forks up. Then we laid ten more poles around the tripod so their upper ends would rest in the forks, and lashed them all together with the strong bark from the upper side of a

coconut frond midrib—this being our rope when we are camping in the wilds. On this cone-shaped framework we laid lots of green coconut fronds with the butt ends down, and later passed the same kind of rope around them two or three times. For a doorway we cut away the leaves in a two-foot square and braided the sides to make it look nice. And finally, working inside, we tucked the loose leaves under the poles so they wouldn't tickle us at night. Our beds were made from armfuls of beach magnolia leaves covered with a mat.

Jakey and Nga made one wigwam and Elaine and I another, while Papa made his usual canoe-sail tent by laying the sail over the canoe and its outrigger, propping it up with a pole lashed upright to the middle of each outrigger boom, and tucking the edges under the canoe on one side and the outrigger on the other. It made a pretty good fair-weather shelter, but our wigwams were better when it rained.

With less than an hour's work we had two snug wigwams and a tent for the boss between them. When the sun had set we had only to eat the scraps left over from dinner, then stretch out at our doorways to watch the clouds deepen in color from gold to red and the frigate birds wing in from the sea, and to guess the names of the stars as one by one they appeared suddenly in the darkening sky. We could hear the tide churning through the floodgate at the shore end of the wharf, ripples playing on the beach, the wind fingering the taller coconut palms. Sea birds croaked from their roosts in the tamanu trees, and we could hear faintly, but more and more distinctly as the night deepened and other sounds were hushed, the distant thunder of the sea on the barrier reef.

A cable's length from shore a lantern swung from the *Taipi's* boom, scarcely brighter than Sirius in the sky above us. The sand had a dull sheen; the trees were murky shapes, and there were moving shapes in the jungle that reminded us of the men who had died on lonely Suvorov. Perhaps that was why Elaine told Papa we had found a dead man on the sea side of the island.

"Dead man!" Jakey scoffed. "It was only a grave,

Papa."

"By a big Hernandia tree, where we played Indian," Nga said.

"Was there a name on the grave?" Papa asked.

"Yes, the name of Jack Buckland," I told him.

"Then the grave of Captain Robert Burr was some place nearby," Papa said. "I remember those graves. Mama Desire and I found them one day when we were hunting coconut crabs, and when a little girl named Johnny was back in the clearing, minding the baby, whose name was Jakey. Some day you will read Robert Louis Stevenson's novel *The Wrecker*. Then you will meet Jack Buckland under the name of Tommy Haddon. Jack was a friend of Stevenson's, and of another writer, named Rider Haggard, whose exciting stories you are sure to read."

I asked Papa how Jack Buckland had died—and the other man, whose name I had forgotten, and he told us that Captain Robert Burr had died of delirium tremens and that Jack Buckland, a few days later, in a fit of depression or drunkenness or madness, had sat on a keg of gunpowder, touched a match to the bunghole, and blown himself to kingdom come!

We lay still for a little time, cuddled close to our father, when suddenly we heard, so distinctly that we knew there could be no mistake, a rooster crow some place in the black jungle. "That must be the ghost of Joe Bird," Papa whispered. "We must keep out of the jungle at night, with Lord knows how many ghosts snooping around looking for people to scare to death." Then he told us a little about the men who had fought and loved, dug treasure, hunted pearls, and died on Suvorov in the old days.

First, there was Señor Senoro, a mysterious Spanish castaway. Native pearl divers often claimed they had seen him, gaunt, one-eyed, in topboots and leather breeches, stalking through the jungle in search of a flint for his musket. Then there was Mahuta the Rarotongan who had swam ashore from a ship that had brought a gang of women divers

from Manihiki, and had been torn to pieces by the women who fought for him. And the ghost of Jim Mair, who had died of pneumonia after finding the treasure of Tom Carlton. And the ghosts of Tom Carlton, Louis Tirel, and Joe Bird.

Tom Carlton had arrived mysteriously in Suvorov aboard a pearling cutter with a few natives, one woman, and an iron chest full of treasure. At Suvorov he had found Louis Tirel and Joe Bird. Joe was called Bird because he had a beak of a rooster and the same cruel temper. And vain! He was so vain that he wore a black alpaca frock coat and a silk hat aboard ship. He strutted around in his fancy clothes just like a barnyard rooster. And he died on Suvorov—he, Louis Tirel, and Tom Carlton.

The story goes that Joe beat his houseboy to death. The Penrhyn Island divers, wild savages in those days, seized him and the other two white men, so there would be no witnesses against them, bound them hand and foot, tied coral rocks around their necks, carried them in a cutter to the passage, and threw them overboard. Louis was thrown in last, weeping and whimpering like a woman, but when he was sinking he managed to wrench free his hands and rid himself of the rock around his neck. His lungs bursting, he swam to the surface, and there had time to gulp a last lungful of air before the oar of one of the divers crashed down on his head!

Their ghosts joined the others, and the secret of Tom Carlton's treasure was lost, for a time.

"Maybe we'll find it," I said sleepily, when Papa had finished his story, but Jakey, Elaine, and Nga said not a word, for they were fast asleep. Sirius had slipped a few degrees down the "rafters of the sky." The lantern on the *Taipi's* mizzen boom had blinked out. The wind patted my cheek; I cuddled close to Papa. He sighed in contented weariness, leaned over to kiss me, and, "Good night, Johnny!" he said.

"Good night, Papa. O.K., Papa!" Then suddenly I felt my mother's presence. It was the first time she had come to us since we had left Puka-Puka. I bade her good night, as I

always do when I know she is near. "Good night, Mama! O.K., Mama!"

27

WE EXPLORE AN
UNINHABITED ISLAND

My diary tells of the blue light we saw above Tou Islet one night, shining steadfastly for several minutes, when suddenly it blinked out. And of the two warplanes that roared over Anchorage Island, and how we ran to a rubbish heap to wiggle in and hide like rats. Probably they were the first planes ever to flash their silver wings over Suvorov. Papa, who saw the planes better than we, said their silver bellies were tinged with the blue reflection from the lagoon. We learned later that they were hunting for three lost airmen named Dixon, Pastula, and Aldrich. We thought they might be Japanese, for we did not know that the stars on their wings belonged to our own Uncle Sam. And my diary tells of the day the incoming tide caught us on the reef in the northeast bight, and how twenty-five sharks were cruising about us before we made the land; and of the great fishing parties on the reef; and of the days we

gathered wide-awake eggs on One Tree Islet; and of the three-hundred-pound green turtle we caught—and let go again, for it would have been shameful to have killed such a gigantic creature of God for the few pounds of meat we could have eaten. My diary is full of such adventures, but I will skip pass them, for I am impatient to take you to Manihiki, the most beautiful green siren isle in God's beautiful green world—a land no one has written about because scarcely anyone has been there.

We arrived at Suvorov on January 11, 1942. A few days later Captain Cambridge sailed for Nassau, only about two hundred miles to the northwest, there to land the balance of his cargo. When we bade him goodbye he promised to return in a week or ten days and take us to Rarotonga, but it was many a week before we saw his ship again, and in the meantime we had experienced the great adventure of our lives.

We built a little shack near the water tank, with a thatched roof, and board floor from the wreckage of the trading post. There we stored our gear, but for living quarters we built a story-book house, twenty feet off the ground, in one of the big tamanu trees. The pearling cutter had been repaired by Captain Cambridge, but the *Panikiniki* was much nicer for visiting Suvorov's twenty-six islets strung like gems in a necklace around the barrier reef. Some of these islets were no more than sand cays with a few hardy bushes and about ten thousand birds, but others were big enough to get lost in, wooded with all the atoll trees and fairly squirming with coconut crabs. I guess there was enough food on Suvorov to have supported all the six hundred and fifty people of Puka-Puka, and yet, as I have already told you, a city man might starve to death in this land of plenty.

The months we were "marooned by request" on Suvorov would have been a wonderful time to go native, but our boss wouldn't allow us to be happy savages more than half the time. Every morning we were forced to rise at dawn, wash our faces, brush our teeth, and comb our hair. After the

breakfast things had been washed and put away, one of us, turn and turn about, was obliged to drive the other three, with blows and curses, to clean the yard, drill like common soldiers, and then study, for hours at a stretch, stupid schoolbooks, when all about us lay Suvorov Atoll, adventure such as we never again could hope to enjoy!

But I must be fair. The truth is that one of us took charge of the camp every day, and the one who had charge slept with Papa the night before. In that way we each were as happy as kings once every four days, for not only was it fun bossing the other three cowboys, but it was even nicer sleeping with our father. You must remember that we had no mother—nor any relatives here in Suvorov—so our father was the one we had to love. He liked best for me to sleep with him because I did not kick in my sleep (though he said I snored, which I don't believe). Elaine he liked next best because she was so fat and soft she didn't hurt him when she jammed her elbows and her knees in his back. Jakey and Nga were too bony and restless to be good bedfellows, but Papa gave them their turns just the same. When the child beside him was asleep, he would lift her head from his arm, move over a little, and put his long bolster, his Dutch wife, between himself and the child.

One of us slept with him on the bunk he had built in the tree house while the rest of us slept on a mat on the floor. And what a place to sleep!—high off the ground, above the underbrush and the damp jungle smells, with the moon and the stars looking through the window, the trade wind blowing cool and fresh on our naked bodies, and the grand thunder of seas on the barrier reef mingling with the song of the wind all about us in the great tamanu trees! There were no mosquitoes or flies, so we did not need a net, but sometimes, when the night was hot and windless, we would take our mats and bedding to the end of the stone wharf, where there was a patch of gravel big enough for us all. There we would sleep under the stars, hearing in our dreams the lapping of ripples, a school of mullet leaping and plunging in the calm water, or

the jungle sounds. And if we had eaten too much coconut-crab fat before turning in, maybe we would dream that these sounds were the curses of Joe Bird, the drunken songs of Jack Buckland and Robert Burr, or old Señor Senoro muttering to himself as he poked around the jungle, hunting a flint for his musket.

You can sleep under the stars on an atoll, for there is no dew, and that's what we did, night after night, when we sailed the *Panikiniki* around the island, stopping at almost every islet to explore, picnic, and, when night overtook us, to sleep.

We left Anchorage Island bright and early, with all of our great spritsail set, for the breeze was gentle and the lagoon calm. Perhaps this was taking a risk—Papa thought so later when the wind freshened—for Suvorov's lagoon would be a bad place to capsize. In the first place there were very few coral heads or reefs to hang on to while one righted the canoe, bailed, and reset the sail, and in the second place sharks were dangerous even inside the lagoon. So we were alert until we had crossed the passage and run the *Panikiniki* into the beach of the first islet of the Gull Group. There we stowed the spritsail yard and folded down the peak of the sail, changing it to a leg-of-mutton sail. With it we would be safe even in a strong wind.

The Gull Group were flat "drowned islands," half under water during spring tides, with dense low bush and more birds than any place in Suvorov, which may mean any place in the world. Huge black frigate birds with red turkey wattles on their necks nested in the pemphis bushes. Though finer eating than a fat young chicken, the frigate bird fledglings were about the ugliest creature in God's world, gawky, with sneering beaks and cruel insolent eyes. They were less afraid of us than we of them. When Jakey knocked one off his perch the whole colony bawled him out, call him nasty names, and one of them made a dive for him and would have hurt him badly with her long sharp beak had not Jakey swung his stick like a sword and knocked her down, where

she lay kicking on the sand but still cursing Jakey to the hot place and back again.

On the sea side of the islet we found a colony of tropic birds, each with two scarlet-red tail feathers as straight and slim as an arrow, cruel red eyes, white breasts, speckled backs, and bright-yellow webbed feet. We plucked a hundred or more of their tail feathers, and this, too, raised a row of scolding voices. The tropic birds were harmless so long as we kept our hands away from their beaks. Nga was the best at plucking their feathers. Being so small, she could crawl under the bushes, sneak up behind them, and with a darting motion of her hand snatch the tail feathers before the birds knew she was there. They would squawk their heads off for a few seconds, as though it were expected of them, and then suddenly forget all about it, start preening their feathers or blinking their eyes, and go to sleep. There was nothing cruel about stealing their feathers, but it was profitable, for tourists would pay us a shilling each for them, and later we found that American soldiers would pay a dollar or more! How those poor Yankee soldiers were stung by my own "innocent childlike" people!

We captured five tropic-bird fledglings and stowed them in the forepeak of the *Panikiniki*. Had we been on an island where food was scarce or we were about to go to sea, we might have captured a hundred—or a thousand for that matter—and killed them as we needed them. Aboard South Sea trading schooners you often see the decks crowded with tropic-bird fledglings and the rigging crawling with coconut crabs, as well as a green turtle or two up forward where the spray will keep them damp, and the usual assortment of pigs, chickens, and ducks.

Early that afternoon we left the Gull Group to skirt the lee of the east reef and then sail southeast to Seven Islands. With the wind blowing a merry gale we spooned through the calm water, the feather from our bows rising like Neptune's white mustaches, our wake churning. I perched on the outrigger itself; Jakey stood beyond the mast stay on the

outrigger boom, and Elaine sat on the canoe side of the stay, while Nga, in the canoe, bailed for her sweet young life. With the paddle vibrating aginst the hull as fast as a snare drummer's sticks, and the dry reef to windward often so close aboard that we could spit on it, we scudded over the ripples, five miles to Seven Islands in not more than twenty minutes. Give a Puka-Pukan sailing canoe a calm sea and all the wind she can bear, and there's nothing under sail that can pass her.

Papa eased off the sheet when we were close to the biggest of the Seven Islands, the boom swung out, the sail slatted, the *Panikiniki* lost way until Jakey and I jumped into the shoal water to pull her close to shore, where we anchored her.

Jakey ran up the beach first; then he stopped, put his hands to his elbows, and stared.

"What you found, Jakey?" Nga squealed.

Leaving Papa, the rest of us joined our brother to find him staring at twelve bronze bolts, sticking straight out of the sand, about two feet apart.

"Papa, Papa!" Elaine screamed, running down the beach to be the first to tell him. "*E mea*, Papa, *e mea!*" (A thing, Papa, a thing!)

"Oh!" said the boss, and hurried to the shore bush, with fat little Elaine tugging on his arm.

We dug around the bolts to find that they had been driven through a hardwood timber about eight inches thick. It was the keel of a cutter, we guessed, and for a little time we talked about it, wondering if it could have been Tom Carlton's boat or the one the Penrhyn Island divers set adrift after they had murdered Joe Bird and the others, so their story about how the three white men had sailed away, with a fortune in pearls, would hold water.

Maybe you are wondering why I have bothered to mention so unimportant a matter, but remember that we were on the remotest islet on one of the remotest atolls in the world, where one does not need a massacre or an atomic

bomb to awaken one's interest; and anyway those twelve bronze bolts started a whole saga of what my father calls "adventures of the spirit," which were to influence our lives for over two years—and also there was the Castaway!

It is hard to believe the things one finds on a tiny islet that probably has not been visited for a quarter of a century—if once since the Castaway was there. That day we picked up from the beach two of the big glass globes the Japanese use as floats for their fishnets, a round cordia-wood cricket ball that I was sure had floated there from Puka-Puka, a corked bottle with a paper in it telling where a certain ship was on a certain day, and when we had gone inland, two horseshoes! Now, I ask you, how did two horseshoes get on Seven Islands unless the Castaway had brought them to play with? And the Castaway?

While we were poking around, close to where we found the horseshoes, hunting for the fat female coconut crabs with abdomens full of delicious unlaid eggs, we came to one of the hollow hernandia trees that you find on almost any atoll. Of course Elaine and Nga had to crawl in, pretending they were cave women; the rest of us sat outside to rest and smoke.

"Papa!" Elaine screamed suddenly, as scared as though a cave man were after her. *"E mea, Papa, e mea!"*

"Take it easy!" Papa growled. "You and your *meas*," for he was hot, sweaty, and in a bad humor.

"It's a dead man!" Nga squealed, then started to whimper, while Elaine bawled outright, and both of them made such a dash for the opening to the hollow that they got jammed in it and could not get out until Papa had pushed Elaine back to let Nga out first. Then Papa squeezed in, Jakey followed, and in a minute I crawled halfway in, where I could see at first only a white blur, but later, when my eyes were used to the light, a skull and a pile of bones!

Papa picked up the skull to shake out some hermit crabs and then to stare at it for a long time, turning it this way and that, frowning. Presently I felt a little more brave, so I

crawled all the way in, and soon Elaine and Nga joined us, their fright gone, quarreling as to which one had seen the skull first.

"Be quiet!" Papa snapped.

He laid the skull on his knees, face up, rolled a cigarette and lit it. He didn't speak until the cigarette was finished, and when we tried to break the eerie stillness in that hollow tree, with all those bones about us, he closed our mouths with a frown. His smoke finished and the butt thrown among the bones, he smiled in his kindly way again, and said:

"This is the skull of a man. We can tell that by the size of the teeth; and a white man, because half of the teeth are missing while the rest are mostly decayed; and a poor man, because there are only a few amalgam fillings, no gold. Yes; I should say that he was an oldish poor man, with a wooden leg, by name Captain Benjamin Pease. He had sandy hair, dead fishy eyes, and an undercut chin like a shark's. Yes; and a more wicked man you'd never find this side of hell itself. He was so wicked I feel like bashing him in the snoot right now, even though there's nothing left of his snoot but a hole."

Again Papa sat silently while he rolled another cigarette. We children were patient, for we knew what was happening in our father's head. In a few moments he went on: "This man, Captain Ben Pease, came here in search of the gold of Tom Carlton, but his cutter broke adrift in a northwesterly gale, piled up on the beach where we saw the bolts, and Ben, being alone and crippled, could not relaunch her. He was marooned on this desert island. He couldn't make Anchorage Island by the shortest route because of the passage and all the man-eating sharks, and he couldn't go there the other way on account of his wooden leg. There is one strip of bad reef ten miles long, without a single cay or rock to rest on, and he could never cover that distance during low tide unless he had two sound and spry legs. So he stayed right here on Seven Island, playing horseshoes with

himself—but the problem is: where did he get the horseshoes?"

Maybe he was superstitious," I suggested. "He had them aboard the cutter to bring him good luck."

"Or maybe he always carried horseshoes with him because he liked to pitch them so much," Jakey added.

"Fine!" Papa exclaimed. "That accounts for the horseshoes! You cowboys keep your wits working, because it will take all five of us to work out the story of Captain Ben Pease."

"I think he went crazy," Nga said very seriously, staring at the skull.

"Sure thing!" Papa agreed. "He went crazy as a bedbug, or anyway he'll certainly go crazy in the book we're going to write about him. And he died right here in this hollow tree, while . . ." and Papa glanced at me, so I told him that the handsome hero and the beautiful heroine found the treasure of Tom Carlton, got married, and lived happily ever after, amen!

"Please, Papa! Tell us the whole story—all of it!" Elaine begged, cuddling close and petting him.

"By and by, when all five of us have worked out the plot," Papa agreed. Then he gave Elaine a kiss, which made Nga cuddle to him also, frowning her jealousy.

We did not feel safe on that "drowned island" when the sun had set and the wind, building up to half a gale, howled in the treetops. There was so little land, and it was so isolated, out there in the middle of the great lonely ocean, and it was so low—maybe five feet above sea level. Because our islet lay on a point of reef, the sea was on two sides of us while on the third side lay the lagoon. Overhead was the gloomy threatening sky, its owl-eyed moon watching us through the clefts in the clouds.

For a long time I lay awake, troubled with a dumb fear; then, all at once it took shape in my mind in the thought that maybe we could never leave this dangerous islet. Maybe the *Panikiniki* had broken adrift, leaving us marooned like

the castaway!! And maybe this sudden gale was the first of a hurricane that would wash Seven Islands into the sea! I whispered my fears to Papa. "Let's see if *Panikiniki* is all right," I said, but he only laughed and told me that if she had broken adrift all the looking in the world would not bring her back, and anyway the waves would wash her up the beach if they didn't wash her to sea.

I lay close to Papa, listening to the unwearied screaming of ten thousand birds, the vicious gusts of wind, the crashing roar from the barrier reef, and even in my sleep my dreams were troubled with these sounds. But February is a fickle month in the South Seas. It is steadfast in neither its storms nor its fair weather. Next morning I woke to see the lagoon calm and sparkling again, while in the clear blue sky those same ten thousand birds were flying busily to the fishing grounds like so many busy housewives hurrying to the early morning market.

28
THE SEA AGAINST THE
LAND

W e got back to Anchorage Island in the nick of time. The fair weather lasted only until about noon, then the sky clouded over again and vicious little squalls drove across the lagoon to strike us with such force that the *Panikiniki* plunged crazily, and even with our sail luffing it was all we could do to keep the canoe from capsizing. Had she turned over, there would not have been a hope in the world for us. But we did not know that. We did not know that we had seen the last of our fair weather for many days to come, and that when again the sky cleared and the wind moderated, Suvorov would be scarcely more than a memory.

We made Anchorage Island, soaking wet and exhausted, and from then on, for three days, the wind built up from a moderate gale to a storm. Steadily the barometer fell, but we did not believe that a hurricane was bearing down on us, for the wind held steady in the north-northeast. South of the equator, when a hurricane is in the offing, the wind shifts

to the north as the storm approaches—unless the storm center is headed straight for you, when it holds steady in one quarter. If you wonder how a teen-age girl knows this, remember that I was born and brought up in the hurricane belt and my father is a sea captain.

At first we were unwilling to believe the worst; we thought the high wind was only one of fickle February snorters, and we went about our business unworried but pepped up with the energy high winds and rain squalls always give us in the tropics.

When the elements go berserk, the wind howls, the combers thunder along the barrier reef, and the coconut trees beat their wings against the lowering sky, a sort of madness comes over me in keeping with the storm. The jungle smells are swept away by the fresh-smelling rain and the spray from the barrier reef; a new vitality fills me and brims over. I eat like a stevedore. Relaxation is impossible, and if there is work I do it gladly, almost furiously, and if there is nothing to do I dash around like a puppy chasing its tail.

About noon on February 21st Jakey and Papa went to the beacon, which was close to the fringing reef alongside the passage. When they returned Papa warned us to stay in the clearing, but Jakey, his eyes sparkling, told an exciting story of how the sea had gone mad and combers the size of a church were piling over the reef. A few hours later, because I rashly felt I was more than a match for any danger and Jakey felt so, too, and because the chill wind and rain had given us so much vitality, we disobeyed our father by leaving camp to run toward the low land on the north point. We followed the inland path, for by then the sea had eaten away the jungle along the beach and flooded the low land, where our swimming pool used to be, under a fathom or more of churning water. Above the roar of the wind in the treetops we could hear the breakers thundering close at hand on either side, When we had gone about three hundred yards we broke suddenly from the jungle to find clear white sand before us where formerly had been a half mile of bush. All that jungle,

and much of the land, had been swept away!

About a hundred feet to our right, very close to the fringing reef alongside the passage, stood the box-shaped beacon made of cemented blocks of coral, eight feet high and six feet square. There must have been a lull when we stared at it, for though the breakers curled twenty feet high and crashed along the fringing reef, none washed beyond the beacon.

Perhaps it was the storm's madness in our blood that made us leave the safety of the jungle to run across the clean-swept sand and climb to the top of the beacon.

There, almost instantly, we became hypnotized by the violence before us. The passage was a frothing whirlpool. Wave crashed against wave to fling geysers of spray fifty feet into the air; driven mist obscured the Gull Group beyond. Bracing ourselves, for the wind raged past us at easily a mile a minute, we watched the enormous combers moving slowly but deliberately, rising twenty feet or more to thunder along the fringing reef, surge to the base of our beacon, and then wash back into the next trough. And this was a calm spell! Other waves had rushed past the beacon to flood the entire northern point. In our excitement we gave this not a thought until suddenly, at our feet, I noticed a pool of water in the basin-shaped top of the beacon. Breakers must have piled over the beacon itself, would soon pile over it again!

I grabbed Jakey's arm to point to the pool at our feet. Instantly terror spoke from my brother's eyes. And as for me—I was frozen in sudden panic! It was then that a comber, twice the size of the others, crashed onto the reef with the sound of a bomb blast, surged past the beacon, all but submerging it, and tumbled inland to cover the entire point under six feet of water!

The sight of that foaming rushing water did not frighten me; for a few seconds my panic was gone, until all at once there came the appalling thought that we were separated from our father, Elaine, and Nga! We would never again see them! Standing isolated on the beacon, with violence all

about us, the roar of breaking seas, seething water, wind all but picking us up and flinging us into the turmoil, we thought we were truly lost. The picture of my father and sisters snug in camp, unaware of our peril, flashed through my mind while I looked at the raging water about me and heard its thunder! In those few seconds I knew how much I loved and needed them! That Jakey and I would be drowned did not frighten me, but the thought of my father and sisters waiting, growing alarmed, searching, giving up hope, sorrowing, made me so frantic that I nearly jumped from the beacon into the water to stop the pain.

Several combers passed, one washing knee deep over our beacon while we stood braced, clutching each other. Then suddenly the seas subsided, rocks rose above the retreating water. Holding desperately to each other, we crawled down the beacon to wade as fast as we could, often hip-deep, back to higher ground, where, our strength giving away, we could scarcely totter back to the clearing.

I don't know what Jakey did back in camp. As for me, I broke down entirely. With my last strength I ran into my father's arms, crying hysterically.

The feel of him close to me, the sound of his voice, gently bantering but nevertheless worried, gave me the strangest sensation I have ever known. It was something new in my life: a feeling that I had been separated from a part of myself but now was reunited—a feeling of complete security. I wept for a little time, but with tears of relief. Then Papa carried me to the ground house, laid me on a mat, and put a blanket over me.

Here I am, talking about myself and with scarcely a word about my brother. The truth is that I remember nothing of Jakey from the time we were running away from the beacon. I have just asked him how he felt when he got back in camp. He only shrugged his shoulders and said that only females get scared of little things like hurricanes; as for him, he never had more fun in his life. Which shows you that, even though boys may be braver than girls, they are certainly

bigger liars!

Lying in the ground house, I watched Papa fit braces under the roof; he then cut two-fathom lengths of half-inch rope, tied one around each of our waists, and tucked the ends under the tied parts so we would not trip on them. These were to lash us to the limbs of the tamanu trees should the sea wash through the clearing. Already the combers had eaten away the jungle and much of the land to within a hundred feet or so of the clearing, and each comber that rushed by took away a little more bush, a little more land. We knew it would be only a matter of hours before the whole island was gone.

Night came suddenly. The wind rose to nearly hurricane force, but we managed to keep snug in the ground house, with some of the wind's force broken by the remaining jungle. We also contrived to keep a lantern burning in a kerosene case which was sheltered in turn by chests and boxes.

The house shook with each gust of wind; the roof buckled until we thought it must cave in; the tall coconut trees flung their heads wildly, and many broke crashing to the ground. At any moment one might fall on our house and kill us all. Often eddies of wind swept into the house. Their chill touch and their damp smell seemed to whisper of the excitement outside.

After my one fright I was very calm, almost peaceful, though my nerves were tense. I could hear the great combers surging past on both the lagoon and the sea side of the clearing, a faint rushing sound in the clamor of the wind, closer and closer, eating away the jungle foot by foot, washing away the top layer of matted roots and sand, until, with nothing but loose gravel left, a single wave could sweep it clean, leaving only the coral reef below. The wharf had gone early in the night, Papa said; more than half of Anchorage Island was gone—and still the body of the hurricane had not struck us! This was only the outer edge, warning us of the awful terror some place out at sea,

thundering straight down on us!

I slept from midnight to 4:00 A.M., arm in arm with Jakey. Papa was close to us, with Elaine and Nga in his arms. In my sleep I still heard the wind and the sea raising their voices to the roar of a million wild beasts, and all that time the rushing water ate away the jungle, closer and closer until, at four in the morning a monstrous sea uprooted the last fringe of bush to surge through the clearing four feet deep!

"The sea! The sea!"

I could scarcely hear my father's shout. We jumped to our feet, huddled together. For a bare second I was aware of the sound of rushing water close at hand. My knees went weak with terror. Then the sea swept through the house, carrying brush and rubbish on its crest. Picking us up, it washed us against the side of the house, and then drained away, leaving us in darkness, calling to one another, fighting to free ourselves from the wreckage and brush, coughing the salt water from our lungs. Would the next wave sweep us across the island and drown us? Then we heard our father's voice, calling sharply. We crowded about him and clutched his arms, and for a moment we stood still in the clamorous darkness, while our father gathered together the lifelines. On hands and knees, fighting our way upwind, tunneling through the solid air, we reached the tamanu trees before the next comber surged roaring through the clearing.

At dawn we were high in the trees, lashed to the biggest and strongest limbs. Below us, all about us, God had given our beautiful world to violent death.

29

THE HURRICANE

You will have to excuse me for skipping the worst of
the hurricane. The memory of that experience is
more than I can bear. We were courageous, but even
now we wake up at night, screaming in terror because of a
dream of the seas surging across Anchorage Island, carrying
everything in their path.

My diary was saved by being in the tree house, but I
did not touch it until four days after the storm, and then it
was only to scribble a few notes about how exhausted we
were, and about how the sun had at last come out and we had
kindled fire. I don't remember making that entry; I guess that
even then I dreaded thinking and writing about the storm. For
twelve hours the sea had flooded the land, often ten feet deep
on the highest part of Anchorage Island, where we were
lashed to the limbs of one of the five Tamanu trees. With all
the jungle gone we were truly isolated in a treetop in mid-
ocean, surrounded by violence and destruction. There was no

land; only here and there a coconut tree leaning far over in that turmoil of rushing water. Then for a moment the sea would drain away, showing us a bleak sandbank strewn with coral boulders and piled-up masses of broken trees—a sandbank shrinking smaller and smaller after each comber had passed. The night before, the trees had swayed and beat their wings against the sky, but during the twelve hours when the wind was at its highest, the heads of the palms seemed closely packed in a grip of solid air.

We watched the trees topple over, one by one, to be washed swiftly across the island and into the passage, where the current tossed them and spun them, submerged them and swept them out to sea. It seemed certain that our tree would be next, but some god took pity on us, holding the tree firmly in the shifting sand. When every other tree except a few coconuts had been torn from the land our five tamanus still stood bravely in the flood. Often I wondered what we should do when the tamanu fell. I had no hope that they would outlast the hurricane. Each time I saw a great comber charging toward me I felt certain that nothing could withstand it, that surely our tree must this time be uprooted and washed into the sea. When this happened, Papa, Jakey, and I might possibly jump to one of the few remaining coconut trees, climb its wet slippery trunk to safety, and lash ourselves there; but could we leave little Elaine and Nga to the mercy of the sea? From temporary safety could we look down at our little sisters frantically trying to climb the slippery trunk of a coconut tree—until another of those awful seas rushed roaring across the island to pick them up in a mass of churning water, brush, stones, and rubbish and sweep them away?

Yes, some god looked down on us. Surely so when, about four o'clock that afternoon, our tree was finally uprooted by a sea far larger than any of the others, and flung against the four remaining tamanus! We must have been under water for a full minute. When the comber drained away we saw Elaine hanging limply by her lifeline. The rest

of us were unhurt except for some scratches and bruises and salt water in our lungs. Papa freed Elaine first, and found she had fainted; then he helped the rest of us untie our lifelines and yelled in our ears to climb one of the remaining tamanus. This we tried to do, but we were like half-drowned rats scratching at the sides of a cistern, trying to get out. For a long time we tried to boost each other up to the first limb or crawl up the leaning trunk, but we were so weak that the wind toppled us off the trunk or even blew us over when we were standing below the tree. Crazy with fear, we scarcely knew what we were doing. Holding Elaine in his arms, Papa would yell to Jakey and me: "Get up to the firm limb and I'll hand you Elaine and Nga!" Then he would lie flat on the trunk, his arms grasping it, and I would try to boost Jakey up to his shoulders. If I succeeded, Jakey would try to climb the remaining foot or two to the first branch—and the next thing we knew we would be tumbling to the ground, bruised, angry, desperate.

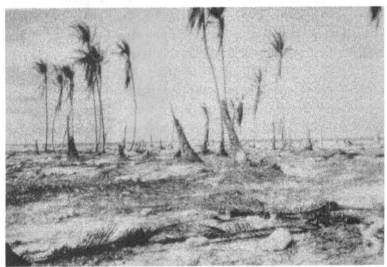

Suvorov After the 1942 Hurricane.

I don't know how long we struggled to climb that tree, but at last we gave it up to huddle on its lee side. It was

then that we first had time to wonder why another sea had not swept across the island, and that we became aware that the wind had shifted suddenly to the northwest. Papa pointed upwind and grinned at me. We stared at each other, with the same thought. We did not speak, for to do so we had to yell in each other's ear. Another ten minutes we waited; then we knew we were safe. The storm center had passed over Tou Islet, six miles across the lagoon, and the wind, swinging abruptly to the northwest, had flattened the enormous offshore seas.

Huddled together in the lee of a pile of coconut logs, we slept in spite of the rain pouring on our unsheltered bodies.

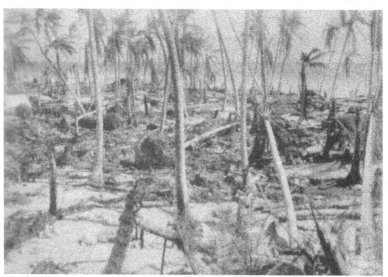

We Searched the Rubbish Pile for Food.

Next morning, when we stared dully about us, we were aware only of rain pouring on a land of heart-breaking desolation. Since then, I have seen pictures of Tarawa, taken after the United States Army, Navy, Marine Corps, and Air Force had blasted it to smithereens, but I can tell you truthfully that Tarawa looked less damaged than Anchorage

Island did the morning after the hurricane. There wasn't any Anchorage Island. Three quarters of the land itself had been washed away. Where a densely jungled little paradise had grown up from a tranquil tropic sea there were now three tiny sand cays of two or three acres each. There is no doubt that Anchorage Island would have been swept clean away, and we with it, had the hurricane lasted another two hours. That morning we stared through the rain at a waste of dead white sand, with here and there the stump of a coconut palm, a live tree with three or four bedraggled fronds, the four remaining tamanus, great white chunks of coral, weighing tons, that had been wrenched from the fringing reef by the might of those gigantic combers and then rolled and tossed a quarter mile to the top of the island. One such coral boulder was ten feet in diameter! And here and there we saw, caught by the stumps of broken trees, masses of uprooted jungle and coconut palms, and finally, down the middle of the island, a long rubbish heap six or eight feet high.

At first we wondered why the waves had not washed this rubbish off the island; then we remembered that the seas had approached Anchorage Island from the north to divide at the point, wash simultaneously up the east and west beaches, and meet in the middle of the island to sweep southward to the channel between the first and second cays, leaving the long pile of rubbish down the middle of the island.

"Rise and shine! Rise and shine!" How miserable our father's voice sounded! It was particularly miserable because he tried so hard to make it cheerful.

"Cock-a-doodle-doo!" a rooster crowed some place in the desolation. He repeated his call several times, and I remember thinking vaguely of the ghost of Joe Bird, and also that the rooster's crow had been more honestly cheerful than our father's "Rise and shine!" I may as well say now that he proved to be a real live rooster, not a ghost. Probably the last labor gang had left him. He became quite friendly before we left, as people do who are thrown together by a calamity. And as to how he lived through the hurricane—well, your

guess is as good as mine.

"Rise and shine!" I stared up at my father, with mouth open and my eyes glazed. I saw a determined smile on his lips. The next instant I felt him slap me sharply. "Sorry, Johnny!" he said, and slapped me again. Then he turned to the rest of the cowboys to shake them and slap them until they had risen stiffly to their feet.

"Snap out of it!" he roared, and any baby would have known that there wasn't the least spirit behind his voice. I guess he knew that we would have huddled there until we had died of exposure. Slapping us, pushing us, shaking us, he made us walk, then run, until presently we were salvaging coconuts from the rubbish heap and capturing sea birds that were even more numb than we. We ate the birds raw, with coconut meat and utos; then, feeling a little better but still with eyes inflamed, aching heads, and sore bones we went to work building a shelter, which was sufficiently done by night to protect us from most of the rain. It was pure luxury to lie under that leaky roof, naked and chilled to the bones, listening to the rain pour down and the last of the storm blow itself away.

On the fifth day the sun came out. We made fire; our spirits as well as our bodies were warmed.

We felt that we had lost a friend; often we spoke of our sorrow that the Suvorov we had known was gone forever. But gone it was. Of twenty-six islets strung along the reef only six were left. Even when the sea rebuilt the islets and the jungle grew again—which, of course, it would—Suvorov would be a different land. It would be different in the same way that a new home, built to replace a burned one, would be different, even though the new one was exactly the same and was furnished the same as the old one, and this would be because the familiar spirit of place had disappeared. Yes, after the hurricane we understood why our father spoke so often of the spirit of place. A new spirit would be born with the growth of the new island, but the old one was gone forever. Truly we had lost a fickle but nonetheless a lovable

friend. Little things had made that friend known to us, landmarks that were gone: the hollow hernandia tree and the graves of Jack Buckland and Robert Burr, the beacon, the wharf, the jungle, the breadfruit trees; an old coconut crab who raided our cookhouse every night, a fuzzy little love-tern fledgling whose pinfeathers were sprouting; and even more than these, the pungent smell of the jungle and the muffled voices of innumerable birds.

Now all these were gone. We waited to meet the new spirit of place, determined to snub him as an act of loyalty to our dead friend. Now even the smells and sounds were different. The wind might bring us the stench of dead things in the rubbish heap at one minute, but the next minute it would bring the clean fresh smell of the sea. For a month there were few birds to haunt us with their lonely cries, but the sound of reef combers came across the barren sand in a sustained roar.

Then slowly the new spirit forced himself upon us with each sprouting tree and returning bird. I was first aware of him one moonlight night when a flock of tropic birds wheeled over Anchorage Island, calling to one another in voices that told me of all the romance of lonely islands. In those voices I recognized the new spirit, and I loved him as much as the old one.

30

LIFE ON A DESERT ISLAND

It looked like a cave. A pile of coconut trees had been uprooted and washed against the four remaining tamanus. One of the trees lay crosswise on top of the others so that its slim straight bole jutted out like a bowsprit. We used this tree for our ridgepole. For rafters we laid poles from the ground to the bole, on both sides, and we covered the rafters with pieces of mangled iron roofing from a rain-water catchment. These last we dug from the sand, laid them across a log, and hammered them flat with a stone. The finished house was so low we had to crawl into it, and it was so small we scarcely had room to sleep packed close together, but it kept out the rain, and what a blessing that was! Because of the desolation about us, that makeshift hut seemed the most luxurious home we had ever owned.

We ourselves were like blowzy cave men. Without combs, our hair was soon tangled into rat's-nests and filthy with sand and rubbish. Without a razor, Papa soon grew a

beard like a Catholic priest. Our ankles and wrists were swollen, our fingers raw, cracked, and bleeding; our eyes were inflamed, and our brains dead from the shock of the thing we had been through. Only our teeth were kept clean and white by the food we ate—coconut meat, utos, palm "cabbage," fish, and sea birds.

We had only the clothes we wore during the hurricane. Papa said we must keep them for our journey to Rarotonga, so we worked and slept in the clothes God had given us. Let me tell you now that this nudist business is not what it's cracked up to be—not on an atoll, anyway. Soon our skin was black as a native's, rough, and covered with scratches that took weeks to heal. Because there was no soap, or fresh water except when it rained, our armpits and groins became badly inflamed. I laughed when I saw Jakey, Elaine, and Nga walk with their legs spread apart so as not to rub their inflamed thighs together—but I guess I looked just as funny. Sweat and salt water burned the sore places. At first we washed in coconut water, but soon the green nuts on the fallen trees had rotted, and from then on we bathed only after a heavy rain, when the basins in the upheaved coral on the north point were filled with the half-fresh water. How gratefully we wallowed in those tiny pools of brackish water! And when a heavy squall charged over the island, how joyfully we rushed into it and rubbed the fresh cold water over our hot sweating bodies!

I believe every rat on Suvorov survived the hurricane, and they all set up housekeeping between our camp and the rubbish heap. In the evenings, when they were hunting food, we would see at least a hundred at one glance. Papa offered us one cent (to be paid later, for he had lost every cent he owned) for every rattail we collected. I don't remember how many we killed, shying stones at them or running them down, for they seemed to breed faster than we could kill them off, but I know Papa owed us more than a thousand pennies before we left the island.

Most of the lizards had been killed, but the hermit

crabs must have burrowed in the sand during the worst of the blow, while the ones that were washed off the island had only to crawl back again when the sea went down.

Lots of coconut crabs survived, and, like the rats, they kept house between the rubbish heap and our camp, spending the day burrowed in the rubbish and the night tormenting us. Never a night passed that several of them did not crawl in the cave house. We would hear them moving over the coral gravel under the floor or scratching the thatch. The noise would bother Papa so much that he would get up, poke around until he found one, and throw him into the rubbish heap. But in two minutes we would hear the sound again, the tinkle of coral gravel or the scratching sound in the thatch. One night a huge fellow crawled across Elaine's face. Brave girl! He dug his sharp toes into her face as he pulled after him a dead fish about a foot long and very smelly. Elaine never moved a muscle. She knew that he could clip off her nose or an ear with his powerful claws. Next day her face looked like she had small pox. And one night some strange luminous worms crawled all over us, leaving behind them long paths of phosphorescence. Papa saw them first and wakened us. It gave us a horrible feeling to see those paths of fire on our skin. We took our mats to the beach for the rest of the night.

Yes, we had mats and bedding—after we had dried them—for you will remember that we slept in the tree house before the hurricane. This house was squashed flat by a huge limb that had broken from one of the trees, but the things in it were saved—the mats and bedding, Papa's typewriter and manuscript chest, the *Panikiniki's* sail, some books and writing material, my diary and Papa's journal, and some tobacco and matches, all of which were soaking wet but not spoiled. There were also a few other things that would not be worth mentioning under ordinary circumstances but now were beyond price, such as a bush-knife, a pair of scissors, a package of aspirin, a flashlight, and so on.

Before the hurricane we had thought there were no

flies or mosquitoes on Suvorov, but within ten days the place was swarming with them. I guess the flies bred in carcasses of dead birds in the rubbish heap. They were so thick that, if you put some food on the ground, within two seconds it would be a solid black mass of flies. I have seen them so thick they frightened even the rats away. When we tried to eat, it was often impossible to put the food in our mouths without a few flies darting in at the same time. For that reason we did most of our eating between sunset and sunrise. For the first week or two the flies were a nuisance crawling over our naked bodies, but we got used to that; when they were too troublesome we would crawl into the cave house, close the open end, and be partially rid of them in the semidarkness.

With all these trials we were soon a happy family again. There was too much work for us to have time to mind our troubles. We didn't have to be told that it was work or die. There was no store where we could buy our bread, no hotel to shelter us, no generous neighbors to save us from death. At first it had seemed that the hurricane had spared us only for a slow death by starvation—but the sand cays supported us much the same as the desert supports the Bedouins. We even gained weight and grew stronger.

We settled our water problem first by making a catchment from twelve sheets of corrugated iron. We would see the bent corner of a twelve-by-two-foot piece of iron roofing bedded in the sand. We would dig it out with our bare hands or with coconut shells, and when we got it above ground it would look like a crumpled handkerchief. Knowing we must have water or die, we would go to work, hammering it with stones, jumping on it until it was flat enough to catch water, when we would put it on a crazy makeshift framework and weigh it down with stones. When we found two kerosene tins and an oil drum in the rubbish heap we used them for tanks.

While making the catchment we had to rustle food, but at first that was not a great problem. For a week we were

able to catch exhausted sea birds and for a month there were plenty of coconuts in the rubbish heap and a few sprouted coconuts with their apple-like utos inside. At low tide we found shellfish on the reef and caught parrotfish with our hands. They had an ostrich-like way of thinking themselves safe when they poked their heads in a hole. Later we made fish spears from the six-inch spikes we salvaged from the tree house.

There were other foods. When we had salvaged an axe from the rubbish heap we were able to chop the heads from fallen coconut trees and cut out the "cabbage." There would be five to ten pounds of good food in each tree. The fruits of pandanus trees we ate cooked, and there were some seaweeds that we munched without much enthusiasm.

We soon realized that within a month the food on Anchorage Island would be gone; but there was plenty to eat on both Tou and Turtle Islets, for there the land was higher and had not been entirely flooded. Luckily we still had the *Panikiniki*. One day we found its bow exposed above the sand where it had been caught by the stumps of two coconut trees. It was an exhausting job digging her up with coconut shells for shovels, hours and hours of work in the blazing sun, and without any certainty that she was not broken beyond repair. Often one of us would say: "What's the use! She's sure to be stove in." Or we would remind Papa that it would be easier to move to Tou Islet than to repair the canoe and bring the food here. But the Old Man kept us at work, and when finally we had the canoe above ground and the sand scooped out of her, we found only a small hole in her bottom, a smashed gunwale, and broken outrigger booms.

There was no material to make new booms or spars on Anchorage Island, so, bright and early one morning, during low tide, we walked the six miles along the reef to Turtle Islet and there cut tough *nonu* poles for outrigger booms, and a guettarda mast and boom. This was our first trip to Turtle Islet since the hurricane; we had only guessed by its appearance from Anchorage Island that there would be

plenty of food. Now we found that a good half of the jungle was left, and, best of all, the wide-awakes had returned and were laying!

Can you realize what that meant to us? All the eggs we could eat for the next two months! My! My! Talk about a riot! Jakey found the nesting ground on the seaside of the islet. After grabbing a couple of eggs as proof, he came dashing to the rest of us, yelling bloody murder. When he showed us the eggs and breathlessly told us that the beach was covered with them, we dropped everything, whooped, yelled, and ran pell-mell for the beach. There we found the usual great concourse of birds, squatting sluggishly, as laying birds do, closely packed in groups of a thousand or more that blackened the sand, while other thousands were flying to and from the fishing grounds. And there we found, over an acre of beach, speckled wide-awake eggs so thick we could scarcely walk without trampling them. We made baskets from coconut leaves, and we would have gathered a thousand eggs had not Papa driven us out of the colony with threats and mean words after we had filled our baskets with about two hundred. And when we had returned to our camp he wouldn't let us cook them until we had built two wigwams for the night. When they were made we gathered a few drinking nuts—the last we were to taste for many a month—and gorged until we were so groggy we could scarcely roll into one of our wigwams and sleep.

That's the way cave men lived. I have a book named *The Cave Twins*, which tells of their days of hunger and their days of gorging. All they lived for was to rustle food and fill their bellies—and that's about all we lived for on Suvorov, though we had school every day, even after the hurricane, and we still remember and talked about our Uncle Sam's warriors at the gates of Tokyo. We began to half believe that those warriors were waiting for us, as the Greek heroes waited for Achilles. We half believed the war could not end until our father arrived to chase the Japanese Hector around the walls of Tokyo, slay him, and drag him behind his

chariot.

There were no stomach aches for the Suvorov cave children that night. We were too tough and healthy. It being a chilly night and we having no bedclothes, we crowded into one wigwam to roll up in a ball, as snakes do when they hibernate. Elaine coughed badly. Since the hurricane there had been something the matter with her lungs and because of our mother's sickness this worried us terribly. Maybe her lungs had been hurt when our tree fell over and she had hung unconscious on her lifeline. Anyway, she coughed badly and often was feverish.

Well, that night, when we had crowded into the wigwam, she worked up a case of jealousy and started coughing worse than ever. Presently she threw her arms around Papa, cuddled close, and whispered: "I love hurricanes, Papa!"

"How's that, Elaine?" Papa asked, and then the selfish little worm replied:

"Because after a hurricane you let me sleep with you every night, Papa."

Now what do you think of that for a jealous scheming child without any consideration for her brother and sisters? You see, Papa let her sleep with him every night after the hurricane because of her cough and to keep her warm—so, of course, she didn't want to get well. Long after Papa had cured her with fresh shark-liver oil she faked a cough so she could still sleep with him and leave the rest of us out in the cold.

I think you will be glad to have me break from my story by telling you that we all took fresh shark-liver oil for three months, a teaspoonful twice a day. Talk about pep! It made us as lively as jumping jacks, and it didn't make us sick like stale cod-liver oil does. When I have children, fresh shark-liver oil is going to be my cure-all for them. To make it you cut a shark's liver into little pieces, put them in a pan, and bake them slowly for about six hours. When Papa first dosed us with it he said: "It will give you sharp glinting teeth

like a shark's, and make you strong, and dangerous. When you sound your bugles before the gates of Tokyo and the Japs see that fiendish, ferocious, sharky look in your eyes, they will lay down their arms and flee to the mountains!" After hearing that we lined up eagerly for our two doses of shark-liver oil a day.

We were up at dawn the next morning and made a hurried breakfast of wide-awake eggs. With the first of the low tide we started back to Anchorage Island, Papa carrying the mast and boom and we cave children the outrigger booms, and a few baskets of eggs.

Lashing the outrigger booms to the washboards and pegging the outrigger to the booms was only a day's work. With a pocket knife we trimmed the hole in the hull, fitted in a new piece of wood, toenailed it, and filled the seams with tamanu gum. Then we patched the broken gunwale—or washboard—trimmed the mast and the boom, and were ready to sail our sweet *Panikiniki* again! I have told you that the sail was in the tree house during the hurricane. Paddles we whittled from the tree house floor boards.

The work took about two weeks. By then we had eaten all the coconuts on Anchorage Island, so we used the *Panikiniki* to sail to Tou and Turtle Islets for food, and by that time Captain Cambridge had returned in the *Taipi* and was ready to sail again!

31

THE ADVENTURES OF CAPTAIN CAMBRIDGE

I can't tell you where Captain Cambridge had been because he himself knew only that for two solid months he had sailed north and south, also east and west, with never a sight of land!

I have told you that his chronometer was broken, but I do not remember mentioning that, though a fine seaman, he was half blind, and Bruce Robertson was not very hot as a navigator. He weathered the edge of the hurricane, hanging onto a sea anchor made from his boom and ground tackle thrown over the bow and sunk to about thirty fathoms. For ten days at a stretch the sky had been overcast, and after that he knew not whether he was to the east or west of Nassau Island, which he had been headed for. Finally he decided to sail a zigzag course for Manihiki, take a new departure from there, and try again to find Nassau—or some other island.

For over a month he sailed on the starboard tack and he sailed on the port tack, keeping within twenty miles of the latitude of Manihiki. Food ran low; the last water drum was nearly empty. There were long calms and light fickle winds. Only the captain's optimistic spirit kept the men on watch. When he had decided that he was to the east of Manihiki, with eight hundred miles of empty ocean before him, he ran down to the latitude of Suvorov and sailed west, to sight the wrecked island ten days later and to stare at us and shake his head, astonished that we were alive.

We filled one of his drums with rain water and brought several canoe loads of utos, coconuts, eggs, birds, and crabs from Tou Islet; then we set sail for Palmerston Island, where we hoped to fill the rest of the water drums and buy enough provisions to last us to Rarotonga, 515 miles to the southeast.

For nine days we wallowed in a windless stagnant sea. Our water supply was down to one quarter drum of putrid stuff so thick with rust and mud that we had to chew it before we could swallow it. We made good only 105 miles! And then, on the ninth night, in the middle watch, Captain Cambridge wakened Papa and asked him to come into his cabin. I tagged along.

There was no bulkhead between the captain's cabin and the lazaret, which is the part of a ship under the poop deck. Flashing our torch into this space we saw, on the port side of the rudder post, a jet of water squirt in every time the ship settled down on her stern!

The captain straightened up to glance at my father and grin in his self-satisfied way. "It was the edge of the hurricane we weathered so handsomely in the vicinity of Manihiki," he said, using the word 'vicinity" because he had hunted for Manihiki for over a month without finding it. "We rode out the hurricane without taking a drop aboard, but I'm afraid a little caulking must have crept out of the seam between the rudder post and the horn timber."

Papa glanced back in his weary unhappy way. "Yes;

it looks like that," he said. "Now we can drown quickly instead of dying of thirst!"

"Hmm!" said the captain; then, "Well."

"Well," Papa agreed, then glanced at me, so I said, "Well," too, and went on:

"We're going back, aren't we?"

"Sure, certainly!" Captain Cambridge cried, as though it were a fine idea. "Of course!"

"Yes!" Papa agreed. "Of course! The pump doesn't work but we've got a bailing tin. We're going back as far as we can. We've been nine days sailing 105 miles and the captain was over two months hunting for Manihikli, 360 miles away, and the ship is sinking!"

"She's a lucky ship!" the captain interrupted crossly, "and, if I do say it, she's as tight a little packet as I ever sailed in!"

Papa glanced down at the lazaret and sighed; then he straightened up. "Let's snap out of it!" he cried. "We'll shift the cargo forward; then, maybe, with fair weather and lots of bailing and Johnny sitting on the leaking seam like the Dutch boy on the hole in the dike, we may not have to swim very far on the home stretch before the sharks get us."

"Is it that bad, Papa?"

Then he realized he had been scaring me, so he put his arm around me and said: "Johnny, after going through the worst hurricane ever to strike the South Seas I guess we'll get this tub back to port. You just pray hard that the sea keeps very calm!"

Bruce Robertson had been asleep. The captain wakened him and the watch below; then, all hands climbed into the hold and started shifting the cargo to the forecastle. It made a lot of difference. The leak was almost stopped but the poor little Taipi looked like a diving duck, with her head under water and her backsides pointing to the stars. She was about as easy to steer as a barrel. Soon a fresh breeze sprang up, which drove her on a zigzag course toward Suvorov, burying her head in every sea and with her stern rippling in

the breeze like the flag of Costa Rica. She started leaking again, but we were in less danger from the ship than from starvation. Our only food was raw oatmeal, and our water was a cup of mud a day, squirming with mosquito larvae.

Poseidon had no grudge against us. He gave us such a spanking quartering breeze that we got back in two days. We sailed so fast that we came within twenty yards of piling up on the landless south reef at 2:00 A.M., while that fellow Metua was snoring so loudly at the wheel that no one could hear the roar of breakers on the reef until we were nearly in them. I heard them first. Wakening suddenly I sat up, in a panic, sensing that something was wrong. The *Taipi* seemed to be pitching too much and yawing this way and that. Certain of disaster, I turned quickly to look ahead, and there, full in the moonlight, almost under our bows, great combers crashed along the barrier reef! I screamed. Almost instantly everybody was on deck; there was yelling, cursing, rushing this way and that. Metua tumbled into the scruppers when Bruce struck him with his fist; the *Taipi* swung into the wind and gradually edged away. When we were safe again Papa collapsed beside me to groan: "My God, Johnny! That was a narrow escape, and all because a damn fool goes to sleep on watch! Oh, but I'd like to hammer his head to a pulp!"

"So would I! That fellow Metua nearly starved little Nga to death, then he went out and committed adultery, and now he's nearly killed us all! But would we have been killed, Papa?"

He pointed to the moon. "It's high tide," he said. "There is four feet of water rushing across the reef. There is a deep lagoon inside. It is five miles to the nearest islet. But one happy certainty is that we would be drowned before the sharks started in!"

Back in Suvorov, Captain Cambridge remembered that he had a bag of cement in his Nassau cargo. He mixed it with sand and water and poured it around the rudder post. When it had dried, the *Taipi* was as tight as ever. Then a long squall furnished him enough water to fill two of his drums,

he collected a canoe load of food from Tou Islet, and in a week's time he sailed again, this time leaving the five of us "marooned by request" on the barren sand cay that we were learning to love. We had risked our lives for the last time on Captain Cambridge's black hollow ship!

32

FROM THE DIARY OF A CASTAWAY

April 16, 1942, was a big day in our lives because that day we had our hair cut. Dressed for the occasion in stained but fairly clean pants and slips, we lined up before the cave house. I nodded to the boss, took my place at the head of the line, and from that minute there was no more foolishness, for the Old Man took charge.

Wearing a loincloth, his skin a darker brown than ours and his beard grown nearly as long as his hair, Papa clicked the scissors we had salvaged from the tree house, looked fierce, and growled:

"Cowboys, you look like hell! I can overlook the fact that your eyes are bleary, your ears dirty, your legs and arms scratched and scarred, your skin about as soft and velvety as a crocodile's, but we gotta do something about your hair. Jake's, being shortest, doesn't look any worse than the nest

of an old frigate bird, with grass and rubbish sticking out every which way, but there's nothing on earth to compare with the rest of you unless it is a thatched roof after a hurricane. Now, who'll volunteer for a haircut?"

Elaine stepped up first but the rest of us were glad to take our turns, for what with sand and rubbish and bugs, our heads itched continually. When Papa was cutting my hair I saw, in the folds of his loincloth, the bit of laundry soap he had begged from Captain Cambridge, and, you know, it almost made my mouth water, I was that impatient to use it on my head. Also, in the same place, I saw the comb he had cut from a piece of copper, with a hacksaw borrowed from the captain.

When our hair was cut and trimmed we didn't look too bad. Papa clipped his own head. Then he came out with a snappy, "Right face! Forward march!" and tramped us down to the north point, where we bathed in the biggest pool of rain water, soaping ourselves thoroughly and afterwards combing what hair we had left. Let me tell you we felt like a million dollars. My! My! It was the first bath with soap and fresh water we had had in nearly two months, and it was about the last one we would have, for our soap was nearly gone.

Papa then marched us to a stretch of beach where the sand was fine, hard, and smooth, and there for an hour we were taught the secrets of higher education. The sand was our blackboard; sticks were our chalk. We worked principally at spelling, drawing, and arithmetic. We found it much easier to work sums when the figures were six inches high. Nga learned her A B C's in both small and capital letters on the sand of that barren wind-swept desert island, and it was there that I taught Elaine more arithmetic than she had learned in all the years before. Also, almost every day, Papa would teach us some special subject like simple geometry or squares and square roots—not hard things, of course, but things like the names of the different triangles and how to make diagrams of the squares of numbers so we would know

what they were, in pictures, so to speak. One day he taught us to measure the height of a tree by its shadow. Another day he showed us how to lay out a square in the ancient Egyptian way, with a string knotted at the ratio of 3 : 4 : 5; and later he explained why the square of the base of a triangle plus the square of the perpendicular equals the square of the hypotenuse, which is really the same problem as the one with the knotted string. Problems like that were easy when he made pictures of them in the sand and later proved them in practical ways.

This particular morning the sun soon blazed down so fiercely that we moved to the cave house, there being no other shade on all that island except for narrow patches under the fallen trees and the hot space under the rain catchment. The rest of our schooling was mental arithmetic, reciting our multiplication tables, and writing, in which last we used for paper the backs of Papa's manuscripts.

School lasted about two hours. Our job was then to rustle food. Papa took his fish spear to the reef to hunt for the fat rock grouper called *natara* in the atolls, while we four cowboys put away our precious clothes in the cave house, and then, because school had closed earlier than usual, we played marbles for half an hour before we went to work. And that was the time Jakey behaved in his strange manner.

First I must tell you that, after the hurricane, hundreds of tamanu nuts fell from the five remaining trees, along with the leaves that hadn't been blown off by the wind. These nuts, when husked, made good marbles. In fact tamanu and hernandia nuts are the marbles of atoll children.

It is not hard to tell when Jakey has something on his mind. He has Papa's way of staring at you, and at the same time staring through you, and at the same time seeming not to see you at all—what you call a "vacant look." I saw that same look later, in Rarotonga, when I stood before the glazed window in the door of Judge Ayson's office. Suddenly the window turned bright yellow because a light had been switched on in the office. A moment later, when the light was

switched off, the window became grey and vacant again. While this was happening I felt so strongly that my father stood near me that I glanced over my shoulder, expecting to find him there, and it was with surprise that I saw only the empty anteroom leading to the judge's office. It must have been several days later, when I saw my father staring at me again in his vacant way, that I realized the light switching on and off behind the glazed windows had reminded me of his vacant stare, which suddenly brightens when something interesting passes through his mind.

Anyway, that's the way Jakey's eyes were this morning. But suddenly he straightened up, frowned, switched on the light behind the glazed windows of his eyes, and asked me the date of his birth.

Nga giggled. I glanced at her to see an elfin look twinkle mischievously in her eyes, and before I told Jakey that his birthday was October 8, 1933, I remember wondering what secret the pair of them had up their sleeves—or wherever people keep their secrets when they have no sleeves.

"Hmm!" said Jakey. He brought in his chin, grinned sternly, and repeated very slowly: My birthday is October 8, 1933!"

We continued our game of marbles, but I noticed that Nga kept glancing at Jakey in her sly way until the big cowboy suddenly frowned again, this time with thunder on his brow, and asked me:

"When did you say was my birthday, Johnny?"

Again Nga giggled. Jakey gave her a fierce look.

"October 8, 1933," I repeated, and again Jakey spoke the date slowly, solemnly, and sternly, but ten minutes later, for the third time, he asked me the question. For the third time Nga giggled and for the third time I told him, half cross by then.

Jakey nodded his head thoughtfully, all seriousness, and repeated, "October 8, 1933! October 8, 1933!" Then, instead of returning to the game, he walked slowly a few

paces to the shady spot by the trunk of one of the tamanu trees, repeating "October 8, 1933! October 8, 1933!" and there, he sat, his brow more thunderous than ever, to repeat over and over again, between clenched teeth, "October 8, 1933! October 8, 1933!" When he had said it not less than fifty times he smiled, nodded his head, and returned to the game.

We played for fifteen or twenty minutes longer. I had forgotten his funny little act when abruptly, just as we were picking up our marbles, Jakey straightened up, as he had done before, but this time with no frown on his brow and, smiling, he asked himself: "William H. Frisbie, when is your birthday?" He paused then, and, in a tone of satisfaction, he replied: "My birthday is on October 8, 1933! I got it now!"

"Why are you so anxious to remember your birthday?" I asked. "It's a long time until October 8, 1942."

Then Nga surprised us, though of course we knew she had some secret in that funny little head of hers. She has the most annoying way of saying things that are almost intelligent, when to look at her you'd think that not a thought passed through her head in a blue moon.

"I know!" she chirped.

"Shut up!" Jakey snorted.

"I know! And I know why Papa cut my hair and let out school early! It was because this is Papa's birthday!"

I felt terrible! I could have slapped her! Last night had been my turn to sleep with Papa, and I might have wakened him with a "Happy birthday!

"Papa told you!" I snapped, but at that Nga closed up like a clam, as she always does, and gave me her funny elfin look out of the corner of her eye, as though to say:

"That's one time more, big lady, that I put one over on you!"

"If that's the case," I said, as if I were replying to her look, "we'd better rustle plenty food—enough for a dinkum surprise feast for Papa!"

"Isn't that what I've been trying to tell you for the last

hour?" Jakey growled, and I replied that he had a goofy way of telling me things.

We didn't quarrel long because there was too much work to do. For the last week we had seen a few tropic birds circling over the third and smallest sand cay of the three that formerly had been a part of Anchorage Island—the cay nearest the passage and farthest from our camp. We hadn't bothered them because we had hoped that they might nest on the cay, but today we decided to take a chance on frightening them away, preparing a surprise feast for the boss was worth taking a chance.

Jakey took the axe and I the bushknife. We crossed the channel to the middle cay and there chopped the head from a coconut tree that had been blown over but kept alive by having some of its roots in the sand. After chopping away the fronds we split the bud of the tree and cut out the long white cylinder of "cabbage." It certainly didn't look like a cabbage, and I think that's a silly name for the solid waxy-looking heart of a coconut tree. There being about ten pounds of it, we ate its tip, where the bud had formed into white leaves and midribs. Then we made a frond basket for the rest, and, a few minutes later, added to it two fine female coconut crabs that Elaine had found. Their abdomens were as hard as rubber balls with fat and eggs. Kings and queens ate no more delicate food than those coconut crabs.

Leaving the basket on the middle cay, we crossed another channel to come to the third cay, which was a hillock of sand about twenty feet high and three hundred yards around, with a dozen or more tangled heaps of uprooted trees and bush. Six tropic birds were circling the cay, squawking discordantly, often swooping down as though about to land. We told Elaine and Nga to hide and wait for us but they would not hear of it. Giving us a mean look, they sneaked into a pile of rubbish to disappear, while Jakey and I crawled along the beach to another heap of fallen trees, wormed our way into it, and waited.

I guess we must have crouched there for a half hour,

watching the birds and waiting for them to land. Once we heard a great squawking on the lagoon side of the cay. It was silenced suddenly. Jakey and I glanced frowning at each other. "I guess they got one!" my brother whispered. "Now they've scared the rest away!"

But even as he spoke we saw two birds flutter down to the edge of our rubbish heap. Flapping their wings and with legs braced out as though about to land, they approached us several times but only to bank suddenly and soar away. We sat so tense and still we scarcely dared to breathe. By her heavy motion we knew that one was a female carrying an egg. The other was her mate and both were so fat they could scarcely rise from the lee of the rubbish heap to where the wind caught their wings.

Again we heard a great squawking on the lagoon side of the cay.

"Fool's luck!" I hissed.

"That finishes it!" Jakey snarled. "They've scared them away and of course they've not caught a one—or not more than one."

Still we waited. We knew where the birds would land—if they came back—so, when they were again circling behind us, we crept from our hiding place to crouch among the fronds of a fallen tree. The birds returned, for a wonder, circled narrowly above us, fluttered within three feet of our heads to eye us suspiciously, and again soared away. I could feel my heart thumping! Jakey crouched as tense and alert as a tiger ready to spring. Again the birds returned, and this time, unafraid, they braced out their legs to skid along the sand about as gracefully as a pair of chickens flapping down from their roost. They looked this way and that, made a croaking noise, stretched the kinks out of their wings, and settled down busily to preen their feathers.

"Now's the time!" Jakey whispered. "Pray, Johnny!"

"No. You pray! You're a man!"

Jakey lowered his head. I could catch his words, spoken in Puka-Pukan: "*Te Atua ei! tauturu mai ia maua*—O

God! Help us this day! It is Papa's birthday! Help us this day to catch those tropic birds for Papa's feast! Amen!" Don't think for a minute that there was anything joking or sacrilegious about Jakey's prayer; he was in dead earnest.

"Amen!" I whispered. Then we leaped forward like a pair of wildcats. I don't remember my feet touching the ground. It seemed we made an arc through the air, with sparks flying, to land on the birds and grab their necks. For two seconds they squawked bloody murder. Then we had twisted their necks and turned to grin at each other; all at once I felt myself breathing freely for the first time in a half hour. It was as exciting as hunting lions!

We started for camp, picking the birds as we walked, for the feathers come out easiest just after the birds have been killed. Rounding the side of the cay, we saw Elaine and Nga, each sitting in the shade of a tree trunk, picking birds. That took some of the glory out of our hunt; but when we came close to them we felt fair sick with jealousy, for we found that each of the vain little wretches had caught two birds!

"Shall we slap them or forgive them?" I asked Jakey. He hesitated a minute, to give his sisters a severe once-over, to size them up and debate whether they had caught four tropic birds particularly to shame us or because they wanted Papa to have a grand feast. Finally he decided to give them the benefit of the doubt, so, with a nod, we hurried to the middle cay, picked up the basket of "cabbage" and coconut crabs, and returned to camp, our sisters at our heels.

Papa had not returned.

"He's a long time," I said. "I hope he's all right."

"I think he's giving us time to remember it's his birthday," Jakey suggested. Or maybe he's making sure of a feast by rustling his own food."

This being my day as boss of the camp, I put the gang to work: Jakey to husking utos, Nga to finishing picking the birds, and Elaine to making dough balls of maniota starch (I did tell you that Captain Cambridge had given us a bag of maniota starch, some twist tobacco, and soap?), while I

kindled a fire in the native oven with a few live coals taken from the permanent fire of pemphis logs that we kept smoldering for four months after the hurricane. We had about half a box of safety matches but we needed them for our trips to Tou andTurtle Islets, it being a nuisance to carry fire.

Our native oven was a pit eight inches deep and three feet square, lined with bricks from the old underground water tank. I built a fire of coconut shells and husks in the pit, heaped on it lumps of hard antler coral, and when the fire had burned down to coals I laid the tropic birds, wrapped in green coconut leaves, on the hot stones, filled the space around them with uto coconuts, laid on top the piece of coconut "cabbage," the dough balls, and the two coconut crabs. Then I covered the oven with rough mats made of green coconut leaves and, finally, a piece of galvanized iron roofing, which last I weighted with rocks and covered with sand so the oven was pretty nearly airtight. The green leaves would make enough steam to keep the food from burning or becoming dry and tough.

With Papa's birthday feast safe in the oven we walked to the point, where we jumped in the salt-water pool to wash off the sweat and then bathed for the second time that day in the basin of rain water. Papa had left when the tide was ebbing, and, it being new moon, the reef would be dry until midafternoon. Scanning the six miles of reef to Turtle Islet, we at last made him out, a fine line visible against the rising and falling wall of breakers. We guessed he would be back in an hour, which suited us fine, for by then the oven would be ready to open.

At about four o'clock we returned to camp, got out our precious clothes and dress: pants and shirt for Jakey, slips and dresses for us three girls. It was the first time we had worn all our clothes since the hurricane. We felt quite flashy and self-conscious in those ragged dirty clothes, and for a little time we posed as the girls do in pictures of fashion shows. It was lots of fun. Then Papa came storming into camp, bunches of coconuts and a string of fish and lobsters

on a pole across his shoulder. He pretended to be in a mean temper, and let me tell you he looked fierce, with his whiskers chopped off any old way and his eyes bloodshot. He scowled at his four macaronis lined up as though in attendance on the King of Siam and dolled up in their flashing clothes.

"What t' hell's the big idea?" he thundered. "Haven't I told you to leave those clothes alone? Where do you think you're going—to the theater? I'm hungry, damn it! What have you been doing all day? Twiddling your thumbs? Why haven't you got something to eat? I'm starving!"

Of course he had seen the covered oven and had guessed what kind of a surprise awaited him, but he was trying to make us happier by pretending he was angry because we had prepared no food, thus giving us a chance to make him seem ashamed. Papa is always doing that—pretending he is right when he knows he is wrong so we can have the fun of correcting him.

He turned to peer scowling into the cave house; then suddenly he was spun round by Jakey. "One, two, three, go!" yelled the biggest cowboy, and then, with all our might, we whooped:

"Happy birthday, Papa! O. K., Papa!" And with screams of laughter we jumped on him to kiss him and all jabber at once about how we had caught the birds. After that we opened the oven to show him the grand feast we had prepared. He pretended to take it all grouchily, as though it were no more than his due, but we saw tears in his eyes before he turned away to hide them.

33

THE GOLD DIGGERS

I t was a life of feast and famine—a true cave man life. One day we would eat until we were groggy, but the next day we would go hungry. During calm days or moonlight nights even little Nga could spear enough fish to feed a dozen hungry men, but it wasn't really spearing; it was just poking the six-inch spike, seized on the end of a pole, into the fat natara, parrotfish, and lobsters that tried to hide under the ledge in the shallow reef pools. On Turtle Islet the wide-awakes laid enough fresh eggs every day to fill a fifty-gallon oil drum, and we soon learned to cook these in tasty ways. One nice way was to beat them, add salt and coconut milk, pour them into the big flat leaves from newly sprouted coconuts, tie up the corners of the leaves, and bake them. But the tastiest way was to mix them in about one-quarter part coconut-crab fat, add a pinch of salt, and cook the mess in coconut shells by dropping in hot stones.

Eggs, birds, lobsters, crabs, fish, shellfish, sea

centipedes, eels, coconut "cabbage," utos, pandanus fruit, seaweed, dough balls—great heaps of food when the weather was fair; but twice, when northwesterly gales thundered down for four or five days on our perilous little sand cay, we went to bed hungry night after night. We had used up our bag of maniota starch by the end of April, the food on Anchorage Island had been devoured, no more tropic birds ventured to nest on the first cay, and we had pretty well fished out the calm patch of reef alongside the passage. We could bring food from the islets across the lagoon in the *Panikiniki* or by carrying it along six miles of reef. During stormy weather this was impossible, so we had to live on what few fish we could catch in the lee of Anchorage Island and on the few utos we dug from the sand when they had sprouted, thereby showing us where to dig. We hated to do his, for each sprouted coconut might have grown to a lofty palm to beautify the new Suvorov.

During most years the wind holds steady from the southeast to the northeast between April and December, but in 1942 there was a gale from the northwest in May and a worse one early in June. It was during the second blow that seas washed up to the Tamanu trees, eating away a little more of the poor old battered Anchorage Island, and, in doing so, *exposed the top of a rusted and broken iron chest!*

Of course we believed—and still believe—it was a treasure chest. People don't bury cast-iron boxes full of mouth organs.

So picture the five of us, sitting on the barren beach of that barren desert island, in that great emptiness of sea and sky filled only with the thunder of seas and the screaming of birds!—and in the center of our little circle, its cover rusted away, its sides broken flakes of iron rust, that reminder of the age of buccaneers, blackbirders, missionaries, pearl divers, and traders!

We sat around it for a long time, increasing our excitement by anticipation, and perhaps a little afraid to dig, for it seemed so improbable that we should find the gold of

Tom Carlton. We dreaded disappointment.

When we did go to work we scooped out the sand slowly with the halves of coconut shells. The iron chest was no more than rust held in shape by the sand; it crumbled when the sand was scooped away. We paused often, our nerves tingling and our minds thrilled by the knowledge that we were actually digging for treasure.

First we found a small stone jar, then another and another, until nearly one hundred were unearthed. If they ever had been stoppered, their corks were long since rotted away. When we emptied the sand from a few we found them covered inside with blackish flakes which Papa guessed was opium. Was that the Suvorov treasure—an iron chest full of opium? Next we found a rusty thing we took to have been a knife; then the remains of a pistol; then a plain gold ring and seventy-two Chilean dollars!

There you have it! The dollars were in the sand where the bottom of the chest must once have been, but now was no more than a few flakes of iron rust. The latest date stamped on the money was 1842—one hundred years ago!

"Well," said Papa, scratching his whiskers, "here are some pieces of eight, but where is the gold of Tom Carlton?"

"It's still here—some place," said Jakey.

"Yes; I believe it is!"

We planted a triplet coconut—one with three sprouts—in the bottom of the chest. The iron rust would make it grow to three vigorous trees; they would be our *akairo*—something to remind people that we had been there. You will see them if you ever visit Suvorov, on the lagoon beach midway on the third and largest cay.

A few days later we sighted a sail to the southeast. By her speed in drawing close we guessed she was the *Tagua*. We were certain when she was close enough for us to make out the cut of her sails.

Sitting on the beach of the first cay, where we had caught the tropic birds, we watched her stand down to the passage. We felt terrible. We had not realized how much we

had learned to love the new Suvorov until now, when the time had come to leave. I think Jakey expressed our feeling when he pointed to a coconut tree and said: "Look Papa! It is blooming again! And out of the point there is a tree with tiny nuts the size of my thumb!" He turned, and at the same time pointed inland. "And Papa! See all the young trees and the ferns and even the grass! Suvorov is green again!" He hesitated a moment, looked confused. "Isn't it brave, Papa!" he said in a tone of awe. "Isn't Suvorov brave!"

"Cock-a-doodle-doo!" Joe Bird crowed.

"We'll take him with us—to wherever we're going," said Papa.

"Aren't we going to Tokyo?" Elaine asked.

Then I said: "Do you remember, Papa, long ago, when we lived in Puka-Puka, how the *Taipi* came with news of our Uncle Sam going to war, and how we packed and left, thinking we would be with our Uncle's warriors in a few weeks?"

"Yes, and we're still on our way!" Papa sighed. For a little time he stared at the *Tagua,* now with her sails furled, steaming in the passage. "I'm afraid we'll be too late, Johnny. Now that we're broke except for seventy-two pieces of eight, and our clothes are in rags, it's going to take a long time to get on our feet again. Uncle Sam is a mighty warrior; he'll make short work of the Japs. I'm afraid the war will be over before we have saved enough money to join him—but maybe we'll get there for the *coup-de-grace* at the gates of Tokyo."

Jakey wagged his head, very serious and very disappointed. "What a waste!" he muttered.

"What do you mean, waste?" Elaine asked.

The big cowboy gave her a glance of contempt. "What do I mean?" he snapped. "I mean we'll never join our Uncle Sam in time to kill any Japs—and think of all that shark oil we've been drinking to make us fierce! All wasted!"

PART FOUR

The Cowboys Abroad

34

ASHORE ON A SIREN'S ISLE

No two atolls are alike. I have heard traders and supercargoes say that when you have seen one atoll you have seen them all, but that sort of people sees nothing in an island except copra, shell, pearls, home-brew, and women. Oh, I know all about them! What they mean is that copra and trade, beer and women are the same on all the islands. All day long they sit by the storehouse under-weighing copra or stand behind the trade-room counter overcharging for goods, and all night long they sit in the trading station drinking home-brew or sneak into the village to commit adultery.

They brag about how they cheat my people; then they get drunk and spoil the young girls. And they are so shameless they do not mind if children hear their drunken talk. It makes me sick to see them come to my lovely atolls, get roaring drunk, and chase women—where their wives can't catch them. And after they have succeeded they brag about it to their friends. If they meet one of their girls in the

clear daylight, they pretend not to know her.

Manihiki would be a favorite hunting ground for that sort of people were it not that few schooners visit the island and no strangers are allowed to stop there unless they have business ashore or are old-timers like Papa and his cowboys.

We were popping with excitement when the *Tagua* steamed up to the open roadstead of Tauhunu Village and made fast to the buoy that lies about a hundred yards from the fringing reef. We were sitting by the skylight on the midship deckhouse. This was the first inhabited island, except for Puka-Puka, that Elaine and Nga had seen. Their little brown eyes sparkled, but they pretended they weren't impressed; Jakey, having been in Samoa, acted as though this were old stuff to him. As for me, I was Miss Ulysses from Puka-Puka. I had broken the ropes that bound me to the mast; I had taken the wax from my sailors' ears; ashore I saw the sirens beckoning and I heard their song. For Manihiki is the siren isle of the South Seas.

From the roadstead we could see the big white church, schoolhouse, and government building tinged with the gold of the setting sun, a few wattle-and-thatch huts, the red galvanized-iron roof of Abel Williams' trading station, groves of coconut and breadfruit trees, and on the wide white beach, tinged also with the fading colors of twilight, at least two hundred people, more than half of whom were women and girls in bright print dresses, waiting for the passengers to come ashore.

Three dories shoved off from the beach, seesawed over the reef combers, plunged into a cloud of spray, then reappeared to pitch and roll in the broken water and finally to speed toward us, with brown men bending their naked backs to the paddles.

If we had not known off which island we were lying we would nevertheless have known that Manihikians were paddling those dories, for, like the islands themselves, the natives of each atoll have something about them which makes them different from the others. These Manihiki men in

the dories were wild and shaggy, dark-skinned, sharp-featured, full of life and laughter. Their eyes were those of a faun, long, narrow, and tilted, more black than brown, and their bodies were slim and muscular, with narrow waists and strong legs. On the other hand, as I knew from lots of Manihikians who had stopped at Puka-Puka, the women were soft, purring creatures, with Mongolian eyes, pouting lips like Elaine's, wide hips, big breasts, yielding bodies and minds, and, like kittens, they were so full of the joy of life that it was impossible for them to relax. If they were washing clothes, cooking dinner, or walking through the village, their hips would swing unconsciously in the motions of the *upa* dance. Excitable and emotional, song and dance, love and laughter were all they understood. And their voices! They didn't talk; they sang! They had lilting voices. The preacher in church, trying to be solemn, the girl buying prints in Abel's trading station, the man calling across the road to his neighbor—they sang their words!

Soon the boatmen were clambering over the bulwarks, shouting and laughing and huge Abel Williams broke the law of gravity by heaving his three hundred pounds of healthy fat on deck to stand in the waist and puff like a happy walrus, his goggle eyes twinkling as brightly as his bald head in the last rays of twilight.

"Where have you been lately, Ropati?" Abel asked my father after he had finished his business with the captain. He spoke in a wheezy tone, as though he had a bad cold in the head. We children gathered close to our old man to stare at Abel in open-mouthed wonder.

"Puka-Puka," Papa replied; "but before that my daughter Johnny and I were in Makongai. We met a lot of Manihikians there—Teofilo, Mahuta, Mariana"

Abel turned, as quickly as a fat man could, to the lad in his dory. "Hey, Tioni!" he wheezed. "Ropati of Puka-Puka is aboard with his children—four of 'em! He's been to Makongai. He saw Teofilo and Mahuta and Mariana there! Tell Tuakanakore´ to fix up plenty kaikai and put plenty

home-brew in the icebox. We're gonna what-you-call celebrate tonight! Hey! Bloody! Bloody! Wait a minute, you thingamajig!" Abel yelled as the lad in the canoe started frantically for shore, in the excitable Manihiki way. "Wait a minute! Take the mail bags with you! And don't open them like you did last time! It's against the law! Oh, bloody, bloody! You leave them alone till I come ashore! Ain't I the resident agent and postmaster of Manihiki?" Then, turning to us, gasping for breath, grinning from ear to ear, "I see you got four kids now, Ropati," he said.

"Five!" Papa corrected him proudly. "I've got one in school in Rarotonga."

"Five! Holy smoke!" Abel gasped. "You sure been busy! I heard you lost your woman up there in Puka-Puka. That's too bad, all right. I remember that duck she cooked for me last time I was up your way. I never eat anything like as good since. And that special No. IV Brew she used to make! Oh, bloody, but it had a kick! Well, Ropati, you stay here in Manihiki and have plenty new wives, plenty babies! That's fine! Ha! *Ropati te cowboy! E' eré te maamaa!*"

The last was Tahitian, and it meant: "Robert the cowboy! There's no nonsense about him!"

Then Abel leaned over as far as his big stomach would let him, to grin over us kids, pat our heads, and sort of purr like an old tomcat, and he whispered something about me being a fine big girl and how the Manihiki boys would "blink their eyes" aplenty when I stepped ashore.

It was getting dark by then but there was a big yellow moon tethered like a captive balloon above the coconut trees of Tauhunu Village. The mail bags were being lowered into Abel's dory. "We'll go ashore in a minute," Abel said. "We gotta give them time."

"Time for what?"

The fat man chuckled. "Time to know you're here, of course," he said. "They gotta celebrate, ain't they? We'll go ashore in the padre's boat."

He must have noticed how ragged and dirty we were,

how Papa wore only a pair of shorts and a singlet he had
borrowed from the captain, but he was too polite to mention
it. Instead, he told us that a bad hurricane had passed close to
Manihiki on the 20th of February but had only touched them
with its edge. "I guess you must'uv got the blow something
fierce up your way," he added.

"Yes, it blew pretty fresh, all right," Papa said. "We
were on Suvorov at the time. We were tied to the limbs of a
tamanu tree for twelve hours while the sea washed clean over
the land. It was what you might call a helluva blow. Twenty
islands were washed off the reef, big Bird Island among
them. And there is nothing left of Anchorage Island but three
sand cays. Of course we lost nearly every blessed thing we
had except the clothes we stood in, but what t' hell, Bill,
what t' hell!"

"Whee!" came from Abel. Again he rolled to the
bulwarks, this time to tell the boatman everything Papa had
said, and this time there was no holding the lad back. With a
yell he shoved off, bent his back to the paddle, and scooted
for shore.

"They'll be a helluva hullabaloo, all right, all right!
You're heroes now! I guess you ain't got much gear to take
ashore, so I'll just step into the cabin to sign for the mail and
we'll shove off."

It took Abel a long time to sign for the mail because
the captain had a bottle of spirits on the saloon table waiting
for him. In a minute we heard him calling for Papa. "Don't
drink too much!" I whispered to my old man as he dived for
the cabin doorway, but I might as well have talked to a brick
wall.

The moon was a good two feet above the coconut
trees when finally we climbed into the dory. Abel came last. I
held my breath and clutched the sides of the boat while three-
hundred-pound Abel clung to the Jacobs ladder. The
schooner, being light, rolled something fierce, hoisting Abel
sky-high one minute and almost ducking him underwater the
next.

"Now, Abel. Jump!" one of the boatmen yelled, but Papa's fat friend could no more jump than could a sea cow. He dropped into the dory like a slingful of copra, then slumped down on the midship thwart with a deep-bellied sigh. "Lordy! I done it again!" he grunted, while we steadied the boat and one of the men bailed the water that had slopped over the sides. "I really gotta start what-you-call dieting," he sighed. "I'm getting a little too much of this here *embonpoint* around the waist!"

The boatmen set to with their paddles, straight for the wall of breakers that crashed and thundered and flung clouds of spray high into the air. Then suddenly, above the roaring sea, we heard the boom of shark-skin drums and the clangor of kerosene tins, and from the crowd of two hundred or more Manihikians on the beach came the shouted words of one of their native songs. We were in the reef combers then. The sweaty backs of boatmen glistened in the moonlight as, yelling, they dug their paddles into the foaming crest of a breaker. Tumbling water thundered about us, creamed along our gunwales, and as we spooned at a mile a minute shoreward we heard the shouted song, the boom of drums, the clangor of kerosene tins. "They're singing for you! They're singing for you!" Abel cried, but his voice seemed far away. Jakey yelled. Elaine buried her face in Papa's arm. Nga stared straight ahead, self-contained, smiling in her elfin way.

That was our arrival at Manihiki, the siren isle of the South Seas. The dory skidded out of the foam and through the twinkling shallows to run her stem into the moonlit beach of Tauhunu Village. Still the people shouted and sang, the drums thundered. We could see lines of girls formed up the beach, their arms thrown out and their hands thrown back, dancing with a fierce sort of abandonment. I felt myself lifted by strong arms. I looked up into laughing black eyes under a shaggy mass of hair. Other men were carrying my father, brother, and sisters. They put us down on the sand at the top of the bench. Abel lumbered to us. The sirens ended their

song.

"*Ko Ropati-tané Puka-Puka!*" someone yelled (It is Robert the man of Puka-Puka!), and for a few seconds the drums boomed and the girls danced. "*Ko Piritipi-tané-ma-te kau-liki!*" (It is Frisbie the man and his little ones!), and again the drums boomed and the girls danced, as they did after each of our names were shouted: "*Ko Tiané! Ko Tieké! Ko Erené! Ko Nga!*" (It is Johnny! It is Jakey! It is Elaine! It is Nga!) Then they crowded about us, and during the next fifteen minutes we were kissed by every man, woman, and child of Manihiki. They kissed us, petted us, cried over us as though we were long-lost relatives, their spirits overflowing with loving welcome.

And suddenly I knew how to reply. Maybe it was an inspiration, but I think it was only that I was a South Sea girl acting after the manner of her people. I nudged Jakey and whispered in his ear. Then the two of us stood up, and in a few seconds Elaine and Nga joined us. We were not afraid; we were among our own people. Ragged hurricane refugees from Suvorov, we knew we were doing the one thing to make our welcome complete. Loudly we sang the beautiful song I had learned in Fiji:

Isa lei! Isa lei!
Nabu lawa! Nabu lawa!

After the first stanza Elaine moved in front of us. My! My! I was proud of my little sister then! I realized, and for the first time, how gracefully she danced! In dead earnest, without a trace of a smile but with a frown of concentration, she danced slowly, with fairylike grace, as serious as though she were dancing before her god!

When the song was ended we scurried to our father and cuddled close to him. For a half minute there wasn't a sound from the Manihikians. We knew they were having a hard time believing that four half-caste children from Puka-Puka could have put on that little show. Papa petted us, smiling proudly. Abel's eyes seemed to bulge more than ever. Then suddenly the crowd roared their delight, and

picking us up again, carried us above their heads, dancing and singing to Abel William's home set back in a grove of breadfruit trees. There in the lamplight, Abel leaned over to stare at Elaine for a long time, wagging his head and blinking his eyes; then he straightened up with a grunt, glanced at Papa, and gasped: "That daughter of yours, Ropati—that daughter of yours, she—she—danced! Holy smoke! I never see'd anything like it! Oh, bloody, bloody!"

If you can sing and dance and laugh and love, you will be welcome in Manihiki.

35

WE DANCE IN THE
MOONLIGHT

I have told you that our landing at Tauhunu Village was like a fairy tale. Well, it did not end on the beach, for to us, Abel's house was the palace of a fairy prince. I suppose it didn't take much to impress us after those six months marooned on a desert island—months when we had lived like cave men, when we had almost forgotten what the simple comforts of home were like. My memories of the beautiful homes in Fiji and Samoa, the luxury aboard the *Monterey,* had faded to an extravagant dream; reality was a crazy leaky hole into which, dirty and exhausted, we crawled to sleep after a day of hard work.

But Abel's home would have been comfortable even in Samoa. The floor mats were the sort of things you hang on the walls like pictures; the parlor chairs and sofas were

upholstered, while the veranda ones were deep, comfortable, and piled with cushions. Hand-embroidered cloths covered the tables; a chandelier lit the sitting room, and six lanterns hung between the baskets of ferns above the veranda railing. There were heavy kapok mattresses on the beds, white sheets and crazy quilts; the pillows were plump and cased in pillow slips embroidered with all the flowers of the field and flags of the nations. Paintings of kings and queens and sailing ships, octagon clocks, and enlarged photographs hung from the wall, with carved camphorwood chests below them, also some bookcases, and two or three foot-pedal sewing machines. It was the house we had described as King Noah's palace in *Amaru,* and of course *Amaru* was Manihiki.

On the back porch the first thing that caught my eye was a buffet about six feet wide by three feet deep and eight feet high, with a huge mirror, tier on tier of shelves stacked with wine and liqueur glasses, tableware, and all kinds of pretty knick-knacks. Also, we found a lovely big white refrigerator that ran with kerosene and actually made ice, and a long dining-room table covered with a red-and-white checkered tablecloth and set with painted china, gleaming silverware, crystal-clear tumblers and wine glasses!

Waiting to welcome us on the dining porch were Abel's gentle wife Tuakanakoré (Older Sister), the household womenfolk dressed in lovely flowered voile, muslin, and print, and Abel's menfolk in colored sport shirts and white-drill trousers so stiffly starched they would stand alone if their owners hopped out of them. We glanced down at our disgraceful selves—dirty, ragged, sun-blacked, blowzy and bleary flotsam the sea had cast ashore!

There was a hole in the seat of Jakey's pants. He had no singlet, and, because he had been without shoes for so long a time, his toes were spread out like a duck's. But what a chest and shoulders that boy had! And what sturdy legs! His muscles were as hard as steel, yet as supple as a cat's. Elaine, fatter than ever before, was the most presentable cowboy. Naturally almost as white as European, her skin had

kept smooth and velvety and had not tanned, and her auburn hair did not tangle like Nga's and mine. Elaine wore her piece of a dress wrapped around her waist like a *pareu,* exposing her sleek shoulders, which were nearly as muscular as Jakey's. Nga didn't bear description, poor little ragamuffin, and I'm afraid I didn't either.

We were a pitiful if not a ridiculous sight, and believe me we felt it!—for a minute or two. No people could be more courteous and hospitable than the Manihikians—not even my own Puka-Pukans. As soon as we had been kissed and petted Mrs. Abel took the four of us to the bathhouse, where we had our first honest-to-goodness bath in five months. A shower bath! Soaping and re-soaping with a big cake of smell soap! Rubbing down with a towel big enough to be a blanket! A dab of brilliantine on our hair! A powdering with Three Girls talcum! Oh, la, la! It was horrible to think of dressing again in our dirty rags! . . . but just then Mrs. Abel called us into a bedroom where she laid out lovely new or nearly new dresses, rayon slips, panties, dungaree trousers, and a striped shirt!

As excited as when we had stalked the tropic birds, we eased toward the clothes to reach out and touch them timidly, as though they might bite. I don't know how long it would have taken us to work up the courage to dress in them had not Mrs. Abel laughed and grabbed us and pulled the clothes on.

Self-consciously we marched single file to the porch, where we found that Papa had bathed, shaved off his whiskers, and dressed in a white shirt and white-drilled pants. So there we were, civilized again, even though we had no shoes, ready to learn all over again how to eat a white man's dinner with knives and forks; to say, "Please pass the bully beef," "thank you, sir," and "Excuse me, ma'am."

There was a dance that night in the courthouse. Bright lights and pretty clothes! An accordion, guitar, cocolelés! Everybody singing, singing, singing! Smiles and laughter, bright eyes and loving words! "Waltz me around again,

Willie, around, around, around." That was the music for my last dance, and my partner's name was Willie Ellis. He had danced with me more than had any other boy, and maybe that was the reason they played the song.

Willie smiled and glowed with pride. He was a half-caste boy from Tukao Village six miles across the lagoon, a shy boy with big dreamy eyes and long sleek nice-smelling hair that he brushed back without parting. "The music is dreamy, all peaches and creamy," he sang as we danced. Next I found myself in a crowd of boys and girls, walking arm in arm with Willie, down the deeply shaded road toward Papara Point. Here and there in the inland groves I could see moonlight splashing from the white coral gravel. The breadfruit leaves were pools of silver. The wind ruffled the palm fronds overhead, shaking a shower of gems from their long polished leaves. And then I was sitting with Willie under a pandanus tree and he had put his arm around me.

"You're lovely, Johnny!" he whispered. "Oh, how I love you!" Then he was silent, and so scared that I could feel his fingers trembling on my shoulder.

The beach glowed like sunlit foam; it was the phosphorescent wake of a ship. The old Pacific tumbled her rollers across the barrier reef and the sea beyond lay dark and brooding. About us were the young people of Manihiki, watching Elaine and Nga, who stood alone a few feet down the beach, full in moonlight, facing us. They were teaching the Manihikians our Puka-Pukan songs and dances. I have told you that Elaine is the best dancer of the four of us, but Nga is the prettiest dancer. She is so tiny you are surprised that she can dance at all.

Toku motu lelei, ko Motu Kotawa . . . (My beautiful island, my Frigate Bird Isle . . .) they sang. Soon a boy picked up the refrain on his cocolelé. My sisters danced beautifully, and in a few moments, when the Manihikians had learned the song and steps, they lined up to dance in their excitable way, making the groves ring with their song and laughter.

Elaine and Nga taught them the Fijian *meké*, which wasn't much of a success, and then the *tara-la-la*, which went over big, and in which we danced in a circle around the cocolelé player, each of us choosing his own step but all singing some lively island song. When we were tired of dancing we sat back under the trees to play guessing games and tell stories. Willie and I sat together, but before long he stretched out on the sand to rest his head in my lap and stare into my eyes like a boy in love. He didn't seem to hear or see anything else until I started telling of our journey to the Fiji Islands, when he became all ears. Yes, all ears until I had finished my story. Then he sighed happily, closed his eyes, and in two minutes was fast asleep. That's how the boys make love in Manihiki.

After my story Jakey told the hair-raising yarn of his voyage on the battleship *Keith* to Samoa, of his cowboy friends who lived in a cave, held up stage coaches, and shot two pistols at once, one in the right hand, one in the left hand—bang! And then the four of us took turns describing the Suvorov hurricane, until all at once we noticed that the moon had sunk far down over the Western sea. Feeling a little guilty, we straggled along the beach back to Tauhunu Village to arrive there a little before dawn, and if Willie told me about fifty times that he loved me I don't see that there's anything so terrible about that. It would have been terrible if he had thought me too ugly to love.

36

THE LIFE ON A SIREN'S ISLE

Though we were beachcombers we lived off the fat of the land with Abel Williams, and I suppose that was because we were experienced beachcombers who knew the tricks of the trade. Abel's motherly wife Tuakanakoré sewed a dozen or more pretty dresses for us and plenty of slips and panties; one of the village men sewed dungaree and white-drill trousers for Papa and Jakey. Also, Papa bought singlets and shirts on tick in Abel's store, and found a pair of canvas shoes in Ben Ellis's Tukao store, so in no time at all we could walk to church with our chins up and looking down our noses—well-dressed ladies and gentlemen from Puka-Puka. This was as it should be, for no white man or white man's child is honored in the South Seas unless he dresses and behaves in a civilized way.

We had lost about £300 in New Zealand currency in the hurricane, which was all the money we owned, but we had saved the manuscript of *The Island of Desire,* which had been in the tree house, and we had written a second part of it at Suvorov. Even little Nga knew that that manuscript meant money to us—that torn, crumpled manuscript sodden with rain water, covered with blotches, its pages sticking together. At Manihiki Papa made a clean copy while I did most of the work on the map of Suvorov that was published on the end sheets; also I made the map of Puka-Puka that was used on the title page. Two years later I opened the book to find that I had been given no credit for my work. But the Lord helps those who help themselves, and if you don't blow your own horn no one will blow it for you, so I am telling you about my work now.

We mailed the manuscript by the first ship, which happened to be the *Southern Seas,* a small army transport of which I will have more to say later. We knew it might take three or four months for the manuscript to reach New York and as long again before our agent had sold it. And we knew we would receive no pension checks for at least six months, for our mail was all muddled up. How were we to live in the meantime? Even in Manihiki one needs a little money. Well, there was a radio station in Tauhunu Village run by a local boy who had been trained in Rarotonga, so Papa sent a radiogram at three shillings and seven-pence a word to our literary agent in New York City, asking him to send $500 to Burns Philp & Company of San Francisco and to tell that company to cable the money to A. B. Donald Limited of Rarotonga, who in turn would wireless Abel to pay it to us. In a month we had the money. I think we owed this agent a few dollars but he sent the money nevertheless, to help us out!

All this is not very interesting, but I have explained it carefully so you won't get the foolish idea, which so many young men have, that you can live in the South Seas without money. You can in Puka-Puka, but I don't advise you to try it

because my people look down on a white beachcomber even though they give him food, a house, and a share of their copra money. You see, money is the white man's *mana* (power) in the South Seas; craftsmanship is the native's mana. Because a white man can't catch fish, climb a coconut tree, make a canoe, or thatch a house, he needs money to give him a good standing—money, nice clothes, a European house, a sailboat, and such things. The white man who tries to go native makes a fool of himself. He can't do a native's work as well as a native can, and he is unable to make up for his lack of skill by doing a white man's work or by having the white man's mana. The Frisbie family has plenty of mana: they run the only honest trading station in the South Seas, they write books, and one of them is a ship's captain.

But at Manihiki, after making a clean copy of *The Island of Desire,* drawing maps, and writing lots of letters to admirals, generals, and congressmen we sort of let ourselves go. It was so simple and pleasant to live like the Manihikians, wild and irresponsible, thinking more about dancing with Willie on the outer beach than about riches, fame, and power. Even little Elaine and Nga had their sweethearts, as everybody had in Manihiki from old gentlemen to young kids. Only Jakey looked on the better sex with contempt, as he does today.

Papa got mixed up with an emotional type he called Calypso because she tried to keep him in Manihiki for seven years. My father is not much of a woman chaser—he never liked women after Mama Ngatokorua died—but Calypso was a number-one man chaser. There was no escaping her once she had made up her mind to get her man. She would crawl into our mosquito net at night and try to sleep next to Papa, but we children would waken him and he would chase her out. It did no good. She would crawl in again just before dawn, when we were sound asleep, so that people would see her leaving the house in the morning and would say that she was his woman. Or she would steal his trousers and singlets and wear them in the village for the same reason. Or when he

went walking in the evening she would dart from a house to join him, to pet him and rub her cheek against his shoulder and things like that to soften his heart. If Papa was cross enough to send her packing she would plump down in the middle of the road and bawl like a spoiled child; and then, if Papa spoke gently, saying he was sorry, she would wipe away her tears on the hem of her dress and in two seconds be laughing and swinging her hips and petting him again. She was a good deal like Elaine in that way. Of course Elaine was jealous of her but the rest of us liked poor lovesick Calypso.

Finally Papa said to me: "Johnny, do you remember what Mama used to say when things weren't going exactly to her liking—Che sarà sarà? Well, I guess it's che sarà sarà with Calypso and me for as long as we're in Manihiki, so we'd better make the best of it by calling her our housekeeper."

That pleased me. Calypso was such a happy, laughing girl, and so playful that she kept Papa from worrying, and anyway, I knew that no woman could take Mama's place in his heart. When we took her into our house we found she could cook fairly well, wash, and iron clothes; but that was about all she was good for, which is strange when you remember that Manihiki women are the most skillful hat makers in the South Seas, maybe in the world. Their material is the skin from a budding coconut leaf bleached milky white by a secret process. When we were in Manihiki the women sold their beautiful pure-white hats for three shillings (.50) each, but later we heard that those same hats were resold in New Zealand for two guineas ($7) each. Papa sent some of the very finest hats to Honolulu where they sold for $25 each!—but I'd better go slow; I'm giving away altogether too many trade secrets in this autobiography.

Both Abel and his wife were half-castes, as well as big Ben Ellis, who ran the trading station in Tukao Village, six miles across the lagoon from Tauhunu. Abel was the bigger trader of the two, both in pounds dead weight and sterling; also, he was resident agent, postmaster, judge, and

so on—the same sort of job Geoffrey Henry had in Puka-Puka. But Abel didn't hold his job permanently because every once in a while the resident commissioner in Rarotonga remembered that there was a patch of reef and palm up near the equator named Manihiki, and thereupon he sent a white man north to handle the government business. And because there was no government business to handle, the white man had to kill time some way, so he got himself a Calypso and went wild. Then by and by the Reverend Johns or some other old spoilsport reported him for being happy; he was fired, and again Abel became temporary resident agent.

Abel's father was Manihiki's gentle hearted dictator for about half a century. The people worshiped him because he made every day a feast day and didn't mind the people drinking home-brew while he sat on the bench fining people for drinking home-brew so he could collect a few shillings to make home-brew himself. The big trading companies were his bitter enemies because when they sent their trading schooner to Manihiki, old Mr. Williams would start the drums abooming and the girls adancing; everybody would be invited ashore, and there would be such a wonderful celebration as long as the schooner was there that nobody would work the cargo.

So Government, Business, and Church frowned on happy old Mr. Williams while he went his naughty way, singing and dancing and loving his neighbor's daughter, right up to the last day of his life when, having fallen in love with a little witch of a girl from Rakahanga and been jilted by her, he had died of a broken heart. Had the dear old gentleman lived, he would have been eighty years old on his next birthday.

The King of Manihiki was a sputtering old man named Noah, who lived in a filthy little hut a mile out of the village. He hated everybody except Papa and me. Often we visited him to hear his stories of the old days. He remembered Tom Carlton well, but he thought Tom's treasure was pearls, not gold. It was Noah who gave us much

of the final plot for *Amaru*. We made him a character in the novel as well as Abel.

And it was King Noah's house, built on the end of a wharf in Tukao Village, that we rented when our literary agent had sent us the $500.

What a house! There was only one big room, but we spent most of our time on the wide veranda that looked down from the end of the wharf into two fathoms of clear and sparkling lagoon with a white sand bottom and here and there a jagged mountain of coral. Hundreds of butterfly fish, painted all the colors of the rainbow, darted in and out of the holes and crevices in the coral, and there were big-eyed red *malau,* yellow snappers, and bonefish, which we caught at night with a long bamboo pole and a hook baited with hermit crab. If the fish weren't biting fast we laid the pole across the railing and braced the butt end under a chair so that the line fell in the water three or four feet beyond the end of the wharf. Or in the daytime we caught hard-fighting cavallas by throwing out a baited hook and line so that it lay on the sandy bottom.

Believe me, that veranda was paradise for fisherman Jakey. Calypso's biggest job was cleaning the floor of fish scales and blood. And hardly a day passed when we did not see a huge green turtle flopping sluggishly along close to the wharf, nibbling the seaweed growing from the coral or poking her head above the surface to breathe noisily and stare at us. Then, with whoops and yells, we cowboys would plunge in and chase the old lady. She didn't seem to mind us more than some tame old cow would mind a boy chasing her home. She would flounder away so slowly that often we got close enough to slap her back. The Tukao people told us she had lived in that part of the lagoon as far back as they could remember.

We lived in King Noah's house on the end of the wharf for the better part of our eleven months in Manihiki. The biggest sensation during that time was the arrival of "Superman." First came a wireless message from resident

commissioner, reading something like this:

> *RESIDENT AGENT, MANIHIKI*
> *Ship arriving soon to take two hundred laborers from*
> *Manihiki, Rakahanga, to an island for three months.*
> *Wages four shillings a day and food. War work. Sign*
> *on laborers on arrival agent.*
> *Signed: RESIDENT COMMISSIONER*

Then Superman came!

Jakey had left Tukao with Ben Ellis and a boatload of men and women, dressed in their prettiest clothes, to attend a wedding in Tauhunu Village. They were sailing slowly, with a reefed mainsail, so no spray would dampen their new starched dresses and shirts, when all at once they became aware of a humming sound!

"Airplane!" Jakey shouted, he being the only person aboard who had seen a plane. Of course everybody started jabbering and gazing upward, and in no time at all they had decided that it was a Japanese plane come to bomb their island. Though Ben is an expert boatman he forgot what he was doing: the boat yawed every which way; water slopped over the sides; she nearly capsized several times. The humming sound rose to a roar. A gigantic seaplane shot out of the clouds like a bolt of lightning and thundered down straight toward them. For two seconds they gasped and held their breaths; then a woman shrieked and the next second, with screams and yells, they piled overboard, pretty starched clothes and all, to strike out like mad, hand over hand, in all directions!

With a helluva hullabaloo the plane boomed close above them, banked, came back, and landed in a cloud of spray to taxi to and stop by the deserted boat. A hatchway opened. Superman poked out his head. "Hello, folks!" he shouted. "Anybody here speak English?"

"Talk to him, Jakey!" Ben gasped. He was standing with my brother neck-deep on a coral head. Elsewhere the

rest of the wedding guests were clinging to coral reefs or still swimming for all they were worth.

"He is not a Jap," Jakey said to Ben. "That's an American plane. It's got a star on it like the ones that flew over Suvorov before the hurricane." Then he shouted to Superman that he spoke English.

"Well, tell these birds that we're not going to bomb them or eat them alive. Tell them to bring their boat alongside. I want to see a gent named Mr. Abel Williams. Does he happen to be swimming around here any place?"

"No, sir!" Jakey sang out, not at all scared—or so he claimed. "He's in Tauhunu!"

"Is that a fact!" Superman shouted. "And what's that—jail?"

"No sir. It's the village over there!"

"Well, son, tell these bathing beauties to bring their boat alongside before I get mad and start laying eggs!"

Of course the man was only joking, but when Jakey translated, word for word, there was a terrible commotion. The Manihikians had never heard bombs called "eggs," and they were so flabbergasted that they were ready to believe that this Superman, who had flown down from the clouds, might really make a nest on one of their bird islets and start laying eggs in it. Somehow that seemed terrifying. No one would move.

"What the hell's the big idea?" Superman yelled, and Jakey who had started to get a little flabbergasted himself, replied:

"They're afraid you'll lay those eggs, Mister! They never saw a man lay an egg before!"

There was a lot of laughter after that. When Superman laughed the Manihikians laughed, sort of nervously, and their laughter broke down their fear. By and by the stranger told them, slowly and patiently, that he wasn't an egg-layer at all but just a plain man who had come to sign on two hundred laborers for a new airstrip on Penrhyn Island, and that a steamer called the *Southern Seas* would arrive

soon to take them away. Also, he explained that the seaplane had to return to Penrhyn that afternoon, and, as there wasn't much time to lose, would the good people of Manihiki, who he had always heard were about the swellest guys in the South Seas, please bring their boat alongside and take him ashore.

At that the Manihikians began to understand how foolish they had been. They swam to the boat, which luckily had run aground on a sunken reef, lowered her sail, and paddled her to the sea-plane. Superman handed out two suitcases and then lowered himself into the boat, shouting "goodbye!" to the others in the plane. Immediately the seaplane's engines roared, she moved off, faster and faster until, with a thunder of power, she left the water to roar over Tukao Village and plunge back into the clouds. The boatload of wet and bedraggled wedding guests proceeded to Tauhunu Village, singing and laughing and, if they were girls, making eyes at Superman.

In no time at all every boat and canoe in Tukao Village set sail for Tauhunu, with Elaine, Nga, and me aboard one, to hear the news and join in the celebration that always followed a stranger's arrival.

And what a celebration! Because of the marriage that Jakey had been on his way to attend, at least six feasts had been prepared and were waiting. Of course they became feasts for Superman, with the married couple only too happy to take back seats. Abel and Papa took charge of him to lead him from one feast to the next one, in the Manihiki way, but warning him to take it easy because he was expected to eat a little at each one. Between feasts they took him to Abel's house for a few bottles of home-brew, and once to the padre's house where they drank strong raisin wine.

When the sun had set and still the feasts continued, Superman became worried. Every now and then he would stop, look wild, and exclaim: "Say, listen, guys, I'm here for a special job. The *Southern Seas* may arrive at any minute. I gotta get these laborers signed on. It's orders. And I gotta

have them on the beach with their gear, ready to go aboard at a minute's notice." Then he would look at Abel and Papa in a funny way, and say: "Perhaps you guys never heard the latest news, here in Manihiki, but it's a fact that there's a war going on!"

Then, "Sure!" Abel would wheeze. "They say this here war is something fierce—people getting killed every day and that kinda thing. But you can't miss Parson Rahui's feast. Just think how bad he would feel! He's a big son of a gun and he'd never let any church members sign on if he got peeved, and there ain't nobody here that's not a church member! Oh, bloody, bloody! Come on, Mister; there ain't many more."

As they went from feast to feast, with the Puka-Pukan cowboys tagging close behind, jabbering for all they were worth, Superman saw many beautiful brown-skinned girls dancing—dancing in the houses, dancing on the streets, dancing at the wedding feasts, smiling, laughing, singing, making eyes at him! And after the last feast came the wedding dance in the breadfruit grove by the government building. Torches flared, drums boomed, kerosene tins clangored, long lines of girls and boys were dancing their wild Manihiki dances, singing their wild Manihiki songs of love and adventure, full-throated, shouting their songs into the night! And then the European dance on the wide veranda of the courthouse: the thrumming of guitars and cocolelés; lovely brown girls in print dresses; handsome brown boys in colored shirts; flower wreaths; the smell of perfume and brilliantine; "Waltz me around again, Willie, around, around, around. The music is dreamy, all peaches and creamy, around, around, around!"

I knew something of civilized life from my journey to Fiji, so I could picture the dreary unromantic place Superman had come from; and, remembering the thrill we cowboys had had on landing in Manihiki, I could understand that Superman was experiencing something few men, indeed, have known. He had dropped from the clouds into a land

strangely beautiful, exciting, and unreal, and, when the dance was ended he lay flung out on the moonlit beach, listening to a siren's song for him alone

And next morning he saw a village almost as dead and deserted as the City of Brass! Scarcely a human was in sight. A few chickens scratched sluggishly under the magnolia bushes. A stray pig or two hoofed it down the village road, following their snouts toward the garbage heaps outside the houses of feasting. One or two bleary-eyed old women squatted in their cookhouses, blowing the embers of yesterday's fires as they chattered about the unholy racket that had kept them awake all night. It was not until noon that Superman had signed on the last of the one hundred and twenty men to work in Penrhyn Island. Then he sailed in Ben Ellis's boat to Rakahanga, twenty miles to the northeast, to sign on the remaining eighty men.

Manihiki was left with only boys under sixteen, babies, old men, the sick, Papa, Abel, Rahui the preacher, and about three hundred heartbroken women and girls. This was the sort of thing that had happened in the old blackbirding days, but then the people did not return.

There was lots of joking. "Don't worry, boys," Abel would wheeze. "Ropati and I will feed your chickens while you are away!"

"Oh, yes, nevvah mind!" a young buck would whoop. "Just wait until we start feeding those nice young hens in Penrhyn!"

"You leave those Penrhyn Island hens alone!" a girl would snap, "or you'll never again stick your nose in a Manihiki hen-house."

"Oh la la! Titoto mai te vainé Omoka, mei te manu rai pitoté!" which are the first two verses of a song, and they mean, in English: "There's not a spot on my Penrhyn lady; she's as pretty as a peacock's tail!"

Well, the little steamer *Southern Seas* arrived to take away the Manihiki and Rakahanga men, and she took our letters addressed to admirals, generals, and congressmen, in

which we offered to help our Uncle Sam clean up the Japanese mess. We had been nine months on our way to the gates of Tokyo, but were only three hundred miles from Puka-Puka. Though we had fought no battles, we had lost about everything we owned in the world. Even our property in Puka-Puka had been wiped out by the same hurricane that destroyed Suvorov. Now at last we had sent word to the heroes that we were on our way, and we were silly enough mooncalves to believe that they might take some notice of us.

37

DEPARTURE FOR CIVILIZATION

I guess Superman must have told the brass hats in Penrhyn about Manihiki, for when the *Southern Seas* returned in three months, eleven officers came ashore with the returned laborers. I won't tell you about the celebration that followed because I have already described two such happenings. I'll just say this: add our welcome to Superman's welcome, multiply by ten, and the result will be a funeral in comparison to that frenzied night. One hundred and twenty Manihikians had returned to their wives and sweethearts; eleven millionaires had landed (all white men are millionaires); for three months three hundred women had been hoarding up tubs of home-brew and loving hearts. Result: one grand and glorious explosion!

Papa tried to talk to a few of the brass hats about our

adventures and ask for some suggestions as to how we could be of service to our Uncle Sam, but the army officers seemed not to understand him. With the drums booming and about fifty girls in lovely voile dresses and chaplets of flowers in their hair, swinging their hips and making eyes at the officers, with homebrew everywhere, raisin wine at the padre's and rum at Abel's house, they must have thought my father was dippy when he suggested that he could take charge of a small transport like the *Southern Seas.* "Or maybe," he said at last, when his temper was pretty hot, "I could be of some service in a literary way. I could correct the correspondence of admirals and generals for spelling and punctuation."

"Yeah, yeah!" a colonel agreed, not understanding a word Papa had said. "Take a slant at that hot baby!" he gasped, pointing to Calypso among the dancers. "What's her moniker? Do you suppose you could get her to take a walk on the moonlit beach with a colonel of the United States Army?"

"Undoubtedly," Papa replied coldly. "I was speaking of spelling and punctuation."

"Come away, Papa!" I whispered, and started pulling his arm.

"Atta boy!" the officer guffawed. "That's a good one! Haw-haw! Spelling and punctuation! I'll teach her spelling and punctuation!"

We lost a lot of our interest in being heroes for a few months after that, but it came back little by little.

Next morning the place was deader than we had ever before seen it. The *Southern Seas* was to leave at 2:00 P.M. to land the eighty Rakahanga laborers on their island, but before that the whole two hundred had to be paid off. Jakey, Elaine, Nga, and I had slept with Papa in Calypso's house. At eight o'clock that morning we wandered over to Abel William's place to see the eleven big shots, as blowzy as we had been after the hurricane, needing shaves, their eyes bloodshot, their jaws hanging down, slouched around the

breakfast table, drinking strong coffee spiked with rum. Every one of them had his elbows on the table, which is very bad manners. Maybe they thought no one would know the difference on a primitive island like Manihiki. They must have been badly brought up. One of them ate with his mouth open, another one held his fork in his fist as though it were a fish spear, and a third one knocked his coffee cup over because he had left his spoon in his cup.

We could see that Mrs. Williams was ashamed of her guests; nevertheless, after the meal, she gave them each a beautiful hat and a fan. We could hear them thanking her and promising to send her all kinds of wonderful presents, and we could see her weary smile. She had been hearing those kinds of promises since she was a little girl but seldom had she received any of the fine presents. The same applies to my family.

By and by the three policemen were sent to waken the laborers and herd them to the government building, where each one signed his name on nine forms and received his pay. This was done by noon. In the meantime Abel's trading station had been opened, with the shelves piled high with cheap jewelry, scent, smell soap, talcum, brilliantine, toys, lollies, fancy shirts, embroidered voile, rayon chemises—the kind of things young men in the islands buy. By noon over three hundred dollars had flowed into Abel's moneybag; the rest would dribble in during the next few weeks.

The brass hats, a little livelier by then, marched back to Abel's house for a farewell feast with plenty of beer, and it was then that many of the laborers and their wives came to give them presents that often were worth more than the wages they had received. At two o'clock sharp the officers, loaded with presents, with flower wreaths hanging all over them, and pretty unsteady on their feet, boarded the *Southern Seas* and steamed away to Rakahanga.

The Frisbie kids lost most of their mana from that onward. Since our arrival Jakey had been telling his hair-raising stories of murder and robbery on the King's highway,

and I had been telling of my narrow escapes from the Fijian cannibals, but now we had one hundred and twenty competitors. When it came to lying I've got to admit that the Manihikians put it all over the Puka-Pukans. At first they kept to the truth, describing the bulldozers that bellowed and snorted like wild boars as they rooted up coconut trees, pushed over houses, and pawed islands into the sea; of the machines that sucked salt water from the lagoon to change it magically into rain water; of the carryalls and graders and dredges; and finally of the four hundred Negro and six hundred white soldiers that were vomited out of a fleet of landing crafts like Jonah from the belly of the fish. They told of their tanks, jeeps, trucks, big guns, searchlights; and of the transport planes, fighters, bombers that swooped down daily; the big ships and the men-of-war—but that is probably old stuff to you. To the Manihikians it was more incredible than Manihiki must have been to Superman.

And the money those Yankees, especially the Negroes, threw away was simply scandalous! My! My! According to the labor gang, they would buy anything and pay any price for it. Every man, woman, and child of Penrhyn Island was making more money every day than a strong man made in a year before the war. You see, before the war Penrhyn Island was much the same as Puka-Puka and Manihiki except that more white people had been there and the natives had learned from them the value of money and had become greedy. So when the soldiers landed they knew how to sting them good and plenty. Nothing was sold for less than $1; most things were $5 or more. If a man wanted a boy to climb a coconut tree and throw down a single nut it cost him $1; if he wanted his clothes washed he paid $5. Day and night the people worked making the shoddiest kinds of curios—like coconut-leaf mats, or half-polished pearl shells, or fans, baskets, and hula skirts. And the soldiers bought them as fast as they could get them. Some of the native men made big money selling bad home-brew for $1 a bottle. Every girl over fourteen years old and nearly every married

woman had a soldier lover. Women who formerly had only one old dress for Sunday meetings now had new gowns every day, high-heeled shoes and silk stockings, and they smoked American cigarettes, too, and chewed gum with their mouths open! The women simply threw themselves at the soldiers as no Puka-Pukan woman would ever do. They had never seen anything like the American soldiers: a thousand snappily dressed, good-looking young men with their pockets full of money, chewing gum, candy and cigarettes, and not giving a damn what anything cost. Can you blame the women, when you remember that an atoll man is rich if he makes $30 a year?

I will copy from my diary what some of the laborers told us:

"One day I saw a black fellow walking toward me," Tari said. "I picked up a piece of coral gravel from the road. I gave it to him and said: 'Very fine native curio. One dollar please.' The black man looked at it, grinned, stuck it in his pocket, and gave me a dollar. Later I saw him showing it to other soldiers."

Another laborer said: "An airplane came from the fighting in the Western islands. A lieutenant landed and came to the village. He seemed wrong in his head. Later we heard his brain was sick because of all the death and destruction he had seen. He saw an old man sitting on a doorstep with a pretty hula skirt across his knees. 'How much for your grass skirt?' he asked. The old man savvied plenty, so he said: 'I give him to you, my fr'en'. You give poor old man what you like.' The pilot pulled a handful of American money from his pocket. 'Is that enough?' he asked. 'Oh, yes,' the old man replied. 'Thank you, my fr'en', oh, thank you very much!'" He took the money and counted it—$167!"

Still another laborer said: "One of the black men was my friend. He was a cook. Every day he gave us Manihiki boys food from his kitchen, a quarter of beef or a whole lamb or a bag of sugar. But that was nothing. We saw lighters loaded with many tons of mutton, lamb, and pork towed out

to sea where the food was dumped overboard. You see, the soldiers didn't like mutton, lamb, and pork. They would eat only beefsteaks, chickens, and what they called hamburgers. My black friend loved chickens. At first I gave him young fowls that I bought in the village for $0.25 each. Later I couldn't buy them because the black boys started paying $5.00 each for them.

And here is a last one, chosen from maybe twenty others.

There was so much money that schoolboys were shooting dice for $1 a throw, men and women played poker with a $1 ante, and sometimes a man would get drunk and throw his money on the road to see the boys fight for it. No man bought less than a six-pound tin of bully beef for dinner; formerly he couldn't afford a one-pound tin a week. Poiri made $5,000 on bush gin; some of the wild girls made $100 a night. And you should see Omoka Village now! Jeeps, trucks, half-tracks, motorcycles speeding past in clouds of dust every minute of the day and night; electric lights, telephones, picture shows, jitterbug dances, drunken parties, soldiers everywhere, and money, money, money!"

And only four months ago Omoka Village in Penrhyn had been as quiet and sleepy as Roto Village in Puka-Puka. I wonder if Puka-Puka would be destroyed if a thousand soldiers landed there? I'm afraid it would. I'm afraid my people wouldn't see the danger as I, who have traveled so much, can see it. My island and my people would be destroyed overnight. No longer would old Tapipi and the rest of the village fathers stand on the beach with drinking nuts to offer to the strangers from the ship. All the beautiful old life would disappear. Just imagine a Puka-Puka boy meeting a stranger with, "Hello, Joe; gimme a smoke!" or a Puka-Puka girl offering herself to a soldier for money! I can't bear to think of it!

So the Puka-Pukan cowboys with their stories of Fiji, Samoa, and Suvorov took a back seat when one hundred and twenty Manihiki men had such amazing things to tell. And

the outcome was that everybody on Manihiki started working like mad, making really beautiful things to sell in Penrhyn: lovely pearl-shell brooches, carved boxes and idols, hats as fine as Panamas, gorgeous flowered belts, baskets, all kinds of pretty things; and, about everybody decided to go to Penrhyn by the next schooner to make their fortunes.

When the *Tiaré Taporo,* A. B. Donald's crack trading schooner, came in December she took about fifty Manihiki passengers and several tons of curios to Penrhyn. On that voyage she sailed from Penrhyn to Tahiti to refit during the hurricane season. When she returned in May 1943, the Frisbie family took passage on her to Rarotonga. We had been away from home over a year and four months but still were no closer to our Uncle Sam's warriors at the gates of Tokyo.

When I bade my boyfriend Willie goodbye he cried. He said that maybe he would live to wait for my return but more likely he would kill himself that very night or else waste away and die of grief. But I knew my native boys well enough to be sure that Willie would be on the outer beach that very same night, staring dreamily into another girl's eyes. Perhaps he was disappointed because I didn't cry very much. I have never been much of a man's woman—except once, as I will tell you later.

As for Calypso, we were surprised and maybe a little disappointed because she didn't tear out handfuls of hair and plump down in the middle of the road and bawl. She cried hardly at all, and we couldn't understand this until late that night. We were sleeping on a mat on the cabin top. Sometime after midnight Nga and I were wakened by someone squeezing between us and Papa. Then we heard "someone" giggle and saw her rubbing her cheek on our father's shoulder and purring like a kitten, and so we knew that Calypso had stowed away on Ulysses' raft.

She brought with her nothing but the clothes she wore! On the five-day voyage south Papa had to lend her his singlets and trousers. That pleased her, because his clothes

fitted her so snugly they showed off her shape. Well, anyway, she was a great help, for we had foul weather the whole voyage and, not being seasick, she tried to make up for her naughtiness by taking good care of four very sick cowboys. The only trouble was, as Papa told us, that Rarotonga would gobble Calypso up and destroy her as completely as the soldiers had destroyed the Penrhyn girls.

"Land ho!" A new port in a new island! The dizzy peaks of Rarotonga rose fresh and green from the sea; the palms waved their fronds in welcome; little Elaine and Nga, atoll babies, stared at their first mountainous island, their eyes popping with wonder!

38

BROTHER CHARLIE

I shall skip lightly past our one year and seven months in Rarotonga, and you can take my word for it that you are missing nothing. It was the dullest period in my life, brightened only when old Piki-Piki let Brother Charlie visit us for a few days.

During the first five of those nineteen months we watched Calypso change from an innocent child of the atolls to a blowzy street-walker, but at last we were rich enough to buy some pretty things for her and send her weeping back to Manihiki. She thought we were being cruel. We got her aboard the *Tiaré Taporo* by pretending we wanted only to say goodbye to the captain and some friends among the passengers, but when we had her in the captain's cabin we told her she was returning to Manihiki. Some of her relatives had sent her bundle of clothes aboard secretly, and the Chief of Police had agreed to keep her aboard once we got her

there.

Poor Calypso! First her mouth dropped open a little, her eyes became round and filled with tears; then, as the tears started streaming down her cheeks, the corners of her lips turned down and suddenly a great sob almost exploded from her lips. The next two or three sobs she tried to hold back. It was no use; she broke down completely and bawled as loudly as she could, tore her hair, plunked face down on the cabin deck, and gave herself up to such grief that you would have thought she had just lost her father and mother and sweetheart and friends.

Captain Andy poked his head in the cabin to show his gold tooth in a big grin, and shout: "Lord, Johnny! Don't let your dad beat that poor little girl to death! You'll be giving the schooner a bad name!"

I knew he was joking, and so I didn't say anything. I guess he'd seen lots of such scenes during his thirty years on a South Sea schooner. A minute later he came back to the doorway, this time to hand us two tall and one small glass of ice-cold beer. We sat on the floor by Calypso, sipping our beer, but when Papa offered her a glass she pushed it away like a spiteful child.

There was nothing we could do until her crying had stopped. Then I told her a lie: I said the Chief of Police was sending her home because she had been drinking too much and that Papa and I were saving her good name by making it look as though she were leaving by her own accord. Otherwise the police would drag her aboard, and that would look terrible. We were doing this, I said, because we loved her so much, and very soon—perhaps by next ship—we would join her in Manihiki and live there in King Noah's house for ever and ever. Maybe it is wicked to lie, but all women are terrible liars anyway, and I don't want to be different, making myself conspicuous and having people say I'm too proud to be like others.

Papa talked about Manihiki—about moonlight on the lagoon, the trade wind, the girls and boys dancing on the

outer beach, and all that romantic stuff. I could have told him that it was wasted on Calypso, but presently he used better judgment by telling her about the pretty dresses and things he had bought for her and packed in a brand new camphorwood chest with a tinkling lock, which was in the saloon awaiting her, and that here was the key. She wiped the last tears from her eyes when he said that she would be a big woman in Manihiki. All the people would gather round her, green with jealousy as they listened to her stories of wild times in Rarotonga and stared enviously at her pretty things.

We stayed with her until the engine was warming up and the mooring lines were being hauled aboard. She started bawling again, of course, when we kissed her goodbye, and climbed into the last boat for shore, but later, when the *Tiaré* returned, we heard that she was laughing and flirting with the big Atiu second mate before the schooner was an hour at sea. Well, you have read in Homer's poem about what happened to Ulysses in Ogygia; now you know what happened to Calypso in Ithaca.

Jakey saw his first picture show in Rarotonga, as did Elaine and Nga, but for my brother it was a big adventure while for the two girls it was only a lot of fun. The picture was *Rogue Male,* and to Jakey even the hurricane on Suvarov was small potatoes in comparison to this adventure of spies and patriots. A tremendous thing had come into Jakey's life. Riding home with us in the truck he sat perfectly still, frowned, and pushed us away. Once he tried to say something but emotion broke his voice.

You see, Jakey's brain works slowly, surely, and independently; mine works by leaps and bounds. If I fall in love it probably will be love at first sight; with Jakey it will be a carefully thought-out problem. I'll probably have lots of love affairs; Jakey will have only one. My brother, you see, has the Polynesian temperament. He reacts slowly, as Araipu did after the Fiji voyage and as Papa's sailors did after he had taken them up in an elevator in San Francisco. During the show we three girls whispered, laughed, and wept—and we

forgot all about it as soon as we were outside the theater. Jakey sat through the picture in silence, frowning, his fingers gripping the arm of his chair.

Back at our home in Arorangi, Elaine and Nga toddled off to bed; I stood back in the shadows, watching Jakey. Before long he looked toward me in a worried way. "I've got to tell Papa!" he whispered. "He's got to know about it! I hope he doesn't get mad when I wake him! If he'll only let me start telling him about it before he gets mad!"

With his breath coming fast, Jakey tiptoed into Papa's room. By the bed he hesitated again, but finally he reached out to touch him. I could all but hear him holding his breath. "Yes, Jakey," Papa said. "Did you have a good time?" At that the little cowboy's confidence returned. He knew he had something to hold even his father spellbound, and so, leaning over, his voice trembling:

"Papa," he whispered, "do you want me to tell you about the picture show now or can you wait till morning?"

"I'll try to wait, Jakey-boy," Papa replied, very seriously. "Yes; I'll wait for most of it till morning, but please tell me the most exciting parts now."

Papa lit his candle, rolled a cigarette and smoked it, while Jakey poured out his story, his voice husky with excitement. Papa was certainly patient that night; I guess he understood what a deep impression the picture must have made on Jakey. My brother, once he had started, could not stop until he had told the whole story to the last detail.

During those nineteen months Papa worked as he never had worked before, writing *Amaru* and lots of articles to make up for our losses in Suvarov. Little by little the money started to flow in. We paid our debts and started putting money in the bank. You will understand how excited we were when the following radiogram came from our agent:

"*Atlantic* offers one thousand dollars for *Marooned by Request.* Advise acceptance."

It had been a tough struggle up to the time that money came, for, you see, in Rarotonga we had to wear nice clothes

and shoes, rent a European house, and live like white people. That meant money or debts. Later some friends of ours in Honolulu helped a lot. They read in the *Atlantic Monthly* the serial Papa wrote about the hurricane and, without our asking them or even knowing what they were doing, the Junior Red Cross collected and sent to us, by army bomber, four big cartons full of clothes! We had a grand time opening those cartons, squabbling over the clothes, laying them out on the beds, tables, and chairs, and putting them on, one after the other or one on top of the other. We received nearly a hundred dresses, over two dozen each of pants and shirts for Jakey and Brother Charlie, and lots of hats, underthings, pajamas, and so on! Overnight we became the best dressed children in the South Seas, and some of the clothes were so good that we still have them. Jakey has a navy-blue shirt and Elaine a suit of pajamas from the Red Cross packages that are as good today as anything we can buy in Samoa!

I hope some of the children of the Junior Red Cross will read this and know how wildly excited and thankful we were. At that time there wasn't a yard of dress goods in Rarotonga; we had only the clothes Abel had given us and those we had bought in Manihiki—and then, suddenly, *presto chango*! Our boxes were packed with pretty things! We each could wear a new dress every day for a month. The Rarotonga children were so jealous they wouldn't speak to us until we had loosened our heartstrings and given them the clothes that didn't fit us.

During those nineteen months Papa received many letters from admirals, generals, and congressmen. Admiral Nimitz wrote that he thought Papa was very patriotic. Admiral Halsey said that war was moving west, out of the islands Papa knew so well, but that he would keep him in mind. Some generals and colonels advised him to report to the nearest island where troops were stationed, but none of them had any work for him to do. Poor Papa! He really wanted to do something to help win the war. He had lost all his worldly wealth in trying to join Uncle Sam's warriors,

and he had lost his health by overwork. Now, with more money than we had ever owned, he decided to take us first to Penrhyn Island and then to Tahiti, where he would make a last attempt to get back to the United States and offer his services. As for me, I said nothing. I did not want to discourage him, but I knew he was far too ill to work for Uncle Sam. Often, when I noticed the dark rings around his eyes or sat by him to comfort him when he was bent over in pain, I wished we had never left Puka-Puka.

The crack trading schooner *Tiaré Taporo* was to sail at 5:00 on December 21st, bound for the Northern Islands and Tahiti, with our old friend Captain Andy Thomson the skipper. For three days big Brother Charlie and his foster mother fat old Piki-Piki had been staying with us in Arorangi, helping us to pack.

"Lord, Johnny," Papa said often during those days, "what a burden worldly possessions are. Think of those happy days when we had lost everything in the hurricane and traveling meant only to put on our clothes and board a ship! I almost wish we were that way now."

We had everything arranged to take Brother Charlie with us: his permit to travel, his passage by the *Tiaré,* new clothes, a sea chest, and twenty pounds left with our friend, Mr. William Watson, to be paid at the rate of one pound a month to Piki-Piki. She had agreed at first to Charlie going, probably because of the money. (All natives become greedy when they live in a big tropic port—they have to be!) But when the time approached for the *Tiaré* to sail she weakened. Suddenly, without warning, she would throw her arms around Charlie, burst into tears, and scream: "Oh, how will I live without my darling boy!" As the time for our departure grew nearer these attacks came oftener until, on the last day, she was weeping half the time. As for Charlie, he liked old Piki-Piki but he didn't love her as a mother. I think he felt ashamed of her hysterics. When she held him in her arms to bawl like a baby, Charlie would glance at me, with a puzzled sort of frown, half ashamed of and half sorry for his foster

mother. On the day we were to sail, Piki-Piki broke down completely.

"I've got to talk to you! I've got to talk to you!" she cried, tears streaming down her puffy cheeks. "Come to me, all of you; I've got to talk to you now! Don't be angry with old Piki-Piki! I'm only a poor lonely old woman! I've got nothing in the world but Charlie, my darling Charlie! I can't part with him! No, I can't, I can't! Oh, Ropati, you won't take my darling boy away, because if you do I'll die! I know I'll die if you take him away! Oh, Charlie. Charlie!" And then for a few minutes her voice was so broken by sobs that we could scarcely understand her.

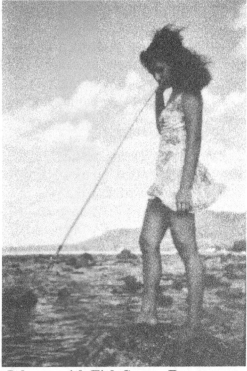

Johnny with Fish Spear, Rarotonga.

The outcome was that Papa said he couldn't force Charlie to come with us, for Piki-Piki had adopted him and

had taken care of him since he was a baby. He said it would be for Charlie's good to come with us and see the world but that he would leave the decision to him. Then he called us away, so that Charlie could be alone with his foster mother. We went on the front porch to sit by the cheerful Bebé Tanga, our housekeeper, who was ironing clothes.

"If Charlie can't go let me take his place," Bebé begged.

"No!" Jakey broke in. "Charlie is going with us. He is my best friend! I won't let that old Piki-Piki have him!"

"Yes," said Bebé smiling, "but when you sail, if he is not aboard, you'll let me take his place, won't you?"

"Yes—no!" Jakey growled. "That is, I mean that Charlie is going to be aboard and you mustn't think any other way about it."

Bebé had been trying to sail with us since she had learned we were leaving, but there had been no room for her aboard the schooner. She was an orphan and she had been having a hard time of it in Rarotonga. . . . But I'd better not tell you the whole story—only that she knew she would be happier on the atolls, where she had some distant relatives.

Soon Charlie joined us. He kept his eyes on the floor and I saw him bite his under lip. Moving over to Jakey, he put his arm across his brother's shoulders and together they left the porch to walk to the grove of ironwood trees down on the beach. I glanced at Bebé. She was ironing at a mile a minute, and she was so excited and happy she could hardly keep from smiling, which wouldn't have been the polite thing to do at such a sad time. Then old Piki-Piki came on the porch, grinning and chattering like a mynah bird. We've never liked Piki-Piki since that day, but we have realized what a brave and unselfish boy Charlie is. He stayed with the old woman simply because he felt sorry for her and when his whole heart was set on striking out to see the world, arm in arm with his brother Jakey. Charlie is in Puka-Puka now, as I write this chapter. If he wants to stay there Papa is going to open a trading station for him, but if he returns to Rarotonga

we will either send for him to join us or send him to the Central Medical School in Fiji, where natives and half-castes are trained to become native medical practitioners.

Perhaps you wonder why I mention Charlie only now, when we are preparing to bid him goodbye. The truth is that I have written at least twenty pages about him—and I have torn them up as fast as I have written them. Always something was wrong; they didn't "click." After talking it over with my father, we finally decided that to write well about Charlie we would have to describe his background, Rarotonga. That would mean forty or fifty pages describing a place we dislike; so we decided to explain this frankly to you, as I am doing now, and assure you that Charlie was very dear to us—is very dear now—but we do not know how to write an interesting chapter about him without bringing in his unpleasant background.

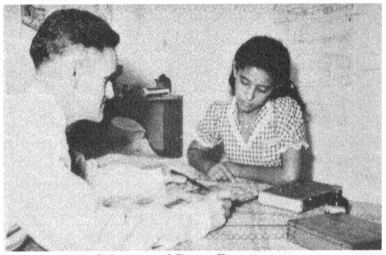

Johnny and Papa, Rarotonga.

While in Rarotonga Papa had a business partner named Fariu, a half-caste Chinese-Polynesian, who made lots of money running a store in Arorangi. Papa and Fariu bought fine native handicraft and shipped it to Honolulu. Well, Fariu

owned a big army truck which he had painted bright red. It was the flashiest thing in Rarotonga. He offered to take us to the wharf in his truck, and so, about two o'clock that afternoon, he stopped before our house in Arorangi to load our gear aboard. We four children, Piki-Piki, Charlie, and Bebé Tanga sat in back while Papa sat in front with Fariu, and away we went, in style, over the seven miles to Avatiu Harbor where the *Tiaré* was anchored.

The wharf was packed with people, standing between and sitting on the piles of cargo for the Northern Islands. Fariu found ten men to carry our baggage down the wharf and stow it in one of the reef boats that worked between the wharf and the ship; then, we climbed aboard and were sculled out to the ship, where we carried our "wanted" baggage into the main saloon and told Takika the mate to stow the rest in the hold with the Papeete cargo. Then Jakey and Charlie went aft to sit behind the wheel box and be truly miserable, while Bebé, Elaine, and Nga stood by the taffrail with Piki-Piki to watch the commotion of departure. Papa and I said goodbye to Fariu and then went into the saloon, where Captain Andy, Peter Holland, the manager of A.B. Donald and Co., and the Chief of Police were drinking beer.

To understand what I now have to say, you must remember that my father was a very sick man. He had been bleeding internally for several months, his skin was pallid, and he had lost about thirty pounds. Also you must understand that he has sailed many thousands of miles with Captain Andy. They are old shipmates. In 1919 they took that long dangerous voyage to San Francisco in the *Tagua* at the time when her masts were so rotten they were ready to fall over the side. They were 131 days at sea and all the crew had scurvy when they entered the Golden Gate.

Now you will understand why Andy said, as soon as we were seated: "We're in a bad way, Ropati. Look here"— showing us a slip of paper—"This is a telegram from Niue. It says a hurricane is blasting the island to pieces and is headed our way. That means we've got to clear out of here in a

hurry—get lots of sea room." Then Andy picked up another piece of paper, this one crumpled and dirty. When he handed it to us we read, scribbled in pencil:

> *Dear cap I very sorry I too much drunk. I been drink too much no can go to sea today. You pleas cap no get too much mad dear cap. I come aboard tomorrow sure think I no come today too much drink.*
> *Yours truly John.*

"The cheeky blankety-blank, blank!" Andy growled when we had returned the letter. Then: "Well, Ropati, the Chief of Police has his whole force hunting for John but there's not much chance of finding him. With a hurricane brewing from the north-northwest we got to get out of here *muy pronto.* Have you any suggestions?"

Papa hesitated a minute. "You've got your oiler and greaser aboard?" he asked.

The captain nodded his head.

"Well, then let's get under way!"

"You think you're strong enough?"

"I'm not sure. I'll try. You'll have to take that chance."

At that Andy called through the alleyway to Takika his mate: "Send all the visitors ashore in the next boat! If there's any cargo left on the wharf it'll have to wait till next trip! Throw off the mooring lines and bring her up short on her anchor!" Then to Papa:

"You'd better get your engine warmed up, Mr. Frisbie."

"Aye, sir," Papa replied. "I'll send my boy ashore and then turn to."

It sounded strange to hear them talk that way, such old friends, but that was the way they always talked when they were on duty at sea.

We found Jakey and Charlie still sitting aft of the wheel box, still being miserable. Papa called to Charlie while

I went to Piki-Piki to tell her she must go ashore. At that she started getting hysterical again and jabbering as fast as she could. Leaving her, we crowded around Charlie but we didn't have the heart to say scarcely a word. And my big brother—I knew every thought that was passing through his head. When he glanced at fat, weak, sentimental old Piki-Piki there was a glint in his eyes that meant more than anger. And when he glanced at us, especially at Jakey, I could see how much he had learned to love us. Every second that we stood there, waiting for that vulgar old woman, squealing and jabbering, to lower herself into the boat, I expected Charlie to break down. Strong, brave, unselfish boy! He held back his tears until the last moment; then he *did* break down, terribly. He burst into tears suddenly and begged Papa to take him along. It was the only time I ever saw my big brother cry. Poor Papa! He didn't know what to do. He was crying, too. Suddenly, looking sort of foolish, he dug his hand in his pocket to take out a handful of money and shove it into Charlie's pocket. Then we heard Piki-Piki, who must have smelled something wrong, start her hysterics again. Charlie glanced at her, clenched his teeth, and suddenly had himself under control. He kissed each of us, wiped his eyes, and bravely bade us farewell. Then he climbed into the crowded boat. Papa left us to go to the engine room. We watched Charlie until he had climbed on the wharf and was lost in the crowd. Suddenly we heard the engine exhaust and, looking up, saw a puff of smoke and sparks.

"Lordy!" I thought, though I was still in tears. "I hope Papa knows how to run the damn thing!" for, you see, my father is not the kind of man you would expect to run a Diesel engine. Then I climbed on the cabin top, where Bebé Tanga had laid out our mats and pillows.

39

THE ISLAND THAT DIED

"**Y**ou're sailing again, Johnny, you're sailing again! On the *Tiaré Taporo* this time, the crack trading schooner of the South Seas!" That is what I was saying to myself, but, alas! You must board the schooner yourself to feel what I felt that first night aboard the *Tiaré,* when, after more than a year and a half ashore, I sat on the cabin top during the middle watch and threw open the windows of my soul.

Our mats had been spread on the forward starboard corner of the after-cabin deck. A few native passengers had chosen the same place to sleep, while the rest were on the main hatch, over which a tarpaulin had been stretched. There were no quarters below for native passengers. If it rained they were supposed to stay on deck, but most of them managed to squeeze into the galley and the forecastle until the worst of the squall had passed. When there were days of

foul weather they simply had to grin and bear it—as we did after the Suvarov hurricane. The natives paid only a pound or two for their passage, without meals; the cabin passengers paid fifteen shillings a day. On this voyage we had in the cabin only Dr. Cowan, a native medical practitioner, and Joe Strickland, the half-caste manager of Manuae Island.

Papa came on deck at 4:00 A.M. It was the middle of his watch in the engine room, for on the *Tiaré* the engineer and his greaser stood watches of six hours on and six hours off. Papa had taken the watch from 12:00 to 6:00 A.M. and P.M., but he didn't have to spend much of his time in the engine room. He went below every two hours to oil the machine and once a day to clean the fuel-oil filter. During the first few days he spent hours below, sitting on the workbench, studying the engine. Sometimes one of us children would sit with him until the heat and fumes made us sick. He said that by looking at the engine he learned all he needed to know to run it. Maybe he did. Anyway, he kept the thing running for ten days, and if we did enter Penrhyn Island's lagoon on two cylinders, it was pretty good for a man who knew nothing of diesels when he left Rarotonga.

Bright and early on December 24th we were tied to the army buoy off Aitutaki's barrier reef. I, for one, realized instantly that this had been a beautiful island before the troops had moved in.

Aitutaki is a mountainous island rising from the wide deep-water lagoon of an atoll. The barrier reef is twenty-five miles in circumference, and it is threaded with tiny low-lying coconut islets like those of Suvorov and Manihiki. There is no natural passage through the reef but the army has blasted a gash about a half mile long and ten yards wide from the village beach to the offing. No one lives on the reef islets; the three villages are on the mountainous island, and there the army has cleared two airstrips and built its camp of plywood, tarpaper, and galvanized iron.

We were no sooner tied to the buoy than we saw an army tugboat towing out a barge for our cargo, and almost

instantly I realized that we had sailed out of the Great South Sea. Aitutaki brought home to me that Uncle Sam had been at war for over two years, that for two years we had been trying to break out of the wilderness to where we could meet military people. Long ago Papa, Araipu, and I had seen Australian soldiers in Fiji, but since we had left Puka-Puka I had seen only the eleven brass hats who had landed on Manihiki from the *Southern Seas*. And during all that time it had been impossible for us to realize clearly that the rest of the world was at war. To me World War II had been no more real than the Trojan War. I knew about the latter by reading Homer and talking about the Greek heroes with my father, and I knew about World War II by reading scraps of radio news and talking about it with South Sea natives. Because Homer was more convincing than the man who wrote the radio news, the Trojan War was more real to me than World War II.

Yes, it was brought home suddenly to me, like a slap in the face, that the world was actually at war, that the remote islands on the borderline of paradise were being destroyed one by one. A hundred years ago Blackbirders had raided Aitutaki to steal most of the strongest men for the slave islands; then scores of whalers had kedged off the reef while their crews stormed ashore to carouse, steal women, burn villages for the fun of the thing, shanghai native men, and murder anyone who defended his life and home; then traders had come to teach the need of clothes and food and rum; then Government had come to make laws, to fine people and put them in jail. Yet through all this Aitutaki had held fast to its happy spirit—until, finally, transports had steamed up to the reef to land a thousand soldiers and all their noisy smelly tools of war. Then, overnight, Aitutaki had lost its soul.

When we went ashore we saw the dead body of an island. Most of the soldiers were gone, which made it worse. Their empty camp, smelling of stale diesel oil, strewn with tin cans, rusty wire, broken bottles; the two airstrips hedged with great piles of uprooted trees; the hot oiled roads; the

unpainted Quonset huts; the abandoned broken trucks and jeeps; the gap out through the barrier reef and shallows, lined with blasted coral rocks—this was modern Aitutaki, a junk heap.

The people seemed to be suffering from a bad hangover. We saw men trying and failing to return to their old way of life. Their plantations were grown to jungle, their boats and canoes were rotten, their houses were falling to pieces. No one had saved any money and no one had bought any useful goods, like houses and boats, because such things were not to be had during the war. They had spent their money on silk dresses and high-heeled shoes, American cigarettes and cigars, chewing gum and candy, canned food and liquor. Now they were repairing their houses with old plywood and tarpaper thrown away by the army. They were unwilling to return to their cool, comfortable, and beautiful thatched houses because they thought that by doing so they would appear primitive. They were trying to keep going by selling fake curios to the twelve soldiers still stationed on the island and to the airplane passengers that stopped over for a night. I saw a girl come aboard the *Tiaré,* as she must have gone aboard many army transports. She was not like the happy laughing sirens of Manihiki. There was a hard glint in her eyes when she winked at the men aboard. She sucked a cigarette in a vulgar way, threw it over the side when it was only a quarter gone, and lit a new one; and, worst of all to me, she chewed gum with her mouth open and used army slang, much of it so filthy it sickened me.

Ashore we found the men as bad as the women: conceited because of the money they had made and resentful because they were now beggars. . . . But why write more? I want this to be a pleasant book. We sailed on Christmas Eve, bound for three of the atolls of the Northern Group— Manihiki, Rakahanga, and Penrhyn Island—bound for the group we had sailed from two years before!

40

NORTHBOUND FOR PENRHYN ISLAND

We had dropped off Joe Strickland and Dr. Cowan and we had the whole after-cabin to our own sweet selves, and because there were only a few deck passengers left after the labor gang had been landed on Manuae, the captain had closed the poop deck, alleyways, and cabin top to the remaining passengers. It was like sailing on a yacht. Captain Andy being an old sailing mate of Papa's, we were a happy family during the four-day sail to Manihiki. We chose the food we wanted from the big locker under the settee; we took turns sleeping in the six bunks that lined the saloon bulkheads, and if we didn't like them we had Papa's bunk in the engineer's cabin. In the mornings we could take our time in the bathroom, and every day we could fill the washbasin as many times as we pleased and bathe our

whole bodies. That was luxury you seldom have, even on a crack trading schooner.

Papa seemed to grow stronger every day, but still he had spasms of pain that lasted an hour or two. Now that we were rich again and could take things easy, for a whole year if we wanted to, he felt certain that soon he would be as strong and healthy as he had been on Suvarov. "Maybe after the war we'll buy a little Tuamotu cutter," he said, "and sail her through the Golden Gate. Then all the newspaper reporters will come aboard to take our pictures and write stories about us; and nice old ladies will ask us to tea; and we'll put on our fancy clothes and our shore faces and go to see a circus and the zoo and a Wild West Show." We Puka-Pukan children knew what these three things were, from pictures in magazines. Sometimes we talked about them, but we were never foolish enough to believe we would actually see them.

"Then we won't have to stay in Reverend Vernier's school after the war?" I asked, and he replied that seeing the world was better education than the best of schools, and that we'd buy our ship as soon as the guns stopped firing.

"You can repeat your multiplication tables while standing your night watches," he said. "You can learn your arithmetic by calculating your position at sea, learn languages by talking to people in foreign ports, writing by keeping your logbook and writing the story of your travels. In other words you can learn about life by living."

And now, as I write my diary, I wonder if it will ever come true, that dream of ours? Well, we steamed up to the boat passage off Tauhunu Village early on the morning of December 27th. It was Sonny's watch in the engine room (6:00 A.M. to noon). Papa sat with the five of us on the cabin top, and of course we were excited, for we hoped to go ashore, meet our old friends, feel the good clean sand of a real atoll under our feet again. Our hopes slipped away when we were three or four miles off the island and saw mist rising to hang like a curtain in the still morning air. That meant

heavy seas on the reef. When we were lying off and on in the open roadstead we knew the captain would allow no one to land on that side of the island, for huge combers flooded the shallows six feet deep and surged far up the beach. Before long we saw one of the policemen waving a red cloth and pointing to the south, which told us that even the Manihikians were unwilling to launch their dories. Captain Andy rang the telegraph for full speed ahead and we steamed the four miles to Tupuaika boat passage in the south reef. Abel Williams and Ben Ellis would have to ferry their cargo across the lagoon in their pearling cutters.

Manihiki seemed different. It was as beautiful as ever, even though it was half lost behind the rising clouds of mist, or perhaps the mist made it even more beautiful. I felt that somehow it had slipped away in time and space, and I wondered if we had truly lived there once upon a time, sung with the sirens on the outer beach, listened to Willie speak of love. When we went ashore on Tapuaika Islet it seemed a little more real, but even there it was not the same. Maybe it was because the ship was there. I told you in the beginning of this book that an island changes when a trading schooner is lying in the offing.

On the south reef of Manihiki there are about fifty tiny islets, some of them only big enough to grow a few coconut trees and a fringe of bush. While we were living in King Noah's house we had often sailed to these islets to spend a week or two fishing and loafing, and so now we were at home. With Bebé in tow, we wandered from one islet to the next, swam in the channels and the reef crevices, and later, after gathering flowers, we sat under the magnolia bushes to string them into wreaths. About noon Abel, Calypso, and Willie came over from Tauhunu Village. Abel had no more than time to kiss us before he went aboard the *Tiaré* to talk business with the captain, which meant drinking much beer and making out an order for much more when the ship returned. Willie hung on to me the rest of the time we were ashore. He seemed shy. I guessed that his conscience

hurt him because he had taken a new sweetheart after having promised me faithfully that he would die of a broken heart. As for Calypso, she was much fatter but otherwise the same overgrown baby. It seemed that the wild time in Rarotonga had not done her any lasting harm, and I was glad of that. Willie told us she had married a deacon but she swore she had not. She whispered to me that she intended to stow away, as before, and go to Tahiti with us. I think she would have done so had the ship been lying off Tauhunu Village. Luckily, no shore people were allowed aboard, and so Calypso had to stay at home, where she belonged, instead of having the fun of drinking French wine and making love to stokers and stevedores in Papeete.

Before we went aboard we gathered two big bunches of green drinking nuts. Bebé and Calypso carried one while Jakey and Willie carried the other on a pole between them. At the reef boat they dumped the nuts aboard, then we kissed goodbye and cried a little so that people wouldn't think we were hardhearted. With Calypso and Willie standing on the reef waving to us, we were rowed back to the ship, where we found Andy and Abel on deck, two sheets to the wind. When the captain saw our two bunches of nuts he said we were first-class passengers in more ways than one, and he was proud to have aboard real atoll children who knew enough to rustle a little fresh food.

On the evening of December 31st we sighted Penrhyn Island, or Tongareva, the biggest atoll in the Cook Group. By dark we were in the lee of the land; then the captain took in sail, the mate threw a trolling line over the taffrail, and we steamed slowly along the fourteen miles of reef to where Omoka Village lies on the point of a long island close to the northwest passage. It was nearly nine o'clock when we hove to, but, being New Year's Eve, the village twinkled with lights and someone on the beach flashed an electric torch at us in the Morse code for "Happy New Year. Plenty to drink ashore."

"They'll be having a big time, all right," Captain

Andy said as he stood by us on the poop. "Captain Roper and Dr. Powell will be in from the Camp, and there'll be old Papa Viggo and Father David and Dan Ellis, all at Philip Woonton's place, tossing them off for a fare-you-well . . . Hmm! What do you say, Mister: shall we go ashore in the reef boat?"

"None of it for me, Captain," Papa replied, and I squeezed his hand when he went on. I'm what Johnny calls a rabid teetotaler. You go ashore if you want to and I'll be here to feel sorry for you tomorrow morning when you come aboard with a big head."

"Well, if you'd know the truth of it," Andy said, "I'm just as pleased to be out here. We'll lay off the stuff until we're sitting tight in the Bougainville Club in Papeete and Alex is mixing a round of his rainbow cocktails—but I guess a bottle of Diamond lager will do us no harm, seeing it's New Year's Eve. What do you say, Mister?"

"You took the words out of my own mouth, Captain," Papa replied. So they went below, drank one bottle of beer, and then turned in on the cabin top like respectable gentlemen, and very proud of themselves, for men are that way.

"I'm sure glad we didn't go ashore!" Andy muttered.

"Sure thing," Papa agreed. "Nothing like moderation, Captain. I'm glad I can take my glass of beer and then stop."

"Me too, Mister. I don't believe in prohibition. I believe in moderation. Always moderation. But, of course, for some people you know"

"Yes, of course, for the poor fish who don't know when they've had enough"

And so they talked, as smugly as a pair of L.M.S. missionaries. As for me, I lay awake long after they were asleep, dreaming of the Tuamotu cutter we might buy when the war had ended and we had lots of money, of sailing the calm blue tropic seas, of landfalls and departures. "Think of being on our own ship, lying at anchor off a far-away port on a moonlight night like this!" I dreamed.

It seemed very real and very possible that night, maybe because the moon was full and the sky clear, and because the *Tiaré* wallowed gently in the long easy rollers. Anything is possible to me on a night like that; my dreams are more real than reality. I lay on my mat, wrapped in a warm woolen blanket, and watched the lights of Omoka Village dim and disappear as the schooner drifted off the shore. The blaze of lights in the church was the last to go. The moon was straight overhead when they went out suddenly, leaving the island sharply outlined against the sky. A moment later the man on watch struck eight bells. It was midnight: 00.00 hours, January 1, 1945!

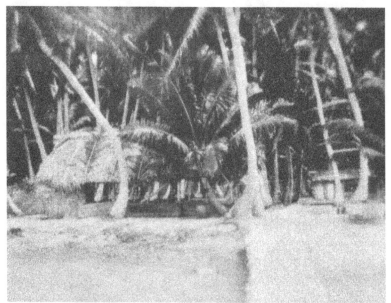

Our House on Motu Toto, Penrhyn, Where We Lived for 5 Months Waiting for Papa to Get Stronger.

I remember hearing someone breathing heavily, and I wondered vaguely if the schooner was asleep and I was listening to its heavy breath. Then suddenly, as I felt myself slipping off, I felt the presence of my mother leaning over me, and for an instant I was sure I smelled the gardenia

blossoms she loved to wear in garlands around her neck. She seemed to lean closer to me, slowly approaching until I felt her lips pressed to mine in a kiss. I heard her voice, whispering distinctly, "Johnny! Johnny!" Then I was calling for my mother, and the next instant Papa was beside me, saying, "Go back to sleep, Johnny. Mama is here. She is always here!"

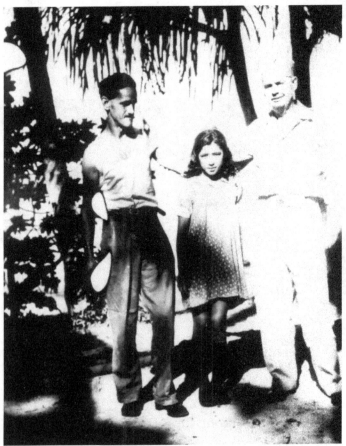

Penrhyn Island, Papa, Johnny, and Captain Charles Powell, Army Doctor.

And now, as I write this, I am sure my mother knew of the sorrow that was about to come into our lives and that

she had come to watch over us, to comfort us, for, next morning, Jakey, Elaine, Nga, and I stumbled ashore, following our father, who lay on a stretcher carried by two sailors. His face was colorless and his eyes glassy. It was like following a hearse. Early that morning he had gone below to start the engine. A half hour later Sonny had found him lying in a pool of blood, unconscious. Straining himself when turning over the flywheel, he had brought on another hemorrhage!

41

THE BOMBER, THE COMMANDANT, AND THE JEEP

It was very cold. I had never known that the air could be so bitter cold. Flying in a Navy bomber, we four children huddled together on a pile of mail bags, bundled in woolen blankets. It was the morning after V.J. day and we were being flown the eight hundred miles from Penrhyn Island to Tutuila, American Samoa.

Through a tiny porthole I could see, ten thousand feet below me, a sheet of galvanized iron, corrugated, brand-new, and dazzling. The great Pacific rollers were ripples. The *Tiaré Taporo*, beating up from Manihiki on her midyear voyage, was no bigger than the toy ship Jakey had towed in the *Taipi's* wake from Puka-Puka to Suvorov. It seemed silly

to believe that full-grown men and women were on that tiny craft, that perhaps a hundred tons of copra was in her hold! And the clouds! How white they were against the deep-blue ocean!

Soon Jakey worked himself down between two mail bags, rolled up in his blanket until only his nose was visible, and went to sleep.

Elaine and Nga seemed giddy from the high altitude and the monotonous roar of the engines. Their eyes sparkled mischievously. They glanced at the three young enlisted men sitting across the compartment from us, reading illustrated magazines. Then Elaine glanced at me out of the corner of her eye and timidly left the pile of mail bags to sit by one of the sailors. At first the boy seemed afraid of her, or wondered what he should do with this funny little brown girl who had suddenly joined the navy. He grinned in an embarrassed way, leaned over to pull a magazine out of his duffel bag, and handed it to Elaine, whereupon she crossed her legs, leaned back, and started looking at the pictures as unconcernedly as you please. It would not have surprised me to have seen the cheeky little girl beg the sailor for a smoke. A minute later Nga did precisely the same thing; so there was I left alone to watch the five of them, sitting in a row, seemingly unaware that they were flying above the clouds in God's own heaven, but interested only in the latest movie or the latest styles from ten thousand feet below.

So Elaine and Nga had their sailor-friends before they were in the air an hour, I might have been sitting by the third sailor if he had not been afraid to give me more than a timid smile, and that because I had grown into a big girl during the past six months or so. And I did not encourage him because my handsome boyfriend Ensign Jack Waddell was in the cockpit, piloting our plane.

Jack had taken Papa to Samoa five months ago, and now at last we cowboys were on our way to join him. It would take quite a while to tell you about the months when Papa was sick, and I am about ready to end this book. So I

have decided the best way to explain what happened is to show you part of a letter Lieutenant James Michener wrote back to America. Here it is:

Sometime ago I flew up to a very small island to evacuate a sick man. We found Robert Dean Frisbie critically ill. He was living with his four children at the home of a fabulous old pearl fisherman who had just inherited a quarter million dollars from a long-forgotten relative. Frisbie and the children were getting as good care as an island could provide. Some American medical men were assisting him from time to time, and they had decided that he should be evacuated to better facilities.

In the early morning we carried Frisbie to the plane. His children and the old fisherman tagged along. Johnny, whom I had seen the night before at a party, is a superb girl. She's about thirteen, straight, clean, quietly confident, and the darling of the enlisted men. She takes care of her father and her small family. She is very quick, has light-brown skin, and flashing eyes.

As we lifted Frisbie aboard, Johnny and Jakey could not hold back their tears. They tried hard, but to no avail. A very large cook tried to comfort the girl, but she pushed him away, and stood with Jakey until the plane took off. Nga held on to the pearl fisherman's big hand and seemed unaware that much was happening. The children all waved goodbye.

We were up to 11,000 feet when I was formally introduced to Frisbie. The pilot, who had met him before, suggested that he might like to meet someone who had once worked for a publishing company. I went to the rear of the plane where Robert Dean lay wrapped up in blankets and a sleeping bag, for it was now extremely cold.

Frisbie was as pleased to see me as I was to meet him. I had already read his books and had found

them delightful. On several islands I had heard of him, and so I was not affected when I said it was a treat. I sat on the edge of his blankets and we talked for about two hours. We saw the three islands he wrote about in his last two books, and Amaru lay wonderfully clear more than two miles below us.

We talked mostly about publishing. Frisbie must have thought me pretty stupid, because I know little about trade practices, but I told him what I did. We talked that heady business of editions, royalties, advertising, first printings, reviews, third and fourth books, characterization, plot, illustrations, Hollywood, success d'estime, titles, and all the other jargon that authors ought to talk over with their publishers. On many points Frisbie was better informed than I, but we nevertheless had an excellent chat.

When we had been in Jack's plane a little while my boyfriend opened the door leading forward to the cockpit and poked out his head. My! My! But he is a good-looking young man, clean faced, boyish, and really in love with me! He shouted something but I could scarcely hear him above the noise of the engines. I guessed that he was asking me to come forward, and so I left my blanket on the mail bags and went into the forward compartment, which was divided into a radio room and a cockpit. It was much warmer there. Jack gave me a cup of hot coffee, a sandwich, and an apple and told me to sit on a stool by the radioman's table. When he put the things on the table he squeezed my hand; then he told me we would be over Manihiki in twenty minutes.

"Tell my sisters, Jack, please!" I shouted, so he stuck his head out of the doorway again, this time to shout the news to Elaine and Nga. I guess they were pretty jealous of me, but they had tried to put one over on me by grabbing boyfriends, so we were no more than even.

Sitting close to me at the table was Radioman First Class Frank Clarke, an old friend of ours, and sitting in a

corner, drinking his coffee, was the enlisted man who took care of the machines. Both of them, as well as the passengers, were dressed in faded dungaree trousers, blue work shirts, and the ugly heavy brown shoes that the Navy makes her sailor boys wear when they are traveling while the officers wear nifty uniforms, which isn't fair. Jack Waddell and his copilot Ensign Asbury sat in the cockpit, with not a thing to do, for the plane was guided by its automatic pilot, as Jack showed me later.

When I had finished my lunch Mr. Clarke moved my stool into the cockpit between the two pilots, and for a few minutes Jack tried to teach me about the dials and levers and things, but I understand only that they were very pretty and shiny and that somebody must have worked hard to polish them so brightly. Then Jack pushed a button, saying that it was the automatic pilot, and immediately grabbed the "stick," which looked like half of an automobile steering wheel. Instantly I felt a sinking feeling in my stomach. I looked out the windshield—or whatever it was called—to see the ocean rolling onto its beam end and the bank of clouds that had been a little below us now soaring half way to the zenith, where it wobbled crazily from side to side. And then, as I looked, the ocean started easing onto an even keel again and the clouds sank until they had returned to their natural place. Then, so suddenly that I screamed with surprise and delight, I saw an island rise like a miracle from the sea!

"Jack!" I shouted like a silly girl, grabbing his arm. "Jack! Look! Manihiki!"

"Sure thing, Johnny," he replied, grinning. "It's Manihiki all right. That's where you used to live, on the siren's isle, as you told me—and I guess you were the prettiest siren there! I came down to five thousand feet so you'd have a good look."

Ours was the second plane ever to fly over Manihiki! I wondered what the people were doing, thinking, and, oh! how I wanted some way to tell them, "It's me, Johnny! I'm in this plane! Hey! Willie! Calypso! Look up! Can't you see

me, Johnny?"

` No use. Manihiki lay dreaming below us, a painted island in a painted ocean, with the creaming surf, the green islets, Tauhunu and Tukao villages, the exquisite lagoon with its vermilion coral heads and reefs and its deep-blue water and white shoals. And there was Tukao Church, and Abel's trading station, and King Noah's wharf! I fancied I could see people running this way and that.

And then I saw Puka-Puka! Jack flew a little off his course on purpose to show me my island. At first I couldn't see it until he asked, "Where are you looking, Johnny?" and I pointed down into the middle of the clouds. "No; not there," Jack said. "Higher up. Almost on top of the clouds."

I looked farther off and in a moment I saw it, first one green isle, then a second, then a third! But they were not in the sea! No. Those islets were floating among the clouds, and that's the only way I can describe them. There was no horizon; the sea and the sky had merged together in the gray mist, with here and there a fluffy little cloud, and in their midst, cocky and debonair, Puka-Puka, escaped at last from sad old earth to float away with the clouds to paradise! When I stared at those three green gems among the white wings of the sky I could not believe that I had lived there most of my life; that it was the home of Grandma Tala, old Heathen William, Araipu, and Geoffrey Henry; that under its clean white coral sand my mother lay at rest! Those green isles had never belonged to the world; they had been dreamed out of nothingness and set adrift among the clouds.

Two hours of empty sea and the monotonous roar of the engines, the air became so cold it hurt me to breathe; I could feel it like ice water in my lungs. The clouds thickened. Gradually we nosed down to skip over them from crest to crest, like a skipping stone, like the Panikiniki! Do you remember the time we bounced over the coral reef in Puka-Puka lagoon, ages ago? The noise of the engines died away until I could scarcely hear it. I became panicky, believing the engines had stopped. Then I remembered something Jack had

told me, so I held my nose and forced my breath into my nostrils. Something clicked in my ears and suddenly the engines were roaring gain. We passed over a rainsquall. The plane bounced, bucked, rolled from side to side. I saw the enlisted men fasten belts around Elaine and Nga to hold them in their seats, and when we had flown into calm air again, Jack came out of the cockpit to put me in a seat and buckle me to it.

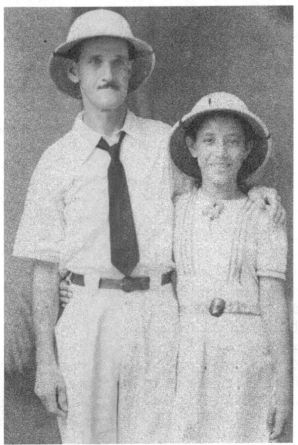

Papa and Johnny. Apia, Samoa 1946.

We saw the mountain peak of Manua, and for a few seconds a gap opened in the clouds to show us a steep black

precipice falling into the sea, where breakers thundered against the rocks, the sea boiled, and steam rose to drench the cliff. It was both grand and terrible. The plane bucked and rolled again, while I held to my seat so as not to be thrown against my belt. Elaine and Nga were giggling and their eyes were flashing, and they were chewing gum! I wondered what kind of lunatics or wild South Sea savages the sailors thought we were! Jakey still slept in his little foxhole among the mail bags. Maybe Jack had not seen him or maybe he thought him safe. I kept my eyes on him so that, if he wakened, he would not try to leave his hole.

Finally we plunged down below the clouds and there, suddenly before us, lay the rain-drenched mountains of American Samoa! I recognized them from the time I had been there, four and half years ago, with Papa and Araipu. We circled over a low ridge and eased down to the airstrip by Nuua Point. The ground flew past at a mile a minute. The wheels touched, we bounced twice, and finally stopped near the sea end of the strip. My boyfriend turned the plane around and taxied to "Operations," at one side of the middle of the strip. The engines were stopped, and one of the enlisted men moved slowly through the compartment, pumping a flitgun so that we would land no Penrhyn Island mosquitoes to bite the noble Samoans.

I looked out the porthole to see some officers and sailors hurrying toward us but not a sign of Papa. Then I unbuckled my belt and wakened Jakey. He sat up, rubbed his eyes, and grinned.

"Did you have a nice sleep, Jakey?" I asked, perhaps a little sarcastically, as we waited for the hatch to be opened.

"No," Jakey grumbled. "I dreamed too much. I dreamed about Charlie."

"Do you realize that we have flown eight hundred miles to American Samoa?"

Jakey frowned; then suddenly his eyes brightened. He glanced around the cabin, and, "Is Papa here?" he asked, which showed me he was still half asleep.

Elaine and Nga were gaping through the portholes and jabbering as usual. I looked out again but still saw no sign of Papa. I did not tell Jakey the thought that was puzzling me, but I kept thinking about how Fate had kept us away from World War II from January 1942, to VJ day. Our father had done everything in his power to join Uncle Sam's warriors, but first a hurricane, then poverty, and finally illness had kept him out of the fighting and his children safe in the islands. Then VJ day came and Fate had seemed to shrug her weary old shoulders and say: "All right, cowboys; the fighting is over and the seaways are safe again; you can join your father now and travel to your hearts' content." And, the next thing we knew, we had been whisked eight hundred miles, in five hours, out of the primitive South Sea Islands to one of our Uncle Sam's naval bases!

Just then the hatch was opened. We picked up our things and climbed out, blinking and as unsteady on our feet as sailors ashore, to find ourselves in a crowd of uniformed men, but still not a sign of Papa. For an instant a lump rose in my throat. I felt certain that he had fallen sick again. Then Jack was beside me and I felt better.

"Seen anything of Frisbie?" he asked one of the officers. "This is his daughter Johnny and these are his other children."

"Yeah. He's over at Operations with the Commandant—there they come now!"

A big green touring car, flying a blue flag covered with stars, drove up. Papa jumped out to run to us and kiss us. He was followed by a grey-haired navy captain with rosy cheeks and a big smile. Papa's cheeks were rosy, too, and he was fatter than I had ever seen him—and talk about proud! He acted as though he were introducing the royal family to the Commandant when he said: "Meet my daughter Johnny, Commandant. She's the one I've been talking so much about. Pretty good-looker, eh? And this is Son Jakey, the strong man from Puka-Puka! And this fat sweetheart hanging onto me like a periwinkle is Daughter Elaine, the best dancer in

the Cook Islands! And take a slant at Daughter Nga, the prettiest girl in the South Seas!"

Delighted! Hmm! Delighted!" said the Commandant. I've heard a great deal about you these past months but now I see that you are worth talking about." Then to Papa: "Splendid children, Frisbie, splendid children!" He patted my cheeks, and went on: "I give you back your daddy, children, sound as they make them. Half the men of this base have given him their blood and the best doctors in the navy have worked on him day and night so that the cowboys would not lose their daddy and so Uncle Sam would have another good man working for him." He smiled and turned away. "Visit me often!" he called over his shoulders. "Glad to see you at any time."

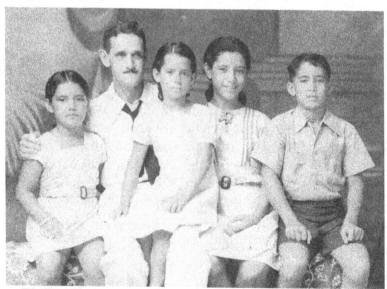

Elaine, Papa, Nga, Johnny, Jakey. Apia, Samoa 1946.

I stepped back to stare at Papa, dressed in nice new khaki and with black polished shoes, and I thought how fine it had been for him to meet us with the Commandant, who had spoken to him like an old friend. Then my father had some men take our baggage to the jeep in front of

Operations. I kissed Jack goodbye, and followed Papa in time to hear Jakey ask him: "Papa, is it true? Are you really working for Uncle Sam?"

"Yes, Jakey. We'll all be working for him from now on. I didn't tell you in my last letter because I wanted it to be a surprise."

We climbed in the jeep and Papa sat behind the wheel, with me at his side.

"You're not going to drive, are you?" I cried, suddenly scared. "Doesn't somebody drive for you?"

"Drive for me? Nonsense! I'm the crack jeep driver of American Samoa!" Papa replied, laughing, and with that he pushed something with his foot and the engine started. Leaning out, he waved to the Commandant, who was watching us from his car, with half a smile and half a puzzled frown. Then Papa pushed something else and the jeep started with a jump.

Across the airstrip we speeded, against regulations, as I learned later, and then down a long curving road we flew at more than a mile a minute, I'm sure. Papa leaned over to grip the wheel, his teeth clenched and his eyes glued on the road. For a second I glanced back to see Jakey, sitting stiff as a broomstick and grinning like a million dollars, Elaine and Nga holding to the sides of the jeep, their eyes darting this way and that.

"We'll be in Honolulu tomorrow!" Papa said. "We've got a job there with the navy!"

I scarcely heard him, for, suddenly, with a feeling of guilt, I knew I was shirking my duty. We were going altogether too fast.

I leaned over to grip my father's arm and shake him. "Papa!" I scolded, "Please be careful! Do slow down!" Because, you see, my father is not the kind of man you would expect to drive a jeep.

PART FIVE

Epilogue and Author's Notes

42

WE GO TO AMERICA

With the war over, there was no job in Hawai'i, and Papa decided to return to Rarotonga, Cook Islands. We had two happy years with him until he developed a fatal illness.

In November 1948, Robert Dean Frisbie, our father, began his journey to *Po* in the early morning hours. He was buried at the London Missionary Society churchyard in Avarua, Rarotonga. Burial was not our choice, for he would have loved to swim his way to Po, body rolled up in a fresh pandanus mat and weighted down with a coral stone at the bottom of the ocean. My younger sisters, twelve year old Elaine Metua, and eleven year old Ngatokorua-i-Matauea and I sat on the white lime painted wall holding each other's hand, looking down at the freshly covered grave of our beloved father as friends and our mother's family walked away, respecting our need to be alone. I was sixteen years

old, and had now lost both my parents.

"Do you think Papa is with Mama already?" Nga asked.

"I think he might be checking up on our brothers Jakey and Charles in New Zealand before he paddles his canoe to Mama."

"What are we going to do without Papa?

"Elaine, Papa wants us to go to America. That's his dream."

We did not wish to leave the place where our father lay covered in sandy soil because we needed to be together to fully understand that we were on our own, a little while longer to be convinced that we were without the one and only guardian we had ever known. We were not scared at all, not fearful, or worried of what might happen to us. We were surprisingly in a state of utmost calmness, individually safe in the knowledge that the "big" sister would take care of things. I remembered what our father had asked of me, that I take care of my sisters and brothers. Our mother, before her death, had asked our father not to separate us, and with that deeply entrenched in my heart, which passed the message on to my brain, I was at peace, secure in the knowledge that somehow we would paddle our three-woman outrigger canoe to America.

Two weeks after the morning my sisters and I sat on the white wall surrounding the church, George Weller of the *Chicago Daily News* stopped briefly at Rarotonga to meet with our legal guardian Lionel Trenn and me. Lionel was a friend of Papa's who'd agreed to assume this responsibility. George asked me what I wanted to do with my life. At sixteen years old, my dream was to go to the land where my father came from, taking my sisters with me. Thereafter, George Weller corresponded with many of Papa's friends to find ways that would make my wish come true: to be either educated in New Zealand or America the white man's way. I had no idea exactly what the "white man's" way was really like. I based that notion on what I knew of my father's

obsession with education and not marrying a Puka-Pukan man. The *Atlantic Monthly* readers who followed with sympathy James Norman Hall's memoir of Papa helped with the funds to take care of us. James Michener, Lee Barker of Doubleday and Company Inc., Edward Weeks of *The Atlantic Monthly*, Kenneth Emory of the Bishop Museum and Papa's literary agent Harold Ober called themselves the "fund club" and consulted by mail with our newly appointed legal guardian Lionel Trenn in faraway Rarotonga.

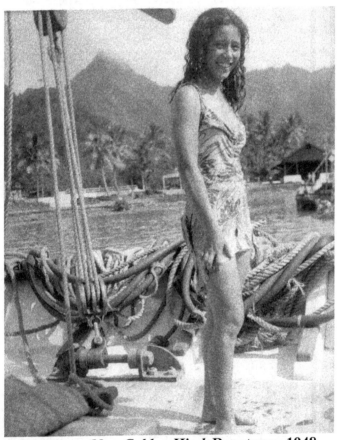

Johnny on *New Golden Hind*. Rarotonga 1948.

Without fail, when a yacht from a distant land entered Rarotonga's Avarua Harbor, I would be there to conjure up

dreams of faraway places, and why they chose to visit our island. So, April 1948, seven months before Papa died, the yacht *Loafer* motored into Avarua Harbor. As she was being secured with many dock lines to the little wharf, a giant of a man called out:

"We were told Robert Dean Frisbie lives on this island."

"He's my Papa, he's my Papa, I blurted out in excitement."

"My name is Peter Engle of Honolulu, Hawaii. Please take me to him."

Each day and part of the night when Peter and his wife Barbara visited with my father I stayed on *Loafer*, the most beautiful floating object in the world. Knowing that he did not have long to live, Papa asked Peter and Barbara if they would invite me to live with them in Hawaii to be assured of an American education.

On April 22, 1950 I sat in my seat on a very small airplane by a tiny window looking at my sisters, Elaine sitting on a wooden fence and Nga clinging to her new mother's arm. We did not wave to each other, neither were there tears. Strange. My heart temporarily lost its sense of feeling, perhaps in denial, when I think now of that day in April, vividly as if it happened yesterday. We sensed that this was not to be a long separation.

At Nandi Airport, Fiji, I boarded an impressive giant British Commonwealth Pacific Airline plane, arriving in Honolulu on April 25, 1950. There I reunited with Barbara and Peter Engle, along with their three children, Stephen, Diane, and Susan. The Engles lived near a lagoon that reminded me of many of the atoll lagoons on Puka-Puka, Manihiki, Penrhyn and Suvorov. And there were coconut trees everywhere! I was at home, at last.

Elaine was sent to New Zealand to live with Mrs. Grace Sowerby of Kawau Island, schooling by correspondence, herding sheep and cattle, sailing, and writing me letters every month. Nga remained in Rarotonga with

Willie and Marie Watson who wanted to adopt her. But, I had other hidden plans, which was to approach Barbara's friends, Lee and Sue-Mar Dawson, if they would like a 12-year old daughter.

"You see," I hinted, "she would then be a sister to Peter, David and Michael." Unbeknown to me, arrangements were made. The night before she arrived, Barbara entered my bedroom and whispered in my ear, "Nga arrives tomorrow to live with the Dawsons." Sleep did not come that night. On the way home from the airport we sat next to each other with our fingers intertwined, in silence.

During the summer of 1951 I was invited to be one of eight counselors at Kokokahi Camp in Kaneohe Bay on the windward side of O'ahu. It was during this summer that I came to know Pa and Ma Pfaender who managed the Kokokahi Camp, parents to Janet and David. I was a counselor in charge of seven eight-year old boys and girls who quickly learned the art of sharing a cabin—gracefully! One day Janet came to me and said, "I hear you have a sister in New Zealand. Would you like her to join you?"

Yes! Elaine arrived on November 28, 1952, the day before her sixteenth birthday, or she would lose her right to American citizenship. The three of us stayed together that night in Elaine's new bed, holding hands. Together at last.

We adapted quickly to the American approach to learning, and to discipline, and to being punctual, so unlike our father's easy-going, playful, no-homework-style-of-education-because-it-would-take-up-time-to-fish-hunt-and play. That was his approach to education and made our father happy. I am sure he danced to the music of many drums with other souls in the Po underworld as each one of us received our high school diplomas.

43

RETURN TO PUKA-PUKA AND GHOST DEATH SICKNESS

After graduating from high school I had various jobs. One day I met Carl Hebenstreit, a popular radio and television personality known as "Kini Popo." In 1953 he presented Hawaii its first television broadcast on air. We were married in 1956. Subsequently we decided to move to New Zealand and traveled there via Rarotonga, in the Cook Islands. While at Rarotonga, I decided on a side trip to see my Grandmother Tala and also to visit my mother's grave. It was 1961, I was 29 years old, and it was the first time I'd been back to Puka-Puka. There I experienced a tragedy that reminded me of the sad times in my own life, but also was telling in the sense of how "progress" had upset the natural order of our ancient culture.

Imilia was my aunt Pati's seventh daughter who I first

encountered in Grandmother's sleeping house before the feast of her first birthday. She was standing, her right hand secure in her mother's palm. The diaper pinned securely around her thin body with a safety pin was part of an old dress of Grandmother's, cut into a square. That was how it was on our little atoll, old clothes found new meaning. The flannel square diapers, white and soft, were not even heard of at that time.

Imilia was sick with the dreaded "ghost" death sickness, which happened to be a curse suffered by most of my aunt's children.

In the thatched roof house were many women who came to lend support to members of the immediate family: women singing happy songs followed by whispered recitation of a prayer, or offering Imilia the sweet life-giving juice of a young drinking coconut. Other than the whispering of prayers, silence was the sign of respect to the sick and, also, to those of our people who live in harmony in Po, or the underworld, awaiting our arrival. We believed it to be a paradise and so death was not necessarily something to fear. Though we could barely see each other, there was enough light that we were able to see the shadowy form of each other—until a ray of sunlight peeked through a gap in a coconut frond shutter like a Peeping Tom.

When visitors entered they were welcomed with nodding heads and smiling faces. As they left they were assisted with many hands waving to them in a way that they could leave with a sense of peacefulness. It is okay to leave, for we are here.

Imilia was learning to walk that day. She relished the attention of the women quietly looking on as she showed off by sliding one foot forward, then pausing to look down at the foot, that it moved, that it was in front of the other. She turned to her mother, puckered her lips in expectation of a kiss, and thanked her mother with a smile that lasted a while. We clapped, lightly touching the palms of our hands so as not to rattle the purity of a sacred moment.

My aunt sat on a fine pandanus mat, one woven especially for her by the women, having been each allotted a portion of the mat to weave until it was completed. It, the mat, was in itself medicinal for it was woven by many loving hands. She lifted Imilia's fragile thin body and fitted her nicely into the concave of her fat thighs, one of Imilia's arms dangling down like the tentacle of a tired octopus. A ray of sunlight pierced through a slit in the coconut frond shutter straight onto Imilia's hollowed chest. She tried to brush it away several times, pausing, for the moment, to scan the room while pondering who the stranger might be, since we had not met before. I offered a smile and a nod. She looked up at her mother, then closed her eyes to sleep for a while. I fell in love.

Weakened with an overwhelming sadness, for it seems Imilia was destined to join her sisters and brothers in Po, and stifled by the tropical heat, we cooled ourselves with fans woven from the leaves of the pandanus tree, all the while eerily mindful of a visitor in the form of a wisp of a breeze wafting through the doorway to carry our Imilia away.

Not long after, perhaps a week, women rallied again in Grandmother's sleeping house by the sea. The shutters remained anchored to the white pebble floor by corals from the nearby reef.

Bending from the waist up, a sign of respect to all of us who were seated, three elderly women entered the room one behind the other. As they prepared to sit, they spontaneously did what all women do before sitting cross-leg, effortlessly and gracefully tucking the lower part of their skirts between their thighs. Their presence was timely, further offering moral and spiritual support as they had done many times before with Imilia's brothers and sisters on their journeys to Po, here in the same thatched roof house of our Grandmother's.

The Lord's Prayer was recited by Grandmother, a passionate plea for the recovery of yet another of her grandchildren, followed by a very long prayer that nearly

lulled us to sleep, begging God to forgive sinners in the family—if that might be the cause of Imilia's sickness.

"She has the family sickness," Grandmother whispered soon after the prayer ended. "I have died many times with each one of them, because I could not bear the thought of them traveling alone even though the journey would be smooth and safe. I was just someone along to hold their hands."

Grandmother, taking the listless Imilia from her mother, placed her neatly within the concave of her thin thighs, head resting on a bony knee. As she had done many times before, she gently kissed her seventh granddaughter on the forehead, inhaling for tell-tale signs of what ailed Imilia. I was reminded of how Grandmother kissed my ailing mother from forehead to feet, tears trailing behind her lips.

A woman whose head was covered in one of Imilia's dresses whimpered a soulful lament, triggering a chorus of chanters to follow. The chanting called on the spirits of the dead for compassion—and to not rush to take Imilia to be their own.

There was crying and I wanted more. Cry, cry and cry some more but keep it in your stomach so Imilia would not hear. Whimper and sniff, but do it outside in today's dusk.

"She has the family sickness, of course, we all know that," Grandmother whispered. "Someone has entered her— the wretched rat!"

"A venomous scoundrel!" from the woman whose head was covered in Imilia's dress. "It's time to seek the wisdom of the *Tangata wotu*. He would know by now who is playing around with the life of this little one."

"The tangata wotu is powerless these days, a useless ghost himself. He can't even make his way into their world anymore, not like before. The fool is blind and deaf, if you ask me. He can't hear because his ears are full of rubbish; nor can he see clearly enough to find his way to the outhouse, even when the moon is there to light the way."

"Yes, he has become a ghost because he digs too

deeply into the world of ghosts. Plus, he's listening to the foreign doctors. That's what's gone wrong with him now."

"Sssh! Lower your voices. Stop the silly talk. Have respect!" Grandmother scolded the women the way of the matriarch, as if they were her children.

"Just hear me," the woman pleaded to be heard. "It's the beginning of the end for him, if you ask me. He knows very well he is not to fool around with our ancient medicine, gifts from our forefathers endowed to him alone, yet he exchanges them with visitors for tobacco, a box of matches, or a tin of mackerel. Those people from somewhere make fun of our healing practices, for sure. One of them laughed when I mentioned the healing magic of the juice of the green husk of a certain coconut, that it rids the stomach of all bad things."

"His journey will not be smooth," mumbled another. "He'll be whacked with a coconut broom for sure, like a child."

"Humble yourselves and close your lips!" Grandmother uttered a more crushing command. "We are in the presence of a dying child. Don't blame the white man. Instead, we must invite the tangata wotu to come to us. "

Aware that they had openly criticized one who spoke to the spirit of the dead, they gazed past each other in silence, praying to the new god for forgiveness, unaware that they too have fallen victim to the people who brought them the new god and who, in turn, confused them as to whom they are. Why was there no respect for what we had?

There is a large boulder in the midst of the coconut grove near the Christian church where the taro patches lay side-by-side in neat rectangles. It was once a truly comforting god for those before us, in the days before our present tangata wotu came into the world. The sacred stone is now surrounded by layers of decaying coconut fronds sheltering families of delicious land crabs. It is no longer dressed in a skirt of shredded coconut leaves, no longer prayed to, revered, and caressed until finally burnished from constant

touch.

This sweet story is shared often among my people: Our tangata wotu's father wrapped his son's umbilical cord in a bundle of puapua leaves, alternating the layers of green and yellow leaves, for that would be pleasing to the eyes and sensuous to the touch. With the half shell of a coconut he scraped a small grave at the base of the lofty revered boulder. After laying the precious bundle in the shallow grave, he gently sprinkled upon it an abundance of fragrant white puapua blossoms, and then covered it all with the rich soil of our atoll. He squatted there for a while, leaning against the boulder, mourning the resting place of his son's *pito*, aware that he had clung, like many others of his people, to the belief that this stone could not be replaced by the white man's god. Arriving home, the mother of the newly born asked:

"Did you give him scented flowers?"

"Plenty," the father replied. "He will live long. He will be special."

"I know that." the mother assured the father, "He is now with Earth mother."

Days pass…

The same group of women have gathered in my Grandmother's house.

"Did I not warn you about the name Imilia?"

"You should not have given it to her. You knew very well it's a bad luck name."

"It's jinxed, for sure, forever. Bury it!"

"Close your lips!" Grandmother blurted.

"She needs fish and taro, and the warm water of a young coconut. It's healing, we know."

"Yes, her body has been starved long enough."

"What about the tangata wotu?" I asked.

"Leave him for last." was the reply.

"Maybe raw eggs and rice will bring back her appetite," I suggested. "I'll take charge of her diet."

I learned quickly that it was not easy to find eggs, for most hens are pampered and encouraged to nest as close as

possible to the sleeping or cook house without being in the way. This way, for certain, the eggs are safely protected from young thieves. Eventually the eggs will hatch and increase the flock and there will be plenty of chickens for the Sunday table.

In the fading sunlight west of the lagoon a distant flock of frigate birds, framed against a lonesome cloud, caught my eyes. The lagoon surface shimmered in the soft twilight and, in the water closer to shore, children splashed and played with each other. I joined them.

"I need eggs for sick Imilia," I said, "in exchange for cabin bread, lollies, and fish hooks. Bring them to my place if you have any."

Later, in the dark of that day, several boys stealthily crept up to our house with eggs carried in coconut shells. In a hurry I handed them each a cabin bread, some colorful lollies, and a fish hook, and within the blink of an eye they ran off, barefooted on gravel, into the darkness.

"Tiané é," an old woman called out to me from the shack next to ours. "Why are you giving those half-naked thieves colored lollies and fishooks? No doubt they stole the eggs from Maloku's lot while she was alone in the taro patch weeding. If only my legs were young again, I'd chase them to the edge of the reef. Go get them Papa!"

"Let them be," he replied. "It's a fun thing to do, now and again. It brings back memories!"

Unfortunately, one of the boys, in his desperate haste to find a safe place to relax and suck the lollies, stumbled over an old couple lying on pandanus mats awaiting the evening curfew. A strong right arm grabbed the wiggling young boy by the ankle, and pulled him over to the mat.

"What are you going to do with me? Let me go or I'll tell my grandpa!"

"Well, first of all, you are an egg thief, just like your grandpa. What a laugh!"

Grandpa, who was nearby, beamed with pride, nodding in agreement that he, too, had been a first class egg

thief.

"And, for your punishment you will provide the policeman and his family, and the pastor and his family also, with fresh drinking coconuts for the next two days."

"My hen lays me eggs every day and you stole them just like that!" A faraway voice whined. The crowd applauded, not in sympathy with the woman, but in support of the boy who had the courage to steal eggs from her.

"Ship's captains, servants of the church, school inspectors and wireless operators—all of them important visitors—have smeared their faces with the delicious fat of my chickens. Now, there won't be any for a while."

Sitting on a plaited fresh coconut frond, the sun about to enter the mystery cave at the edge of our ocean where it rests for the night, taking with it the day's shadows, my aunt revealed her tragic story.

"Each of my babies began the sickness with a simple cough. There was nothing we could do to stop the cough. Eventually the time would come when they would become nothing but mere skeletons. I knew then their souls would soon leave the shrunken body before the heart stops beating, not wanting to bear the sight of itself in decay. No matter how often and passionately we chanted for the soul to return, the emptiness in the eyes of my babies told me that our people in Po had claimed them. I can't make myself believe in the other heaven, you know, the one up there that the preacher goes on about. Ours is a much nicer place to be. It is where I know for certain that I will see them again, where they are cared for until I join them. You know, don't you, that though our people go to church every Sunday, in the end, they choose to join all the others in Po because they know that our own people will be there for sure."

My aunt unfastened the turtle shell comb from the pyramid of plaited hair on top of her head. It unfurled over her right shoulder as she unraveled the braid by combing the strands with her fingers. She took aside nine very long strands, carefully examining each one in the light of the

curious moon. She chose one that was very grey.

"I like to think that this hair is Imilia," Aunty Pati said, pointing to the single strand, coiling it around her forefinger as if to make ready to pull it out by its root. "It, meaning Imilia, has reached its end of life on our island. It will go back to where we came from. My heart longs to know what it's like over there, and that longing gets stronger with each loss. Mama said it's our paradise, though Papa, being a minister of the foreign church, keeps telling us that our paradise is up there amongst the clouds. Mama kept her thoughts to herself so as not to disappoint Papa. Bless his soul. I wonder where he ended up at—down or up? Would he have been given a choice?"

"I am sure Grandpapa is where he is meant to be," I assured her.

After all, he was promised a heaven unlike the underworld that they accepted to be their future home for eternity—a much more lasting place.

"The continuing pain and mourning have chiseled a big hole of nothingness in my heart, a hole about the size of the crab hole under Papa's canoe. I wonder sometimes if my soul has already deserted me because I feel so empty. I wouldn't blame it if it's had enough of me."

Moving closer to her, I carefully freed the nine strands of hair from her fingers, then dutifully began to massage her scalp, instinctively knowing that she would like that, that it would sooth her heart.

"It's sometimes a good thing to be that way," I said, "to feel nothing."

"I don't want to bury another child. I don't think there is another tear left. And I don't want ever again for the minister to preach in the church that God took my children from us because I am a sinner. I feel guilt and I don't know why. What sin have I committed? Only that I sleep with my husband a lot, making babies, you know. Sin of the flesh, he preached?

"None of them gave me trouble at birth. No pain.

Each one came into my mother's waiting, comforting palms. They were not the normal healthy ones; they were already consumed with the death sickness. At the first sight of them I screamed with horror. The villagers immediately understood. They came to pray and to offer comfort. Mama begged me to 'stop the slaughtering,' as if I intended it that way. Don't you think they knew that I loved them? That I wanted them?"

Gathering a fistful of hair she buried her face in it, smelling the scents of her lost children as she would if they were being held in the fold of her loving arms.

"Just one healthy baby—but no. God is intent on punishing me for so many sins of the flesh. How else does one conceive? You tell me!"

She rose unsteadily from the coconut frond and staggered out of the shadows into the moon's light, taking off her dress and placing it on the bow of grandfather's outrigger canoe, then quietly slipped into the warm sea to bathe the heart of many aches. Later, we sat in the night shade of the coconut tree watching the moonlight on the surface of our lagoon and drinking the sweet juice of two of Imilia's coconuts.

"Let us not get dried up," she whispered. She was referring to our wombs.

"Go ask the tangata wotu first thing in the morning to come to us, please."

Before my aunt gave birth to Imilia, the tangata wotu tried very hard to break the death sickness curse by reciting certain chants to the dead, or he would squat amidst large sea-slab headstones, talking to ghosts, either scolding or pleading with them. They did not seem to reply loud enough for the rest of us to hear.

Not too far inland I walked towards the tangata wotu's house, if one could call it that, perched lop-sided atop a half dozen of the knobby roots of a Barringtonia (utu) tree. It was a home built without a plan, or even thought of seriously. It grew upward with the roots. It was funny looking and we wondered what he would do once it reached

the lower branches! He did not care. He had more important things to worry about for he was in great demand making peace between desperate living souls and mischievous ones of the other world, or concocting foul smelling medicine. The vigorously healthy, very old Barringtonia tree within the graveyard served a useful purpose by sheltering the crooked house from the sun and rain. She, the utu tree, was a famous and popular tree among the children of our time, as it was the favorite gathering hideaway for ghosts. They simply appeared in the night from their deep graves, we were warned, to meet among the branches in the moonlight. No wonder it suited the tangata wotu to live there in the shadow of the utu tree. It was the perfect place to get to know them.

We loved the tree house. Time and again we would build our own huts on tree roots, copying his haphazard plan.

Nearing the hut as I meandered through headstones towards our medicine man, a slight breeze from Ngake village rattled the coconut fronds. Drooping taro leaves awakened as if to acknowledge my presence, waving their supple leaves toward the utu tree and, I sensed, wishing me good luck. Pairs of dragonflies dozed on the firm tips of thirsty tall grass, motionless as if to conserve their energy. As kids we would make a noose with the end of a coconut midrib and with a steady hand lasso the sleeping dragonfly. But not today, there was no time to waste. I was on an important journey. Headstones everywhere glaring at me— faceless—nameless. Long ago these very flat and oval shaped large stones once covered the ocean floor so it would look nice and smooth for all the creatures of our ocean, but now were dried up and pitted from the tropical heat.

I took a moment to pray close to my ancestral plot, asking for courage to continue the journey for the sake of Imilia, and that I not turn back and scram for the safety of my Grandmother's hut by the sea. I even prayed to the ghosts in the vicinity that they be good and helpful.

We were told many ghost stories that we imagined to be true, that these moonlight nighttime creatures played in

the darkest interior of the tree, clacking their bones as they chased each other, or so we were made seriously to believe. They practiced scary and mischievous laughter, cackling like hens or cooing in mock affection with each other like wood pigeon's in Puapua trees. It was necessary to pray at that time of the moon's passage to darkness, when ghosts seem to come alive to play and scare those who dare walk out in the night or cause sickness. It is the time of the moon when they kidnap the souls of those who in their dreams wander off too far from home. My Grandmother reminded me to stay indoors during those dark nights until the quarter moon takes the shape of a ripe banana. During their nocturnal games they would pluck the beautiful pink and white flowers hanging like frilly bells to sprinkle onto the moist ground. In the early morning even before the sun rose we would hurry to the tree to look for tell-tale signs of ghostly activities of the night before, and we would find large orange leaves strewn all over the ground, having spiraled down to carpet the land around the tangata wotu's hut.

We would reverently gather these leaves, for they were loved by ghosts the night before. The uncontrollable pounding of our hearts blended nicely with the pounding of big waves upon the reef's edge. The purpose for gathering together dozens of these large leaves was to count the number of red spots on each one, bruises we believed were ghostly love bites for they looked exactly like the love bites on our aunties' breasts and on the side of our uncles' necks. We squealed with delight at the idea of ghosts making love, even feeling sensual ourselves, spines tingling as we imagined hairless creatures with dangling bones hugging each other. We competed with each other's stories, becoming more and more romantic with each one told. True to our atoll people we nodded in agreement, and smiled pleasantly that the red spots on yellow leaves were indeed ghost love bites. We were so certain of it.

And, sometimes in the middle of the night we could hear, on the far side of the graveyard, the tangata wotu

chasing after a bony visitor round and round the massive utu trunk. If he should be lucky enough to catch one of them, the island trembled as the rattling bones grappled with the tangata wotu in the dark.

"There he goes again," an old woman would comment for all in the house to hear, as well as those within the safety of thatched roof huts nearby.

"Don't let him fool you, he is pretending to be a hero. Go to sleep," a male voice replied reassuringly.

The tangata wotu was squatting in the entrance to his hut camouflaged in a cloud of rising smoke from a pile of smoldering coconut husk, fanning the fire with a leaf covered in love bites. I nearly giggled at the sight of him with a mottled leaf in one hand, but it would have been disrespectful. "The family needs you right away," I said.

"Yes, it's little Imilia. I have been waiting."

Along the winding narrow pebble path that earlier took me to him, he paused in front of a grave covered with fresh sea pebbles still smelling of the scent of the ocean. Covering his lips with the palm of his right hand, he gestured for me to be quiet. Then he picked up the tail end of a coconut frond and smacked the fresh white sea pebbles covering the grave again and again, all the while moving towards the upright sea stone where he thrashed it many times.

"You pig!" he squealed, for he was a little man and his voice was not like that of my uncle who would have growled! "You Satan! You promised you would behave. Don't let me see you near that house or I'll have you dug up and turned upside down so you'll never move again!"

At the end of the winding path was another sea slab headstone decorated with gardenias, and though he did not stop to look at it, he nevertheless swiped at it with the tip of the coconut frond.

"He stole her from me. He's having a hard time getting to be where we'll be one day, I am told."

In the entrance to Grandmother's house the tangata

wotu lowered himself onto a mat, crossing his legs one on top of the other before slithering gracefully on his bony bottom like a legless man toward Imilia. His half-naked skinny body reeked of an odor reminiscent of coconut cream fermented in the fat of common beach crabs. Grandmother muttered that the smell was enough to chase helpful spirits to kingdom come. The women covered their mouths to hide their mischievous grins.

"You are kind to come to us," Imilia's mother whispered.

From a green bottle the tangata wotu trickled drops of coconut oil onto Imilia's naked stomach, then his supple bony fingers tip-toed like a crab up to Imilia's nipples then down below the navel, now and again to pause for a while, steady as the lizard staring down from the thatched ceiling.

Then we lost him to a realm beyond the reach of our understanding.

A breeze entered the room, as is often the case when a tangata wotu is in a trance making contact with his friends. It stirred the sacred silence; it whizzed around the room touching each one of us lightly on the cheek before undulating its way through a gap in the overhanging leeward thatched wall.

"It's almost too late to fix the harm done. I know which of the rascals is responsible; I will visit his grave tonight. Continue to pray."

"What do you mean it's too late?" Aunt Pati blurted.

The women wailed, then chanted and wailed again, a forewarning quavering chorus of death. Confused, Imilia gazed up at the tormented faces looking tearfully down at her gaunt cheeks.

The following day I joined Grandmother in the family cookhouse by the sea, where she was dutifully rocking Imilia in her arms to the rhythm of a chant. I crawled silently on my hands and knees to her side, then, closing my eyes I tried to enter her world, but to no avail. Perhaps that is the price I have to pay for leaving my atoll—never to be able to reach

those who were in the world beyond.

"Look at me, child, not at them. Do not surrender. You are a hero. You are the daughter of Watu Manava Nui who had eight hearts. Here, Tiané, take her from me, I must clean this place of them. Now that the moon is full, the next three nights are when spirits wander more than on any other moon nights."

Then, with a coconut broom, she swiped at the air, attacking any lurking uninvited visitors. There was not a part of the house she did not reach out to. It was the first time that I have seen my Grandmother behaving like a crazy woman. Bending down she began to sweep the floor of ghost bones, or kidnappers, as she sometimes called them.

The make-believe drama livened Imilia, as it was meant to do. She reacted nicely to the swishing of the broom in mid-air and the rattling of white pebbles as the broom swept the "beggars" out through the entrance way. Imilia followed every move with a smile, now and again bursting into hysterical laughter.

"Aue!" Grandmother cried. "She has become spirited." Kneeling over the smiling Imilia she said, "I know you're a hero; don't you die on us."

The rain drops began splattering on the lagoon's surface at dusk. No one bathed in it for there was no glowing sunset. The rains came down in a fury, as if angry at us. Then, near dawn, a rooster crowed, followed by many more. It was then my nephew was seen running from house to house respectfully announcing the death of Imilia, followed by ear-piercing outbursts of women wailing, a haunting chorus trailing on the heels of the young man as he led them to Imilia.

Nestled in the corner of our cookhouse by the sea, leaning against a polished pandanus post, a feeling of relief came upon me that it was, perhaps, time that one of ours should come and carry Imilia away to our paradise, that it would only be a temporary separation before we would touch noses again, anyway.

Grandmother, with Aunt Pati by her side with Imilia tightly held in her arms, had covered her head with one of Imilia's floral dresses, rocking back and forth as she whimpered in and out of a chant reminding us of the beauty and innocence of children.

Lovingly made comfortable on a pandanus mat woven especially for her, clothed in white fine lace reminding me of a cluster of Barringtonia flowers plucked from the tree where ghosts play, she was poised in death.

The tangata wotu sat cross-legged in his usual fashion in the far corner of the room, his wrinkled eyelids shut in meditation. He had fitted himself discreetly amongst the mourners. He only spoke once to assure us that she had been safely carried to Po. While the chaotic flow of chants from the women heightened, the men were outside the thatched roof house sheltered in the shadows of coconut trees hurriedly crafting a coffin for Imilia out of boxes that once contained forty-eight cans of condensed milk.

We covered her with atoll sandy soil close to the revered giant utu where our tangata wotu lived, for we wished her to be looked after by him. Though we knew that she was on her way to Po holding hands with one of ours, we stayed longer beside the grave, for we needed to be there until she freed us from her.

The village wept. Tears in time were collected by a passing storm during its hurried visit amongst the houses on the evening after we sealed the grave with sandy soil. The wind and rain cooled us. As it traveled westward this massive body of rain and wind separated itself into little individual weaklings, blindly hurrying to blend into the setting sun before he dips gracefully out of sight, dutifully splurging the green, teasing, instant of farewell as he joins Imilia.

No'o ai koe wakalelei e Imilia, taku yana tama wawine. (Sleep prettily my precious Imelia.)

Aue...

The people wailed in silence, frightened that they may be heard and again condemned to hell for believing

wrongly: always, then, to themselves.

What to do? Move on, they were commanded.

But we like the steadiness of our lives.

The tangata wotu, between then and now, found ways to oblige the demands of the new god's missionaries, while, at the same time quietly continuing to support the ancestral and cultural practices expected of them.

"Is this the beginning of us?"

"Maybe…"

"What are you talking about?"

"You fool—don't you sense the new god's purpose? We will no longer see, in the same way, the sun's early light as it excites the wits of the coconut trees to a wind dance."

"It will be different, you mean?

"Yes, the new god."

"Oh! That's the word they scream about, almost choking themselves."

"The large stone embedded in the mound of dirt between the two taro patches isn't looking safe anymore. One of them said that it was the devil—a sin even to go near it. Its nobility, its beautiful roundness and strength—it is now being called a sinful thing! What is sin, anyway? Are we so ignorant that our thoughts are not worthy of them?"

Our beloved and revered tangata wotu were shamed as criminals. Their deep-rooted knowledge of natural medicine, their behavior—beneficial or harmful toward the spirit of the departed—was condemned by the early missionaries as primitive nonsense. You see, those newly arrived servants of foreign religions did not understand, nor were they taught to respect, that of which they had no understanding. So began their task of destroying the very essence of our deep rooted connection to things spiritual; a culture of believing in the wonders of nature just wouldn't do! The old had to be wiped clean in order for the new to take its place. There was no love shown, but severity ruled the mind on the journey to loyalty for the new god.

Within the confines of their thatched roof houses my

people talked to each other when the white people were asleep: "They are telling us that because we are bad, when we leave this world we will be sent to a chief whose name is Satan. He will burn us forever and ever. No chance to explain. They describe his fire as one whose flames burn furiously, reaching the sky...yet it is in the underworld."

"Let's hope it is not close to Po. We better change our ways; burn the wooden gods and roll the sea boulders behind the big tamanu tree in the forest, where the low-lying branches of the puka tree will hide them from view—and us when we visit them. It seems, from what they preach, that we have been godless. So confusing! What will happen to our tangata wotu who takes good care of us, who chases away the evil spirits and cures us of sickness? He has been put in the rubbish alongside the carcasses of coconut crabs and fish bones. He is our holy medicine man. How can they do this?"

The people cried at first as silently as possible so they would not be sent to Satan. They sneaked in the night to the god hidden among the branches of the puka tree, sobbing because there was a choice that did not make sense—that the one hidden in the forest, covered in fallen blossoms, was touchable, where the other had no face.

We have to grow up, they say...

Aue.

Atawai.

44

EPILOGUE

Carl and I had four children, the last one born in New Zealand where we'd decided we wanted the children to be raised. Our children are Ropati, Carla, Haumea and Stirling. Carl and I are no longer married, but remain close friends.

Throughout my life I have maintained a journal in which I recorded my daily experiences. This practice was a legacy from my father and has provided the basis for my stories and books. My second book, *Frisbies of the South Seas* (1959), was also autobiographical, and was written in Hawai'i after my father's death. Subsequent writings include an account of my return to Puka-Puka and reunion with my Grandmother (*Atlantic Monthly*, 1965)—included here in the previous chapter; newspaper columns about life in the Pacific (*The Mirror, 1978*); and numerous short stories about children's experiences of life in the Pacific that were published by the Department of Education in Wellington, New Zealand.

As for my sisters, Nga married Adam West, movie and television actor, probably best known for his role in the ABC television series *Batman*. Adam and Carl were acquaintances. Nga gave birth to Hunter and Jonelle who now live on the Big Island of Hawaii. Elaine married Don Over. Between them they created a rare treat for tourists and locals—the Puka-Puka Otea show at the Queen's Surf in Waikiki.

Elaine gave birth to sons Tai and Tau. The marriage ended, and Elaine then married Marine Captain Robert Werts and gave birth to a daughter who they named after our mother Ngatokorua.

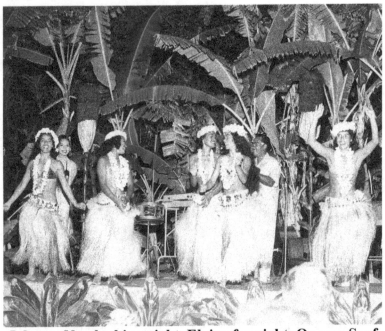

Johnny, Nga looking right, Elaine far right. Queens Surf Luau, 1956.

Elaine now lives in California, and my brother Charles lives in Puka-Puka. When a man reaches the age of eighty years, rare among our people, he is considered a *Wola*.

As a Wola he is treated like royalty to the end of his life. He is respected, and served for dinner the most sought after, mouth-watering part of a tuna fish—the belly flaps. Life for Charles on our atoll is heavenly.

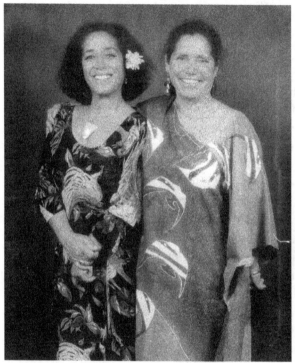

Johnny and Elaine 1998.

My dear brother Jakey and sister Nga are with our parents in Po.

Just recently I participated in a documentary film, *Homecoming: A Film About Puka-Puka*, to be released in 2016. I am hopeful that it will highlight the plight of the Puka-Pukan people (and other atoll island dwellers) facing the consequences of global warming and sea level rise. Of course, I continue to write and will do so until the final curtain falls on my earthly act and I set off on my own voyage to Po.

Glossary

Akairo (Rarotongan): To make a mark so not to be forgotten.

Atawai Wolo (Puka-Pukan): Thank you.

Aue (Puka-Pukan): Exclamation expressing surprise, joy, sadness, etc.

Barringtonia: A genus of flowering trees found in Africa and the Pacific.

Burns, Philp and Company Ltd.: Once a major Australian shipping line and merchant company.

Cavalla: King mackerel.

City of Brass: A story in the *Thousand and One Nights.*

Cocolelé: A type of coconut shell ukulele.

Dinkum (Australian): Authentic, genuine.

Full stop (British): A period at the end of a sentence.

Guettarda (Puka-Pukan): A tree in the family *Rubiaceae* whose wood is used for making local canoes and wooden bowls; leaves for wrapping food; blossoms added to coconut oil gives it fragrance.

Kaikai (Puka-Pukan): Food.

Lavalava (Samoan): A colorful fabric traditionally worn around the waist by Polynesians.

LMS: London Missionary Society.

Mako (Puka-Pukan): A poetic style of chanting.

Malau: A seaport in the Fiji island of Vanua Levu; a red squirrel fish.

Mana (Puka-Pukan): Power.

Nonu: Indian Mulberry tree (*Morinda cirifolia*), fruit and leaf used for medicinal purposes.

Natara: Rock grouper.

Offing. (English): A nautical term for a position offshore where a vessel might lie before anchoring or unloading cargo.

Pandanus (tree): *Pandanus tectorius*, or Screwpine, is native to eastern Australia and the Pacific islands.

Pemphis (bush): Pemphis is a genus in the family of *Lythracea*, and is found in tropical and subtropical areas.

Pito (Puka-Pukan): Umbilical cord.

Po (Puka-Pukan): Afterlife, home of deceased, sometimes referred to as the underworld.

Sulu: A Fijian lavalava."

Sirens: In Greek mythology, sirens were beautiful but dangerous creatures, formerly handmaidens to the goddess Persephone, who used their beautiful voices to lure sailors to their doom.

Tangata wotu (Puka-Pukan): Medicine man, witch doctor.

Tamanu (Rarotongan, Wetau in Puka-Pukan): The Alexandrian Laurel, *Calophyllum inophyllum* A large flowering tree common in Africa and the tropics; known by many different names. Wood excellent for canoes, seeds used as marbles.

Topee (British): Pith helmet, worn in tropics as sun protection.

Uto (Cook Islands): A coconut that has sprouted; the white spongy kernel inside a sprouting coconut.

W.C. (British): Water closet (toilet).

Wola (Puka-Pukan): The oldest person on the island; a respected elder.

Yaqona (Fijian):Called *Kava* in Tonga and other islands, it is an intoxicating beverage made from *Piper methysticum*.

Notes

1. The first edition of *Miss Ulysses from Puka-Puka* was published by the Macmillan Company in 1948. I'm thankful that they saw fit to support a young unknown writer.

2. Chapter 43 is adapted from Frisbie, Florence (Johnny), "Mama Tala," *Atlantic Monthly*, February 1965, Volume 215, Number 2, pages 69-74.

3. Hall, James Norman: He was co-author of *Mutiny on the Bounty* and other books. He was a friend of my father Robert Dean Frisbie, and helped the family many times.

4. Luke, Sir Harry: Sir Harry was a former British diplomat and governor of Fiji; also author of "*The British Pacific Islands, From a South Seas Diary,* and other books.

5. Michener, Lt. James: While serving in the Navy during WWII in the Pacific, Jim Michener flew with Robert Dean Frisbie to a hospital in Samoa when he was critically ill. Michener is known as author of *Tales of the South Pacific* and forty other books.

6. Dixon, Pastula, and Aldrich: See Chapter 27. These airmen crashed at sea during WWII. The pilot, Harold Dixon, navigated their ungainly 8-ft inflatable raft over one thousand miles from the crash site to Puka-Puka, where they were rescued. Their dramatic story is told in *The Raft,* by Robert Trumbull, 1942, New York: Henry Holt and Company

Acknowledgments

Thank you, atawai wolo, and meitak ma'ata! To many long-time friends who awakened me from a long slumber, in fact, they pestered me to "do something about that book of Puka-Puka." Then along comes Cosette Harms of Lanikai who introduced me to my publisher Craig Smith, whose instant enthusiasm and tactful editorial guidance nudged me along to make this second edition possible. Atawai solo, Keleki. Ken Windsor supplied a photo of me in Rarotonga in 1948. John Lockwood in Ventura, California, rejuvenated many of my old but treasured photographs. Mark Neal, also from Ventura, kindly made a very exciting new map for the second edition. Don Long of Wellington, New Zealand, publisher, *South Pacific Press* who, in 1992, convinced me to write stories for young readers and helped me make it happen. I'm grateful to Michael Uhlenkott who in 1996 came to Rarotonga to plan an event that would consist of a family reunion and exhibition of never-before-seen memorabilia, photographs, manuscripts, art and historical documents at the National Library of the Cook Islands. Also, Gemma Cubero del Barrio of Talcual Film for stirring memories of long ago, and with Amelia Hokule'a Borofsky, were my companions on a return visit to my ancestral home in 2015. Liz Bennets of Christchurch, Jean Mason of Rarotonga, Leo and Alison Anderson of Corona del Mar, Ken McHenry of Provo, Utah—how lucky I am to be able to relish your friendship. Also long time friend Marivee McMath of Christchurch, New Zealand, who knows better than I where a semi-colon is most comfortable. Aloha to the Frisbee-Frisby-Frisbie Clan of our great country. Finally, I acknowledge the continuous support of Carl, Ropati, Carla, Haumea and Stirling, big hearted sister Elaine and our (tuakana eldest brother) Charles. May you, dear Reader, experience moments of pleasure, such as swimming in the soothing lagoon of Suvorov, munching a uto, drinking the juice of a young coconut, or just dozing under the waving fronds of a coconut tree, from the pages of Miss Ulysses of Puka-Puka…

For Further Reading: Other Books by Florence
(Johnny) Frisbie and Robert Dean Frisbie

By Florence (Johnny) Frisbie:
Miss Ulysses from Puka-Puka (1946)
The Frisbies of the South Seas (1959)

By Robert Dean Frisbie
The Book of Puka-Puka (1929)
My Tahiti (1937)
Mr. Moonlight's Island (1939)
The Island of Desire (The Story of a South Sea Trader)
(1944)
Amaru: A Romance of the South Seas (1945
Dawn Sails North (1949)

CPSIA information can be obtained
at www.ICGtesting.com
Printed in the USA
LVHW04s0441240718
584738LV00006B/20/P

9 780692 646960